Graphic Women

GENDER AND CULTURE

‖‖‖‖‖‖‖‖‖‖‖‖‖

GENDER AND CULTURE
A SERIES OF COLUMBIA UNIVERSITY PRESS

||||||||||||||||||||||

Nancy K. Miller and Victoria Rosner, Series Editors
Carolyn G. Heilbrun (1926–2003) and Nancy K. Miller, Founding Editors

CONTINUED ON PAGE 299

Hillary L. Chute

Graphic Women

LIFE NARRATIVE AND CONTEMPORARY COMICS

COLUMBIA

UNIVERSITY

PRESS

NEW YORK

Columbia University Press
Publishers Since 1893
New York Chichester, West Sussex

Columbia University Press is grateful for a subvention from the David L. Kalstone Memorial
Fund of the Rutgers Department of English toward publication of this volume.

Library of Congress Cataloging-in-Publication Data
Chute, Hillary L.
 Graphic women: life narrative and contemporary comics / Hillary L. Chute.
 p. cm. — (Gender and culture)
 Includes bibliographical references and index.
 ISBN 978-0-231-15062-0 (cloth: alk. paper)—ISBN 978-0-231-52157-4 (e-book)
 1. Comic books, strips, etc.—History and criticism. 2. Women in literature. 3. Women
cartoonists. 4. Women in art. I. Title. II. Series.

 PN6714.C49 2010
 741.5′973—dc22

 2010000458

Casebound editions of Columbia University Press books are printed on permanent
 and durable acid-free paper.
Printed in the United States of America
c 10 9 8 7 6 5 4 3 2 1
p 10 9 8 7 6 5 4 3 2 1

Designed by Lisa Hamm

THIS BOOK

IS DEDICATED

TO MARIANNE,

CAROLYN,

AND HARRIET

Contents

Preface

G raphic narratives are not as constrained as most contemporary literature in the matter of publication size. The proportions of texts in the field vary greatly. For example, Art Spiegelman's *Maus* is small, "digest sized"; his *In the Shadow of No Towers* is comparably huge, "broadsheet sized"; a recent issue of the comics anthology *Kramers Ergot* (no. 7) appears at 16 by 21 inches.

The importance of the size of pages and panels in comics is one that came to me more gradually than it should have. Writing about *Maus* several years ago, I had already discussed how crucial the one-to-one ratio of composition and product is for that work (in other words, Spiegelman drew it the same size that it appears to readers), when I learned that Spiegelman had taken legal action against the publisher of a coffee table book for, among other reasons, enlarging a page from *Maus II* that shows Hungarian Jews burning alive in a pit in Auschwitz. I realized then that I myself had enlarged this very same image in my own (as yet unpublished) work on the text. The size of an image is constitutive of its meaning, of how it functions.

Therefore, all the images here, insofar as it is possible, are reproduced at or close to their actual size. I have not enlarged any images (in a very few places, such as with Lynda Barry's 14-by-11-inch *Naked Ladies* images, it was necessary to reduce them simply so they could fit on the page). I also insist on the importance, in order to facilitate access to those images that are part of my discussion, of placing figures within each chapter as the chapter unfolds, as opposed to aggregating them at the book's center or in an appendix. In analyzing comics, one needs to be able to quote an image, just as in analyzing poetry one needs to be able to quote lines from a poem. Last, I am grateful to be able to reprint in color all comics work created in color (these images appear first in black and white within the text and then again as color images in a section of color plates).

Acknowledgments

The most important thank you goes to my parents, Richard and Patricia Chute, for their unstinting support of my intellectual endeavors and their constant willingness to talk to me about all aspects of my work. Marianne DeKoven, Carolyn Williams, and Harriet Davidson made this book possible. The adage deserves repeating: the good ideas are theirs; the mistakes mine. I am deeply inspired by each of them, as scholars, teachers, and people. Their grace, generosity, and perspicacity are a model and a motivating factor for me in all aspects of my life, professional and otherwise. I am also grateful for the friendship and intellectual support of Richard Dienst, who helped me develop much of the language that shaped my sense of my own writing. At Rutgers, I would also like to thank John McClure and Elin Diamond, from whom I have learned considerably, as well as Cheryl Robinson and Eileen Faherty.

At the Society of Fellows at Harvard, I wish to express my immense gratitude to Diana Morse (thank you also to Amy Parker, Frances Danilkin, and Kelly Katz). I have benefited hugely from conversations with and the friendship of Dan Aaron, Greg Nagy, Peter Galison, Jurij Streidter, and Nancy Cott, who invited me to give the 2007–2008 Schlesinger Lecture at Radcliffe on the subject of this book. I am lucky to have had such a rigorously engaged audience at the University of Chicago when I went to the English Department in January 2009 to talk about *Fun Home*. The comments and questions I received while at Chicago profoundly shaped my thinking about chapter 5, and I am grateful in particular to Bill Brown, Tom Mitchell, Debbie Nelson, Leela Gandhi, and Janice Knight. I would also like to thank Andy Hoberek for inviting me to speak at the Post.45 conference at Yale in 2008 and giving me the opportunity to try out ideas that became a part of the *Fun Home* chapter.

An enormous thank you to Lynda Barry, Alison Bechdel, Phoebe Gloeckner, and Aline Kominsky-Crumb for their extraordinary goodwill in allowing

me to interview them extensively. I would also like to thank those cartoonists and comics-world denizens who aren't covered in this book, but whose conversations with me have shaped my thinking about comics: Charles Burns, Scott McCloud, Françoise Mouly, Joe Sacco, and Chris Ware. Art Spiegelman deserves a special thank you here. I am grateful to have him as an interlocutor. I immensely appreciate how giving and enlightening he has been in discussing his work, and comics generally, with me. Even when we disagree, it's an interesting conversation. He is one of the most astute, inspiring, and intellectually generous people I know.

Ed Park assigned and edited my feature on *Fun Home* in the *Village Voice* back in 2006. Writing this piece for—and basically kind of *with* Ed, as we were in constant contact about the book—was one of the most valuable writing experiences I've had. I am further grateful to my editors at the *Believer*—including Ed, Vendela Vida, and Andrew Leland—for supporting my work, including publishing my interviews with Lynda Barry, Phoebe Gloeckner, and Aline Kominsky-Crumb. Thanks to Million Year Picnic in Cambridge, Massachusetts, where I first discovered many of the comics I write about here; to Bill Kartalopoulos for practical support and conversations about comics; to Kelly Bowse (spring 2008) and C. Ché Salazar (spring 2008–winter 2010) for crucial research assistance; to Maggie Doherty for proofreading; to David Merrill and Amir Mikhak for technical assistance; to Geraldine Kelly for longtime help; to Bruce Smith for teaching "The Red Comb" in my creative writing class at Andover; and to my own often brilliant students at Rutgers in a number of courses: "Principles of Literary Study: Narrative," "Contemporary Fiction," "Contemporary Graphic Narratives," "Readings in Theory: Visuality," "Topics in Genre: Literature, Gender, and the Visual," and "Feminist Literary Study."

I wish to thank Nancy K. Miller and Victoria Rosner, editors of the Columbia University Press's Gender and Culture series, of which I am proud to be a part, for their engagement and advice at every stage of the project, and my editor Jennifer Crewe for her guidance and patience, along with CUP's Afua Adusei-Gontarz and Susan Pensak. In addition to her early enthusiasm, Nancy's own scholarship on comics and life narrative, along with Marianne Hirsch's, has been very important to me. I am also grateful for the institutional and financial support I received for this book, including the David L. Kalstone Memorial Fund Award from the English Department at Rutgers University in 2008 (thank you to John Kucich, Meredith McGill, and, most important, Richard E. Miller for facilitating this award); a Milton Fund Fellowship from Harvard University in 2008; and subvention funding from the Society of Fellows at Harvard University, made possible by the generosity of chair Walter Gilbert in 2009.

This book would not be possible without its images, and I gratefully acknowledge those who made that possible. For the cover, I am obliged to Rutu Modan, along with Eileen Cosenza and Sally Heflin at Heflinreps. Thank you to cartoonists Justin Green, Trina Robbins, and Shelby Sampson for giving me permission to reprint images from their work in the introduction. Thank you to Aline Kominsky-Crumb; Frog/North Atlantic Books; Lynda Barry and Michele Mortimer at Darhansoff, Verrill, Feldman Literary Agency; Pantheon Books/Random House and 2.4.7. Films; and Houghton Mifflin Harcourt, Alison Bechdel, and Redux Pictures, respectively, for permission to use the images in chapters 1–5. A portion of chapter 4 appeared in a somewhat different version as "The Texture of Retracing in Marjane Satrapi's *Persepolis*" in *WSQ: Women's Studies Quarterly* 36.1 and 2 (Spring/Summer 2008): 92–110.

Finally, I wish to extend a thank-you to my friends and colleagues who read and responded to chapters and thus contributed in large part to the texture of the book. Marianne kindly read the entire manuscript, providing her usual valuable advice. So did David Elmer, from whom I've learned a substantial amount and whose own writing I esteem; thank you, D, for taking the time and helping me so much. In addition to numerous early-stage pieces of writing, Brian Norman and James Mulholland each read my initial proposal and the introduction, and Brian also the Satrapi chapter; I hope we continue to share our work, as we have now for almost ten years. Anna Henchman read the Kominsky-Crumb and the Bechdel chapters, in both cases in a pinch; Amy R. U. Squires read the Kominsky-Crumb, Barry, Satrapi, and Bechdel chapters; Hanna Rose Shell read the Gloeckner and the Barry chapters; and each offered key improvements. James, Joe Ponce, and Rick Lee responded usefully to my writing in my beginning stages of thinking through the project. I got a lot of important feedback on the last chapter of the book. Sohini, among others already listed, listened to me read a presentation of my initial ideas. Noah talked to me a lot about *Fun Home* and read the final chapter. Chris Pizzino provided thoughtful, precise, and provocative comments. Anna and David, along with Greg Nagy and Lenny Muellner, the so-called *atelier des anciens et modernes*, offered detailed suggestions.

Boo, it's for you.

Graphic Women

Introduction

WOMEN, COMICS, AND THE RISK OF REPRESENTATION

I n July 2004, the *New York Times Magazine* ran a cover story on graphic novels, speaking of them as a "new literary form" and asserting that comics are enjoying a "newfound respectability right now" because "comic books are what novels used to be—an accessible, vernacular form with mass appeal." However, this lengthy *Times* article virtually ignores graphic narrative work by women: the piece excerpts the work of four authors, all male; depicts seven authors in photographs, all male; and mentions women only in passing: "The graphic novel is a man's world, by and large" (McGrath 24, 30). It would be impossible for anyone to make this comment today, only six years later. Marjane Satrapi's *Persepolis* (2003) and Alison Bechdel's *Fun Home* (2006), both of which are best sellers, are possibly the two biggest literary graphic narratives since Art Spiegelman's world-famous *Maus: A Survivor's Tale*.

Indeed, there is a large field of women creating significant graphic narrative work: in addition to the five authors in the vanguard that this book addresses, there are Jessica Abel (*Mirror, Window; La Perdida*), Gabrielle Bell (*Lucky, Cecil and Jordan*), Lilli Carré (*The Lagoon*), Sue Coe (*How to Commit Suicide in South Africa, Dead Meat*), Sophie Crumb (*Belly Button Comix*), Vanessa Davis (*Spaniel Rage*), Diane DiMassa (*Hothead Paisan*), Julie Doucet (*My New York Diary, 365 Days*), Debbie Dreschler (*Daddy's Girl, The Summer of Love*), Mary Fleener (*Life of the Party: The Complete Autobiographical Collection*), Ellen Forney (*I Was Seven in '75, I Love Led Zeppelin*), Roberta Gregory (*Bitchy Bitch, Bitchy Butch*), Miriam Katin (*We Are on Our Own*), Megan Kelso (*The Squirrel Mother*), Hope Larson (*Salamander Dream, Gray Horses*), Miss Lasko-Gross (*Escape from "Special," A Mess of Everything*), Erika Lopez (*Lap Dancing for Mommy*), Rutu Modan (*Exit Wounds, Jamilti*), Ariel Schrag (*Awkward, Definition, Potential, Likewise*), Dori Seda (*Dori Stories*), Posy Simmonds (*Gemma Bovery, Tamara Drewe*), C. Tyler (*Late Bloomer, You'll Never Know: A Graphic Memoir*), and Lauren Weinstein (*Girl Stories, The Goddess of War*).[1]

Some of today's most riveting feminist cultural production is in the form of accessible yet edgy graphic narratives.[2] While this work has been largely ignored by feminist critics in the academy, interest is now growing from outside the field of comics, as we can see in recent essays in journals such as *Life Writing, MELUS, Modern Fiction Studies*, and *PMLA*.[3] Feminist graphic narratives, experimental and accessible, will play an important role in defining feminisms that could "provide a model for a politically conscious yet post-avant-garde theory and practice" (Felski, *Doing Time* 187).

Specifically, there is a new aesthetics emerging around self-representation: contemporary authors, now more than ever, offer powerful nonfiction narratives in comics form.[4] Many, if not most, of these authors are women. This book analyzes the work of the key women in this growing field, who each present stories that are both written and drawn documents of real events. Inventing and expanding this new aesthetics, their work challenges readers in profoundly different ways. I call these texts graphic narratives, as distinct from the less-inclusive *graphic novel*, and here I place Lynda Barry, Alison Bechdel, Phoebe Gloeckner, Aline Kominsky-Crumb, and Marjane Satrapi alongside each other, probing how and why the stories these authors both tell *and* show could not be communicated any other way.[5] The stories to which women's graphic narrative is today dedicated are often traumatic: the cross-discursive form of comics is apt for expressing that difficult register, which is central to its importance as an innovative genre of life writing. However, the authors do not project an identity that is defined by trauma: they work to erase the inscription of women in that space. And—perhaps most crucially—the force and value of graphic narrative's intervention, on the whole, attaches to how it pushes on conceptions of the unrepresentable that have become commonplace in the wake of deconstruction, especially in contemporary discourse about trauma. Against a valorization of absence and aporia, graphic narrative asserts the value of presence, however complex and contingent.

The authors in this book, like other established names in the graphic narrative field, such as Spiegelman (*Maus, In the Shadow of No Towers*) and Joe Sacco (*Palestine, Safe Area Goražde*), offer the work of retracing—materially reimagining trauma.[6] They return to events to literally re-view them, and in so doing, they productively point to the female subject as both an object of looking and a creator of looking and sight. Further, through the form their work takes, they provoke us to think about how women, as both looking and looked-at subjects, are situated in particular times, spaces, and histories. The graphic narratives I analyze are not only about events but also, explicitly, about *how* we frame them. The authors revisit their pasts, retrace events, and literally repicture them. Spiegelman calls

this "materializing" history, a verb I never fail to find striking (Brown 98). It is not necessarily an emotional recuperation—I always disagree with the idea that these life narratives are "cathartic" or didactic—but a textual, material one.[7] In the following chapters I discuss five women who are political and experimental in diverse ways, but in whose work, across a range of subject matter and stylistic approaches, we may recognize Cathy Caruth's assertion that "to be traumatized is precisely to be possessed by an image or event" ("Trauma and Experience" 4–5). And while each text is anchored differently in traumatic history, each yet insists on the importance of innovative textual practice offered by the rich visual-verbal form of comics to be able to represent trauma productively and ethically.[8] For this reason, graphic narrative, invested in the ethics of testimony, assumes what I think of as the *risk of representation*. The complex visualizing it undertakes suggests that we need to rethink the dominant tropes of unspeakability, invisibility, and inaudibility that have tended to characterize trauma theory as well as our current censorship-driven culture in general. Indeed, each of the five authors I examine here has directly faced censorship at some point in her career.[9]

Graphic narrative designates a book-length work composed in the medium of comics. While the much more common term *graphic novel* has been gaining momentum as a publishing label since the 1980s, I prefer graphic narrative because, as I have explained elsewhere, the most riveting comics texts coming out right now—from men and women alike—are not novels at all.[10] Instead, even as they deliberately place stress on official histories and traditional modes of transmitting history, they are deeply invested in their own accuracy and historicity. They are texts that either claim nonfiction status or choose, as Lynda Barry's invented term "autobifictionalography" well indicates, to reject the categories of nonfiction and fiction altogether in their self-representational storylines.

I am interested in bringing the medium of comics—its conventions, its violation of its conventions, *what it does differently*—to the forefront of conversations about the political, aesthetic, and ethical work of narrative. Unquestionably attuned to the political, these works fundamentally turn on issues of the ethical, in Lynne Huffer's important sense of the ethical question as "how can the other reappear at the site of her inscriptional effacement?" (4). *Graphic Women* explores this notion of ethics as it applies to autobiographical graphic narrative: what does it mean for an author to *literally* reappear—in the form of a legible, drawn body on the page—at the site of her inscriptional effacement? Graphic narrative establishes what I here, writing about Marjane Satrapi, term an expanded *idiom of witness*, a manner of testifying that sets a visual language in motion with and against the verbal in order to embody individual and collective experience, to put contingent selves and histories into form. The field of graphic

narrative brings certain key constellations to the table: hybridity and autobiography, theorizing trauma in connection to the visual, textuality that takes the body seriously. I claim graphic narratives, as they exhibit these interests, "feminist." All of the authors I discuss here investigate concerns typically relegated to the silence and invisibility of the private, particularly centered on issues of sexuality, and all address childhood trauma.

The medium of comics can perform the enabling political and aesthetic work of bearing witness powerfully because of its rich narrative texture. In *Sexuality in the Field of Vision* Jacqueline Rose writes that the encounter between psychoanalysis and artistic practice draws its strength from "repetition as insistence, that is, as the constant pressure of something hidden but not forgotten—something that can only come into focus now by blurring the fields of representation where our normal forms of self-recognition take place" (228). This repetition is manifested with particular force in the hybrid, visual-verbal form of graphic narrative where the work of (self-) interpretation is literally visualized; the authors show us interpretation as a process of visualization.[11] The form of comics has a peculiar relationship not only to memoir and autobiography in general, as I will note, but also to narratives of development. Additionally, comics and the movement, or act, of memory share formal similarities that suggest memory, especially the excavation of childhood memory, as an urgent topic in this form. Cartoonist Chris Ware suggests that comics itself is "a possible metaphor for memory and recollection" (xxii). Images in comics appear in fragments, just as they do in actual recollection; this fragmentation, in particular, is a prominent feature of traumatic memory.[12] The art of crafting words and pictures together into a narrative punctuated by pause or absence, as in comics, also mimics the procedure of memory. These connections establish the groundwork for childhood, then, as well as the specificity of childhood trauma, to assume a primary place in graphic narrative.

In all these works there is a first-person narrator who is graphically visible on the page, all these works deal with violence, and all make a political intervention into mainstream representation through their form. The types of challenging images that we see in women's graphic narrative are not found anywhere else—or anywhere else on a contemporary *post*-avant-garde horizon.[13] Sex activist Susie Bright, for one, argues that the form of comics provides an invaluable space for nuanced representations of desire: "*There is literally no other place besides comix* where you can find women speaking the truth and using their pictures to show you, in vivid detail, what it means to live your life outside of the stereotypes and delusions" (7; emphasis mine).[14] A large part of this nuanced representation, then, includes images that claim political resonance by eschewing an obviously

"correct" feminist sexual politics. This may explain why women's work—which here is often feminist work—is distressingly underrecognized in the emerging field of literary comics. Given the (gendered) suspicion of memoir generally, and especially of the supposedly "extreme" or too divulgent memoirs of women, this may also explain why the idea of such memoirs with the additional element of the visual does not easily win attention.[15] The visual register itself is often seen as "excessive."

Marjane Satrapi's account of her youth in Tehran, *Persepolis*, along with work by a range of American authors, exemplifies how graphic narrative envisions an everyday reality of girls' and women's lives, picturing what is often placed outside of public discourse. Unsettling fixed subjectivity, these texts present life narratives with doubled narration that visually and verbally represents the self, often in conflicting registers and different temporalities. All the authors I discuss write, if not for the duration of their narratives, then at least for a significant portion, from the perspective of a child. They use the inbuilt duality of the form—its word and image cross-discursivity—to stage dialogues among versions of self, underscoring the importance of an ongoing, unclosed project of self-representation and self-narration. In Phoebe Gloeckner's *The Diary of a Teenage Girl* (2002), for instance, as I will discuss in chapter 2, the prose text expresses the perspective of a child self, while the interruptive *visual voice* of the book expresses the perspective of an adult self who recollectively frames the narrative's events in a different light than the child narrator does, mobilizing a tacit conversation across media between different versions of self. This emphasis on the child affords a conspicuous, self-reflexive methodology of representation. It is a way to visually present a tension between the narrating "I" who draws the stories and the "I" who is the child subject of them. In the autobiographical investigations of Gloeckner, Kominsky-Crumb, Barry, Satrapi, Bechdel, and other feminist authors, the comics form not only presents a child protagonist and an adult narrator but also gives voice simultaneously to both perspectives, even within the space of a single panel, layering temporalities and narrative positions. In each of these works we are shown the process of an author interpreting her memory, her recollections, as a visual procedure. Through its hybrid and spatial form, comics lends itself to expressing stories, especially narratives of development, that present and underscore hybrid subjectivities.

The medium of comics (which Scott McCloud is correct to note is "plural in form, used with a singular verb") compels because it is so capacious, offering layers of words and images—as well as multiple layers of possible temporalities—on each page (*Understanding* 9). Comics conveys several productive tensions in its basic structure. The words and images entwine, but never synthesize.

The frames—which we may understand as boxes of time—present a narrative, but that narrative is threaded through with absence, with the rich white spaces of what is called the gutter.

Comics shapes stories into a series of framed moments, and this manifest contouring creates a striking aesthetic distance. Yet this distance is counterbalanced by the act of reading and looking at a text that is entirely handwritten, which creates an intriguing aesthetic intimacy. (I am interested in work—unlike what is produced in the commercial comic book industry—in which the same hand is responsible for both the drawing and the writing.)[16] The medium of comics is not necessarily about "good drawing"—"It's just an accident when it makes a nice drawing," Spiegelman explained to a curator at the MoMA—but rather about what Spiegelman calls *picture-writing* and Satrapi calls *narrative drawing*: how one person constructs a narrative that moves forward in time through both words and images ("Art Spiegelman" 27; Spiegelman, "Comics"; Hill 11). I am fascinated not only by *how* authors construct narrative this way but also *why*: What is it that the idiom of comics offers, and what kinds of stories get told, and shown, in this way? What is gained from this hybrid form of expression? And why—especially since comics comes up against the conventional understanding that the system of *drawing* must be inherently more "fictional" than the system of *writing*—are there so many nonfiction works, especially about trauma, in comics?

As I have noted, the authors grouped in *Graphic Women* offer diverse methods for visualizing their lives and histories. One register of this is graphic style—what cartoonists call the *hand* of a particular creator. While all make forceful use of the multilayered narrative techniques enabled by the comics form, such as the copresence of child and adult narrators and the dialogic relationship of word and image, these authors' approaches to graphic representation vary from hyperexaggerated impressionism (Kominsky-Crumb) to the devastatingly "realistic" (Gloeckner) to proliferative collage (Barry) to minimalist expressionism (Satrapi) and brisk black line art that combines fine detail with cartoon flourishes (Bechdel). Further, all five authors manifest an awareness of the lines of fiction and nonfiction as discursive and their blurring as productive; destabilize the coherence of the subject over time through the presence of visible adult narrators on pages that depict that same narrator in the past; and self-reflexively call attention to the construction of their respective texts, presenting temporal layers of experience while refusing to reify "experience" as the foundational precept of feminist critique.[17] The styles and the narratives of these important feminist texts have been, in some cases, misunderstood as merely "childish"—as merely compulsive, even as repulsive. I counter these misreadings and I argue that feminist

graphic narrative intervenes in the field of contemporary literature, in the new field of graphic narrative, and in the broader study of visual culture, suggesting the enabling role of the visual in self-articulation and in representing the processes of memory, especially traumatic memory.[18]

AN ELLIPTICAL FORM

We have seen several definitions describe the form's fundamental procedures and possibilities in the years since the capacities of comics have become a focus for scholars and critics.[19] Scott McCloud, whose *Understanding Comics* is one of the most widely cited works of comics theory, places emphasis on sequence as the defining principle, as do many other scholars.[20] McCloud's definition opens with the idea that comics is made up of "juxtaposed pictorial and other images in deliberate sequence" (9). Scholars like Robert Harvey, though, emphasize instead the presence of both word and image as the defining feature of comics ("Comedy" 75–76) and further call attention to the print context that is essential to comics, putting its roots, then, in increases in the circulation of print in the eighteenth century.[21] The debate on what comics *is* in this sense has been staged by scholarly volumes such as Robin Varnum and Christina Gibbons's *The Language of Comics: Word and Image*, among others. But, while such disagreements and debates continue, the positions represented by McCloud and Harvey need not be thought of as contradictory.

Rather, there are several key guiding notions, less mechanistic than ostensibly all-encompassing definitions, that are crucial to thinking through the difference of comics from other narrative forms. Perhaps the most basic is that the syntactical operation of comics is to represent "time as space." Spiegelman articulates it well when he suggests that comics works "choreograph and shape time" ("Ephemera" 4). The way that time is shaped spatially on a page of comics—through panel size, panel shape, panel placement, and the concomitant *pace* and *rhythm* the page gestures at establishing—is essential to understanding how comics works. (For this reason, cartoonists such as Chris Ware and Ben Katchor, among others, have compared the form of comics with music, with its beats and syncopation, and the orchestrated tension of its various phrases and parts; I tend to think, further, of the counterpoint between presence and absence in comics as an essentially musical idea.) Because comics represents time as space on the page, additionally, authors such as Spiegelman have been able to push on the conventions of comics' spatial representation to powerful effect by, say, palimpsesting past and present moments together in panels that are traditionally understood to represent only one temporal register.[22]

The notion of representing time as space on the page also points up one of comics' most compelling aspects—especially when the form is used to recount narratives of the past. As McCloud explains:

> In every other form of narrative that I know of, past, present, and future are not shown simultaneously—you're always in the now. And the future is something you can anticipate, and the past is something you can remember. And comics is the only form in which past, present, and future are visible simultaneously. . . . You're looking at panels, which, if you're reading panel two on page two, then to its left is the past, and to its right is the future. And your perception of the present moves across it.
>
> (Chute, "Scott McCloud" 84)

The movement of the eye on the page instantly takes in the whole grid of panels and its particular opening elements at once; comics suggests we look, and then look again. In this sense, it builds a productive recursivity into its narrative scaffolding. This duality—one's eye may see the whole page even when one decides to commence reading with the first box of the first tier—is a defining feature of comics, which lays out its temporal unfolding in juxtaposed spaces on the page, as opposed to say, film, which McCloud reminds us is a "very, very slow comic" before it is projected and then establishes continuity of time through the persistence of vision (*Understanding* 8).[23]

A brief elaboration of the basic structural differences between comics and film points to the former's particular value for articulating a feminist aesthetics. Comics is composed in frames—also called panels—and in gutters. The effect of the gutter, the rich empty space between the selected moments that direct our interpretation, is for the reader to project causality in these gaps that exist between the punctual moments of the frames. While all media forms are, to an extent, framings, in its narrative movement across printed pages, comics claims and uses the space surrounding its material, marked frames in a way that, say, painting cannot. As McCloud points out about this element of absence, "what's between the panels is the only element of comics that is not duplicated in any other medium" ("Scott McCloud: Understanding Comics" 13).

There are obvious similarities between comics and film in terms of framing. A film, before it is shot, goes through the process of storyboarding, in which it is essentially configured in the form of comics: the camera shots are sketched out as frames, in sequence. Yet comics is not a form that is experienced *in time*, as film ultimately is. That it cedes the pace of consumption to the reader, and begs rereadings through its spatial form, makes comics a categorically different visu-

al-verbal experience for its audience. Releasing its reader from the strictures of experiencing a work in a controlled time frame can be a crucial, even ethical difference, especially in presenting traumatic narratives that may include disturbing images. Comics avoids the manipulation often associated with film—in which the camera might linger on an image of atrocity for too long, on the one hand, or wash over it too casually, on the other—by allowing a reader to be in control of when she looks at what and how long she spends on each frame.

One of the important effects of the "time" of comics, then, is slowed-down reading and looking. Comics subvert what cartoonist Will Eisner, speaking disparagingly of film, names its "rhythm of acquisition" (*Graphic Storytelling* 5). The diegetic horizon of each page, made up of what are essentially boxes of time, lends graphic narratives a representational mode capable of taking up complex political and historical issues with an explicit, formal degree of self-awareness, which explains why historical graphic narratives are the strongest emerging genre in the field.[24] Representing time as space, comics situates the reader in space, creating perspective in and through panels. Mila Bongco, then, offers one view of how comics conveys a narrative politics by asserting that, in comics, literally, "discourse becomes a series of views" situating the reader as a spectator in participative readings (58). (Edward Said gives us another way to look at this: writing about the graphic narrative *Palestine*, he describes author Joe Sacco's achievement as the ability to "detain" one on the page [v].) While foundational feminist criticism has detailed the problem of the passive female film spectator following and merging helplessly with the objectifying gaze of the camera, the reader of graphic narratives is not trapped in the dark space of the cinema (or even the voluntary, contingent space of spectatorship generated by her own television or computer). Writing in *Modern Fiction Studies* for a special issue on graphic narrative, Marianne DeKoven and I suggest that, instead, "She may be *situated* in space by means of the machinations of the comics page, but she is not ensnared in time; rather, she must slow down enough to make the connections between image and text and from panel to panel, thus working, at least in part, outside of the mystification of representation that film, even experimental political film, often produces" (770). Hence while the visual form of graphic narrative enables an *excess* of representation (as we will see with representations of sexualized bodies in which the pleasure of looking "tips over" into a different register), it also offers a constant self-reflexive demystification of the project of representation.[25] In graphic narrative the spectator is a necessarily generative "guest" (to borrow Mulvey's term), constructing meaning over and through the space of the gutter.

We may note, then, that the form of comics even at its most basic is apposite to feminist cultural production. It erases, as Jacqueline Rose puts it, "the

familiar opposition between the formal operations of the image and a politics exerted from outside"—and particularly, it adds "the idea of a sexuality which goes beyond the issue of content to take in the parameters of visual form (not just what we see but how we see)" (231). In a discussion of "flash" and "gape" that I read as an articulate description of the effect of the gutter in comics, Roland Barthes writes, "It is intermittence, as psychoanalysis has so rightly stated, which is erotic: the intermittence of skin"—and here I think of the white of the page in between panels—"flashing between two articles of clothing" (*Pleasure* 10). We may understand the very form of comics as feminized, too, not only because of its "low" and "mass" status, but also because of its traffic in space. As William Blake wrote, "Time & Space are Real Beings / Time is a Man Space is a Woman," so W. J. T. Mitchell declares, in his gloss of G. E. Lessing, that "the decorum of the arts at bottom has to do with proper sex roles" (*Iconology* 109).[26] Images are connected, in Mitchell's ledger, with space, the body, the external, the eye, the feminine; words with time, mind, the internal, the ear, and the masculine (110). Mitchell also suggests that, in this schema, blurred genres are feminized, while distinct genres are masculinized. Thus, while we may read comics' spatializing of narrative as part of a hybrid project, we may read this hybridity as a challenge to the structure of binary classification that opposes a set of terms, privileging one.

Comics's hybridity—or, what I have referred to as its cross-discursivity—is also something that we see in its admixture of conventional "high" and "mass" elements. The graphic narratives I discuss here are handmade and yet they are mass-produced. Another feature of the composition of comics, to return to the gloss on key notions, is its *handwriting*, which carries, whether or not the narrative is autobiographical, what we may think of as a trace of autobiography in the mark of its maker.

The form of comics in this way lends itself to the autobiographical genre in which we see so many authors—and so many women authors in particular—materializing their lives and histories. It is a way to put the body on the page (which we see, then, both in terms of denotative content and in production). Alison Bechdel, author of *Fun Home: A Family Tragicomic* (2006), which examines her childhood relationship with her father, says, "I always felt like there was something inherently autobiographical about cartooning, and that's why there was so much of it. . . . It does feel like it demands people to write autobiographies" ("Life Drawing" 37). That the same hand is both writing and drawing the narrative in comics leads to a sense of the form as diaristic; there is an intimacy to reading handwritten marks on the printed page, an intimacy that works in tandem with the sometimes visceral effects of presenting "private" images.

Handwriting underscores the subjective positionality of the author. Emphasizing the handmade aspect of comics, Spiegelman explains that comics is "as close to getting a clear copy of one's diary or journal as one could have. It's more intimate than a book of prose that's set in type. . . . The quirks of penmanship that make up comics have a much more immediate bridge to somebody. . . . You're getting an incredible amount of information about the maker" (*Complete Maus*). Spiegelman points out that James Joyce and Jacqueline Susann can both be set in Times New Roman; I suggest, then, that what feels so intimate about comics is that *it looks like what it is*; handwriting is an irreducible part of its instantiation. The subjective mark of the body is rendered directly onto the page and constitutes how we view the page. This subjective presence of the maker is not retranslated through type, but, rather, the bodily mark of handwriting both provides a visual quality and texture and is also extrasemantic, a performative aspect of comics that guarantees that comics works cannot be "reflowed": they are both intimate and *site specific*.[27] Comics differs from the novel, an obvious influence, not only because of its visual-verbal hybridity but also because of its composition in handwriting.[28]

The works I analyze here are rigorously handmade. They call attention to their craftedness throughout, to their hand-drawn images and hand-framed moments. However, comics is a powerful form precisely because it is also invested in accessibility, in print. Comics works can deliberately disrupt the surface texture of their own pages—often invoking aesthetic practices of the historical avant-garde—yet they model a post-avant-garde praxis in the very fact of their popular availability, in the "mass appeal" of the medium.[29] Unlike McCloud, who chooses not to value print in his definition of comics, this study emphasizes the printing and resultant wide distribution of comics as deeply significant. It is because comics is both a sophisticated and experimental form, and because it has a popular history, that the current work in the field feels so hopeful and invigorating. While graphic narratives may retain the oppositionality inscribed at the level of form that is characteristic of avant-garde production, they refuse the status of art objects.

The cultural connotation, and the very historical definition, of comics points to what is reproducible, reusable, removed from the esoteric "high" sanctity of the unique and the singular. Today, comics auteurs are called cartoonists (I use *cartoonist* and *author* interchangeably here).[30] The word *cartoon* comes from the Italian word *cartone*, which means cardboard, and denotes a drawing for a picture or a design intended to be transferred, historically to tapestries or to frescoes. Yet, when the printing press developed, *cartoon* came to mean any sketch that could be mass-produced. As Randall P. Harrison, author of *The Car-*

toon, explains, "it was an image which could be transmitted widely" (16). This is a notion that the cartoonists in this study embrace; it is resonant with those who value the mass-reproduction of comics—the aspect of the form that has largely kept it from being considered "fine art."

Today, however, most comics authors distinguish the contemporary *cartoon* from the form of *comics*—while *cartoon* denotes a single-panel image, representing one moment, *comics* moves forward in time. Yet the rich history of political cartooning is relevant in a fundamental way to comics. Comics does, as Spiegelman recently pointed out, move toward the discomfiting in how it can both play with and against visual stereotypes ("Comics"). In both cartoons and comics we recognize an immediacy, a process of visual distillation that endeavors to capture the essence of moments, of circumstances, of people.[31] Figures in political cartooning and caricature, then, such as Thomas Rowlandson and James Gillray, in the eighteenth century, and George Cruikshank (who also illustrated Dickens in the nineteenth century), among others, have taken a place in a pre-history of comics.[32] Further, and significantly, the prehistory of today's literary comics ought to include works like Hogarth's sequential pictorial narratives in the eighteenth century, particularly pieces such as "A Harlot's Progress" (1731) and "A Rake's Progress" (1734), whose component frames were designed to be viewed side by side, and Blake's illuminated poetry, in the mid to late eighteenth century and early nineteenth, in which images and words are dependent on each other for full meaning. In the nineteenth century, Goya's Disasters of War series (1810–1820, published 1863), a numbered sequence of eighty-three etchings, pictured the French invasion of Spain and carried captions such as, simply, "This I Saw" and "This Is How It Happened." Goya's goal—to evoke and to show, with handmade images as reporting—is important to contemporary cartoonists as a model for a kind of visual witnessing.

The conventions of modern comics were born with Rodolphe Töpffer, a Swiss schoolteacher working in Geneva in the 1830s, who invented the first stories that combined word and image, and, significantly, used panel borders on the page. He explicitly claimed to be drawing on two forms—the novel, and the "picture-story," as in Hogarth. He earned the admiration of Goethe, who said, "If for the future, Töpffer would choose a less frivolous subject and restrict himself a little, he would produce things beyond all conception" (quoted in McCloud, *Understanding* 17). Töpffer ultimately published eight *histoires en estampes*—works in comics that were referred to as "picture-stories" or "picture-novels" or "literature in prints." In particular, his story *M. Cryptogame*—the first comics work he presented to Goethe, in 1830—was eventually published in the Parisian magazine *L'Illustration* in 1845 and was a public success, having "tre-

mendous consequences for the character and diffusion" of comics, as historian David Kunzle reports in *History of the Comic Strip* (2:65).

But in America, comics has a history that is more demotic. Its inception was in sensational newspapers in New York around the turn of the century. What is widely considered America's first comics work, a strip known as *The Yellow Kid*—which features an obnoxious, ethnically ambiguous child living in a tenement who wears a yellow gown—first appeared in 1896 in Pulitzer's *New York World*, and was such a circulation booster that Hearst's *New York Journal* stole the cartoonist, Richard Outcault, away. The ugly battle over *The Yellow Kid* between Hearst and Pulitzer gave rise to the term *yellow journalism*.[33]

Newspaper comic strips, many of which represent high aesthetic benchmarks, such as in the work of Winsor McCay and George Herriman, were the dominant form of comics work until the 1930s, when comic books, essentially starting with *Superman* in 1938, became the dominant form of American youth culture. In the commercial comic book industry, composing comics was a group endeavor, with the labor frequently divided up among work-for-hire teams for maximum efficiency in output. The so-called Golden Age of comics lasted from 1938 through 1954, when a study called *Seduction of the Innocent* by a prominent psychiatrist, Dr. Fredric Wertham, helped initiate Senate hearings on the purported deviance and violence in comic books and their harmful effects on children. The result of the hearings was the institution of the censorious Comics Code, which prohibited most of the exciting, and even nominally interesting, content of comic books and had such mandates as "in every instance good shall triumph over evil."[34]

CONTEMPORARY COMICS: AUTOBIOGRAPHICAL AND AVANT-GARDE CONTEXTS

The work I consider in *Graphic Women*, as I have already underlined, is diverse: Phoebe Gloeckner takes the radical move of *showing*, of unveiling, sexual abuse in detail, while Lynda Barry uses the elliptical structure of comics precisely to— just as powerfully—*suggest* the scene of trauma, choosing instead to leave us with a truncated panel where childhood abuse began. Yet all of the authors I discuss, however different their approach, content, and style, are extending on or building from underground comics. The prehistory ends and the history—the immediate context for the work this book explores—begins in the post-Code period, with what has been called the underground comix revolution.[35] The Comics Code decimated a previously booming commercial industry and a culture of visual-verbal exploration in which taboos (sexual, violent, villainous) could be

explored and outrageousness given form. In the aftermath of the Code, cartoonists were both unable to publish uncensored work in aboveground outlets and politicized by the activist ethos of the 1960s. The result was an artistic movement centered around comics free from commercial strictures of any kind. This unprecedented work revolutionized notions about what comics could accomplish formally and politically.

The thorny issues that underground comics, which were free of censorship, presented are issues that persist today: what is the nature, for instance, of explicitly sexual images—their force and impact? How do these explicit images yet code as ambiguous? It is here that we see the work—adult, identitarian, experimental, confessional—that created the possibilities for today's diverse comics landscape and it is here that we first see women using comics as a form of personal expression. The underground shifted what comics could depict (its purview, its content) and, crucially, *how* it could depict. The underground saw its rigorous, unprecedented experiments in form as avant-garde; without the considerations of commerce, comics was liberated to explore its potential as an art form.

The comics that created the space for today's contemporary canon were first conceived, nurtured, and published in the underground, which was made up of a collection of cartoonists, primarily located in San Francisco, whose work originated entirely with themselves, was self-published or published by loose collectives, and was distributed through nontraditional channels for an exclusively adult audience. Will Eisner's *A Contract with God*—a series of four linked vignettes chronicling the desires of immigrants in a Bronx tenement in the 1930s—was the first book marketed as a "graphic novel," in 1978. However, Justin Green's *Binky Brown Meets the Holy Virgin Mary*, published in the underground in 1972, is the hugely influential text that inaugurated comics as a medium of self-expression and thus directly paved the way for the body of serious and risk-taking work that this book analyzes. It established a mode of comics narrative—exploring the self seriously—that has since become dominant within literary comics.

Yet the type of work produced in the underground did not come out of nowhere. While "wordless novels" such as Lynd Ward's *Vertigo* (1937), modernist and mass-produced, registered the trauma of the Great Depression in its experimental form, in the 1950s comics became a bridge between the high experimentalisms of literary and visual modernisms and mass-produced American popular culture, mixing stark oppositionality with mainstream cultural appeal, antirealist aesthetics with popular narrative convention.[36] *Mad Comics* (later *Mad* magazine), founded by cartoonist Harvey Kurtzman, was a satirical, self-reflexive comic book deeply concerned with comics aesthetics. Kurtzman created *Mad*

Comics: Humor in a Jugular Vein in the summer of 1952 and "forever changed the consciousness of America" by offering a conscious, oppositional "devaluation of American secular mythology" in a mass cultural genre.[37] With *Mad*, Kurtzman realized "comics as a place outside consensus culture," as Adam Gopnik and Kirk Varnedoe put it in *High and Low: Modern Art, Popular Culture* (212).[38]

And before underground comics became a nationally recognized cultural force in the late 1960s, there was yet a vital underground publishing community that meditated on the possibilities for the medium. In the early sixties, in part inspired by the hugely popular, incisive, and formally self-conscious humor of *Mad*, a culture of fanzines, many of them devoted to *Mad*-like satire, grew across the U.S., with titles such as *Wild, Smudge, Squire, Foo, Blasé, Sick,* and *Klepto*. (Fredric Wertham, who had condemned commercial comic books in *Seduction of the Innocent*, wrote a loving study of fanzines, *The World of Fanzines: A Special Form of Communication*.) These fanzines were self-published cheaply, mostly by teenage boys, in small runs, and informally distributed. A large majority of their creators became underground cartoonists. It was in a 1964 newsletter circulated to members of the Amateur Press Association that the term *graphic novel* was first publicly used, by Richard Kyle; the phrase was subsequently borrowed by Bill Spicer in his fanzine *Graphic Story World*. College humor magazines, many of which were political and also featured comics, grew increasingly subversive and influential in the sixties and further contributed to establishing the culture of the underground.[39]

The underground press appeared in 1965, when new technology in the off-set printing process made it feasible to produce small runs of a tabloid newspaper inexpensively: the *Los Angeles Free Press* was followed by the *Berkeley Barb*, which became the journal of the rising antiwar movement, followed by the *East Village Other*, the *San Francisco Oracle*, Detroit's *Fifth Estate*, and the *Chicago Seed*. These underground papers published uncensored comics and banded together to create the Underground Press Syndicate, which instituted a free exchange of features.[40] Comics were a countercultural vehicle. They were received in a political context as artistic—edgy, expressive, immediate, and significant to left-wing culture. And in San Francisco the production and distribution of rock posters created the infrastructure for that city to become the center of the underground comics community. Underground comics were distributed by the same networks that dealt with the popular rock posters; they were sold at head shops and other countercultural boutiques. Referring to mainstream comic book companies as well as magazines, Victor Moscoso, who worked in both posters and comics, explains: "The posters and the comix were the one-two punch of the counterculture movement. . . . And it had nothing to do with Marvel, DC, *Time*,

Life, or any of the establishment systems of distribution" (Rosenkranz, *Rebel Visions* 86).

The most influential, if controversial, underground cartoonist—and the one whose outsized, iconoclastic success officially helped define the underground as a phenomenon—is Robert Crumb. While fellow cartoonist Robert Williams claims that the sea change in comics created by the underground movement would have happened even without Crumb, since "there was a resentment for authority and government and comics were a tremendous form of personal expression," it is widely accepted that Crumb's achievement was simply to have reinvented the comic book as something tremendously, irrevocably different than it had been before (*Rebel Visions* 95).

The tagline on the first issue of Crumb's *Zap Comix*, which he published and sold out of a bassinet on the street in 1968, is "For Adult Intellectuals Only!" Spiegelman says that Crumb "invented comics that didn't have punchlines," and part of this mode of creating comics had to do with a rigorous, unflinching, and often disturbing honesty, which he refused to curb, and instead gave visual voice to in his comics ("Comics"). This lack of inhibition that translated onto the page was in part the core of Crumb's critique, his satire of American consciousness, but Crumb's work—especially when occupied with race and sexuality—makes the line between satire and embodiment a difficult or impossible one.[41] *Zap* no. 1 galvanized the underground in 1968. Within a year a core group of underground cartoonists had assembled in San Francisco, by the early seventies there were over a million *Zaps* sold, and five years later there were three hundred new underground comix titles (*Rebel Visions* 123, 4). While a cadre of women cartoonists and other feminists came to object to his sexually explicit work as degrading, as I will discuss in more detail, there is yet a sense that the honesty in Crumb's work, however repulsive the content, was so striking as to have been electrifying. While Crumb influenced Justin Green and Spiegelman, among other key figures in comics, he also inspired a majority of the authors this book analyzes: Aline Kominsky-Crumb (who married him in 1978), Alison Bechdel (who saw his underground work as a child and was "mesmerized by the artwork," asserting that he is a "big influence," and "graphic genius"), Phoebe Gloeckner, and Lynda Barry ("An Interview" 1012).[42]

A crucial context within which to understand the force and appeal of the underground is the backdrop of abstract expressionism, the dominant preoccupation of so much of the discourse around art in the 1960s. Spiegelman often notes that in the underground period comics was the last bastion of figurative drawing ("Art Spiegelman" 8).[43] Cartoonists were vigorously experimenting with the formal conventions of comics, but they were still trafficking in the repre-

sentational, and the immediacy of comics was seen as a countercultural value, an effective way of reaching an audience. Justin Green and Aline Kominsky-Crumb—the first two significant autobiographical authors in comics—were both training in abstract expressionism when they decided to turn to comics. Green was studying painting at the Rhode Island School of Design in 1967 when he first saw Crumb's work in an underground newspaper. He describes that it would "change his life": he was instantly engrossed in the "texture" of the page "packed with harsh drawing, stuffed into crookedly drawn panels." It was a "call to arms" for him, and, inspired, he immediately began cartooning (*Rebel Visions* 102). In 1968 he moved to San Francisco, where, he notes, referring to underground comic books, "anthologies were [being] born daily" (Randall, "The Goblin Meets Binky Brown" 3).

One result of Green's shift from abstract painting to comics is the forty-one-page story that established the space for serious work so often gathered together under the umbrella of *graphic novel*. (Here we may note that it is the quality of work, its approach, parameters, and sensibility, that establishes a seriousness of purpose befitting *graphic novel*, not necessarily length and the institutional approval of publishers and bookstores, of which *A Contract with God* had both.) Green is responsible for creating the autobiographical genre of comics that has become the dominant mode of contemporary work. He wrote and drew *Binky Brown Meets the Holy Virgin Mary* in 1971—Spiegelman writes, "I'll never forget seeing the unpublished pages . . . hanging from a clothesline stretched around the drawing table"—and it was published as a comic book of the same title in 1972 by the underground publisher Last Gasp ("Symptoms" 6).

It is fitting that Green would choose comics, a medium that is centrally occupied with experiments in spatiotemporal representation, for a narrative marked by an obsession with space and time. Green explains the focus of the story in an interview: "I have Obsessive Compulsive Disorder. This is a spatial and temporal relationship with Roman Catholic icons, architecture, and doctrine that has been resounding in my life for almost 40 years" ("The Goblin Meets Binky Brown" 2). In *Binky* the Catholic adolescent protagonist views his tiniest sexual feelings as sins and develops a compensatory disorder involving avoiding what he perceives to be "penis rays" that offensively emanate from objects. How space is marked off in the narrator's perception is not only a key theme, but, further, the visual-verbal aspect of the narrative allows the author to powerfully show readers what is in "the mind's eye": the rays that he perceives, with profound consequences, and that others do not. Drawn in black line art that veers from crisp to curvy, with panels that vary shape and size each page, *Binky* demonstrates the powerful effect of comics to show the processes of mental ill-

ness from the perspective of the ill. It externalizes—gives visual body to—a vivid imagination, an interior landscape with which the protagonist struggles.

Writing that "without Binky Brown there would be no *Maus*," Spiegelman notes, "It's no small thing to invent a genre. . . . Before Justin Green, cartoonists were actually expected to keep a lid on their psyches and personal histories, or at least disguise and sublimate them into diverting entertainments" ("Symptoms" 4). The fundamental role Spiegelman assigns *Binky* has two different inflections: broadly speaking, Green's work, by example, directly inspired underground figures such as Spiegelman, and Crumb, and Kominsky-Crumb, among others, to see personal material as relevant for comics. Second, Green's influence extended directly to the creation of *Maus*, perhaps the most globally famous graphic narrative.

Green edited a comic book called *Funny Aminals* in 1972 and invited Spiegelman to contribute a story, encouraging him to finish it despite Spiegelman's reluctance. This invitation and subsequent exchange resulted in Spiegelman's three-page autobiographical piece "Maus," the prototype and the impetus for the longer *Maus* book, which definitively shifted the public conversation around the possibilities for serious work in the form of comics upon its publication in two book volumes in 1986 and 1991.

It is notable that the two most famous cartoonists I discuss in this book—Satrapi, whose *Persepolis* is an account of her youth in Tehran, and Bechdel, whose *Fun Home* is a memoir of growing up gay in rural Pennsylvania, both credit *Maus* as an influence. Even though Satrapi is Iranian, and was first published in France, *Persepolis* was inspired by the nonfiction comics tradition created by *Maus* in the U.S. Satrapi, whose training is in fine arts, did not consider comics as an art form until she saw *Maus*, as she often publicly explains. She recounts: "It's really with *Maus* that things clicked. . . . *Maus* was of the order of a revelation. . . . I told myself, 'There! It's possible to do very serious work with this means of storytelling'" (Hill 18–19). And Bechdel told me in an interview, "I couldn't have done anything without *Maus*. . . . [It is] something so fundamentally influential that I don't even see it" ("An Interview" 1013). While *Maus* is so often credited by those working in nonfiction comics, as we recognize in Satrapi and Bechdel's comments, we may trace a genealogy that actually begins with Justin Green's influential reimagining of the subject of comics.

Sexual explicitness is another feature of this first autobiographical comics story that set the stage for later work. The form of the narrative publicly indulges in the frank look at sexuality that the protagonist is afraid even to think through in private. (This may also be, as with much feminist work, a reason that *Binky* has remained "legendary" but generally obscure to a mainstream public ["Symp-

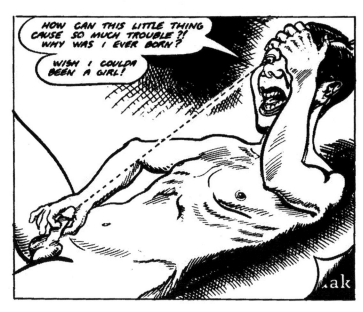

0.1 Justin Green, panel from *Binky Brown Meets the Holy Virgin Mary*, 1972. *Used by permission of Justin Green.*

toms" 5].)[44] Underground comics, which while often subject to local obscenity charges largely stayed outside normative media regulations, were on the cutting edge in the late sixties in their unfiltered portrayal of sexuality—much sexual content could be drawn in comics while not photographed or filmed. However, to present explicit sexuality in an autobiographical context was strikingly new. In *Binky* there are depictions of naked bodies and penises, in particular, which the title character sees grafted onto sundry shaftlike objects. One scene shows Binky masturbating miserably (39; figure 0.1); another shows his fingers and feet turned into penises (42); yet another shows an array of household objects configured as penises ("now even common objects turn into peckers capable of beaming out the hated and feared rays"; 43). The inaugural text of comics autobiography—like so much underground work and so much autobiographical work after it—delves into and forcefully pictures non-normative sexuality, and, for this reason, we may see how autobiographical comics at its outset lends itself to feminist concerns about embodiment and representation.

For Aline Kominsky-Crumb—as for many others who then became and still are chief figures in literary comics—seeing Green's work was the impetus to create her own. "When I was in art school in the late 60s, early 70s, I saw the work of Justin Green, *Binky Brown Meets the Holy Virgin Mary*. It really set a

light bulb off over my head," she recounts. "I was more involved in the world of painting, but there were all these macho male teachers from the western American abstract expressionist school of art" ("Aline Kominsky-Crumb" 163–164). Kominsky-Crumb—whose own sexual honesty in her comics has influenced Alison Bechdel, Lynda Barry, and Phoebe Gloeckner, as each have noted—credits Green with her decision to enter into comics: "When I saw that Binky Brown comic, I really saw something I could do. I immediately wrote a story. Six months later, I moved to San Francisco" (164). That first story became "Goldie: A Neurotic Woman," which was published in the inaugural issue of *Wimmen's Comix* in the same year, 1972, also by Last Gasp. Green opened up a genre, and Kominsky-Crumb expanded it to include the texture of women's lives.

WOMEN'S WORK: MAKING MARKS

There were women scattered in comics prior to underground comics, but the industry, in mainstream comic strips and comic books, was heavily male, and, as cartoonist and historian Trina Robbins points out, women who did have jobs in the field often worked on titles that were rigorously conservative, such as in the commercial, or "aboveground," romance and teen comics of the fifties and sixties that emphasize normative gender roles.[45] Robbins notes that by the 1970s, with very few exceptions, there were no women working in mainstream comics, because aspiring female cartoonists were turning their attention to the underground (*Great Women Cartoonists* 102). The growth of the underground comix movement was connected to second-wave feminism, which enabled a body of work that was explicitly political to sprout: if female activists complained of the misogyny of the New Left, this was mirrored in underground comics, prompting women cartoonists to establish a space specifically for women's work. It is only in the comics underground that the U.S. first saw any substantial work by women allowed to explore their own artistic impulses, and further, women organizing collectives that undertook to articulate the challenges and goals of specifically female cartoonists.

The 1972 issue of *Wimmen's Comix* that offered Kominsky-Crumb's first story is an early and crucial example of women's comics, but not the first. In 1970, Trina Robbins—who was then publishing a recurring feminist-themed comic strip called *The Adventures of Belinda Berkeley* for the left-wing paper the *Berkeley Barb*—organized the first comic book created entirely by women, titled *It Ain't Me Babe: Women's Liberation* (also the name of the first women's liberation newspaper in America, where Robbins sometimes worked), and in so doing effectively created women's underground comics.

The cover, a purple graphic lined with jagged blue, shows characters from Sheena to Little Lulu to Olive Oyl marching off the page with fists in the air (figure 0.2). But while *It Ain't Me Babe* marked an achievement of feminist organization, it did not continue as a comic book title. The first ongoing comic book, *Tits'n'Clits*, appeared in 1972 (the editors briefly changed the name to *Pandora's Box* in 1973 in order to avoid an obscenity charge).[46] The two women behind *Tits'n'Clits*, Joyce Farmer and Lyn Chevely, who worked collaboratively under the name Chin Lyvely, and started a company called Nanny Goat Productions, concentrated on female sexuality. Chin Lyvely, interviewed in a 1979 issue of the magazine *Cultural Correspondence*, assert—as many women within the underground did—that they were "impressed by the honesty" of underground comics, "but loathed their macho depiction of sex" (13). Robbins sees that the first issue of *Tits'n'Clits*—which carried an ad for other women's comics, effectively establishing a network—"launched the heyday of women's comics" (*Girls* 89). But the most substantial work, as Kominsky-Crumb's pioneering piece indicates, came with the publication of *Wimmen's Comix*, which followed *Tits'n'Clits* by three weeks in 1972. *Wimmen's Comix* was organized by the Wimmen's Comix Collective, initially a ten-woman group, including Robbins, who rotated editorship to two members each issue (see figure 0.3).

Wimmen's Comix is a fascinating reference point not only because it became one of the longest running underground comics (lasting, improbably, until 1992 when most underground titles petered out by the eighties); because it is indicative of second-wave conundrums, run by a female collective but published by a man, Ron Turner; and because in its first issue we recognize the kind of autobiographical examination that established an important field of women's work; but also because the rifts that generated from women cartoonists articulating what women's work could be and could look like continue to be informative and relevant. Kominsky-Crumb's five-page "Goldie," which will occupy further discussion in the first chapter here, is about the lived life of its protagonist (Kominsky-Crumb's maiden name is Goldsmith) and picks up from Green in its unflinching, and unglamorous, depiction of sexuality. The second page shows the title character naked, facing readers, masturbating with vegetables. The thought balloon reveals, "I'm fucked up I know nobody else does this," under a text box whose narration reads, "I was always horny and guilty" (2). The expressive drawing style is scratchy and tentative, as if reflecting the protagonist's diffidence; continuity of perspective and character depiction varies (also reflecting her shifting attitudes about her daily life).

"Goldie" is wry, charming, stark, and powerful. In an interview Kominsky-Crumb explains that the publisher did not initially want to publish it ("there

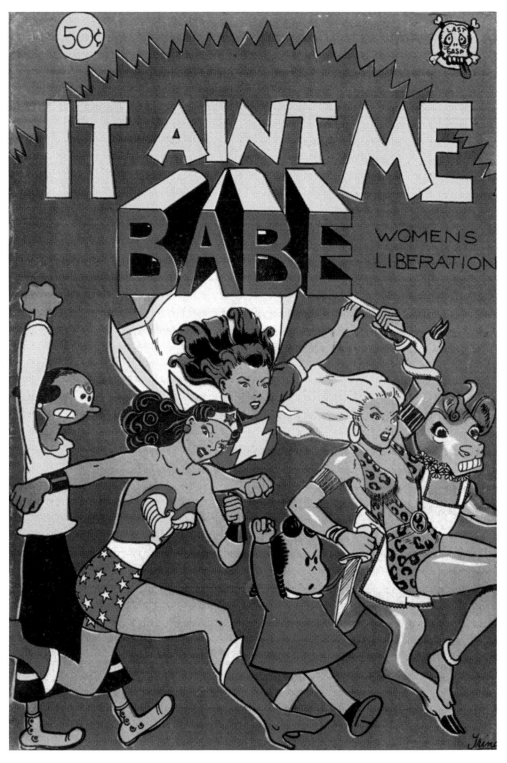

0.2 Cover, *It Ain't Me Babe*, 1970. Artist: Trina Robbins. *Used by permission of Trina Robbins.*

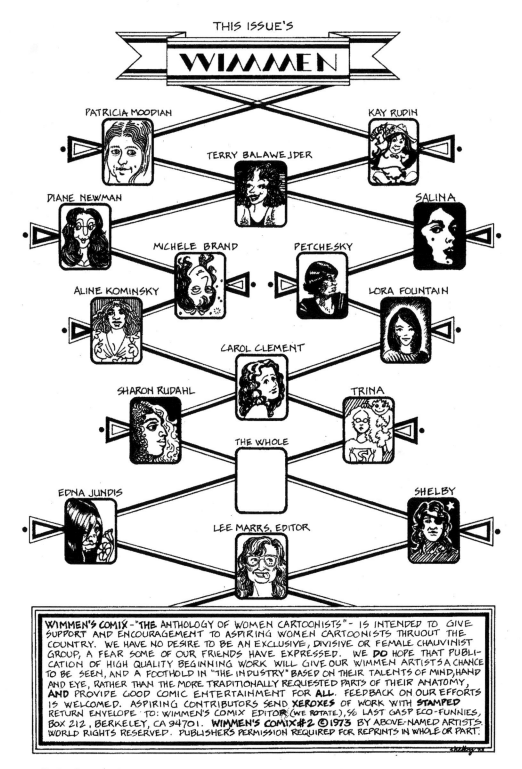

0.3 Shelby Sampson for the Wimmen's Comix Collective, "Masthead," *Wimmen's Comix*
no. 2, 1973. *Used by permission of Shelby Sampson.*

was a big argument over whether my work was publishable"). Neither did she receive much support from the collective, who ultimately found her comics lacked "political correctness"—or a sense of "a significant raise in the level of feminist consciousness" ("Aline Kominsky-Crumb" 166). While *Wimmen's Comix* often presented pieces that underlined women's triumphs both in terms of style and content, Kominsky-Crumb's work showed a different approach. In 1976, frustrated by what she perceived as an almost superhero-inflected glamorization of women under the auspices of feminism, Kominsky-Crumb, with cartoonist Diane Noomin, started her own comic book. *Twisted Sisters*, resolutely deidealized—its first cover depicts Kominsky-Crumb on the toilet, looking into a handheld mirror (figure 0.4)—directly influenced a younger generation of authors such as Phoebe Gloeckner and went on to engender two important book collections of original work (1991 and 1995).[47]

What the purview and pitch of feminist comics might be was already, productively, in contention from the first issue of *Wimmen's Comix*, reflecting the diversity of perspective in comics during the era where we first saw identitarian, political, feminist, and gay work gaining readerships. And if women's comics were first created in, and became a topic of discourse within the underground, so were gay comics, paving the way for work like Alison Bechdel's comic strip, *Dykes to Watch Out For*, which began in 1983. In 1973, reacting specifically to the perceived heterosexism of *Wimmen's Comix*—which featured no gay characters—Mary Wings self-published *Come Out Comix* on an offset press and so created the first lesbian comic book (she published another title, *Dyke Shorts*, in 1976). When Bechdel, strolling through New York City's Oscar Wilde Memorial Bookshop in 1981, picked up *Gay Comix* no. 1 (1980), edited by Howard Cruse and published by the underground company Kitchen Sink, she decided then, she explained to me, to become a cartoonist. Bechdel recalls that she realized, "'You can do cartoons about your own real life about being a gay person.' And that was quite momentous for me... Howard [Cruse] was hugely formative in that sense" ("An Interview" 1013). Writing about this critical moment on the first page of her book *The Indelible Alison Bechdel*, Bechdel notes, "I didn't find out until much later that Howard Cruse had struggled over his decision to draw gay-themed work. . . . Or that Mary Wings, who'd already published *Come Out Comix* . . . had encouraged him to do it. . . . When I stumbled into that bookstore in 1981, there was already such a thing as a lesbian cartoonist" (9–10). In the editorial note in this first issue of *Gay Comix*, Cruse remarks, "Each artist speaks for himself or herself. No one speaks for any one mythical 'average' homosexual. No one is required to be 'politically correct.'"

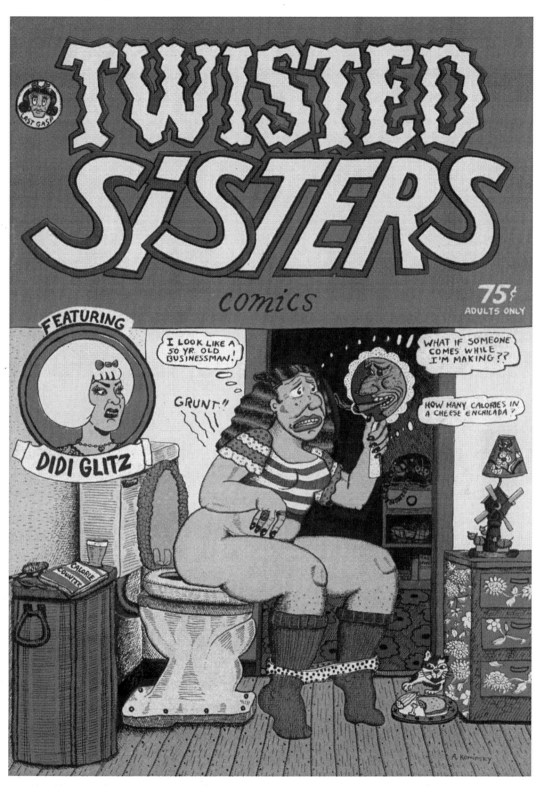

0.4 Aline Kominsky-Crumb, cover, *Twisted Sisters*, 1976. *Used by permission of Aline Kominsky-Crumb.*

* * *

In the work of the five authors I discuss here, graphic narrative moves beyond prescriptive models of alterity or sexual difference. And in every case, graphic narrative presents a traumatic side of history, but all these authors refuse to show it through the lens of unspeakability or invisibility, instead registering its difficulty through inventive textual practice. Since the underground has received little, if any, academic attention from literary critics (and this brief introduction could easily take a longer look), today's readers of graphic narrative may not know how hard-won the opportunity was to visualize non-normative lives of women in an aesthetically engaged format during the significant period when comics shifted from the strictly commercial to the politically and artistically revolutionary. The movement that, as Justin Green notes, "held to the ideal of reaching a common audience while reinventing the formal boundaries that defined the medium," is directly responsible for the existence of today's rich body of literary—and specifically, autobiographical—comics (*Rebel Visions* 4). The underground does not exist anymore; it collapsed, most agree, in the 1980s, if not well before, although an independent publisher here and there survives.[48] But it is crucial to realize how recent—and how politically inflected—the type of work this book examines is. Deeply embroiled with the left politics, the artistic rigor, and the utopian pitch of the sixties and seventies, the underground changed the face of what we consider "literature" and gave us the risk-taking self-representation we see in today's graphic narrative by women. The aesthetic and political issues raised by the underground about the affect and impact of visual-verbal narratives that externalize, that put the body on the page, that push against easy consumption, have not gone away: they continue to present themselves forcefully today. And the need for women's work has not gone away. While a few decades ago comics by women about their lives had to be published underground, today they are taking over the conversation about literature and the self.

Fredric Jameson's famous exhortatory call for "an aesthetic of cognitive mapping" is one that suggests, although he does not state it as such, an important role for the visual. Jameson hopes that through cognitive mapping "we may again begin to grasp our positioning as individual and collective subjects and regain a capacity to act and struggle" (*Postmodernism* 54). In "The Persistence of Vision" Donna Haraway embraces vision as necessary to the work of situated mapping: "I would like to proceed by placing metaphorical reliance on a much maligned sensory system in feminist discourse: vision," she declares. "Vision can be good for avoiding binary oppositions. I would like to insist on the embodied nature of all vision, and so reclaim the sensory system that has been used to signi-

fy a leap out of the marked body" (283). The notion that cognitive mapping may be enabled by vision, by spaces of the visual, leads one to Mitchell's conclusion to his influential *Picture Theory*. Mitchell's suggestion, in the end, is not unlike Jameson's; he posits a kind of ethics of analysis. "In short," he writes, "though we probably cannot change the world, we can continue to describe it critically and interpret it accurately. In a time of global misrepresentation, disinformation, and systematic mendacity, that may be the moral equivalent of intervention" (425). I would like to suggest that Mitchell's critical "describing" is not far from Jameson's "mapping," and that the entreaties of both point to graphic narrative, a form that is rife with possibilities for engaging in those critical practices. "Discourse does project worlds and states of affairs that can be pictured concretely and tested against other representations," Mitchell writes in *Iconology*. "Perhaps the redemption of the imagination lies in accepting the fact that we create much of our world out of the dialogue between verbal and pictorial representations, and that our task is not to renounce this dialogue" (46). Graphic narrative, composed of both words and images, offers textured representations of mapping. One may ask, is cognitive mapping what Phoebe Gloeckner offers when she investigates the terrain of a sexual childhood? Is it what Marjane Satrapi gives us when she draws her shifting geography of 1970s Tehran? Formally and stylistically distinct, (re-)imagining history in different ways, the diverse graphic narratives in *Graphic Women* revise a traditional understanding of literary life narrative, articulating a sophisticated representational aesthetics and ethics.

Scratching the Surface

"UGLY" EXCESS IN ALINE KOMINSKY-CRUMB

The texts I analyze in this chapter, on Aline Kominsky-Crumb, and the next, on Phoebe Gloeckner, deal explicitly with issues of sexual politics. While explorations of sexual and childhood trauma are typically relegated to silence and invisibility, their relevance understood as restricted to the purview of the private sphere, the work of Kominsky-Crumb and Gloeckner responds to this problem by inventing new textual modes of expressing life stories. Kominsky-Crumb, who has a style of hyperexaggerated impressionism, and Gloeckner, who is a trained medical illustrator and favors a viscerally disturbing, provocative style of realism, present images of pleasure and pain that are not found anywhere else in political and accessible cultural production. Their images are challenging not only because, as with Spiegelman and Sacco, they can be confrontational—both authors' work has been labeled "pornographic," an accusation complicated by the very idea that they are re-presenting their own experiences of abuse—but also because they are ambivalent: they refuse to ignore the complex terrain of lived sexuality that includes both disgust and titillation. Kominsky-Crumb and Gloeckner erase the inscription of women in the personal space of sexual trauma, offering nuanced representations that place pressure on notions of what a "correct" feminist sexual politics should look like. While their texts demonstrate the affective power of the visual—and suggest that trauma breaks the boundaries of form—they further place themselves in feminist political debates, as with Marjane Satrapi and Lynda Barry, by emphasizing the ordinariness of their narratives: while Kominsky-Crumb links a range of sexual activity, from the traumatizing to the pleasurable, to the everyday, Gloeckner furnishes the titles of her two books, which present both abuse and sexual desire, with the departicularized titles *A Child's Life* (1998) and *The Diary of a Teenage Girl* (2002).

As one of the pioneers of autobiographical comics, and specifically, as the originator, in the early 1970s, of women's autobiographical comics, Aline Kominsky-Crumb's voice and style inspired numerous cartoonists—including three whose work I explore in this book: Gloeckner, Barry, and Alison Bechdel. Barry specifically praises Kominsky-Crumb for providing "this perspective on being female that's not 'one woman's lonely struggle.' . . . Usually, if you see a depiction of what it's like to be a woman, you see 'strength' and no sexual desire." Crucially, Barry claims this move as particular to the nonesoteric and yet permissive space of comics: "That's one thing about cartooning [we have] that you don't see a whole lot of in society" (Powers, "Lynda Barry" 75). In a similar vein, emphasizing sexual expression, Bechdel comments, referring to Kominsky-Crumb's collaborative comics with her husband, Robert Crumb: "they're very much an inspiration in terms of trying to be as honest as I can, especially about sexual stuff" (Chute, "An Interview" 1012).[1] Kominsky-Crumb consistently presents us with her "secret" and unruly fantasies; she tells us and shows us the "taboo"—for instance, that "confidentially speaking," as she writes, she enjoys violent sex (*Complete Dirty Laundry* 49). Kominsky-Crumb's political project is to visualize how sexuality, even when disruptive, does not have to be turned over to the gaze of the other. Peopled by "excessive" bodies, her so-called uncivilized work, which disrupts a masculinist economy of knowledge production, demonstrates that a crucial part of the struggle to represent the realities of gender beyond sexual difference involves our writing—and drawing—aesthetic elaborations of different ways of being with our sexuality.[2] It is important that Kominsky-Crumb acknowledges both enjoyment and shame; her work does not simply celebrate transgression. In admitting to shame, and visually and verbally detailing it along with joy, Kominsky-Crumb, as with figures such as Silvan Tomkins, suggests shame (or what she calls humiliation or "yumiliation") as productive.[3]

Largely, readers find Kominsky-Crumb's work off-putting: for cartoonists, this is because of her excessively "primitive" style; for some feminists, this is because the sexually explicit content of her work not only depicts the character Aline's body—excrement, blood, and vaginal discharge—intimately but also depicts her enjoying "perverse" or "eccentric" sex (in which, for instance, her husband penetrates her vaginally while grinding her face in vomit). Kominsky-Crumb's uninhibited representations of her own forceful sexuality in a light that is not always palatable, or favorable, make her a pioneering—if underrecognized—figure in the broad world of feminist visual culture. Yet there is virtually no academic criticism of her work and little more in mainstream literary and art journalism.[4] Given that Kominsky-Crumb has been writing the darker side of (her own) female sexuality for almost four decades, it is no surprise that her work

is neglected—her underwhelming reception contrasts markedly to that of her husband, cartoonist Robert Crumb, who has been canonized exactly for writing the darker side of (his own) tortured male sexuality.

But while we may understand the double standard as culturally typical, the case of the Crumb family is possibly *the* defining example of this double standard at work. Crumb is the world's most famous living cartoonist; art critic Robert Hughes, comparing him to Brueghel and Goya, calls him one of the most important artists of the twentieth-century. Kominsky-Crumb, on the other hand, is almost completely neglected as a cartoonist. In the textual, "conversation"-form introduction to *The Complete Dirty Laundry Comics* (1993), a book collection of the couple's collaborative comic strips, Kominsky-Crumb tells her husband: "At least you're famous and considered a great artist and cultural icon. . . . Look at me, twenty years later and still nobody's heard o'me" (3).[5] This predicament brings to mind the Guerrilla Girls' famous poster ("public service message") listing the advantages of being a woman artist, one of which is: "Not having to undergo the embarrassment of being called a genius" (Guerrilla Girls 9).

When she first started collaborating with Crumb in the early 1970s on *Dirty Laundry Comics*, Kominsky-Crumb's presence on the page—they each drew themselves—inspired ugly responses from some members of Crumb's underground fan base, who were appalled by her divergence from his more practiced-looking style: "She may be a good lay but keep her off the fucking page," was typical of the angry letters Crumb received, he reports. "It energized me to think of those fuming twerps wringing their sweaty palms in disgust when they had to look at my tortured scratching next to your fine rendering," Kominsky-Crumb cheerfully remarks in the aforementioned introduction (*Dirty* 4). Kominsky-Crumb's distinctive style, as I will shortly further discuss, provokes because of its messy, "untutored" appearance. She has a thin, wavering line, and her panels, while much of the drawing lacks realistic detail, are regularly crammed and crowded, often lacking "artful" composition and "correct" spatial perspective.[6]

In addition to her quavering line, her work is characterized by deliberate visual inconsistency within its narratives. For instance, she frequently draws herself differently from panel to panel, even within the space of one story: she may draw with varying degrees of realistic linework from panel to panel; Aline's clothes might suddenly change; bodies tend to swell and shrink (see figure 1.1). Kominsky-Crumb's noncontinuous self-representation (like Lynda Barry's accretive collages, as I will discuss in chapter 3) unsettles selfsame subjectivity, presenting an unfixed, nonunitary, resolutely shifting female self. Kominsky-Crumb makes her approach most legible in one striking panel from her graphic narrative

autobiography *Love That Bunch*, in which she draws multiple selves who all declare, sharing a speech balloon, "I can't stand myselves" (63; figure 1.2). The panel presents as impossible the choice of who among the many pictured selves is the "real" self; they all are.

Kominsky-Crumb's texts return again and again to a set of motifs concerning sexuality and subjectivity, and they are layered and visually mixed, invoking in their crowded, irregular look the process of memory and the process of writing autobiography itself.[7] Robert Crumb, addressing her in the introduction to *Dirty Laundry*, asserts: "Fine rendering doth not a great artist make. . . . Fine rendering can be a trap, a web of clichés and techniques. Your work is entirely free of such comic-book visual banalities. . . . You remain amazingly impervious to the pernicious influence of all cartoon stylistic tricks . . . which is mainly why so many devotees of the comics medium are put off by your stuff" (4). Further, even and especially with feminists, Kominsky-Crumb is a divisive figure. She explains, "right from the beginning I got a lot of flak from everyone for being so primitive and self-deprecating. [The feminist underground cartoonist collectives] were influenced by traditional comics. They had images of women being glamorous and heroic. I didn't have that background" ("Kominsky-Crumb Interview" 58).

GOLDIE, SEXUALITY, AND EXPLICIT AUTOBIOGRAPHY: EXPANDING THE UNDERGROUND

Despite the fact that she is a progenitor of contemporary autobiographical comics, now a flourishing and even viably mainstream form, Kominsky-Crumb has always been rooted in the underground and independent comic book publication. With its laid-bare messy bodies and exuberantly messy lines, her work is perhaps the least commercial of the five authors I discuss here in its particular match of content and style. The arc of her career reveals a cartoonist developing a voice (both visual and textual) from the margins, deeply devoted to underground comics and the unconstrained mode of expression they make possible. While she has published three books—and her next, a collaborative work with Robert Crumb, will be published by W. W. Norton—she has also been profoundly involved, from the very beginning of her career, in comic book serialization.[8] She published her work in underground titles such as *Wimmen's Comix*, *Manhunt, Lemme Outa Here!, Dope Comix*, and *Arcade*, among others; edited the acclaimed *Weirdo* for five years; and founded the comic books *Dirty Laundry, Twisted Sisters, Power Pak*, and *Self-Loathing Comics*.[9] Asked in a recent interview what she strives for in her art, Kominsky-Crumb replied, "I'm trying to create something that is influenced as little as possible by all the commercial

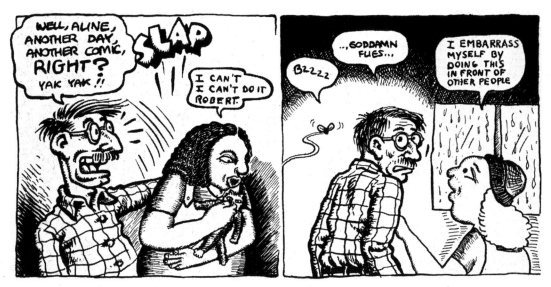

1.1 Aline Kominsky-Crumb (with Robert Crumb), two consecutive panels from *Dirty Laundry Comics* no. 1, 1974. *Used by permission of Aline Kominsky-Crumb.*

forces out there that want to tell me what to buy and what to do" ("Unlocking" 341).

This positioning against mainstream commercial culture stems in part from Kominsky-Crumb's upbringing in a social-cultural enclave she detested. Born Aline Ricky Goldsmith in Long Beach, Long Island, in 1948, Kominsky-Crumb grew up in Woodmere, in the Five Towns neighborhood. She writes in an author's note that she spent her first seventeen years "in an upper middle class ghetto, surrounded by ostentatious materialism and rabid upward striving. . . .

1.2 Aline Kominsky-Crumb, panel from "Up in the Air," *Love That Bunch*, p. 63. *Used by permission of Aline Kominsky-Crumb.*

To say that I never fit into this world of 'post war jerks' is an understatement . . . but such intense alienation has provided me with years of comic-tragic material" (Noomin, *Twisted Sisters: A Collection* 139). She calls life at home with her parents, who were prone to violent fighting, "scary and unpredictable" (*Need More Love* 45). Kominsky-Crumb briefly attended SUNY New Paltz, left school pregnant at eighteen, ran away to join the hippie community of the Lower East Side (where she admits she "had wild sex and took lots of drugs right up until the minute I was ready to give birth"), gave her healthy baby up to a Jewish adoption agency, attended Cooper Union for one semester, and married Carl Kominsky in 1968 shortly after her father died of cancer at age forty-three (*Need More Love* 103). The couple moved to Tucson, where Kominsky-Crumb earned a BFA in painting, in 1971, from the University of Arizona. After she graduated, her friend and neighbor Ken Weaver (from the legendary New York band The Fugs), introduced Kominsky-Crumb to two underground cartoonists from San Francisco, Spain Rodriguez and Kim Deitch, who in turn introduced her to the newest crop of underground comics, including work by Robert Crumb and Justin Green. At age twenty-two, Kominsky-Crumb, whose marriage was short-lived, moved to San Francisco intent on drawing comics: inspired by Green's "masterpiece of autobiographical revelation," *Binky Brown Meets the Holy Virgin Mary*, she had already written and drawn her first story, "Goldie: A Neurotic Woman" (*Need More Love* 126). She glosses her first comics narrative as "about leaving my first husband, getting my Volkswagen, driving away and being free" ("Aline" 164).

By the early 1970s, as noted in the introduction, women in underground comics were producing the kind of work that they could not find in the mainstream or in the often sexist underground press. Yet Kominsky-Crumb's first strip in print, "Goldie"—at which the male publisher of the collectively women-edited *Wimmen's Comix* balked—was clearly innovative.[10] "Goldie" shows Aline masturbating with different kinds of vegetables—the kind of explicit image that simply did not exist previously in the context of autobiography, whether "aboveground" or in the comix underground (figure 1.3). This kind of courageous work, even though she has her critics, made Kominsky-Crumb the "godmother" or at least the central pioneer of women's comics autobiography, and it expanded the range and focus of the underground, without which we would not have, today, a contemporary literary comics culture.

The five-page story opens the 1972 inaugural issue of *Wimmen's Comix*; it commences with a title panel that spotlights Goldie, looking serious, facing away from the direction of reading at a three-quarters angle in front of a black background. "In the beginning I felt loved," the upper-case text begins. To the left of a

small Goldie, wearing a teeny Star of David necklace, clutching a doll, and set off by appearing within her own black-background frame within the larger, lighter frame, is an elderly couple, presumably grandparents; the woman declares, simply, "The Princess," while a younger couple, presumably parents, share a thought balloon to her right that self-servingly expresses their pride: "We made her." The ensuing panels show Goldie excelling in school; mobbed by friends; playing outside: "Life was good," reads a punctuationless floating text box. And then in the last panel of the page Goldie grows up a little: "With puberty came uglyness [*sic*] and guilt " declares a box in the corner of a large panel in which a disproportionate, spotted girl stands facing readers (ellipses in original). The image is an inverse of the title panel: she is spotlighted in a harsh white; her arms are tiny stumps folded into a massive lower body. The creative spelling and inattention to normative rules of punctuation in this first strip establishes Kominsky-Crumb's mode, in which language frequently is not "correct" and sentences are more expressive than grammatical.[11] "Goldie," too, demonstrates how language in Kominsky-Crumb's work often sets up a staccato rhythm for the story that contrasts with the visual plenitude of the comics page.

The second page recalls an incident that Kominsky-Crumb returns to often in her work: her father announcing, about her looks, "Ya can't shine shit!" Goldie's miserable circumstances include listening to her parents have sex— "How can they do it? They're both so disgusting" she muses, her ear up against the wall—followed, disturbingly, by her sexualization by her father: he marches towards her, arms outstretched ("Cum 'ere Goldie") while Goldie, in profile, puts a fist out in front of her tiny breast. Her speech balloon implores "Don't touch me!"; her thought balloon, which here hangs above and between them, contains an image of her father, naked, with an enormous erection longer than his arm extending toward her. In the very next panel, which appears in the same tier, Kominsky-Crumb depicts Goldie masturbating, in the panel to which I have already referred: unclothed, sitting up, legs spread, one finger inserted into her vagina, she stares straight ahead at readers.

"Goldie" is not a "sexy" strip so much as it is simply about the complexity of sexuality. What is so remarkable about "Goldie" in general—and which is starkly evident in this sequence of panels on its second page—is how in the exploration of sexuality and the everyday lives of women that is now common to the form but was unheard of then, Kominsky-Crumb presents both degradation and pleasure, here literally mashed up against one another, running into and over each other, across a very slim gutter. The strip presents the texture of lived life; one does not cancel out the other. It is possible to be repulsed by being sexualized by one's father and yet remain an actively sexual person, to have one's

thought balloon occupied in one panel by a threatening sexual image and to be having a sexual fantasy in the next. While Goldie may face "self-hatred," as the narrator describes it in the story, she is not inscribed, here, as a victim.[12] In the narrative's penultimate panel—after the story narrates years of (mostly sexual) trouble—its protagonist, still endearingly misshapen but bright-eyed, declares, while her cat grasps her shoulder supportively, "I have a lotta putencial," before getting behind the wheel of a car headed to San Francisco. "I set out to live in my own style!" are the last words of the strip—particularly resonant words to conclude a story rendered in a visual style so provocatively "incorrect."

Cartoonist Mary Fleener (*Life of the Party*; *Slutburger*), a contemporary of Kominsky-Crumb's, recalls what a powerful moment it was to see "Goldie" for the first time, "all those horrendous episodes of female adolescent life" on the printed page of *Wimmen's Comix* ("Review of *Need More Love*" 31). The constantly morphing and shifting, satirically disproportionate physical figure of Goldie was both painful and funny—Fleener specifically mentions a panel depicting Goldie, with a tiny head, enormous nose, and gigantic lower body, who appears under a text box that reads, "I was a giant slug living in a fantasy of future happiness." "Goldie" reveals the hallmarks of Kominsky-Crumb's style, including the fluid self-depiction, in which one panel offers a heavily shaded, detailed face, while the next offers a comically distorted profile. It also contrasts this irregularity with a heavy attention to patterning that is part of the visual ten-

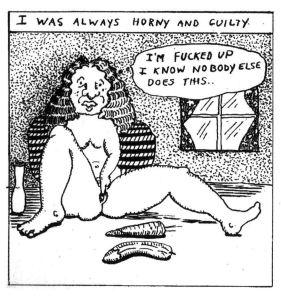

1.3 Aline Kominsky-Crumb, panel from "Goldie: A Neurotic Woman," *Wimmen's Comix* no. 1, 1972. *Used by permission of Aline Kominsky-Crumb.*

sion in Kominsky-Crumb's work. We see this in domestic interiors: bedspreads, floors, wallpaper; in clothing fabrics; and—a feature that gets more pronounced throughout her career—in Kominsky-Crumb's attention to rendering hair. Fleener sees that Kominsky-Crumb's comics work "is tightly controlled chaos, every centimeter filled with detail and texture and patterns"—but in "Goldie" we also see how the protagonist at the center of the narrative visually presents a looseness and fluidity that suggests the shifting layers of subjectivity, as against tight background patterning (34).

Kominsky-Crumb published a second Goldie story, "Hard Work and No Fun," in the second issue of *Wimmen's Comix* (1973), which picks up with Goldie in San Francisco. Again readers see Goldie, in the same posture as in the first strip, naked, save for her Star of David necklace and big black boots, looking right at readers with spread legs, touching herself. In this panel, which opens the strip, Kominsky-Crumb, as elsewhere, draws the character's vagina right at the center of the panel. (After masturbating, Goldie then exercises; makes comics—significantly; picks up an unacceptably sexually selfish man at a party; and walks home.) In the opening frame, too, her body, depicted in orgasm (her speech balloon says, "I'm coming") pushes down into the tier below, diminishing the size of its central frame; the unusual layout of panels shows her body so forceful as to stretch the frames of the page to accommodate her.

But the extant community of feminist underground cartoonists did not subsequently embrace or widely publish Kominsky-Crumb, publicly citing her supposedly underdeveloped feminist politics—a move that she interprets as punishment for failing to idealize women in her narratives. She was rejected from *Wimmen's Comix* no. 3 by that issue's editor, Sharon Rudahl. While Kominsky-Crumb did differ with other women in the Wimmen's Comix Collective both aesthetically and ideologically when it came to what constituted a feminist comics narrative, her rejection by the core group of *Wimmen's Comix* editors was also based, she suggests, on her public association with the polarizing figure Robert Crumb. Crumb was vilified by certain women cartoonists, especially Trina Robbins, the main organizing force behind *Wimmen's Comix*, for the purported sexism in his comic strips.[13] The gender proprieties generated by Robbins and her cohort were too stark, Kominsky-Crumb felt, and too invested in a sense of victimization—which, conversely, generated a countering, idealized comics aesthetic, quite unlike Kominsky-Crumb's own adoption of shaky lines, and abject behavior as her subject matter. Kominsky-Crumb points out that men were responsible for interesting her in comics in the first place, for helping her get published, and for encouraging her work. She recalls showing Crumb, a purported male chauvinist, her first story, "Goldie": "He really cracked up and

from that moment on he has been my best audience. He always 'gets it,' and finds my drawings intrinsically funny. Our relationship could never have worked if we didn't share this admiration for each other's work" (*Need More Love* 150). Indeed, in a striking moment in the 1994 documentary *Crumb*, Crumb recalls starting to draw one of his most violent stories, "A Bitchin' Bod." He threw the pages in the garbage can, thinking it was too "twisted" and "upsetting." Kominsky-Crumb encouraged him to keep drawing it, telling him, "You have to finish this. . . . You gotta see this through" (Zwigoff). Both cartoonists share a commitment to the comics page as an uncensored autobiographical space.[14]

Disappointed with what she saw as the *Wimmen's Comix* approach of "romanticizing women," Kominsky-Crumb, as already mentioned, started her own underground comic book, *Twisted Sisters*, with Diane Noomin in 1976 ("Kominsky-Crumb Interview" 62). (The serial issues generated two book collections, edited by Noomin.)[15] In a lecture titled "Wimmin and Comix," Noomin, creator of the character Didi Glitz, emphasizes that the tone and look of *Twisted Sisters* strove to be distinct from the model of feminist comics that she has elsewhere called "blandly idealized": "Our type of humor was self-deprecating and ironic and what they were pushing for in the name of feminism and political correctness was a sort of self-aggrandizing and idealistic view of women" ("Diane Noomin" 156; "Wimmin and Comix"). This is evident in the previously noted cover: Kominsky-Crumb's bold, full-color image of Aline, blue bows in her hair, red socks, black and white spotted underpants at her ankles, holding a hand mirror to her face while sitting on the toilet. A plate of partially eaten food is on the floor in front of her; one of several thought balloons indicates she is defecating. Phoebe Gloeckner, whose work, while distinct from Kominsky-Crumb's in its rendering, is also focused intently on bodies, claims she was deeply influenced by the cover; Kominsky-Crumb here demonstrates her unflinching focus on the messiness of bodies. This focus includes visualizing masturbation as routine and elevating the most basic and routine bodily function, elimination, as a subject worthy of portraiture. It is also a metaphor for just how uncovering—and also, just how routine—her comics narratives will be. Some read this cover as sexy: in her memoir *Need More Love* (2007) Kominsky-Crumb reprints a photograph from a 1976 porno zine that shows a woman holding up this first issue of *Twisted Sisters* while masturbating to what the author calls "our totally unerotic comic" (163). In fact, in its content, some of the stories deal with erotic themes, but the naked woman on the cover is a deliberate challenge to the idea that any image of a naked woman is supposed to be arousing.

Twisted Sisters marks the establishment of Kominsky-Crumb's enduring nickname, the Bunch, for her autobiographical comics character. This name was

initially inspired by a sexy adolescent character, "Honeybunch Kaminski," which Robert Crumb drew before he ever met Kominsky: "People were calling me Honeybunch before I even met Robert because my last name was Kominsky," Kominsky-Crumb explains. "I wanted to make the thing the exact opposite, a strong, obnoxious, repulsive, offensive character, but with a name that related to Honeybunch, so I shortened it to the Bunch which sounded disgusting" ("Kominsky-Crumb Interview" 66). *Twisted Sisters* was published by Last Gasp, as was *Wimmen's Comix*; publisher Ron Turner told Kominsky-Crumb it sold so poorly he used copies of the first issue to insulate the walls of his barn ("Aline" 166).[16]

Kominsky-Crumb's autobiographical narratives largely appeared in the underground publications *Arcade: The Comics Revue*, founded by Art Spiegelman and Bill Griffith (1975–1976); *Power Pak*, her own solo comic book (1979–1981); and *Weirdo* (1981–1993), founded by Robert Crumb, before her first book, *Love That Bunch*, arrived in 1990. *Love That Bunch* is a life narrative in twentynine comic strips, virtually all of which engage the nexus of gender, sexuality, and subjectivity. Offering a loosely chronological structure that begins in early adolescence and concludes in Aline's forties, the address of Kominsky-Crumb's work is strongly feminist: "I give comics to . . . people that would never go to a comics store or never buy a comic, and they go nuts. They love my work. . . . They are people I can relate to, people I think I'm writing for, other women like me." Kominsky-Crumb further states, "I have a file of several hundred letters that are deeply moving. Some people feel like I express something for them. I feel like that's who I write for if I write for anybody" ("Kominsky-Crumb Interview" 72, 68).[17]

"UGLY" EXCESS IN *LOVE THAT BUNCH*

The first comic strip in the book, "The Young Bunch: An Unromantic Nonadventure Story," explicitly depicts two instances of date rape.[18] In this, it is characteristic of Kominsky-Crumb's work—her texts are dotted throughout with sexual violation, such as when Aline is anally raped after passing out from drinking ("Oh Camp So Dear") and when her mother is maritally raped ("Blabette and Arnie: A Story About the Bunch's Parents"; figure 1.4). Cartoonist Peter Bagge, who conducted the longest interview with Kominsky-Crumb to date, in the *Comics Journal,* correctly assesses the sexual violence in her works in the following way: "You approach walking down the street in the same way that you'd show your parents having sex and beating the hell out of each other. There's no buildup. You just show it" (63). Kominsky-Crumb's work does suggest that

1.4 Aline Kominsky-Crumb, panels from "Blabette and Arnie," *Love That Bunch*, p. 44. *Used by permission of Aline Kominsky-Crumb.*

sexual violence is as common as "walking down the street." In this, it is similar to Marjane Satrapi's visual depictions of trauma as the "everyday"—in which, for instance, she draws a mass execution in one panel, and in the frame directly below it draws the protagonist doing something commonplace such as smoking a cigarette (*Persepolis* 117).

In the sequence that depicts intercourse between her parents, Kominsky-Crumb's hand—her style—calls our attention to the mass of objects in the frames, including her father's penis, which is darkly colored and shaded, in stark contrast to his virtually blank white arm that moves down through the foreground of the right-hand side of the frame. In (dis)coloring the penis, Kominsky-Crumb presents it as a wielded *thing* (it barely looks a part of Arnie's body), matched in its *thingness* by all of the ostentatious stuff of her parents' bedroom, such as the lamp with its female figure motif that conspicuously faces Blabette and literally hangs between her and Arnie throughout the scene.[19] Blabette's face is largely obscured in first panel; we simply see her nose and large dark lips protrude outward from the lower left corner, mirrored by the jutting 1950s-modern style headboard.[20] Panels like this one suggest Kominsky-Crumb's critique of postwar culture, combining the violence of the spousal relationship visually on the page with the prominent, grotesque presence of overdecoration; violence and materialism are literally entwined here, as Blabette, Arnie, and the lamp create a visual heap of bodies in the panel in which he penetrates her ("Yew

love it bitch") (44). In this second panel, his penis is not as darkly shaded; it here contrasts with the black of his pants. The title panel (or, in comics parlance, the splash panel) for "Blabette and Arnie" is a large frame swimming with statements and objects: "It's grim! It's true!" text proclaims, amidst floating ashtrays, a Studebaker, a Dumont television, and the facts "Married in '47" and "First kid in '48" hanging in the upper corners.

The comic strip "The Young Bunch: An Unromantic Nonadventure Story" narrates Aline's first, traumatic sexual experience, as coerced by a classmate, Al, when she is fourteen. Kominsky-Crumb depicts this rape in a six-panel page in which the gaze, and her drawing style, emphasize the casual viciousness of the encounter: in one panel in which Al's penis, viewed from behind as he readies to penetrate Aline's protesting person, occupies the center of the frame, it is roughly the length of his thighs (figure 1.5). The first of these panels is a silent frame, showing Al removing the shocked Aline's girdle. The second offers a text box in the upper left-hand corner—"My First Penis:"—and a supine Aline looking up at a disproportionately large penis gripped menacingly by Al; she thinks, "It's so ugly. Looks like gizzards" (4). Aline's disgusted reactions to traumatic and formative sexual experiences continue in "The Young Bunch": in a later episode a man picks her up and forces her to give him a blowjob in his apartment. "Oh I hate this. . . . It's torture!" Aline's thought balloon reads in a panel in which all Kominsky-Crumb draws are grotesque genitals smashed up against Aline's bewildered face (12; figure 1.6). The remainder of the panels in the strip show Aline crying—first when she realizes, "My father was right I'm no good and it wasn't fun," and then, back in Long Island, when her father bashes her head against the wall. "Now stop that crying or I'll really give you something to cry about," he yells, as Blabette, looking unconcerned, scolds, "Arnie don't kill her!" and the strip ends (12).

It makes sense that this explicit strip—picturing excessive, swollen genitals—commences Kominsky-Crumb's autobiographical collection. One observes details that move toward realism and yet are also *not* realism, as we see in the abnormally large genitals that show up in Kominsky-Crumb's—and in Phoebe Gloeckner's—work. In the fellatio image, the man Vinnie's genitals, as in the sequence with Blabette and Arnie, look almost black in the first panel, and, by contrast, white in the second. Here, Kominsky-Crumb also inverts the dominant color scheme across the two panels. While in the first, Vinnie's body, in forcing fellatio on her, is starkly white against a wide black background, in the second, which focuses closely on Aline's face as he ejaculates, his body assumes the place of any substantial background, filling the frame with its white flesh. His body is represented as planklike in form: with the exception of his protu-

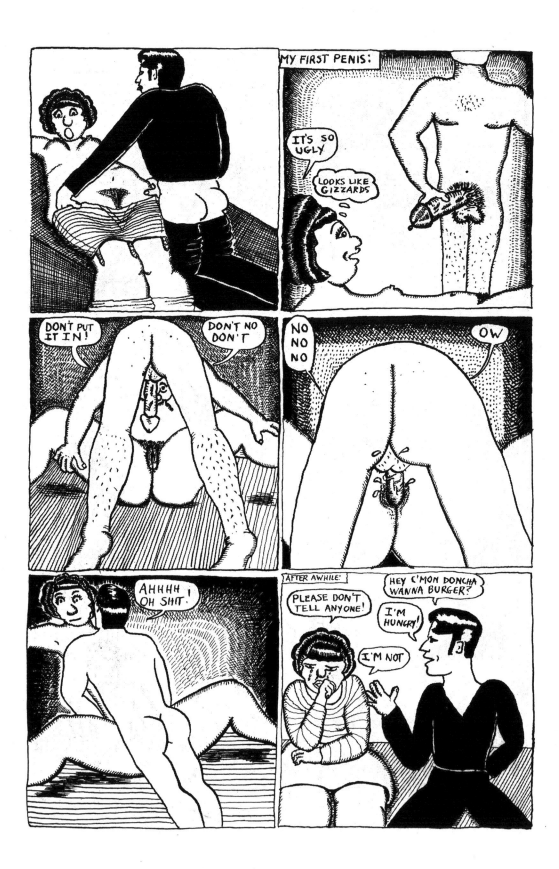

42

berant, hideously veined penis, it is a straight horizontal slab of flesh that bears down on her face. Kominsky-Crumb assigns the penis its own speech balloon, which in big block letters proclaims "SQUIRT!" (12). ("I'm never sure which side of the line of comedy/tragedy I'm treading while I'm working on a story," Kominsky-Crumb proclaims [Duncan 21].)[21] The panel, in which his body fills the top of the frame, expresses claustrophobia (turning the page to view the panel on its side makes evident the amusing, if horrifying, flatness of his body weighing down on her). Yet, while the second panel suggests the claustrophobia experienced by Aline in its features and perspective, we are anchored throughout this disorienting sexual sequence by her hair. The incredible texture of the dark hair, rendered with obsessive detail not afforded to the cruder, cartoony texture of the penis, for example, with its squiggled veins, anchors our focus to her and with her as she experiences the physical ordeal. Kominsky-Crumb's texts, while her project is nonfictional, are not, as I earlier noted, traditionally mimetic. The visual, psychic landscape presented in Kominsky-Crumb's nonfiction work, rather, would seem to have a predecessor in a surrealist sensibility.[22] Kominsky-Crumb presents a psychic landscape of affect and eros; her works are cartoon drawings that put the sexual psyche on the page.

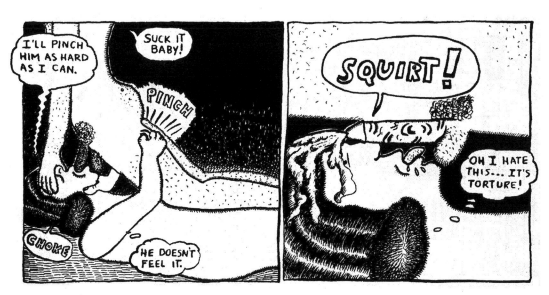

1.5 (*opposite*) Aline Kominsky-Crumb, "The Young Bunch," *Love That Bunch*, p. 4.
Used by permission of Aline Kominsky-Crumb.

1.6 (*above*) Aline Kominsky-Crumb, panels from "The Young Bunch," *Love That Bunch*, p. 12.
Used by permission of Aline Kominsky-Crumb.

The chapter "Mr. Bunch," like "The Young Bunch," also depicts explicit—and disgusting—fellatio. This strip focuses on Aline's male alter-ego, Mr. Bunch, who "lives inside the Bunch," and is usually shown smoking a noticeably phallic cigar (32). The strip presents a fight and reconciliation between Aline and a male character: all we ever get to observe throughout the strip of Aline's partner are his genitals. In the first explicit panel, we see a crude cross-section of fellatio, in which an enormous and grotesquely veined penis inserts itself into Aline's mouth and bumps up against the horrified Mr. Bunch (33; figure 1.7). In the next panel, the view closes in on semen spraying out of the head of the penis and into Mr. Bunch's eye. The subsequent panel shows him crying and wiping his face with a handkerchief. In the strip's very last panel, the boundaries around Aline, Mr. Bunch, and Kominsky-Crumb blur, as Mr. Bunch, now trapped inside an exercising Aline, comments, "I'm telling ya friends if I didn't draw these comics I'd lose my grip!" (33). None of the characters in the strip is shown to draw comics, nor do they mention comics: the performative narratorial voice, claiming a power of authorship, is shown to literally emanate from inside the "trapped," personified physical body of the autobiographical protagonist. And the place from which this authorial voice speaks, then, is from a position of sexual disgust ("They're gonna make up, yuk," he complains as the couple begins to be physically intimate [33]).[23] This strip shows the projection of what we may read as Aline's sexual disgust mapped—literally—onto the figure of her male alter ego. In this manner, Kominsky-Crumb shows us, through a literalizing visualization, how the position of femininity incorporates both desire (Aline) and disgust (Mr. Bunch). By imbuing the *male* figure with the sentiment of sexual disgust, she also critiques—in showing us, literally—that it is the role of the female position in culture to "suck it up."

Kominsky-Crumb debunks traditional expectations for representations of women's bodies, but she also, more importantly, uses the space of comics to offer productive visions of women's sexuality. As such, she is riveted to bodies: "everything about the body's fascinating to me," she claims ("Kominsky-Crumb Interview" 64). We see this clearly in "Bunch Plays with Herself," which she has called "the most disgusting strip I've done" ("Aline" 168). In this two-page, eighteen-panel strip, Aline is the only character. Each page is composed of nine uniformly sized panels, a structure unusual in Kominsky-Crumb's work, which generally employs a loose approach to panelization, but fitting here, as it democratizes each of the bodily activities the story represents. The first page depicts Aline regarding a pimple on her breast, popping pimples on her temple and on her back, scratching her anus and smelling her fingers, picking her nose, eating a sandwich, and licking her fingers. The second page offers Aline masturbating naked—in a

frame similar to that of "Goldie," in which her face and vagina are lined up in the center of the panel as she stares straight at readers; here, her spread legs bleed off into the gutters (figure 1.8). Kominsky-Crumb then depicts Aline lowering herself into a kiddie pool, sunbathing, getting sunburned, napping, and again popping a pimple on her breast. In the last panel, Aline, riveted to her pimple, declares, "My body is an endless source of entertainment!" (22).

The strip, in which one frame is completely filled up by Aline's hand on her vagina, is a representation of female sexuality—and, crucially, self-sufficient female sexuality—as routine and normative. That "Bunch plays with herself," as the title goes, is as everyday an activity as eating a sandwich. The strip also deidealizes the female body: if we see a naked woman playing with her vagina in three panels (the speech balloons for these panels simply read, "Unh unh unh. . . . Ohhh Ahhhh Ahhhh Be Be Be") we also see three panels in which she lifts up her dress, inserts her finger in her anus, and smells it (the speech balloons here read "Eeyew my ass really itches me. I hope no one sees! . . . It smells and I like

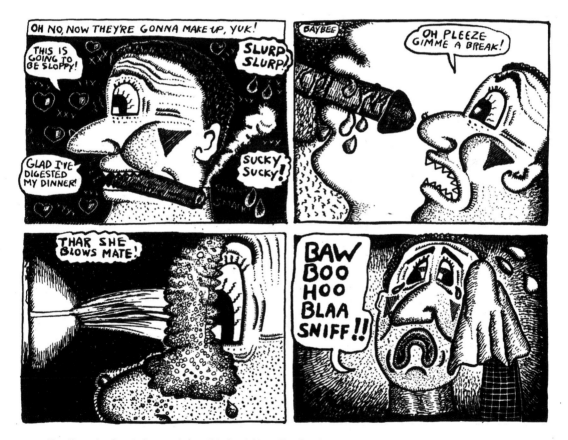

1.7 Aline Kominsky-Crumb, four panels from "Mr. Bunch," *Love That Bunch*, p. 33. *Used by permission of Aline Kominsky-Crumb.*

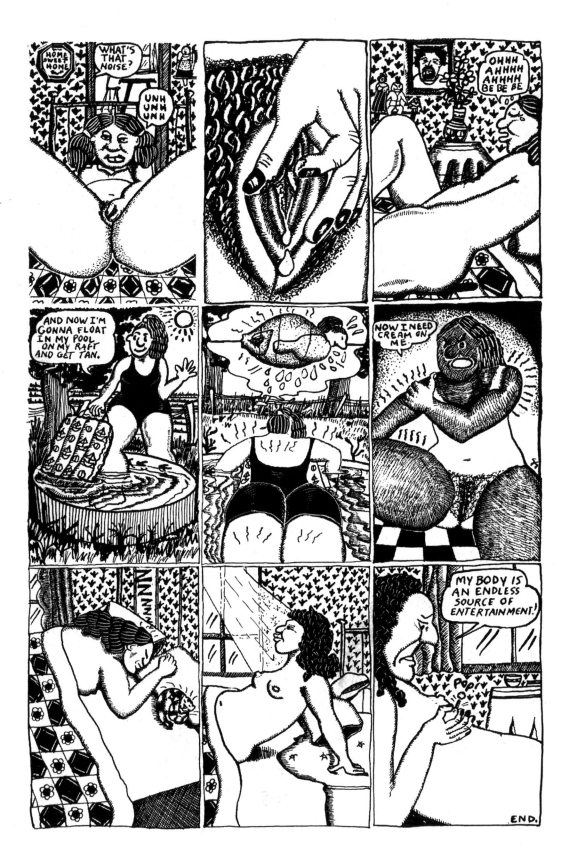

it!" 21). The irony of Aline's comment—"I hope no one sees!"—cannot be lost on readers, who see the pictured body as both a repository of "filth" (pus, smells, snot) and orgasm, in this uncommonly brave theorization and visualization of a body as "play," in many different senses of the word. Kominsky-Crumb writes *through* the body as abject: her body is formidable, her work implies; she recognizes that it threatens traditional representation.

At *Love That Bunch*'s midpoint is a chapter that makes evident Kominsky-Crumb's aesthetic investment in comics, and, further, in her distinctive visual style. It is a condensed, comics-form *Künstlerroman* (a genre of story that is likewise embedded in a larger autobiographical narrative in Lynda Barry's *One Hundred Demons*, as I will discuss in chapter 3). "Why the Bunch Can't Draw" charts the trajectory of Aline's style and commitment to various forms of art throughout her life; its timeframe goes back to her paternal grandfather and ends in the present-tense situation of enunciation of the strip itself. Its appearance halfway through the book demonstrates Kominsky-Crumb's approach to crafting a life narrative: *Love That Bunch* places us, again and again, in her childhood, bringing us forward into her adult life by focusing on separate strands (while, as I have noted, the themes of sexuality and self-formation stay constant). *Love That Bunch* offers a layered narrative structure that gradually builds forward, filling out a full picture of forty-plus years, but across its individual chapters it overlaps time periods and episodes, rejecting a straightforward chronological structure even as it presents, broadly, a series of events that develop a life: death, moving, marriage, childbirth, affairs.

In "Why the Bunch Can't Draw," Aline, or, as Kominsky-Crumb calls her young protagonist, "The Bunch-Child," decides at age eight that she will be an "ahtistic" genius, and she starts by copying modernist masters, a task at which she is unusually adept. "I think I copied this Picasso pretty good!" she declares, wearing a smock, standing beside a palette. "I think I'll do a Modigliani next!" (75). As a "good little copier," she greatly impresses all the adults around her and, encouraged, she starts original work, creating abstract painting with her hands. Showing a painting to her family, she earnestly reports, "My aht teacher said this was a powerful piece of work!" while her parents, despite vocal praise, are mystified ("piece o' gahbidge if you ask me!" Arnie thinks [76]). Kominsky-Crumb highlights how art is, for the Bunch, always a sensual experience: she next creates a "body painting" by "pretending I was a wild pig laying in my mud pen

1.8 (*opposite*) Aline Kominsky-Crumb, "The Bunch Plays with Herself," *Love That Bunch*, p. 22. *Used by permission of Aline Kominsky-Crumb.*

squirming around"; while her teacher frames the work as her tapping into her "unconscious animal self," the suggestion is that the sensuality of the "animal self" is unselfconsciously and unobtrusively on the surface, not below it needing to be irrigated (76).

Her parents, irritated with her "free" art, cancel her art lessons. Yet as the Bunch moves through adolescence, she never stops painting (or visiting the MoMA: in *Love That Bunch*'s penultimate chapter, "La Bunché de Paris Turns 40," Kominsky-Crumb draws the teenaged Bunch staring at a Cubist masterpiece, musing, "If I can figure this out I can escape from Long Island!!" [124]). In her art classes at her first college, the Bunch's art professor Mr. Horowitz, evaluating her sketchbook, deems her unable to actually draw: "This scribbly stuff's just a gimmick, right?? Ya can't really draw," he pronounces, while she miserably resists, thinking, "I'm a ahtist!" (78). A similar structure of interaction replicates itself with a different teacher, who teaches perspective. The text box narration reports, "The Bunch did good on her exercises"—in other words, she learned perspective—but when she does not use "correct perspective" for the final project, turning in a drawing of a Cubist-style house, he scolds her, "But we just learned perspective!" before launching a tirade against "these girls that take these art classes" (78). At her next college, another male art professor—"a famous painter"—humiliates her, announcing, "You call this a human figure?" during a life drawing critique (79). Later, when he asks her to model for him, Kominsky-Crumb, drawing the Bunch with irreverent Cubist-style eyes, retorts, "You're a big asshole" (79). The lack of adherence to standardized rules of realistic rendering—scribbly; no perspective; misshapen human form—earns the Bunch the contempt of all of her male professors, who, further, gender her lack of "correct" technique.

Finally, at her third college, a female painting teacher encourages the Bunch, telling her "I think you have something to say," and advises her to ignore the previous professors "and their pathetic egos" (80). The Bunch, "re-inspired," and noting that her painting is heavily influenced by de Kooning, receives encouragement but not unreserved praise from her teacher, who tells her, "Intrasting attempt . . . keep working" (80). She does not; instead, she is shown sleeping with legion male art professors, earning their approval but ultimately turning "non artistic" (81). It is finally comics that pulls her out of her "non artistic" rut. The Bunch is immediately drawn to the idiom of comics; in a panel in which she is shown reading comic books, the frame shows her surrounded by her own excited speech balloons.

Comics is able to incorporate the abstraction to which she is evidently drawn, while yet, paradoxically, conveying an experiential accuracy—a realism of

quality and feeling if not a visually mimetic realism. The Bunch proclaims, "I c'n relate to this stuff . . . its so raunchy and realistic" (81). "Realism" is her main inspiration: "Inspired by the realism in comics . . . Bunch wrote her own story and took to San Francisco," the narration tells us, below a panel in which "Goldie" is laid out on a table (81). When she joins the San Francisco underground comics community, we learn "even the crudest underground artists gave the Bunch drawing advice," in a panel in which a bearded man tells Bunch to pick an old cartoonist and copy the style—but, crucially, "To no avail," the narration reports, in the conclusion of the story (81, ellipses in original). She started by copying male modernist masters, and in her narrative of development the Bunch is firmly an artist when she finds her medium and refuses to copy anymore, be it from high modernism or low cartooning. She has already developed a distinctive voice and style in which her focus on the registers of both abstraction and realism (that is, conveying her life experiences) coexist and amplify one another.

Like other authors discussed in *Graphic Women*, Kominsky-Crumb was not a comics fan as a child or adolescent. "I'm really coming [at comics] from a tradition of fine art, and trying to make art which is as expressionistic and personal as painting," she notes—a notion expressed in "Why the Bunch Can't Draw" ("Aline" 166–167). Stylistically, then, Kominsky-Crumb has no influences from the world of comics. She derived from Justin Green the notion that comics could be the form in which to communicate "how the truth as I saw it could be more surreal and intense than anything I could ever fabricate." But Green is not a stylistic influence; his work is "strangely fluid-looking to me," she says, especially compared to her own "scratchy-looking" comics ("A Joint Interview" 118). This self-assessment is not a self-critique: "I don't think this makes my work less interesting, just very expressionistic and often very ugly" (*Need More Love* 135). Of the visual landscape of her comics, Kominsky-Crumb asserts that she never connects her work to the style of other cartoonists ("A Joint Interview" 120). She does, however, see her work as part of a tradition including George Grosz, James Ensor, and Alice Neel. Further influences include Cubist painters (Picasso, Matisse, Cézanne) and German Expressionists (Otto Dix).[24] And despite how she flouts comics conventions—importing, we might say, a tradition of painting into a younger tradition built on print—the style in which Kominsky-Crumb maps her psyche onto the wavering frames of her comics pages is not "ugly" to everyone. What she depicts is often ugly, but her style does not have to be considered so.

Salvador Dalí's famous comments, "I think that secret desire represents the true future and, what is more, that the true spiritual culture can only be a culture of desires. No desire is blameworthy; the only fault lies in repressing them,"

feel apposite as a description of Kominsky-Crumb's project (quoted in Mundy 16). Even in its focus on establishing an artistic credo, *Love That Bunch*, significantly, does not move far afield from issues of sexuality: the Bunch is drawn to "raunchy" comics as an artistic mode that expresses—and at the same time advances—a process of subject formation inclusive of an active sexuality. In *Love That Bunch*'s satirical "Of What Use Is a Bunch?" Aline half-jokingly affirms her "eccentric sexuality" as useful: "Her animalistic passion and deep-seated masochism make her the *perfect sex object* for some boys!" (69). Yet what we actually see in the accompanying frame is her "animalistic passion" and "deep-seated masochism" making her a perfect sex object for herself. In graphic narratives, as I have discussed, images never simply illustrate text, but often situate meaning in the space between the differing denotative content of word and image. Thus the panel depicts Aline, strong-bodied, mouth open and tongue out, in underwear and a T-shirt, on her hands and knees, as a man sits on her behind, smacking it and pulling her hair taut: "I'm so bad!" she says. "Punish me good!! Harder, harder . . . Kill me, kill me! Bad . . . bad!!" (figure 1.9). The man, whose skinny body looks depleted next to her powerful form, urges, "C'mon horsie get goin'!" (69). This image—violent, erotic, alluring, and possibly disgusting—is typical of Kominsky-Crumb's unsettling work. Kominsky-Crumb displays a sexual life

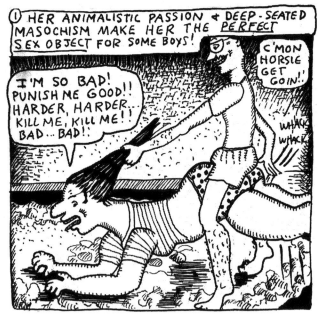

1.9 Aline Kominsky-Crumb, panel from "Of What Use Is a Bunch?" *Love That Bunch*, p. 69. *Used by permission of Aline Kominsky-Crumb.*

that mixes degradation and pleasure: a potentially but not necessarily disturbing portrait that has been underrepresented and undervalued in the cultural mainstream and in feminist visual elaborations of sexuality.

Writing her desires on the page, she is unveiling "secret" urges and, furthermore, envisioning and revisioning them through the form of comics. Quailing at the seeming sexual abjection of her work, Bagge asks Kominsky-Crumb of "Of What Use is a Bunch?": "Were you in a black mood when you did it?" to which she replies, "I was in a good mood" ("Kominsky-Crumb Interview" 63). Referencing the "horsie" panel specifically, he observes, "One reason why you're OK is because you're a perfect sex slave for Crumb. . . . It was like [one] more [reason] for somebody to hate you." Kominsky-Crumb, nonchalant, responds, "Yeah. It's really great. I love it. But it disturbed you when you first read it?" (63). Bagge erroneously assumes the pictured Robert Crumb's desires are dominant and Aline's are acquiescent (and further, that readers would "hate" her in that circumstance). This assumption about who is doing the work of objectification is gendered and misguided, denying Kominsky-Crumb agency even in her own public act of self-representation. In *Dirty Laundry*, coauthored with Robert Crumb, Aline explicitly declares her agency on the very first page of comics, in a short piece called "Let's Have a Little Talk." Grinning, facing readers directly, she addresses us: "I . . . want you to know that I thought up the most depraved panel where he pushes my head in the vomit." A box of text—"proud of being gross"—hovers above her head (7).

VIOLENCE, SEXUALITY, AND THE EVERYDAY: *DIRTY LAUNDRY*

The collaborative collection *The Complete Dirty Laundry Comics* (1993), in which Kominsky-Crumb draws herself and Robert Crumb draws himself in each panel, focuses even more explicitly on Aline's body and her ("eccentric") sexuality. The innovative *Dirty Laundry* project, which Kominsky-Crumb and Crumb began in the early 1970s with a series of confessional comic books, is the first of its kind—a man and woman sharing the space of comics frames, each both writing and drawing in an autobiographical narrative.[25] Here the demystification of bodies and of sex, concurrent with a powerful validation of sexuality, is explored in front of a domestic backdrop. Kominsky-Crumb's "dirty laundry" comics address standard but key feminist concerns: the difficulties of being a daughter and of parenting a daughter, of recognizing one's husband as a partner and as a father, of balancing work and family. This wide-ranging exploration of the domestic sphere positions *The Complete Dirty Laundry Comics* as

a strongly feminist book. The book reproduces the cover to the original *Dirty Laundry* comic book (1974), in which Aline and Robert stand naked under a clothesline on which are hung his etiolated long johns and her tattered, huge, discharge-soaked underpants. "It's not a pleasant sight!" hisses a neighbor. In this graphic narrative, sex between the Crumbs occupies a large portion of what the authors display. "We show ourselves doing it!!!" the original flyer for the comic proclaims (41).

To list some of the activity they draw across the chapters of book: he slaps her (9); she smashes him face down on the floor ("this show of strength is for my women friends out there") (10); Robert, clothed, humps her naked body, stuffing his fingers in her mouth and vagina (11); Aline, naked, attempts to demonstrate "horsey" to a child who walks in on their sexual encounter (11); Robert removes his erect penis from his pants and initiates fellatio for four panels, before Aline vomits and he grinds her face in the vomit, after which Aline praises him: "Robert you're so sweet. You play with me so good" (21); Robert ties Aline up upside down (22); Aline pulls a trailer through a flood with her teeth (29); Aline rejects Robert's advances ("this is not the time for fun") (33); Aline and Robert separately fantasize about Robert humping Aline (39); Aline sits on the toilet, pants at her ankles, thinking "I wonder if my brother likes me?" (46); Robert pushes Aline's face in food while humping her, then penetrates her while her face is in the food (49); Aline remains face down in food, her behind covered with food; when she emerges, dirty, her thought balloon reveals: "Confidentially speaking I enjoyed that quite a bit. I like it ruff, know what I mean?" (49); Aline praises and demonstrates her body's abilities: "I can draw myself and write my name with my foot. . . . Also, I can squirt water out of my cunt!" (52); Robert punches Aline in the behind while holding her head underwater (53); Aline asks Robert after he confesses infidelity, "C'n I suck your penis now to relax me from my hard day's labor?" and initiates fellatio after which Robert jams his hands down her throat, grinds her face into the floor, and punches her behind, culminating in an oversized panel in which Aline has an orgasm while screaming "Kill me!" (55–58; figure 1.10); the Crumbs' baby daughter, Sophie, vomits in Robert's face (84); Sophie, an infant, chants "Mommy drink penis, Daddy drink twat" (88); Sophie masturbates (98; figure 1.11); Aline and Robert stand on the pages of their own comic—the one we are reading—about to have sex (100); Robert sits on the toilet, musing that his nihilist friends will ill judge Aline's installation of a hot tub in their home (105); Robert smashes his hand into Aline's face (114); Robert humps Aline and squishes her face in the kitchen while Sophie watches television in the next room and eventually screams at her parents, still pounding each other when she bursts in, to "act normal" (124).

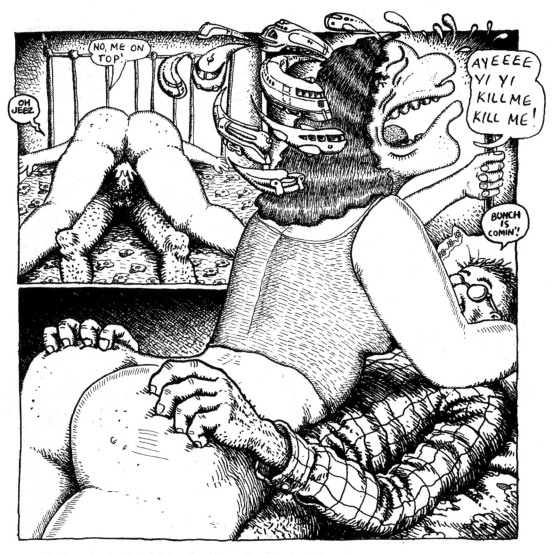

1.10 Aline Kominsky-Crumb (with Robert Crumb), panel from "Krumb and Kominsky in Their Cute Li'l Life Together," *The Complete Dirty Laundry Comics*, p. 58. *Used by permission of Aline Kominsky-Crumb.*

Crumb and Kominsky-Crumb show that the stuff of ostensible "pornography" is what they live on daily basis, along with other ins and outs of domesticity; its representation, especially through creative collaboration, is an attempt to expand forms of life narrative. Particularly, Kominsky-Crumb forces readers to consider the issue of subjectivity and self-representation. Her work recalls two important comments from the volume *The Philosophy of Sex*: Sallie Tisdale's, from "Talk Dirty to Me," "I want not to accommodate to pornography but to claim it. I want to be the agent of sex"; and Martha Nussbaum's, from her essay "Objectification," "in the matter of objectification, context is everything" (379,

398). Kominsky-Crumb narrates a sexual life that *includes* but is not limited to or determined by an "objectification" and "subordination" that she 1. finds pleasurable and 2. chooses herself how to represent. Her comics—even those in which Kominsky-Crumb and Crumb battle for space in a frame—are not inscribed by a (male) gaze that subordinates her. It is important to remember, as Teresa de Lauretis reminds us, that the gaze is a figure, not an image (143). And in her comics, the gaze belongs to Kominsky-Crumb herself.[26] The violence that is part of the couple's sexual interaction is consensual; however explicit it can be, the *Dirty Laundry* project is essentially rather sweet.

Peter Bagge, who was editor of *Weirdo* when the *Dirty Laundry* strip "More Good Clean Fun with the Crumb Family" first appeared there in 1986, tells Kominsky-Crumb in their interview: "I got a lot of letters from people who were really freaked out by [the panel of toddler Sophie Crumb masturbating]. . . . I got [one] from a cartoonist who said he hopes Sophie sues you for character assassination when she gets older." Kominsky-Crumb simply replies, "Putting it in the comics sort of demystifies all of that stuff. If you're drawing your kid it would be one typical thing that your kid would be doing, so you would have to put it in" (68). In combining a focus on "sexuality" with a focus on the "every-day" in her work, Kominsky-Crumb does the crucial and compelling work of both de-mystifying sex, and sexualizing the everyday. Masturbation is presented as the "perfect example" of showing the Crumb family reality, as Robert says in the strip; Aline and Robert emphasize that sexuality, whether "excessive" or "innocent," is part of the weave of their lives (98). As in Kominsky-Crumb's solo work, too, many different aspects of sexuality are shown running together: "More Good Clean Fun" opens on a grim note. On the first page, while Sophie begs to be held, Aline and Robert reveal that, since their last story, Aline had become pregnant and had an abortion, and, even though Robert had a vasectomy, she thinks she may be pregnant again. The next panel shows Aline, with jagged hair, miserably admitting in one speech balloon, "The thought of being pregnant again makes me sick! . . . its repulsive!" while another speech balloon concludes, "But the idea of having an abortion is also horrifying! I can't deal with either possibility!" (96). Two panels later (after a "break-through of shit and blood"), she is preening in front of the mirror in an exercise outfit while her husband squeezes her behind, declaring, "I wanna pork it now . . . Sophie's sleeping" (96). The chapter ends with the two of them working together on a comic strip and then starting to be physically intimate as the pages of the strip flutter to the floor. "More Good Clean Fun" starts with trauma, abortion, depression, moves through masturbation and parenting and comics making and sex, an example of the feminist project of writing through trauma that we recognize in

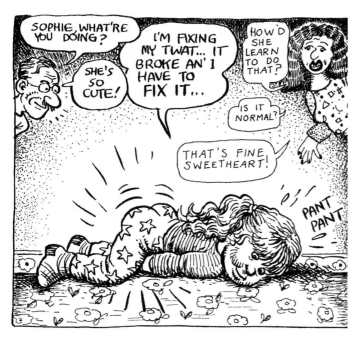

1.11 Aline Kominsky-Crumb (with Robert Crumb), panel from "More Good Clean Fun with the Crumb Family," *The Complete Dirty Laundry Comics*, p. 98. *Used by permission of Aline Kominsky-Crumb.*

the range displayed in these collaborative confessional comics. And, crucially, Aline resignifies "weirdo," claiming it for women without "normal" trajectories to follow: in the penultimate page of the book—after drawing and detailing in the book's preceding pages what many would consider "perverse"—she counters Robert's complaint that "Eccentric weirdos like us aren't fit to be parents" with a firm "Really? I don't think I'm that weird Bob!" (125).

SCRATCHING THE SURFACE: STYLE, EROTICS, AND IMPERFECTION

Kominsky-Crumb's uninhibited self-revelations endeavor to carve out space for the representation of complex lived realities: she is not simply "disclosing," but rather retracing her sexuality in the aesthetic form of comics, resignifying and reversing the negative connotations of female "inconsistency," as we see, for instance, in her representation of both pleasure and pain. We might consider Kominsky-Crumb's unstrictured textual reality a messy, transgressive "representational politics," in the sense of Drucilla Cornell's belief in a representational politics that can enrich imaginary and symbolic resources for women's sexuality. This is not a representational politics, in other words, that operates on a fixed,

prescriptive notion of "representation," but rather one that ignites a contingent set of articulations, expanding what has been referred to as a "feminine" imaginary. As Cornell writes, unleashing a "feminine" imaginary is about living a paradox, about writing through being "branded for life" ("Pornography's Temptation" 551).[27]

Throughout her work, Kominsky-Crumb draws herself in circumstances that appear to conform to Dworkin and MacKinnon's famous ordinance detailing what is inclusive of pornography, in particular: "women are presented as sexual objects who enjoy pain or humiliation."[28] Yet in a charged—and accessible—visual medium, Kominsky-Crumb counters this move to portray women as "fuckees," to use MacKinnon's term, by scripting her own desires and rendering them available and legible. Unfortunately, it is unsurprising that even an underground cartoonist like Peter Bagge so clearly misses the liberatory power of images imagined and depicted by women who are not imprisoned by the predatory gaze, but create their own sexual environments and sexual representations.[29] In the 1980s—the period in which Kominsky-Crumb produced the most work—pornography debates bloomed: while one group called it pleasure, another called it oppression.[30] Kominsky-Crumb's *Love That Bunch* unglamorously presents various sexual registers: it depicts situations of obvious sexual abuse (rape), nonviolent sexuality (masturbation), and consensual violent sexuality ("horsie," among other scenarios), arguing that all are part of a lived reality that has flown below the critical radar.

Potential printers of the book labeled *Love That Bunch*, which was published by Fantagraphics, one of the largest and most influential independent comics publishers, pornographic. This was also the case with Phoebe Gloeckner's *A Child's Life*, which I will discuss in the next chapter. Kominsky-Crumb singles out the censorious "right-wing anti-pornography movement" as deleterious, and in her comic book *Self-Loathing* no. 1, she clarifies, "Christian printers refuse to print my work because it's too pornographic and some feminists are on their side" ("Aline" 169; "A Day").[31] The drawing of erect, and menacingly erect, penises, as opposed to, say, Kominsky-Crumb's intimate drawing of Aline's vagina in "Bunch Plays with Herself," is the aspect of *Love That Bunch* that I suspect is considered the putative stuff of pornography (it was a specific panel of Gloeckner's *A Child's Life* that showed a girl bent over an erect penis that raised the ire of that book's printer; images of women's genitals during sexual acts are also pictured elsewhere in that volume). When I asked Kominsky-Crumb in an interview about the multiple printers who deemed her work pornographic, she emphasized that the fact of women drawing sexual images concerned male printers in a way sexually explicit work by men in the past had not: "Men doing porno

is fine. But women—the way I drew degrading, ugly sex and everything is really a turn-off to men. They hate it. . . . Both Phoebe and I made the whole thing seem very unsavory, but in a way that sort of throws it back in men's faces, or, you know, is very hard to look at" (Interview). Kominsky-Crumb's images display a deidealized version of intimate male-female relationships, placing pressure on both romantic ideals (the "unsavoriness" of sex that is evident in her comics) and also on culturally dominant notions (from both pornographic and romantic economies) about the victimhood and acquiescence of women.

The editor of Fantagraphics, also the editor of the *Comics Journal*, ran the following comment with Bagge's interview in 1990: "*Love That Bunch* . . . is being released after a world-wide search for a printer who wouldn't quail at its explicit depictions of blowjobs, masturbation, ass-picking, and self-doubt" ("Kominsky-Crumb Interview" 51). This comment—offered by her own book editor—highlights one unfortunately common response to the confrontationally "incorrect" visual landscape of Kominsky-Crumb's work: the overemphasis on her self-deprecation in her comics to the point of blindly harping on a narrow vision of "the personal" (neurosis of the author) at the expense of granting her work a wider political purview. Plenty of male autobiographical cartoonists, whose work is much more easily accorded its satirical aspect, are no less self-deprecating in their work than is Kominsky-Crumb. She understands her work as operating in the tradition of Jewish stand-up comedy—what she has called "a certain kind of Jewish fatalistic humor" that is an "anecdotal, self-deprecating humor" (*Need More Love* 333; Arazie 49).[32] The difference is only that Kominsky-Crumb's work focuses on affect and the female body. Bagge, for instance, belabors her "self-doubt." He endows her self-deprecation not with the deliberately ironic—and appealing—self-reflexiveness that is accorded Spiegelman, for example, but rather he fashions it as a "natural" urge: her "personality" transcribed directly to the page. Bagge views Kominsky-Crumb's political representation of the everyday, and of intimate sexuality, as merely a symptom of personally unavoidable open floodgates. "Do you still feel just as strong a compulsion to tell all as you did when you first started?" he asks. Kominsky-Crumb refuses this reading: "It's more esoteric than that. Not to tell all but to tell something" (64).

As with Marjane Satrapi and Lynda Barry, the "something" Kominsky-Crumb "tells" has as much to do with *how* she tells in the form of comics as with what she tells. Yet Kominsky-Crumb's style, as with Satrapi's, is erroneously figured as "natural." Specifically, as is also the case with the content of her narratives, it is figured as the product of compulsion. Kominsky-Crumb depicts imperfect, violent, complicated sexual bodies with a visual approach that she calls "tortured scratching." She describes this style as "primitive, painful scratching

that's not for everybody," in part because she eschews attention to details of realism, such as detailed shading and dimensionality, that, for instance, characterize the obsessively cross-hatched work of Robert Crumb ("Aline" 168). Lamentably, her critics appear uninformed about how visual style is a feminist political issue: the *Comics Journal* editors, for instance, write of her work whose "rough surface is so effective at masking her wit, skill, and intelligence"; and how "her art . . . has never renounced its essential cruddiness" ("Kominsky-Crumb Interview" 50).[33] Unbelievably, Bagge—although couching his question as a "joke"—comments in his interview, "I was going to ask, sarcastically, why you draw so shitty" (68). And as if to underline a (fallacious) direct relationship between perceived style and content, the *Comics Journal*, in this interview, reproduces—enlarging it to twice its original size—a panel from the seminal "Goldie," depicting a disproportionate, large, pimple-dotted, unattractive teenager, in which Kominsky-Crumb's own text reads, "With puberty came uglyness and guilt" (55). Yet the stylized depiction of feeling ugly is surely not itself an "intelligence-masking" lack of talent.[34] As with Satrapi, Kominsky-Crumb has a background in the fine arts; as with Satrapi's, her style, while it codes to some as simply deficient, is an intentional practice. Of course, one does not need an arts degree to be a successful artist;[35] my point in mentioning Kominsky-Crumb's training is simply to highlight how hasty critics are, especially from within the male comics world, in judging her style as lacking. This is not the case, however, from a fine arts perspective: the *New York Times*'s notoriously hard-to-please Roberta Smith, reviewing a thirty-three-year gallery retrospective of Kominsky-Crumb's comics work in 2007, writes that Kominsky-Crumb "excels at the drawn-and-written confessional comic. . . . Her clenched, emphatic style echoes German Expressionist woodblock in its powerful contrasts of black and white, and her female faces—especially those of her thinly disguised surrogate, The Bunch, and her relatives—have a sometimes uncontainable fierceness" (34).[36]

Kominsky-Crumb's style—her "primitive," "painful," "tortured" "scratching"—indubitably represents a political choice. "I could have made my comics more appealing or attractive looking, but I just didn't want to," she clarifies. "Ugly" is *realistic* for her in that what she observes is the everyday fabric of women's lives: Kominsky-Crumb, as noted, writes against what she calls an "idealized feminism" ("Kominsky-Crumb Interview" 58, 62). The editors of the *Comics Journal* claim, surprisingly, "even her most avid fans often admit that their initial reaction to her work was one of revulsion" ("Kominsky-Crumb Interview" 50). This "revulsion," I wager—while the editors feebly suggest that it is a reaction to Kominsky-Crumb's untutored style—is a terrified and sexist reaction to the confrontational presence of a demystified, specifically female body.

Further, it is because her "ugly" rendering contains the conspicuously imperfect quality of the hand—marking her as an "amateur," marking the material, disruptive presence of her body in the work—that Kominsky-Crumb claims her style as a compelling, erotic mode of cultural production.[37] "To me, the struggle is what makes art interesting," she avows ("Aline" 171).[38] Roland Barthes, whose work accommodates a focus on pleasure and pain that we see in Kominsky-Crumb's comics, writes in a famous 1972 essay about the concept of "the grain," which indicates the texture in a work of bodily force, a register of material struggle. A work with a grain, Barthes suggests, has a theoretical value that is erotic (188). He identifies the grain in cultural production in which one can discern "the body in the voice as it sings, *the hand as it writes*, the limb as it performs"; it is "the materiality of the body speaking its mother tongue; perhaps the letter, almost certainly *signifiance*" ("Grain" 188, 182; initial emphasis mine).[39] This grain is evident in Kominsky-Crumb's work, and is, further, an important notion for thinking through the value of graphic narrative broadly. We see with Kominsky-Crumb the struggle for meaning that Barthes prizes as fundamental to *signifiance*: the struggle is an explicitly sensual—and here, in comics, also *tangibly material*—process by which the "subject" that is the focus of the work skirmishes with the "sentimental clearness," the "expressive reduction operated by . . . culture" that would aim not only to eliminate any grain but more specifically to erase the imperfect, even semantically excessive, presence of the body in order to facilitate a quest for the clearest meaning (185, 184). The body can be messy, obstructive, polyvalent.

This prizing of what Barthes deems an "amateur" mode of cultural production as imperfectly sensual provides an important framework for reading Kominsky-Crumb's work. Her comics put across Barthes' grain in a style that has infuriated so many critics seeking the seemingly perfect clarity of more devotedly representational modes—which are here interrupted by the body, both thematically and materially. Kominsky-Crumb not only draws the body—defecating, masturbating, coital—but, more importantly for an understanding of the grain of her texts and of comics generally, she materializes her body on the page in her resolute foregrounding of the work of the hand, much as Lynda Barry does in her attention to the hand. "I like shaky, expressive line quality, that's what it's all about to me," Kominsky-Crumb asserts, claiming what others devalue as "cruddy" as a deliberately erotic mode of production that inscribes her own messy body in her work ("Aline" 171). Her descriptions of her work process are also dotted with a language of sexuality: in *Dirty Laundry* she lets readers know, concluding the four-page introduction, "I hafto go up to my studio all alone. . . . We each have to face that blank white page on our own . . . oy . . . I have the urge

to draw a really smutty story" (5). Kominsky-Crumb's account of the practice of creating comics offers a sensualist reading of the process of composition: "Comics are completely primitive," she claims. "It's a dinosaur medium—working with pens and paper. . . . Sweat drips on the paper and you spill ink on it, you get food on it" ("Aline" 170). The material erotics of the body, then—even everyday erotic practices like eating and sweating—comprises the content of her comics and threads itself onto the page in how she draws. Kominsky-Crumb's style is a specifically feminist aesthetic response to an idealized and culturally male methodology of style.[40]

"For All the Girls When They Have Grown" 2

PHOEBE GLOECKNER'S AMBIVALENT IMAGES

I n literally visualizing the lived reality of women, what cartoonists like Kominsky-Crumb and Phoebe Gloeckner make especially clear is that, in dominant social formations, female sexuality is composed of both pleasure *and* degradation. These graphic narratives unsettle epistemological binaries with the charged, affective images they offer, playing with critical "correct distance."[1] As Marianne Hirsch suggests, "To be a spectator . . . is to respond through body and affect, as well as through the intellect" ("Collateral Damage" 1211). On the valence of the "graphic" in graphic narratives, Gloeckner's publisher Richard Grossinger, referencing Dorothy Allison's famous 1992 narrative of sexual abuse, contends: "There's a resistance to something that's drawn that wouldn't exist if it were written. If you're talking about child abuse, 'Bastard Out of Carolina' is in many ways harsher than Phoebe's work. If you drew that, you'd be marginalized" (quoted in Orenstein 28). Gloeckner's images, confrontational and confusing, convey a deep-seated sense of horror and taboo. Kominsky-Crumb, like Gloeckner, contends that the traumatic is infused into the everyday culture of women (as in the frequent, explicit depictions of rape in *Love That Bunch*).[2] But Kominsky-Crumb's work concentrates less on sexual trauma than on the broad psychic and material efficacy of breaking erotic taboos. Her work is about how, as Paula Webster argues in the influential anthology *Pleasure and Danger*, the collective project of creating an erotic culture for women can be a counter-chorus to a vast organization of repression, and "in recognizing our sexual appetites as normal, we might lose a sense of ourselves as the victims of sex" (396). Gloeckner's images, on the other hand, consistently informed by trauma, are darker; their combination of meticulous, painstaking realism and their non-realism (the puffed-up heads, eyes, and genitals she tends to give her characters) carries an intense foreboding.[3]

A CHILD'S LIFE: THE RISK OF REPRESENTATION

Widely acknowledged as among the finest draftspersons in comics, Gloeckner is "one of the most accomplished artists in terms of mastery of the medium," says cartoonist Bill Griffith, who published her work when she was only a teenager. Richard Grossinger agrees: "In a perfect world, she would have as large an audience as R. Crumb or Art Spiegelman. She's that good. But we haven't been successful in letting the world know about it" (quoted in Orenstein 28).

Gloeckner published her first collection of comics, the semiautobiographical *A Child's Life and Other Stories*, in 1998.[4] The book opens with a full-page, highly detailed and realistically rendered self-portrait of a decaying Gloeckner, eyes closed, head turned sideways, arm across her naked chest, plagued by pemphigus vulgaris, a disease in which one's dermis separates from one's epidermis—otherwise known as a condition in which the skin blisters at the touch (figure 2.1).

It is hard not to read this illustration—commencing a highly autobiographical collection of work—as a metaphor. As if to literalize or visualize a shattered subjectivity, Gloeckner offers readers their first "image" of her as an actual image of a decomposed woman.[5] The image concentrates our attention on her body by absenting any background; the drawing itself, below her torso, decomposes into the negative space of the page, floating her body in space and offering it up to our focus. This image's distinguishing feature is its ambivalence.[6] Head turned away from readers, refusing to look at us, her eyes are closed—in agony? Her brow is furrowed, but the cast of her face could be read as either anguish or a faint sensual pleasure. The image appears to underline the subject's shame: by drawing herself as physically, grotesquely sick—marked—she externalizes the shame of the "sickness" (the ostensible non-normativity) of her experience, her prurience. This portrait of bodily decomposition is accompanied by a handwritten foreword filling the opposite page, in which Gloeckner explains that when she started getting her stories published, "I managed to convince myself that I wasn't too much of a 'bad' person for publishing my 'shameful' work, because, after all, hardly anyone would ever see it" (7). The body in the image is stamped by a circular inset, a close-up examination of skin; this inset is itself stamped by a square inset, an even closer-focus examination; the layers here imply a kind of recursivity of shame and taint. Yet, while we may read the image as a manifestation of psychic shattering (marking or scarring the body, perhaps initially instigated or absorbed *by* the body), her physical presence is not (only) a register of abjection. Gloeckner is also beautiful in "Self-Portrait with Pemphigus Vulgaris."

Her pose, head turned downward at a three-quarters angle, is classical. Her lips and cheekbone are dewy, full; light shades her face. Her hair is lovely,

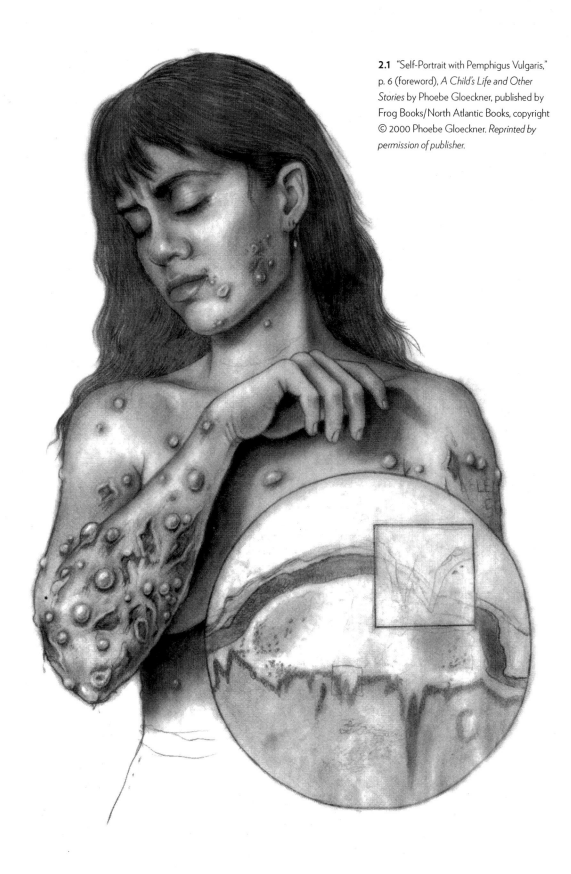

flowing, neat. And she is not departicularized by the blistering: her tattoo is yet evident on her left arm and her left ear is decorated with jewelry. Furthermore, her right hand, which occupies the center of the page—and in contrast to the other parts of her body—is free of sores. This clean hand creates a shadow on her left shoulder, and in the shadow her index finger appears to gently point outward. Her unblemished hand suggests an index of her testimonial agency—to write, and to draw, despite or through "blistering at the touch," and it also, with a sliver of defiance, destabilizes or redistributes the location of shame, shifting it away from merely Gloeckner herself to a larger field. Her posture suggests at least three possibilities: it is self-protective, covering her body—at the same time that it implies a sensual movement across her body—and it is also subtly accusatory.

The repletion in the image that carries both disgust and pleasure is characteristic of Gloeckner's work. Her images also provoke a similar contradictory feeling for the viewer, who may recognize them as both repulsive and alluring. While the content of Gloeckner's work is often unpleasant and discomfiting, this is countered not only by the pleasure of fascination with the revelation of the private and the disgusting but also by the visual abundance distinguishing her style. There is a pleasure in its sumptuous fullness, its careful, controlled attention to literal and figurative fleshing out. R. Crumb writes that her comics are "so densely packed and painstakingly detailed, it's slow going to get a page finished" ("Introduction" 5). This packing of the image, its materialization of detail, is part of what codes its pleasure. That Gloeckner's visually and emotionally rich work requires a slowing down, as Crumb suggests, is part of its political import and power. In Glockener's hand, circumstances (and the situating of the subject) require pause, attention to the sometimes undecidable complexity of detail and tone.

Gloeckner, born in 1960 in Philadelphia, is a professional medical illustrator. She studied art and biology at San Francisco State University, and earned a graduate degree in Biomedical Communications from the University of Texas Medical Center.[7] Currently a professor at the University of Michigan, in the School of Art and Design, Gloeckner has authored comics since she was a teenager and has also used her impressive draftsmanship to illustrate such experimental work as novelist J. G. Ballard's *The Atrocity Exhibition* (revised edition, 1990), in which she uses the hyperrealistic stylings of medical illustration, cross-sections and detailed insets, to point up charged content, such as in her famous cross-section depictions of fellatio (see, for example, figure 2.2). In Ballard's dystopian book, for which she had full creative license, Gloeckner offers dark, often surrealistic content, such as in the opened and festering breasts of a naked, reclining woman, whose siloplastic implants spill out of her body; the

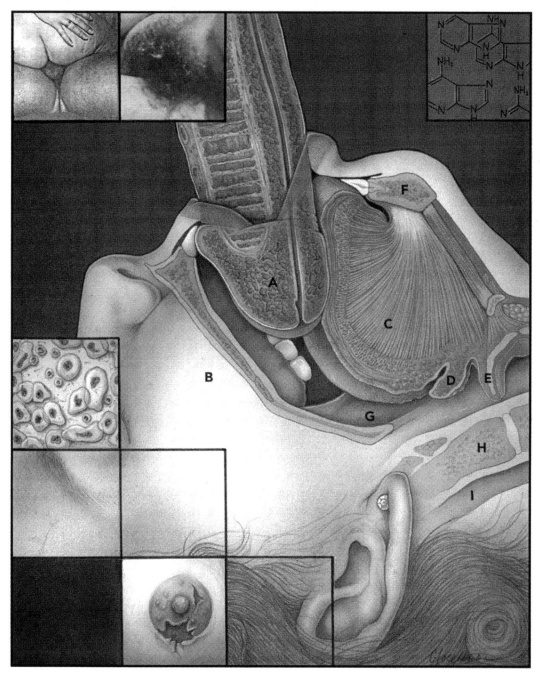

2.2 "Untitled," p. 138, *A Child's Life and Other Stories* by Phoebe Gloeckner,
published by Frog Books/North Atlantic Books, copyright © 2000 Phoebe Gloeckner.
Reprinted by permission of publisher.

image is dotted with insets of diagrams of the nose. Many of these illustrations are reprinted as an ominous conclusion to *A Child's Life*, which also collects work Gloeckner published in the underground comic books *Weirdo*, *Wimmen's Comix*, and *Young Lust*, as well as in the book anthologies *Twisted Sisters* and *Twisted Sisters 2*.[8]

A *Child's Life* features, as does Gloeckner's later work, a child protagonist named Minnie. As one interviewer has noted, "In conversation about her work, Phoebe Gloeckner shifts arbitrarily between referring to 'Minnie' and 'me'" (Orenstein 28). Gloeckner rejects the putative sanctity of "autobiography," asserting as she has in numerous interviews the critical commonplace that "truth" is discursive. Yet, while on one slippery official level Gloeckner resists the autobiographical label, her work is clearly self-representational, and I treat it as such here. The trauma her work returns to again and again—the rape of a teenage girl by a father figure; that girl's descent into psychic oblivion, which includes further rape—matches events in her own life, facts she freely shares. (As Leigh Gilmore does in writing on *Bastard Out of Carolina*, also centered on a nonbiological father figure, I describe this original trauma as incest "instead of the more general child sexual abuse to underscore the family as the context for his violence" [55].)[9] Suggesting the evidential truth-value of her work, her mother has even threatened to sue her over it (Groth, "Interview" 113). And Minnie is Gloeckner's exact visual equivalent, as any photographs of the author reveal (several dot the back page of *A Child's Life*). Several of the stories in *A Child's Life* also present a clear autobiographical framework: an opening image of the present-day author facing readers—an evident adult body, almost confrontationally large, anchoring the narrative in the act of testimony. "Fun Things to Do with Little Girls" presents such a figure, who appears too huge, even, to be contained by the story's first frame. An arrow points to the dare-to-challenge-me face of this woman, who is identified in handwriting as Phoebe "Never gets over anything" Gloeckner and stares intently out to meet the reader's gaze (66).

Likewise, in "Minnie's 3rd Love, or, Nightmare on Polk Street," Gloeckner draws herself in the opening splash panel (figure 2.3). A decorative heart enclosing the subtitle of the story, with the date and byline, is pierced by an arrow that also serves to identify Gloeckner. She doesn't fit entirely within the frame; it cuts off the top of her head. She gazes directly out at readers, with a look that seems benevolent, perhaps, at first glance—she is smiling—but also has a sarcastic intensity; her eyes are huge, defiant, penetrating. Mirroring Gloeckner's body within the frame of the page, a small framed portrait of a toddler rests, also facing readers, on the table in front of her, along with a pacifier (the story takes place in 1976 and identifies in its last scene that eighteen years later, in 1994—the

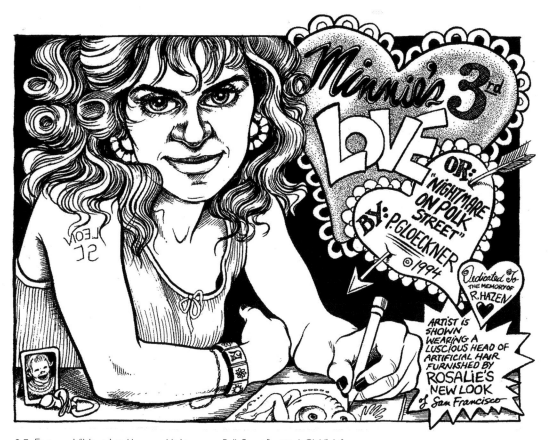

2.3 First panel, "Minnie's 3rd Love, or, Nightmare on Polk Street," p. 70, *A Child's Life and Other Stories* by Phoebe Gloeckner, published by Frog Books/North Atlantic Books, copyright © 2000 Phoebe Gloeckner. *Reprinted by permission of publisher.*

same year of the piece—Minnie has a two year-old daughter). Gloeckner appears in the act of drawing, pencil on page, composing an ominous hybrid: what appears to be frog with female breasts. A paratextual note, underlining the actuality of the scene, reports that "artist is shown" wearing a wig from a specific store in San Francisco. But, most interestingly, especially for a frame invested in the veracity of its details, Gloeckner's tattoo on her upper arm appears conspicuously backwards (in her opening self-portrait with pemphigus vulgaris, Gloeckner's tattoo, which spells out "Leon SC," is also evident, with correctly facing letters). Gloeckner calls our attention to her process of production; as if depicting herself in the act of drawing is not enough, she highlights the act of drawing through an off-kilter detail in the final representation: she draws her tattoo as she would see it in a mirror when posing herself for herself to draw. (Although it looks, in this mirror image, as if she is left-handed, she draws with her right hand and her tattoo is on her left, consistent with figure 2.1.) Through this detail—this shift

in the viewpoint of the subject/creator—Gloeckner features the circumstances of production to remind us of the author's creative and testimonial agency. Her self-representation is as literally marked by her productive act of drawing.

A Child's Life is divided into four sections that are loosely chronological: "A Child's Life," "Other Childish Stories," "Teen Stories," and "Grown-Up Stories." A fifth, final section, as noted, collects a series of single-panel images, mixing color and black and white; while some of these illustrations appear to mix associations loosely, others imply narrative, like *The Atrocity Exhibition*'s "Direction of Impact": a naked woman, crouching, inserts a diaphragm into her vagina, with inset diagrams illustrating the "direction of impact" to tibia and fibula (127).

The book focuses in large part on Minnie's problematic relations with father figures. As a young child, she has troubles with her stepfather, a domineering man who stigmatizes the comfortable, platonic physical relationship Minnie has with her mother, while at the same time sexualizing young Minnie for his own pleasure. Later, as an adolescent, she has a sexual relationship with her mother's boyfriend. The text's first depiction of their sexual intercourse, in "Fun Things To Do With Little Girls," shows him disproportionately enormous, sweating over a small girl who stares out blankly and unnervingly at readers (67; figure 2.4). The clock behind them, suggesting surreptitiousness, reads three; pendulous drops of sweat hang suspended from his brow. In *A Child's Life*, Minnie's behavior as she grows older becomes desperate; one of the most striking stories in the book, "Minnie's 3rd Love," narrates how Minnie, after running away, falls in love on the streets with a teenage drug addict named Tabatha—herself an abuse victim—who then drugs her and sells her body (75; figure 2.5).

Images of sexual acts, and oftentimes images of menacing, enlarged genitals, are prevalent in *A Child's Life*. Most mainstream bookstores do not carry Gloeckner's work; her publisher has suggested to her that without the images of erect penises, her books would be easier to market (Orenstein 29). Gloeckner is wary of the idea that what people react to with fury in her work is an erect penis, rather than to the intimate images of degraded women that have now become so culturally familiar.[10] And while her texts do represent degradation and abuse, her work also focuses on sexual desire, as I will discuss, which is yet another reason Gloeckner wants to fight the cultural edict that bans the representation of erections in any nonmarginalized work. In her interpretation of the "laws of pornography"—which reject a space for visual narratives of female abuse (shipments of her books have been denied entry by French, Canadian, and British officials) and yet also reject a space for visual narratives of female pleasure—

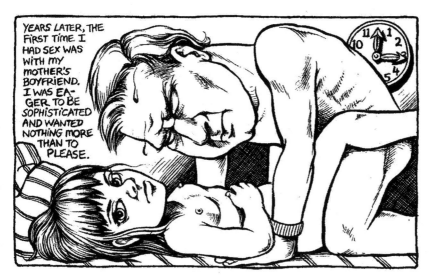

2.4 Panel from "Fun Things to Do with Little Girls," p. 67, *A Child's Life and Other Stories* by Phoebe Gloeckner, published by Frog Books/North Atlantic Books, copyright © 2000 Phoebe Gloeckner. *Reprinted by permission of publisher.*

You can show a woman with her legs spread and some spray on her to make her look like she's all hot and bothered, right? And then you can't show an erect penis. I mean, tell me why? . . . A man can pick up a *Playboy* and see a beaver shot and jerk off on it thinking, "Oh, she wants to get fucked." But *Playgirl* magazine has flaccid penises. I mean, who's gonna pick that up and think, 'He wants to fuck me?' You're not. I think those laws were made because men are homophobic and also afraid of women's sexuality. . . . It's not expressed. . . . I'm fighting against it.[11]

(Collins)

Gloeckner's work is disarming precisely because she takes on both pain and pleasure; she writes "beyond the wound of femininity," as Drucilla Cornell puts it (*Imaginary Domain* 163). And this refusal to adopt one or the other as the foundational contour of the female subject, especially in the context of an account of incest, is reflected in how Gloeckner capitalizes on the visual-verbal form of comics.

In *The Limits of Autobiography*, which considers six primary texts, all prose, Leigh Gilmore writes that "autobiography about trauma forces the reader to assume a position of masochism or voyeurism. . . . Invited to find himself or herself . . . or to enjoy a kind of pleasure in the narrative organization of pain"

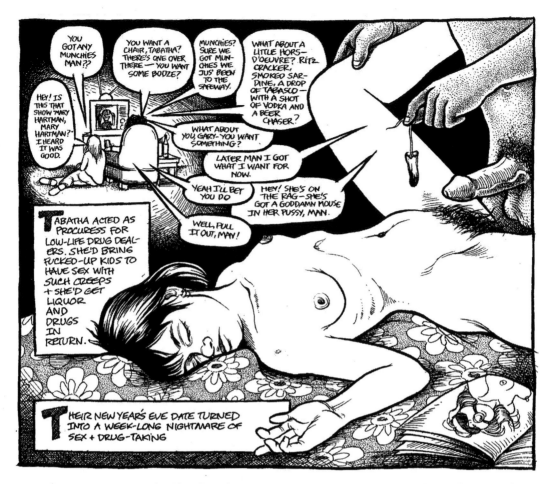

2.5 Panel from "Minnie's 3rd Love, or, Nightmare on Polk Street," p. 75, *A Child's Life and Other Stories* by Phoebe Gloeckner, published by Frog Books/North Atlantic Books, copyright © 2000 Phoebe Gloeckner. *Reprinted by permission of publisher.*

(22). How is this question of dis/identification different when *images* work to create the self-representation? Images trigger an affective response, as Hirsch reminds us, which may not always be translatable into predetermined structures of meaning. Peggy Orenstein writes of Gloeckner's work, "The most explicit images threaten to implicate the reader, transforming a sympathetic eye into a voyeuristic one. This quality may be what offends censors and raises red flags among the bookstore buyers who won't carry her work" (29). Gloeckner's images have what I like to think of as their own cognitive competence—a phrase of Cornell's, from an anticensorship essay, used to describe the complexity of desire ("Pornography's Temptation" 557). They demand a certain affective response. Recalling the agency of images that is also suggested by W. J. T.'s Mitchell's title *What Do Images Want?* Linda Williams notes, "The problem is that there is no

getting around the ability of such images . . . to leap off the page to move view-ers" (*Hard Core* 32–33). (She is explaining her decision to publish a study on visual pornography without including a single image.) Speaking about her own work, Gloeckner too emphasizes how images "move" an audience, mentioning "anytime you talk about sex . . . the galvanic skin response is triggered." Fur-ther, "when you combine that with something that doesn't seem *quite right*, like [images of] a teenager having sex with her mother's boyfriend, it kind of goes haywire. [Readers] feel uncomfortable. They're a *little* bit turned on, but they're supposed to be turned off, or they think they should be" (Andersen). The dis-gust and pleasure that the visual carries is related to a bodily rhythm of reading further underscored, and prompted, by the rhythms of the visual-verbal page, a rupturing alternation between affects (even if occurring at irregular intervals).

Challenging a certain modernist notion of opticality in which vision is abstracted and has a rationalized form, Rosalind Krauss, writing on what she terms the "beat" of the image in "The Im/pulse to See," gives us one way to un-derstand the texture of Gloeckner's images. The beat (or pulse or throb) is not distinct from vision but works deep inside it, Krauss claims. In her discussion of Duchamp's concern to corporealize the visual, restoring the eye as a bodily organ available to the force of eroticization, Krauss writes of the visual beat of desire as productively dissolving the coherence of form.[12] A story in *A Child's Life* in which Minnie sees her stepfather Pascal masturbating naked in the bathroom is called "Hommage à Duchamp" (see figure 2.6); although Krauss does not spe-cifically write about the work that Gloeckner's piece references, *Étant Donnés* ("Given"), it is worth pausing here on Gloeckner's brief yet important three-page story. Gloeckner's work, on all of its levels, enacts what I call a *rhythm of rupture*. "Hommage"'s subtitle is "OR, 'ETANT DONNÉS: le bain, le père, la main, la bitte" (the bath, the father, the hand, the cock). Yet our first view through the peephole that connects Gloeckner and Duchamp's work is on the title page of *A Child's Life*: Minnie and her sister stare through the broken glass in wonderment and disgust at the bold uppercase letters of the title of the book. Later, in the story, this exact image is replicated, but in place of the title we see their stepfather naked, straddling the lip of the bath, his erection disproportionately large and his gaze appearing to meet either ours or his stepdaughters', undecidably. The in-terior of Duchamp's infamous installation *Étant Donnés* (1946–1966), a medita-tion on vision and desire, offers a peephole that presents the naked supine body of a woman (grasping a lamp) whose head and face fail to be visible but whose vagina faces viewers, creating a kind of perceived recession into the space of the vagina. In Gloeckner's version, the man's engaged gaze and the active, assaultive presence of his penis, which creates a sharp angle accented by the sharp angles

of the broken glass, inverts the scenario: the absence becomes confrontational presence. (His penis is even doubled by another, disembodied penis: the washcloth hanging directly above it, from the edge of the sink, forms the shape of a penis and testicles, reminiscent of "subliminal" advertising such as the Joe Camel cigarette campaign of the 1990s. Gloeckner calls attention to the predominance of phallic imagery in everyday life and also, by mirroring the stepfather's genitals with imagery of male organs that are yet flaccid, creates a visual framework that underlines the shockingness of his erection for the child viewers.)

The book establishes a rhythm between presence and absence in the repetition of the peephole frame (a child's life, in one reading of this repetition, is encountering predatory sexuality); in the doubled looking of the image (we look from behind Minnie and her sister, but watch them watching their stepfather as well as watching the stepfather directly); in the presentation of interior and exterior space; and in the disruption that the engorged genitals create in the narrative emotionally and structurally. Time slows down in the frozen moment of this page and then picks up as the children subsequently run away in three different panels on the next. The rhythm of rupture is conveyed in the undecidable directions and tenors of looking (shame, desire, confusion) that the image sets in motion. Minnie and her sister are both attracted and repulsed, and we watch them as we watch ourselves, aware of our own spectatorship.

While Krauss is writing about a different aesthetic context, her language is yet relevant: Gloeckner's work is formally *and* at the level of diegesis about "the rhythmic oppositions between contact and rupture" (67). A form that is also transgression, according to Lyotard as quoted by Krauss, would have to be "a form in which desire remains caught, form caught by transgression" (66). This form, then, is that of "on/off on/off on/off . . . the alternating charge and discharge of pleasure, the oscillating presence and absence of contact, the rhythm 'in whose regularity the subject's unconscious is, so to speak, "caught"'" (66). This gloss serves as both a description of the structure of the gutter-punctuated medium of comics and as a description of how sexual desire is not only represented but also *inscribed* in Gloeckner's oeuvre. And the structure of Gloeckner's most recent long-form book, *The Diary of a Teenage Girl*, clearly presents this kind of beat: it offers verbal text whose flow is consistently interrupted by comics. *Diary*, Gloeckner's second book-length narrative to represent incest and family breakage, overlapping events and characters from her earlier work, is a rearticulation of her central trauma that takes, as its premise, experiments with rhythms of rupture in form.

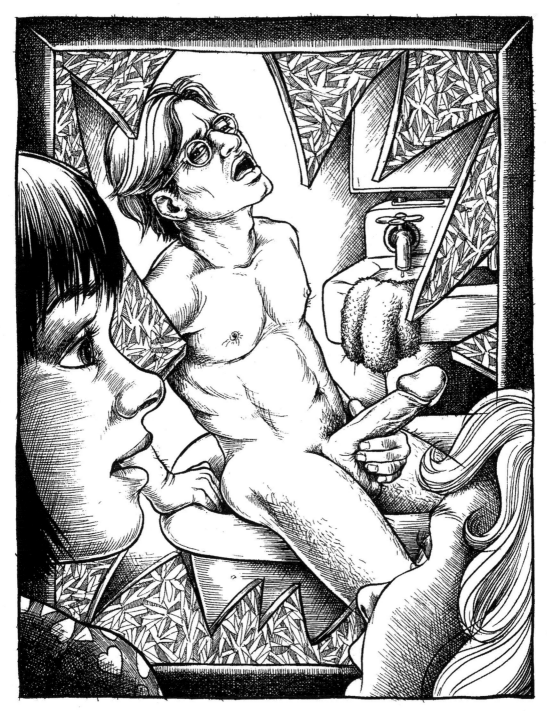

2.6 "Hommage à Duchamp," p. 28, *A Child's Life and Other Stories* by Phoebe Gloeckner, published by Frog Books/North Atlantic Books, copyright © 2000 Phoebe Gloeckner. *Reprinted by permission of publisher.*

THE DIARY OF A TEENAGE GIRL: SHOWING
AS JURISDICTION

Gloeckner's *The Diary of a Teenage Girl: An Account in Words and Pictures* (2002)—a painful text teeming with adolescent sexuality—is an innovative, genre-crossing narrative in an uncharted form. Because of the book's equal attention to prose, illustration, and comics, *The Diary of a Teenage Girl* calls particular attention to Gloeckner's strategy as an autobiographer in two media.[13] *Diary* is a strange generic object: composed in both words and images, it is structurally both a "real" and "fake" diary, threading conspicuous authenticity and inauthenticity. About one-half of Gloeckner's own real diary from 1976–1977 is reproduced intact—word for word—in the book (photographs of assorted typed actual diary pages and a Hello Kitty diary crowd the front and back endpapers, some names redacted). The other half of *Diary*—while events may match her actual teenage experience—Gloeckner wrote as an adult author, re-forming her former diary's narrative structure (Address). *Diary* uses four representational modes: diary entries composed by Gloeckner or Gloeckner's alter-ego character, Minnie; archival comic strips that the author drew during the years of the action of the diary (1976–1977); comic strip narratives that sweep in and periodically substitute for text, composed from an older, wiser narratorial perspective (there are seventeen of these); and twenty-seven full-page and fifty-six in-text illustrations.[14] The cross-discursive form of *Diary* (including but not limited to comics) offers us a diary and a concurrent interpretation of that diary through supplementary and extranarrative visualization.[15]

In *Diary*, composed in at least two temporal registers, the author interprets her own record of her life in "text that bursts into comics" (Orenstein 28). Drucilla Cornell's comment that "a raped woman must have the right to *re-imagine herself* beyond the trauma of rape if she is to recover herself at all" is apposite to *Diary*, which literally reimagines abuse *and* sexual pleasure on a visual level (*Imaginary Domain* 102; my emphasis). Gloeckner clearly shows interpretation as a process of visualization; her retrospective "readings" of the diary entries are distilled and visualized in *Diary's* comic strips and illustrations. The peculiar textual/graphic form of *Diary* makes a case for the breaking of generic boundaries as an urgency of representing trauma.[16] Through a dialogic interplay of text and image, *Diary* exemplifies the profound horror and yet the profound confusion of sexual trauma: it offers a testimony that cannot be adequately represented in words alone. Its images are complicated by a blurring of pleasure and pain; they register how sexual trauma challenges "rational" ways of knowing.[17]

Minnie Goetze's home life is precarious: abandoned by her father, she and her younger sister live with their young mother (who gave birth to Minnie at seventeen) in San Francisco. At fifteen Minnie has her first kiss with and is de-virginized by her mother's longtime (and one-time live-in) boyfriend, Monroe Rutherford, who is over twice her age. Minnie feels that her sanity is contingent on Monroe's sexual attention, and, when she cannot get it, she has sex with boys her own age, at once exhilarated, fascinated, and repulsed by her own sexuality and her sexualization by others.[18] In one scene that is frequently reprised by Gloeckner in her work, while Minnie cries, Monroe tells her, "What dirty old man wouldn't give anything to be fucking a fifteen-year-old regularly?" He then asks for a blowjob. Minnie writes, "I sucked him off, choking and sobbing all the while" (213). Monroe frequently asks Minnie to just give him a blowjob: "He thinks I won't get so emotionally involved if I just suck his dick" (240).[19] And while she struggles to dislodge Monroe as her sole barometer of self-esteem, Minnie's sexuality—even as ignited by the abusive circumstance—in part thrills her. This is the aspect of the book that makes it so powerfully, and so importantly, uncomfortable. Peggy Orenstein, in language reminiscent of Leigh Gilmore's discussion of the "anticonfessional" memoir, writes, "Minnie's complicity doesn't change the fact of her abuse, but it does provide insight into its dynamics. It's a daring sub-theme, and it is part of what makes Gloeckner's work ring true, what makes it transcend the genre of most child-abuse memoirs" (29).[20] Gloeckner's work, refusing to excise titillation, is an ethical feminist project that takes the crucial risk of visualizing the complicated realities of abuse.

One of the greatest political resonances of *Diary* is in the specifically transgressive nature of its images. Yet in 1995, British customs officials seized the anthology collection *Twisted Sisters 2*, claiming that Gloeckner's comic strip in that volume, "Minnie's 3rd Love," was child pornography (a judge eventually ruled in favor of the book's distributor). They were particularly distressed by a panel—known as the "laundry room panel"—in which Minnie, crying, barefoot, and kneeling in front of a basement laundry machine, her Hello Kitty diary at her feet and an opened bottle of wine in her hand, begs an undressing man whose large, swollen penis thrusts in her face: "Please love me!" He responds, "Of course I love you! What man wouldn't give anything to be fucking a 15-year-old? Tell me again how you love to suck my dick. You love to suck it—don't you?" (figure 2.7). The decorated, childish Hello Kitty diary conspicuously lying at her feet, which shows up again on the endpapers of *The Diary of a Teenage Girl* (as does the scene), reminds us both how young she is and demonstrates that even at this young age she was invested in recording her own life (the diary that she

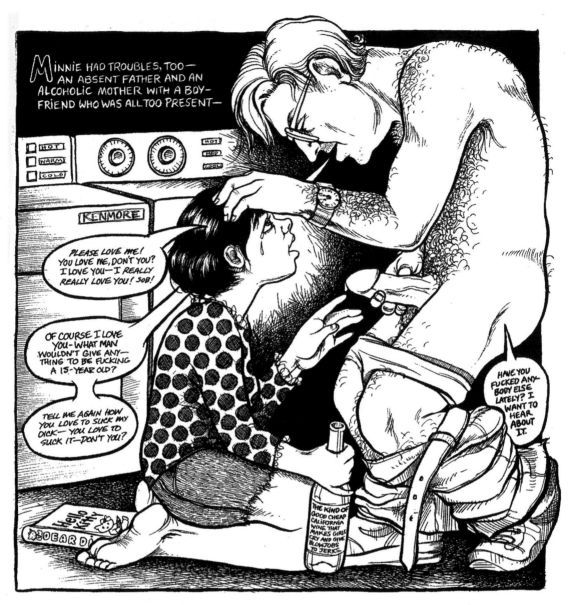

2.7 Panel from "Minnie's 3rd Love, or, Nightmare on Polk Street," p. 73, *A Child's Life and Other Stories* by Phoebe Gloeckner, published by Frog Books/North Atlantic Books, copyright © 2000 Phoebe Gloeckner. *Reprinted by permission of publisher.*

brings into the laundry room is a kind of protection, a future promise). The label on Minnie's bottle of wine reads: "The kind of good cheap California wine that makes girls cry and give blowjobs to jerks" (73).

"Minnie's 3rd Love" is also collected in *A Child's Life*, which was rejected by publisher Frog's printer (Frog ended its fifteen-year relationship with the printer, Malloy, over Gloeckner). And while Frog eventually found a willing printer, staff members at that company also objected to the images in "Minnie's 3rd Love"; the company agreed to work on the book only at night, after official work hours. *A Child's Life* was confiscated at the French border in 2000; it has never been allowed into France. (In a situation that clearly bespeaks a sexist double standard, Robert Crumb's celebrated comics, often sexually violent, incite no such ban.)[21]

Gloeckner's work has further been attacked for its purported obscenity. An invitation for Gloeckner to be the keynote graduation speaker at a suburban alternative New York high school in 2003 was revoked when the principal saw *A Child's Life* one week before commencement. The principal not only compared Gloeckner's work to the pornographic magazine *Hustler*, stating "there was no difference," but he fired the teacher who had shown Gloeckner's work to his class (Andersen). The unease around explicit sexual imagery that we note in such swift and punitive actions as this firing is astounding. Of this incident, Gloeckner told one interviewer, "it was like an arrow going through my heart, because I knew that those kids needed to hear from me"; she pointed out to another, "What I do is the opposite of what *Hustler* magazine does" (Andersen; Redwine). In 2004 the mayor of Stockton, California, a senate candidate named Gary Podesto, banned *A Child's Life* from the Stockton California Public Library System, calling it "a how-to-book for pedophiles" (Cooper). It is still banned in Stockton. "But there are children who experience this, who have the penis in front of their faces. They see it, so why can't I show it to make the impact clear?" Gloeckner contends (Orenstein 29).[22]

The NPR show *Studio 360* covered Gloeckner's work in a 2005 segment on "Decency," and the discourse around the value of her work in that program demonstrates the hostility to the graphic depiction of explicit sex, no matter what the context that shapes the work (for instance, autobiographical depictions of abuse in a literary framework). Both *Studio 360*'s two invited commentators, Michael Medved and the *New Republic* writer Rochelle Gurstein, devalue Gloeckner's work as obscene. Medved asserts that it should be "painfully obvious" Gloeckner's work is "inappropriate" for public libraries and government funded facilities.[23] "I understand that technically speaking the works of Phoebe Gloeckner do not count as hardcore pornography, and yes, they may have some

artistic value, but again, having looked at this material by Ms. Gloeckner, it is so clearly pornographic in some of its imagery," he contends. Host Kurt Andersen follows up with a question about where to draw the line—are nonpictorial narratives with explicit sex, such as *Ulysses*, acceptable for public spaces like libraries? Medved responds vaguely, invoking former Supreme Court Justice Potter Stewart's formulation of knowing pornography when you see it. But the most telling response comes from Gurstein, because it demonstrates an abiding cultural attitude about life narrative that is implicitly gendered and is part of the culture of censure Gloeckner's work contests. First, Gurstein misunderstands the merit and innovation of the labor-intensive form of comics when she notes, in reference to Gloeckner's work, that today people show "little resourcefulness" in their depictions (as if the graphic quality of Gloeckner's work indicates, as she puts it, too "little imagination" instead of a deliberate narrative choice). But, most significantly, she attacks the right of Gloeckner's work to exist in the public sphere at all: "Adults like myself are quite disturbed by [the graphic quality] and wonder whether the author is trying to work out her own horrible childhood of what appears to be sexual molestation by her mother's boyfriend, or stepfather, as well as many other really horrific degrading experiences and whether the public sphere is the proper place for people's psychological traumas" (Andersen). If expressing "psychological trauma" is the criterion for keeping experience private, we would be left without a large portion of noteworthy, even momentous, cultural production across different media. But, more to the point, Gurstein polices the (gendered) boundary of "private" and "public" that Leigh Gilmore asserts is productively destabilized by the very discourse of memoir itself, and I argue is further destabilized by the role of the visual in memoir (Gilmore, "Jurisdictions" 222).[24]

Gloeckner's works are "pornographic" only in the sense that, as Richard Randall puts it, "the transgressive themes and images of pornography confound us because *they invite and repel*" (ix; my emphasis).[25] Part of the ethical drive behind Gloeckner's ambivalent images is to highlight the confusion that sexual trauma may provoke. Orenstein perceptively points out: "In a way, the European border patrol was onto something—Gloeckner's cartoons may be devastating, but they can be arousing as well, because that, too, is part of Minnie's experience" (29).[26] Gloeckner's response to being labeled a child pornographer—in autobiographical work, no less—is to insist on the reality of the ambivalent sexuality she depicts. "Maybe [my work] is titillating," she tells Orenstein. "It can be titillating for a child in a way. But it's also confusing, destructive and horrifying and can be rape and everything else. So to draw things as either black or white is a lie. Because that titillation is in you. I'm not saying it's good, but it's there" (29).

Diary is not a morality tale, even though it deals with subject matter—sexual abuse—whose interpretation would appear to fall easily into a moral schema.

Because it elaborates its protagonist's confusion and self-destruction but also elaborates her refusal to be a "proper victim," *Diary* lends itself well to Gilmore's writing on "scandalous self-representation" as political, "crafting an 'I' through which to join the personal and collective dimensions of history and to take the risks of representativeness" as against "the legacy of disbelief and censure that greets women's representations of sexual trauma" ("Jurisdictions" 716, 713). We see this censure in the reception of *Diary*, especially keyed to the book's visual representation.[27] Since the protagonist of *Diary* for some time willingly carries on a destructive sexual relationship with a father figure, *Diary* is not unlike Kathryn Harrison's *The Kiss*—the 1997 memoir about a father-daughter romantic relationship that is the subject of Gilmore's essay "Jurisdictions."[28] Yet *Diary* is even more complicated than *The Kiss* in being, additionally, a visual text. The word-and-image structure of comics allows Gloeckner to "rise above projecting myself as a victim," she argues, because "the form of a 'comic' sets up a tension" ("Phoebe Gloeckner" 159). The visual composition of *Diary* forces an affective witnessing beyond that which text alone can express, because its visual testimony offers sexual trauma as devastating *and* as erotic spectacle. *Diary* presents the confusion of its subject radically, as the child Minnie herself sees it. Gloeckner's texts, in that her images preserve this horror and excitation, are not outside E. Ann Kaplan's figuration of witnessing as what happens "when a text aims to move the viewer emotionally but without sensationalizing or overwhelming her with feeling that makes understanding impossible. [It] involves . . . understanding the structures of injustice" (23). We recognize the sensationalism of the event for the child; if we feel implicated in becoming ourselves voyeurs then that does not yet obviate understanding the structures of injustice: instead, it points up exactly how widespread that injustice is, how endemic and culturally threaded. (An alternate possibility, as an avowedly traumatized colleague suggested to me, is that the images aim to traumatize readers; this too does not necessarily mark them as sensational or obtunding.)

Thematically, Gloeckner's work is proximate to both Allison's *Bastard Out of Carolina*—in which a child is clearly victimized by a father figure, but the central devastation is the abandonment of the child by the mother—and *The Kiss*, in which a young woman, blinded by need in part created by her emotionally absented mother, carries on a consensual sexual relationship with her father. Both of these texts, as has been argued, can be understood as *alternative jurisdictions*: in place of suing in court, of engaging the legal system to petition for official redress, the subject seeks a different kind of public forum in which to testify;

the subject expresses agency not only in bearing witness but also in the literally productive public act of constructing representation (see Gilmore, *Limits*, "Jurisdictions").[29]

Juridical language, as I have noted, has certainly flown in and around Gloeckner's controversial representation of her adolescence. As mentioned, her mother threatened to sue her over her work; she was especially upset by "Minnie's 3rd Love," which she felt implicated her. In 1990 Gloeckner, presenting a quasi-legalistic appeal, wrote to the man with whom she had a sexual relationship when a teenager, explaining that he owed her the money that had gone to pay for her psychiatric bills, which depleted a trust she otherwise would have received at twenty-one ("Phoebe Gloeckner" 154). (He sent her $500 of $10,000.) And Gloeckner's work does indeed itself operate as an alternative jurisdiction; it is invested in claiming what Gilmore calls "truth-value of an extra-legal kind" (*Limits* 69). The fact that her mother mobilized an official juridical language against her representation in Gloeckner's work makes clear the place and power of Gloeckner's alternative jurisdiction and also underscores the differences between the two discourses in their ability to address injury. As a teenager, Gloeckner had the right to legislate against her mother's boyfriend for her injury under statutory rape laws; she did not (and neither did her mother on behalf of her minor daughter). Instead, as an adult, she wrote and drew two books featuring the chain of events of her adolescence, and her mother activated a juridical language to fight her own depiction. The irony is that the mother appears to be further punishing and censuring the child figure who was the aggrieved party in the first place and who abdicated legally censuring her own parental figures.[30] Gloeckner knows the power of legalistic reproach, but in *Diary* her aims are different. Her (re)articulation of her effacement is more about probing the contradictory registers of a beset childhood—giving space to the texture of subjectivity—than it is about reinscribing injury or complaint in the context of remedy. *Diary* represents the act of *showing* that Minnie (and Gloeckner) desired to make public as a child, when she fantasized about revealing her private life to her mother. (Far from guarding her secret, Minnie longs for her inattentive mother to find out.)[31] And if the question around autobiography as alternative jurisdiction can be thought of as "What does formal representation make visible?" then the visual operations of Gloeckner's work best explain the ambiguity, the tipping, the complexity of desire and sexuality—a multivalence we may recognize, on one level, in the hard, evidential status her realistic hand proposes, and yet its register of sumptuousness (her work denies that these are necessarily opposites). If her sexual abuse effaced her subjectivity, *Diary*'s insistent showing, the rhythms of its visual interruptions, reestablishes her as subject: autobiography as re-face-

ment. To rephrase a question of Gilmore's, what is the language through which the self may reemerge? (*Limits* 42). With Gloeckner, who is deeply aware of the power of the self as constituted visually, in part through a schooling in visual self-objectification, that language is graphic.

However, Gloeckner does not draw the exuberant presence of Minnie's body—crying, wrestling, running, flippantly naked, desiring, watching—as inscribed or trapped by a male gaze in this hybrid text that frames its images with Minnie's own constantly shifting verbal identity formations. And while Minnie as a character bemoans what John Berger identifies as two constituent elements of female identity in the fundamental *Ways of Seeing*—the constant awareness of being surveyed *and* of self-surveying—the images the text presents are not themselves marked by the male gaze (46). To put it another way, the text gets to do what Minnie as protagonist cannot yet accomplish; it is the fruition of herself that yet includes, as opposed to shedding, her younger self. In a full-page illustration of a naked Minnie and Monroe, Gloeckner draws Minnie refusing to dress after sex (79; figure 2.8). The illustration is simultaneously repulsive and sensual. Even as the caption reads, "He said he didn't like stupid little chicks like me trying to manipulate him," one gets the sense here of Minnie's own proclamation in her diary that her body "seems to have an overwhelming presence" (111). While the representation of a naked postcoital girl appears to fulfill a mainstream cultural expectation, Gloeckner here offers a mocking counterobjectification, a female gaze at work: the panel pictures Monroe's testicles, awkwardly viewed from behind as he lifts a leg leering at Minnie. Self-consciously naked, Minnie extends her middle finger: to Monroe, but also perhaps to readers; she looks out at us from the corner of her eye with a countergaze, her irreverent gesture acknowledging our look.[32] The illustration importantly destabilizes the dominant visual mode (of culture, of pornography), which is aligned with the predatory identificatory gaze. The point of view of the illustration—not *with* Monroe—is in fact *behind* him, uncovering him.

In *Diary* Gloeckner uses visual tools—illustrations, comic strips—to point to and undo culture's masculinist predatory gaze. Here, in the illustration, the italicized, typeset font of the caption indicates an official "line"—the sexist pronouncement—that contrasts with the hand-drawn image that marks a more subjective realm of understanding. Looks converge on Minnie but also elsewhere; men are not the "bearer of the look" of the spectator. In the cases where male spectatorship is implied as an idea, Gloeckner undermines the concept of that expectation. Minnie is deflated by, but not formally inscribed by, the male gaze. (She complains, "I hate men. I hate their sexuality unless they are gay or asexual or somehow different from the men I've known. I hate men. . . . At

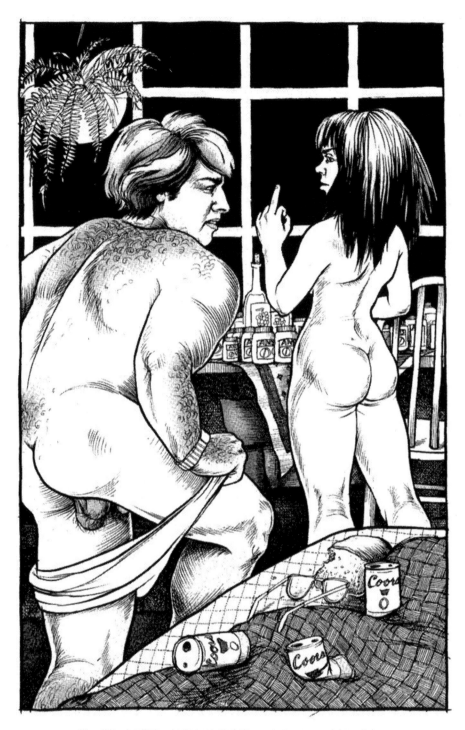

He said he didn't like stupid little chicks like me trying to manipulate him...

2.8 P. 79, *The Diary of a Teenage Girl* by Phoebe Gloeckner, published by Frog Books/North Atlantic Books, copyright © 2002 Phoebe Gloeckner. *Reprinted by permission of publisher.*

least when they're fucking me, they're not looking at me" [215].) In *Diary* men do not articulate the look and create the action: the gaze of the book is aligned with Monroe's "prey." As the narrative's predator, Monroe is consistently pictured as himself looked at. But while Minnie the character deems him an object of beauty, the gaze of *Diary* itself, enclosing him at vulnerable and ridiculous angles, does not: he is swollen, puffy, looming, ironized (figure 2.9). One typical illustration depicts Minnie intensely watching Monroe: her eyes are wide open, appraising his face, taking it in, as he passively sleeps: "Sometimes I watch him as he sleeps, and I feel so much love for him," the caption reads (143). Yet Monroe, the object of the gaze, eyes closed all too peacefully, huge, double-chinned face at rest, is patently disgusting; he is a bloated, projected fantasy love-object. The sharp contrast in skin tone and shading between the two figures—her small, whited-out face is free of substantial shading, while his every protuberant hair seems to be in focus—denotes her childish naïveté and his adult grotesquerie. If Minnie the protagonist is upset by her definition as looked-at, *Diary*'s formal *textual practice*, in its visual aspect, counters that being-looked-at with its own looking, drawing, and framing—which the form of comics makes legible. *Diary*, in its hybrid form, is a conversation between temporal and discursive layers, between text and image, as the "visual voice" in Gloeckner's adult hand enters the text to dialogue with Minnie's child voice and enact formally the thematic issues on which Minnie muses.

Comics, indeed, becomes itself the form of counteraction to inscription by the framing looks of dominant culture. (It is unsurprising, then, that Minnie writes a fan letter to Kominsky-Crumb.) When Minnie takes her work to an underground comics publisher, he affirms the sensuality of the form's material composition: "He picked up one of [Robert] Crumb's pages, and closing his eyes, he moved his hand slowly over the surface of the paper. 'You can feel the drawing . . . you can feel the bump of the dried ink, the blobs and traces . . .' He loved the art. He let me feel it, too" (124). A sensual experience in which an adult man guides Minnie's hands to the page and not to his own crotch is unparalleled in her history. *Diary* is self-reflexive in that its own form is a public rebuke to the status of victimhood and a subject's inscription in the private space of sexual trauma. Comics itself becomes a counterregister of sensuality.

Diary closes with a comic strip: Minnie, crying, calls a suicide prevention hotline at night in a phone booth on a deserted street. The turn of events in her life has damaged her deeply. Minnie had desired and was only waiting for her mother, Charlotte, to find her diary (the one we read); she leaves completed pages of her diary stuck in her Underwood typewriter that sits on her bedroom desk. Minnie's diary, as Gloeckner draws it in the comics interlude in which her moth-

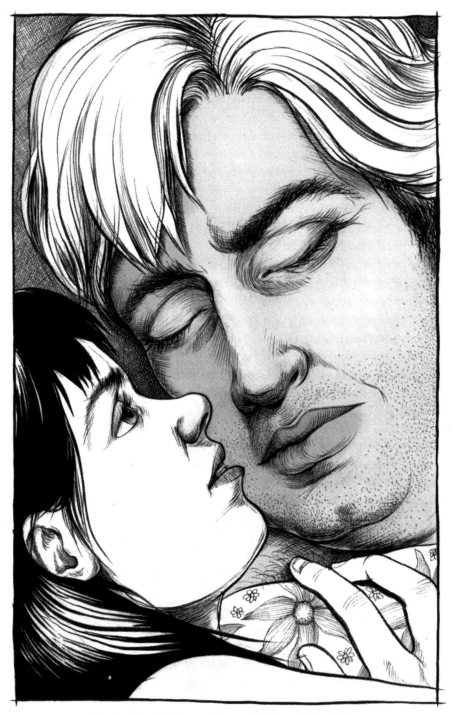

Sometimes I watch him as he sleeps, and I feel so much love for him.

2.9 P. 143, *The Diary of a Teenage Girl* by Phoebe Gloeckner, published by Frog Books/North Atlantic Books, copyright © 2002 Phoebe Gloeckner. *Reprinted by permission of publisher.*

er comes across it, is simply there for the taking, almost begging for discovery. Yet the outcome is not what Minnie expected. Indeed, the biggest heartbreak of the narrative is Minnie's mother's attitude when she finds out about Monroe and Minnie's affair.[33] After the discovery, Minnie appears relieved, restored to prosaic childhood status: she and her younger sister and cat watch television together on the couch. Yet after a telephone call from her mother summons Minnie to the bar where Charlotte and Monroe are facing off, her mother and Monroe, disconcertingly, look to be in agreement. At Charlotte's prompting, Monroe, looking sheepish, suggests that he and Minnie get married. "You're both drunk," Minnie scowls miserably (254). Charlotte rages, "He porked you, Minnie! He PORKED you, and he's going to marry you!" Ignoring Minnie's opinion—and, most basically, *ignoring her injury*—Charlotte reminds her, "I was married when I was about your age, Minnie" (255). Minnie walks out, and returns to her "Dear, Dear Wounded Diary" (256). Her mother does not seem to care about Minnie's affair with Monroe, except to absolve herself of responsibility.

Minnie's diary is synecdochically *her*: *she* has been wounded by her mother's lack of recognition and care, and yet she refers to her *diary* as wounded. She is wounded—injured and reinjured by the indifference to her trauma—and thus addresses her story itself as wounded: its integrity is ignored. Her self *is* her narration. In thinking about the difference between Gloeckner/Minnie's actual diary and the form of *Diary*, it is striking that *writing* her injury didn't "work"; Charlotte does not respond with any active intervention. Years later, *picturing* her injury "works," in a peculiar sense: Gloeckner's mother reacts enough to propose legal action against her. Giving visual body to events, it turns out, is an alternative jurisdiction that provokes response: the affectual register of images is hard to ignore. Significantly, Gloeckner does not abandon the integrity of her original story: it is incorporated into the work she makes public. She stitches together her former wounded diary with layers of the visual—and, losing its authenticity as completely her "real" former diary, it gains an emotional evidential status through the pictorial register.

In the conclusion, Minnie reports to the hotline why she wants to die, as Gloeckner draws her, satirically and sympathetically at once (and departing from her usual realistic style) as a caricaturish child, a little weeping girl: "No one loves me!" When she recounts her mother's "porking" diatribe, the staffer responds, "Marry you? Where's she from? Arkansas? . . . Of course it's sick" (282). It is gratifying that someone correctly identifies "those sickos in your family." But the staffer's words only accord with what Minnie knows already, which appalls her: "Look, if I had a dollar for every stupid little girl who calls here sobbing

about how she let some jerk use and abuse her . . . " She hangs up. The last panel shows her walking away, muttering "fuck."

A seven-page epilogue of text, comics, and illustrations follows: "A brand new diary is a like a brand new life, and I'm ready to leave this one behind me," Minnie writes (287). Significantly, Minnie positions her development in the epilogue—as a person whose speech has shifted from the private to public status—by quoting Robert Crumb's band The Cheap Suit Serenaders: "Baby I'm a fine artiste / And baby I deserve to be kissed" (288). In Minnie's adoption of this credo we note her assertion that a person who has been degraded sexually need not only experience sexuality in a private space of trauma. In the episode that closes the epilogue, Minnie and her friend Chuck go to the beach and write poems, which they sell for 50 cents each to tourists. Monroe, it happens, jogs toward them. In the book's concluding lines, Minnie sells a poem—at inflated cost (75 cents)—to Monroe. But, as if to emphasize her literal *childishness* ("childish" once was an aspect of her behavior she and Monroe both disdained), to *reclaim* that child status from him, Minnie sells Monroe a poem she wrote in fourth grade (and "not one of the best," at that). Critically, the narrative ends with Minnie making her writing *public*; the circulation of her writing (especially to her abuser) dramatizes how she moves from a privately inscribed self to a public self—which is, of course, the same move the book, with its component verbal and visual parts, makes on a large scale. *Diary*'s last illustration shows Minnie, as ever, looking at Monroe. The sign "Poems for sale" literally hangs between them, separating their bodies. Crucially, while we see her face directly—and it registers an uninhibited, childlike happiness—his face is removed from our view, no longer worth even the counterobjectifying gaze that *Diary* so often presents as an antidote to the masculine looking that threatens to define Minnie's feminine persona.

Minnie's scrawled signature in script across the bottom of the page ends the text. Yet the final page of the diary leaves the narrative open because it does not carry the stamp of a page number (like Lynda Barry's final page of *One Hundred Demons* and like Art Spiegelman's final page of *Maus*, in which his signature substitutes for the closure implied by a final page number). Instead, a circling backward occurs, as in Barry's final chapter "Lost and Found": a redoubled, antiteleological narrative. Minnie's signature, expressively stamping the page in large, cursive letters, circles back to Gloeckner's handwritten cursive dedication at the opening of the book, which arches above and below a modest collection of flowers (one wilting slightly) on an otherwise blank page: "for all the girls when they have grown" (figure 2.10).

This handwritten dedication is the closest we have to Gloeckner's own signature. Satrapi, as I will discuss, positions her child self as part of her own

2.10 Dedication page, *The Diary of a Teenage Girl* by Phoebe Gloeckner, published by Frog Books/ North Atlantic Books, copyright © 2002 Phoebe Gloeckner. *Reprinted by permission of publisher.*

dedication, writing that *Persepolis* represents those who "were forced to leave their families and flee their homeland," placing herself within public discourse and history. Gloeckner, too, addresses her self and a collectivity in her dedication: *Diary* is a gift "for all the girls when they have grown" and it is a gift, then, to Minnie from her future self.[34] It is addressed, as the suicide prevention staffer puts it, for "every stupid little girl"; it shapes itself as collective speech. Gloeckner understands the import of her narrative as collective: "She's not me anymore. She's Minnie. She's all these girls. . . . She doesn't have to be me. She's bigger than me" (Joiner).

How can one give one's own child diaries to one's own adult self as a gift? *A Child's Life* offers a full-page illustration of the child Minnie being kissed on the face, sensually, by an adult woman who grasps her face (figure 2.11). This illustration does not appear in the book's otherwise thorough table of contents, and its absence, paradoxically, appears to underscore its importance. Its logic is so central, it seems—its title is "A Child's Life"—that it floats above (or seamlessly threads through) the official description of work in the book. The child wears a shirt patterned with hearts, accentuating her youthful innocence, and her face, mouth open, is partially but not fully turned toward the woman whose hand clasps her chin, pulling her closer. She does not look frightened; her face suggests wonderment and even, perhaps, contentment. The adult's open lips touch the child's cheek; she looks both very aggressive and very tender—predatory, even, and also protective. As in "Self-Portrait with Pemphigus Vulgaris," her eyes are closed and her brow is furrowed. Gloeckner explains: "That picture is supposed to be me as an adult kissing Minnie. In a sense, it's myself kissing myself" (Oren-

2.11 "A Child's Life," p. 32, *A Child's Life and Other Stories* by Phoebe Gloeckner, published by Frog Books/North Atlantic Books, copyright © 2000 Phoebe Gloeckner. *Reprinted by permission of publisher.*

stein 29). In *Diary* Gloeckner frames the work of the actual 1976 diaries with her own, interlacing adult-perspective comics and illustrations: as a gift to her future self, she shows Minnie, in effect, the work of interpretation by *visualizing* the exhilarating, roller coaster descriptions and disclosures of a scarred fifteen year old.

Hardly "pornographic" as her detractors have claimed, Gloeckner's work is a political, feminist project explicitly addressed to a collective witnessing "we": for all the girls when they have grown. The project of *Diary* and *A Child's Life* is not to confess, but rather the even trickier work of *showing*—complicating without evading the power of spectacle—what happens in the laundry room, what happens when a girl is raped. Gloeckner's latest short work, *La Tristeza*, appears in the volume *I Live Here* (2008), which benefits Amnesty International: it is a twenty-two-page reportage piece based on the hundreds—and in many reports, thousands—of unsolved murders of young women in Ciudad Juárez, Mexico.[35] Significantly, comics journalist Joe Sacco contributes a piece on Chechen refugees to the same collection. While these two authors may seem quite distinct, the grouping of their work together demonstrates how we may read the political project of nonfiction graphic narrative broadly: the narrativization and display of what has been typically excluded from the public realm.

The nature of the Juárez murders, as Gloeckner told me, "is very intimate. They're not shooting these girls from a distance. They are raping them and strangling them and cutting their boobs off" (Interview). After a series of trips to Mexico, during which time Gloeckner researched unsolved cases and spent extensive time with the families of several murdered girls, her project began with drawing moments completely, deliberately outside the public eye: scenes of the rape, torture, and killing of women. Gloeckner initially composed these drawings for a series of trading cards, planned to each carry an illustration of the victim on one side and details of her life on the other. "I felt like I had to draw the murders. I had to show the murders, because the girls experienced them," Gloeckner explains (Chute, "Phoebe Gloeckner" 46). But the *I Live Here* project, out of which grew Gloeckner's current in-progress book, for which she won a 2008 Guggenheim Fellowship, ultimately inspired her to create a different kind of word-and-image narrative.[36] This idiom amplifies the tension in her comics between what codes as "realistic" and what is abstract, exaggerated, artificial. *La Tristeza* is a brutal, grim, fascinating narrative: Gloeckner taught herself to work three-dimensionally, hand-building felted wool dolls with wire armatures, and elaborate sets; she poses the dolls to depict scenes including murder, mutilation, and rape, and on the printed page they have digitally integrated photographic faces.[37] The bloody fabric of the bodies mixed with human faces produces an effect that is creepy and moving at once, never coy or flip. (It took Gloeckner three years to build

dolls that she felt looked right, and, even then, working with how to photograph the scenes she constructed in her studio, "I didn't have a vision of what I wanted until I made 50 iterations of the same image" [Zuarino].) This mix of media and styles and codes, so much a part of the language of comics, here informs a new kind of word-and-image document, a testimony to the physicality and materiality of death, an attempt to re-create/resurrect bodies and subjectivities. There is no overarching narratorial voice in *La Tristeza* but rather disconnected boxes of text from many sources, including snippets of official documents; in relation to the striking images, these never seem clarifying, and often even mysterious.

In the first murder scene, a doll is pictured alone face down on the ground amidst debris with a large wooden tortilla-making instrument still sticking out of her bleeding vagina. With a few exceptions—such as a scene in which Gloeckner depicts photographers snapping away at a dead body in the desert, an open, self-conscious acknowledgment of the dangers of voyeurism—all the women Gloeckner creates are dead and alone (or alone among other dead). In other words, she draws them at the moment when *nobody sees*; after their killers have left, before they are discovered. In *La Tristeza*, in addition to maps and traditional photography—the project opens and closes with pictures of hand-made white satin-lined girls' caskets—Gloeckner shows eight different murder scenes. In one haunting episode, a woman with a sculpted fabric body, tight green dress, heels, anklet, human face and ponytail walks down a city street; to her right Gloeckner places a text box, dated "6 of January," taken from the discussion board of *Mexico Sex Tourist*. (The documents she uses all note specific days and months, but lack years, indicating the ongoingness of the murders.) It describes a $20 blowjob given by a Juárez prostitute in which the writer had demanded no condom and forced the woman to swallow his semen. Here, the image of the woman in green, accompanied by the text box, does not quite take up one full page of the book; the facing page awkwardly and disturbingly pushes towards the public street, moving across the seam of the book at least an inch into the first page's right-hand side: death intrudes. We move then from a public street to a nameless private room in which a woman whose face we cannot see lies naked and bleeding profusely onto a bare floor, facing away, her hands tied behind her back. Her waist looks slashed, and there is plastic netting over her head and torso. She is wearing the same shoes and anklet. Readers are left to imagine the time in between the moments that Gloeckner has materialized and juxtaposed for us.[38] In *La Tristeza*, an act of informed but imagined witnessing, Gloeckner offers us hidden, unviewed moments—"hidden" from public eye because the victims are dead and cannot testify—and provokes us to build narratives backward and forward. While on their surface Gloeckner's two

"FOR ALL THE GIRLS WHEN THEY HAVE GROWN"

Juárez projects, *La Tristeza* and her forthcoming graphic narrative, are a departure, they are of a piece with *A Child's Life* and *Diary*, moving outward from the self as explicit subject but also focusing intently on displaying the unseen dehumanization of women that happens in private spaces.

Like all the authors I discuss here, Gloeckner is motivated by a powerful if familiar feminist trope: making the hidden visible.[39] But, in graphic narratives, making the hidden visible is not simply rhetorical. Gloeckner, like Spiegelman, is obsessed with literalizing as the political work of visualizing. Gloeckner's medical illustrations, and her work that tropes medical illustration, are essential intertexts for her graphic narratives; they are literal representations of the (corporeal and psychic) "interior" that she also gives visual form to in *Diary*. Through their medical stylings, referencing a clinical mode of looking, they suggest a visual dissection process that is aligned with a penetrative dominant gaze, and yet the point of view is also, more powerfully, aligned with the implied subject, projecting an interiority. These images may show, together, insets of cells with decomposing breasts: the actual and the emotionally projected view of the body. Gloeckner's is not simply a "visibility politics" but rather an ethical and troubling visual aesthetics, the aesthetic register of the embodied way of knowing implied by Irigaray's "carnal ethics," in which the body is certainly not *only* a metaphor for an elsewhere, a futuricity in language (quoted in Cornell, *Beyond Accommodation* 144).

GRAPHIC NARRATIVE AND THE WORK OF RE-IMAGINATION

Diary is a struggle with the masculine imaginary, but the book itself—like Kominsky-Crumb's *Love That Bunch*, Barry's *One Hundred Demons*, Satrapi's *Persepolis*, and Bechdel's *Fun Home*—is the representation of a feminine imaginary "for all the girls when they have grown."[40] Feminist graphic narratives, which I discussed at the outset of this chapter as interventions into cultural practice in the name of representing—but not foreclosing on—the underrepresented lived realities of women, (re)imagine difference and alterity. I think here of the antipornography feminists who wanted to silence Kominsky-Crumb's possibly troubling yet true representations of her sexuality, of those who label Gloeckner—perhaps because her on-page persona does not fit a victim profile well enough, as Gilmore might suggest—a "child pornographer." And I am also reminded of Teresa de Lauretis's meditation on Laura Mulvey's famous "Visual Pleasure and Narrative Cinema": women's film—or comics, for that matter—needs Mulvey's "new language of desire" but, as de Lauretis says, you do not have

to destroy visual pleasure to get there (155). The real task, writes de Lauretis, is to enact the contradiction of female desire, and of women as social subjects, in terms of narrative—and this should not be, does not *have* to be, a "normative" narrative of liberation (156).

With comics, images carry an immediacy and proximity, while the form overall is deeply, self-consciously artificial, composed in discrete frames; it thus necessarily flags a certain aesthetic distance, an interpretation of depicted events. For graphic narratives, like Gloeckner's, that explore autobiographical violence and desire, issues of aesthetics, as I have been discussing, are crucial to how these texts suggest an ethics and a politics. Drucilla Cornell's theorization of the role of aesthetics for a feminist politics, especially in the context of rebuilding shattered subjectivities, is useful for thinking through the work accomplished by graphic narrative. She writes of the aesthetic and political "struggle to 'find the words to say it'" by those who "engage in this process of re-representation and re-symbolization" and affirms as serious this "struggle to find new words as crucial to feminism" (*Imaginary Domain* 106). While Cornell uses an idiom that fixes on the verbal, the new graphic language of comics, as we can see in Gloeckner's work, contributes directly, and forcefully, to the process of expanding modes of this crucial re-representation.[41]

The authors of graphic narrative whose work is the focus of this book literally visualize themselves beyond prescriptive models of alterity or sexual difference, and they crucially assert these locations as ordinary, as lived, as everyday—and as collective, which is reflected in their subtitles: *a* childhood, *a* teenage girl. The integral feminist aspect of these authors' work entails precisely how they "make sense" in narrative terms that are invested and threaded with collectivity and with nonclosure. They are also positioned against various censors: Satrapi, against the Islamic Republic of Iran, where she is unable to publish *Persepolis*; Barry, against the supposedly more "advanced" writers who trivialize her hand-written, palimpsestic work; Kominsky-Crumb, Gloeckner, and Bechdel, against the antipornography censors who stifle their complicated sexual expressions. These texts, countering effacements and elisions, take the risk of representation; their authors understand the visceral response to images so relevant to political culture today—what Tobin Siebers, writing in an issue of *PMLA* focusing on the visual, calls the "excessive expressivity of images." Again, images in graphic narratives can have the effect of unsettling epistemological binaries. Siebers explains, "Often, the excess of meaning is perceived as emotion, but there is no reason to deprecate it as unintellectual, unless one is interested in policing what intellectual response is" (1316). As Gloeckner comments on the backlash against *A Child's Life*, "If the book had been written instead of drawn, we never would have had

a problem with it. People respond to pictures so much more quickly" (Chun). The particular hold of images, then, provides the political appeal—and a set of problems—for graphic narratives that present the censored and the censured. Yet one sure benefit of the ambivalence, and the ambiguity, with which these texts are stippled (as in the spectacle of the eroticism of abuse, as in the beautiful depiction of pain and torture) is that these graphic narratives, by virtue of their uneasy structure of words and images, frames and gutters on the page, necessarily call attention to an idiom of formalism that is enabling. Drawing us to the texture of retracing, to the position of the detail, and to new ways of reading and "permission to look afresh at looking," these graphic narratives show that the act of visual reimagining is materially, ethically efficacious.[42]

Materializing Memory

LYNDA BARRY'S *ONE HUNDRED DEMONS*

Though both explore of the terrain of childhood trauma, Phoebe Gloeckner and Lynda Barry's comics narratives could not look more different. The visual precision of Gloeckner's carefully shaded and crosshatched images is central to how her work conveys its horror. Barry's visual style, on the other hand, is expressively imaginative as opposed to realistically precise. Her work has the most tactile appeal of the authors discussed here. Her comics are largely composed of black line art, and she paints her words and images with a brush: her lines are thicker and rounder than Gloeckner's, often animated by energetic exaggerations of gesture; they can exude a scruffiness totally absent from Gloeckner's work. Barry also departs from Gloeckner in that Barry continually works with the absences the form of comics provides. Uncovering, revealing, reframing: Gloeckner uses the space within comics frames to show as much as she possibly can; the repletion her images carry gives her work its bite. Barry does not *display* trauma so much as work in the edges of events, unsettling readers by leaving us to imagine the incidents whose aftereffects she plumbs. And Barry, more than any of the authors I discuss here, is deeply engaged with theorizing memory.

Barry was born in Richland Center, Wisconsin, to a mother who emigrated from the Philippines (a janitor who had previously been a WAVE) and an American father (a butcher who had been in the Navy).[1] At age four, her family moved to Seattle, where they lived with several other Filipino families in one house; they ultimately moved within Seattle to a predominantly black and Asian neighborhood that Barry describes as the poorest part of town and one with many mixed families like her own.[2] At Evergreen State College in Washington Barry published comic strips in the campus newspaper. After she graduated in 1978, her comic strips first appeared in the alternative newspaper the *Seattle Sun*, were picked up by the *Chicago Reader*, and went on to national syndication.

Almost from its inception, Barry's work has focused on what she calls "trouble." In the late seventies, Barry says, "people just hated what I was doing," because of the "darkness" in her work; disturbing content and comic strips seemed incommensurable. She had done a comic strip called *Two Sisters*, with light lines and "some really decorative parts," about endearing oddball twins named Rita and Evette, which was popular; but "after a while I couldn't draw Rita and Evette anymore." When she started drawing "comics that had trouble in them," Barry recalls, "people were very upset and I wasn't in many papers at that time. There weren't many comic strips that had a lot of trouble, that weren't funny. The setup for a comic strip is four panels and the last thing should be a punch line, so when people didn't get that punch line they became very upset and they would write furious letters to the editor about how there's nothing funny about child abuse. The strip was not funny, it was sad" (Interview).[3] While there had been comic strips with disturbing content in the underground, Barry's "sad" comic strips in commercial newspapers were new.

Barry started compiling book versions of her comics on her own by xeroxing her work.[4] Around the time that she was getting a sharply negative response from newspaper audiences, in 1979, she sent her comics to New York City's Printed Matter, an arts organization then based in Soho with both a store and exhibition space devoted to artists' books.[5] Their acceptance marked a turning point in Barry's work in terms of her commitment to expanding the notion of what comic strips could be; comics with "trouble" could be viable. She explains:

> Whoever it was wrote me back this note saying, "I really like what you're doing." You know, "We'll buy." I was selling for fifty cents each, and so I think they bought them for twenty-five cents, and "We'll buy a hundred of them," or something. That little letter from whoever it was that wrote completely changed everything for me, because I thought comics were a way that you could write about really sad things, and write about long stories, but there wasn't anybody who was doing it. [Printed Matter] got it, and I thought OK, well somebody else is getting this.
>
> (Interview)

Barry's first book, *Girls and Boys*, was published in 1981 by the independent publisher Real Comet Press; Printed Matter carried that book and her following two titles. As Barry kept producing the type of work she found compelling—as she puts it above, sad things and long stories—popular assumptions about format and content started changing. Newspaper audiences realized, Barry says, "that a comic strip could contain something sad, like a song. A song could be happy or sad, and I thought a comic strip should be the same. Then

people started liking the work, and I realized I could discuss anything in the comics then" (Interview).[6]

Printed Matter, a cultural institution of considerable renown, recognized the relevance of Barry's texts to their framework, "artists' publications," and in so doing defined her comics as art. Their acceptance of Barry's comics lends external support to an idea that I propose throughout this book, which Barry's body of work, particularly, points up. While comics, at least in an American context, was conceived in the field of the popular—and its creators, Barry chief among them, embrace its accessibility and popularity—comics can also be understood as art; comics can be "artists' books." That Printed Matter's support helped to launch Barry's career demonstrates how comics have come to reside productively on the fault line between "high" and "mass." Barry did not leave the commercial newspapers (her comic strip *Ernie Pook's Comeek* celebrated its thirtieth year in print in 2008), or commercial book publishing (Harper released six of her titles in the eighties and nineties) for the fine art world, but she has consistently drawn on the discourses of each, only ostensibly distinct, and moved in between the two, destabilizing their boundaries.[7]

Consonant with this open attitude about cross-discursivity and boundary shifting, Barry's career reflects a deep commitment to innovating different forms and formats. In all her work we recognize themes relating to gender, sexuality, violence, abuse, and play, but her artistic production falls within many categories. She has, for instance, released a funny and trenchant album-length spoken word recording, *The Lynda Barry Experience* (1993), which demonstrates her ability as both a writer and performer of masterfully economical stories (she has also been a commentator for NPR). Barry considers her first book the Xerox-on-demand edition of the collected *Two Sisters,* which she would enclose in an individually decorated manila envelope. Subsequently, she has published ten works of comics—*Girls and Boys, Big Ideas* (1983), *Everything in the World* (1986), *The Fun House* (1987), *Down the Street* (1988), *Come Over, Come Over* (1990), *My Perfect Life* (1992), *It's So Magic* (1994), *The Freddie Stories* (1999), and *The Greatest of Marlys* (2000)—and two novels: *The Good Times Are Killing Me* (1988), about an interracial adolescent friendship, which she adapted as an Off-Broadway play in 1991, and the moving and gory *Cruddy* (1999), whose girl protagonist, Roberta, is kidnapped by her father, a butcher and Navy man, and renamed Clyde. In 1984 Barry published the oversize *Naked Ladies! Naked Ladies! Naked Ladies! Coloring Book,* which features black line art illustrations of fifty-four different "naked" women, each drawn as a playing card in a deck. A fictional first-person narrative runs throughout the entire book; two to four lines appear at the very bottom of each page, scrolling underneath the women. *Naked Ladies,* as I will

discuss further, is a fascinating formal object: it is both a gripping prose story of childhood and a series of visual portraits designed to counteract narrow cultural expectations for women's bodies. The two projects, which meet each other on the page, do not fully synthesize, and it is precisely in that gap that the book succeeds. Barry's most recent books, *One Hundred Demons* (2002) and *What It Is* (2008)—texts that are the primary focus of my analysis in this chapter—pick up on this generic and formal instability to an even greater degree.

Barry's work has included the fine art circuit. *Naked Ladies* was a gallery show, at Seattle's Linda Farris Gallery, in addition to its release as printed book: on display were the fifty-four gouache and ink drawings fashioned after the deck of playing cards, on large bristol board, colored in and decorated.[8] They were sold in sets of six "cards" in custom frames created by Barry. Throughout her career, Barry produced different work with images—drawn, painted, printed, exhibited, two- and three-dimensional—refusing to value one format over another or let one discourse dictate the framework by which to receive her output, showing up the speciousness of imposed categories and value distinctions in visual art.

Barry's first novel, *The Good Times Are Killing Me*, began as an introduction to a catalog of her mixed-media paintings of singers and musicians that had also shown at the Linda Farris Gallery, several years after the *Naked Ladies* exhibit. The book presents forty-one short, typeset chapters, followed by a section titled "Music Notebook" that features eighteen color reproductions of Barry's paintings, along with handwritten page-long biographies by Barry on each facing page. The artworks that were shown at Linda Farris are shadow boxes: they are dioramas within which, for instance, one is able to move the instruments of the musicians. The paintings' handcrafted frames were made by Barry out of aluminum flashing—the material used to put up a chimney—which she bought at the hardware store, cut with tin snips, and decorated by using "screwdrivers or anything that would make a mark." Although she told me "as far as making artwork, that was one of my happiest experiences of all time," Barry's singers and musicians show, featuring pieces created in 1986 and 1987, was her last. She recollects, "I'd get these good reviews, but they'd say stuff like I had to make a decision, was I a painter or a cartoonist?" (Interview).

On the external pressure to differentiate her work with images, Barry explains, "I don't know what it means. I don't know the difference, and at the time it was really upsetting to me. They would tell me basically that if I wanted to be taken seriously as a painter, I had to stop doing cartoons." During the show, Barry discussed the process of making a painting of a Cajun guitarist, Cleoma Falcon, with a gallery visitor. "I said I could remember what TV show was on when

I made her guitar, and the lady looked at me, and I remember Linda taking me in the back room, and she said, 'Don't ever tell anyone that you're watching TV while you're making paintings. Just don't tell them that.'"[9] Reasserting that the various work she was doing with images—collage, painting, drawing—"didn't seem all that different to me," Barry sees her choice the following way: "When I would get these reviews and people would say I had to pick, I just thought, 'No. All I have to do is quit showing in galleries.' So I did" (Interview). Barry rejected others' conception of a divide between "high art" and "mass art." Although her statement "I don't know the difference" might be seen as disingenuous or simply polemical, for Barry, in fact, the fluid boundaries between various forms stems from the fact that images are at the core of everything creative she does. "Writing and painting and all art forms have to do with images," she told *Bitch* magazine. "So I felt very free to be a painter and a cartoonist and a writer and a playwright and an illustrator because they were all the same at the core" (Bilger 34). When I asked her about switching back and forth from comics narratives to prose, she emphasized that her novels all start with an image and are created outward from what the image generates to her—a process that also structures her approach to her work with verbal-visual forms like comics and visual forms like painting (Barry, Conversation). *Image,* however, despite the way it is widely used, is not a synonym for *visual*—although, as Barry says, an image can be visual. An image, rather, in Barry's conception, is about form and sensory shape (and thus, necessarily, about space). An image can take a sound shape or an olfactory shape as well as the shape of sight; Barry calls images "the units, or the things that move through time" (Chute, "Lynda Barry" 57).

Barry has always been interested in the cross-discursivity of narrative forms and in the particular capabilities of a diverse range of media. Her oeuvre is feminist, unflinching, and dark. In *Naked Ladies! Naked Ladies! Naked Ladies!*—a so-called coloring book with fiction, reviewed reverently in both *Ms.* and the pornographic publication *Screw*—Barry gorgeously paints fifty-four naked women, some baring their genitals intimately, because "I love naked women. . . . It's the mysterious and it's the hidden. It's *actually* hidden, like hidden somewhere in the house" (Powers, "Lynda Barry" 65). In *Come Over, Come Over,* Barry refuses to defray the horror of sexual abuse in the comic-strip stories "Did I See It?" and "Is It My Business?" ("If it wasn't her Dad I'd tell her 'Next time he does it, kick him between the legs.' Even Dear Abby would give that advice. Then run. Run like hell"). In *It's So Magic,* fourteen-year-old Maybonne and her sister Marlys witness the gang rape of a teenaged friend; traumatized Marlys, age eight, writes: "Teenagers theres [*sic*] things that they do. And if you tell anyone they will cream you. I saw something I can't even draw it. Don't try to guess it. Just

forget it." In her "illustrated novel" *Cruddy*, the teenaged protagonist, Roberta, commits suicide; the novel we read is her suicide note.[10]

Given the obviously adult nature and address of Barry's work, one can only see the fact that her work has been classified—not always with her intent—as "YA [Young Adult] Fiction" or "Humor" as a gender-motivated misperception. (How her books are taxonomized in stores and libraries is an ongoing subject of debate on *Ernie-Pook-Moderated*, a Web mailing list devoted to Barry's work.) The dark aspects in Barry have typically been ignored. For instance, Melinda de Jesús, in a rare academic article on Barry, fails to mention the sexual trauma that is the subject of "Resilience" in her gloss of the chapter ("The cartoon 'Resilience' briefly describes Lynda's inability to connect with other Asian American girls"; "Liminality" 229). And although Barry's few outspoken fans in the critical ranks offer superlative praise—Nick Hornby writes in the *New York Times* that "Barry seems . . . almost single-handedly to justify the form; she's one of America's very best contemporary writers"—*One Hundred Demons* has not garnered substantial critical attention, aside from the *Times*'s survey piece on graphic narratives ("Draw What You Know" 11). Because she works so often in the form of comics, still associated with the juvenile, Barry must contend with a devaluation of her work as not simply about children but largely *for* children. Further, because she features children (a feminized focus matter), and female children specifically, Barry's work faces an even steeper battle than, say, Spiegelman's *Maus*, which has also erroneously been viewed as appropriate for children.[11] (Spiegelman comments that when parents give *Maus* to their children, "I think it's child abuse" ["In the Dumps" 47].)

"THE RED COMB" AND *NAKED LADIES!*

My central focus is *One Hundred Demons*, Barry's first foray into nonfiction narrative. Yet a brief discussion of selected early works sheds light on the project of *One Hundred Demons*. "The Red Comb," from 1988's *Down the Street*, is a four-panel comic strip that exhibits the darkness in Barry's work, its remarkable economy, and how she amplifies the gaps natural to the comics form in her traumatic storylines.[12] Black and white, "The Red Comb" has no dialogue (figure 3.1). It begins with a text box at the top of the frame, which cuts into the first image, rendering two characters—one small girl in a striped dress and a much larger boy, in black jeans and sneakers—standing silently, headless, in a posture of facing each other. The text obscures their faces. "Everybody knows a bad influence," declare the words, all in upper-case letters. "On our street it was Kenny Watford who could whistle so loud" (100). This first frame is the only one we see

of the male figure we presume is Kenny. Right away the strip activates meaning through incompletion.

The second frame shows us the face of the girl, identifiable by her striped dress. She faces left towards the first panel, hand on a branch, in a thicket of leaves, wide-eyed, childish, pictured from the chest up. "Him sitting alone on some cardboard in the ravine, holding out the red comb to you just ten steps away" (100). The frame is shaded with thin black horizontal lines behind the leaves; this darkening effect appears to indicate evening, or night—or, an alternate temporality, a recollected event. "And he would say it," begins the third frame. 'I want to be your boyfriend, secretly I am your boyfriend, honey.' And you would stand there pretending something else was happening, anything else" (101).

In this third panel the girl stands facing to the left, as before, but the panel focuses up close: she looks as if she is being blown in a strong breeze, bracing her body, hunching her shoulders, closing her eyes, setting her mouth. Movement lines ring her face. And, whereas the second panel introduced horizontal lines behind her, here they shade *over* her, covering her; as if something is washing over her. In the last panel, she faces away, in the opposite direction, kneeling on the ground, covering her ears, literally turning her back on the ravine. The panel is not as still, silent, and clean as the first; it retains some of the patchy dark shading of the middle two. Women's legs, cut off as Kenny's were in the first frame, move in from the right toward the girl, echoing the opening image. "And later, way later, when you hear his whistle screaming from the corner, you'll turn up the knob on the TV so loud that your mother will finally come running in and stop you" (101). The expression on the face of the girl, whose eyes are closed—as in the third frame—is anguished: her body is folded up on itself and her brow is deeply furrowed.

The gaps in the story across which we are provoked to make connections are as much a part of the story as the frames themselves, which display very little interaction between protagonist and antagonist. In order to engage with the narrative on even the most rudimentary level, we are forced to guess the circumstances around which the strip revolves. When I have taught "The Red Comb" to college students, the immediate consensus is that it is about sexual abuse, but the strip never names it as such, leaving us only with associations to piece together ("bad influence," "secretly your boyfriend," the male sexual overtones of a "red comb" Kenny would be "holding out"). The strip even retains the gap between words and images across its storyline, as we guess the girl pictured is the narrator, without external confirmation. Both are nameless, and the prose narration, the first line of which includes all of us—"*everybody* knows a bad influence"—ends with the word "you" and uses the intimate second person throughout: "He al-

RED COMB

LYNDA BARRY '88

EVERYBODY KNOWS A BAD INFLUENCE. ON OUR STREET IT WAS KENNY WATFORD WHO COULD WHISTLE SO LOUD. HE ALWAYS SAID TO YOU "MEET ME IN THE WOODS, MEET ME IN THE WOODS" AND SOMETIMES YOU DID.

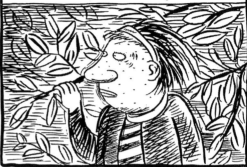

HE WAS SO HANDSOME WITH A TAN SCAR DOWN HIS CHEEK AND BLACK BLACK HAIR HE WOULD ASK YOU TO COMB. HIM SITTING ALONE ON SOME CARDBOARD IN THE RAVINE, HOLDING OUT THE RED COMB TO YOU JUST TEN STEPS AWAY.

AND HE WOULD SAY IT. "I WANT TO BE YOUR BOYFRIEND, SECRETLY I AM YOUR BOYFRIEND, HONEY." AND YOU WOULD STAND THERE PRETENDING SOMETHING ELSE WAS HAPPENING, ANYTHING ELSE.

AND LATER, WAY LATER, WHEN YOU HEAR HIS WHISTLE SCREAMING FROM THE CORNER, YOU'LL TURN UP THE KNOB ON THE TV SO LOUD THAT YOUR MOTHER WILL FINALLY COME RUNNING IN AND STOP YOU.

3.1 Lynda Barry, "The Red Comb," *Down the Street*. Harper and Row, 1988.
Used by permission of Lynda Barry.

ways said to you, 'Meet me in the woods, meet me in the woods' and sometimes you did." The tense of the strip also works to establish the activity and urgency of the story, bringing the reader into the narrative, as the first sentence places us in the present ("everybody knows"), then switches to the past ("it was Kenny Watford") and reverts to a kind of continuous past ("he always said to you . . . "). Throughout, Barry maintains the tense shifting, as when the last panel announces and later, *you will* turn up the volume—a verdict on what will happen in the future. A deceptively simple combination of only four images and nine sentences, Barry's "The Red Comb" retains its haunting gaps, weaving them

into the most basic process of how we understand the story. It is disturbing in what it does present, and even more so in provoking us to ponder what it does not, as it offers us the fallout of a situation we are supposed to imagine. Space is an active, signifying element of the story's rhythm: the space in between words and images—e.g., in between narrator and pictured protagonist—the space in between narrator and hailed reader, and the space of time, which on the page is a visual white space, between linked events.

"The Red Comb" shows what a traditional four-panel comic strip can do in the hands of Lynda Barry. We see that even in her short, fictional comic strips—which certainly do, as Barry suggests, refigure the traditional set-up of a "punchline"—Barry has always used the rhythm and narrative interplay of comics to give form to traumatic events in childhood, thematizing and inscribing gulfs of knowledge on the page. But she has not only addressed the traumatic aspects of female experience. She has also tinkered with the gaps so crucial to comics form, creating new textures for word and image narratives in order to allow readers to productively project a range of experience into the slippage between word and image.

If we see, in "The Red Comb," traditional comics at its most incisive, then in *Naked Ladies! Naked Ladies! Naked Ladies! Coloring Book* we see Barry experimenting with the narrative aspects of comics, expanding them to create a taxonomically and generically unstable book object that also addresses lived sexuality, as "The Red Comb" presumably does, but which focuses on the question of collectivity and representation. *One Hundred Demons*, published almost twenty years later, finally moves into nonfiction, and incorporates the concerns of both "The Red Comb" and *Naked Ladies*: including episodes of sexual abuse, it firmly establishes Barry's method and her interest in collective address.

The idea for *Naked Ladies* came from a deck of "nudie playing cards" Barry bought in Las Vegas that advertised "52 different girls." When Barry gave the deck to her little brother, he asked if it actually was composed of photographs of different women, or rather "five girls with 52 wigs" (Powers, "Lynda Barry" 65). The question resonated; it prompted Barry to realize that it could really be five girls with fifty-two wigs, because "the body types are always the same," as she told the *Comics Journal*—or, as she phrased it in an interview with me, "There's only one naked lady, right?" (Powers, "Lynda Barry" 65; Interview). Barry started drawing naked women "with every type of body" in response, and it "turned into a show; it turned into some paintings; it turned into this coloring book. And then," she explains, "I wrote this narrative to go with it" (Powers, "Lynda Barry" 65). *Naked Ladies,* which is unpaginated, opens with black endpapers filled completely with handwritten women's names in white, separated by com-

mas; they bleed off every edge, roughly 250 of them: Georgene, Linnea, Aiko, Ola, Ada-Mae. The title page features a spread of five playing cards face down in the center of the page: they are each decorated with a large seashell, framed by a curvy dagger above and a long snarling fish below. The bivalve seashell, which recalls Botticelli's *The Birth of Venus*, provides an icon of femininity, which is edged, as we can see in the deck's dagger and fish motif, with anger.[13]

The most salient aspect of *Naked Ladies* is its form: the book puts portraiture and prose fiction together, but does not match them in any precise denotative or illustrative way: they exist graphically together on the page, but neither narrative—the sequence of images, or the prose story—explicitly acknowledges the other, except loosely, thematically. The words thread under the black linework portraits, which arrive one per page—providing, from a graphic angle at least, a platform for the unfurling images. Sometimes there is a full stop at the end of a page, but the sentences are largely fragmented across the pictures, propelling one forward through the images, but not necessarily corresponding to them. The images present a wide range of women—American, African, Japanese, Samoan, Indian, middle-aged, pregnant, elderly, bodybuilding, bulimic (pictured vomiting)—in various poses. There is no one type of woman in whom the book is anchored; they are all equally weighted in between its covers. Most are aware of being looked at and look back at the viewer.[14] The prose narrative, on the other hand, provides a strong first-person voice—a voice that recollects girlhood in a frank, idiosyncratic way and establishes an "I" immediately. Below a tribal African woman, with necklaces, bracelets, bare breasts, headpiece, and spear (the Ace of Diamonds), the text begins: "When I was about five years old my cousin who was the same age came running around the corner from the back of the house and said did I want to see a boner." Although the entire book is billed as "fictitious," one may plausibly map this first-person voice onto the figure of Lynda Barry the author: her spoken word recording *The Lynda Barry Experience* opens with the performance of a piece called "Naked Ladies" that almost precisely matches her book's story.

This construction, this odd formal interplay—What to process first? How to read, how to view?—is the most interesting aspect of the book, even as it produces a bulky rhythm of consumption, or "acquisition," to use Will Eisner's term, because it establishes a major theme of Barry's oeuvre: the self in conversation with collectivities (5). We get Barry's verbal narrative, here, across visualizations of *many* women. The form of the book models how Barry's texts aim to address and include collective bodies; it is a book that involves but decentralizes the self. Barry adds herself among the women pictured (she is the Ace of Spades), but it is in the disjunction between words and images in *Naked Ladies* that we recognize

Barry's aim to enlarge and address readerships. The book works in the unconstructed space in between the words and images where we are interpellated. The prose narrative, which traces the process by which girls come to realize that they do not live up to a standard of beauty, gradually moves outward from the "I" to speak for an "us"—"it put us in a bad mood for the next ten years" is the last line—but this "us," because it does not fuse with the images, retains its particularity. The gap that is kept open between this particularized narrative, and the spectrum of women the book presents visually, proposes space for both possible connection and disconnection. *Naked Ladies* does not profess to speak for all women—certainly not even for the women it represents pictorially. The book allows itself to have a first-person voice, but it is a double tracked text, allowing its spate of images their own independence and integrity and, in so doing, demonstrating its desire to move beyond the individual. Barry posits her story as only one among many and asks us to consider our own and others' positionality.[15] The "coloring book" form of *Naked Ladies,* which implies interactivity and participation, is a metaphor for the book's central suggestion: its readers "fill in" the narrative with their own experience.[16]

What is a naked lady? In Barry's book, "naked ladies" does not mean literal nakedness. While several are unclothed and come "complete with explicitly rendered pudenda," in the words of the *Ms.* magazine review, many are partially or even totally clothed (23). While John Berger suggests that a nude woman is one who is aware of being seen, but who is merely looked at and objectified, many of the women in Barry's book acknowledge our look and appear to relish it.[17] The only "naked lady"—in the sense of the powerlessness before the beholder that Berger suggests—is, here, a representation of a representation: a Greek statue, whose appearance provides an exception to the story's mismatch of text and image (figure 3.2). Underneath the armless statue, which is draped below the waist, the text tells us: "By then we all knew we were naked ladies. We knew it and the boys knew it and some of the girls started being called sluts and some of the girls started being called prudes." The statue is a "naked lady" because "she" has no agency; she is simply crafted as an ideal, and her gaze in the picture is literally empty, her eyes two hollowed-out almonds. The vacancy of her gaze is underlined by literal underlining on the woman occupying the facing page, who stares intently, her eyes circled in thick black (figure 3.3). While in the sequence of images she arrives as the King of Hearts—an ostensible position of status that might seem in this context to indicate a kind of sexual puissance—the book actually elides the statue from its color fold-out section: she is replaced by an image of an undressed woman seated on a chair, breast-feeding a baby. The book suggests that unlike the statue, a classical representation of feminine beauty to be

BY THEN WE all knew we were naked ladies. We knew it and the boys knew it and some of the girls started being called sluts and some of the girls started being called prudes.

3.2 Lynda Barry, page from *Naked Ladies! Naked Ladies! Naked Ladies!*. Real Comet Press, 1984. *Used by permission of Lynda Barry.*

We couldn't even hardly look. The music was "Goldfinger." Pretty soon she started
going with this guy from Fort Lewis. A guy with a *car* and she was only a ninth grader. I think
she was originally from North Dakota where they are different.

3.3 Lynda Barry, page from *Naked Ladies! Naked Ladies! Naked Ladies!*. Real Comet Press, 1984.
Used by permission of Lynda Barry.

held aloft and enjoyed, its other women are crafted for and by themselves: they look, they act, they engage our gaze. They are "naked ladies" only in name, by virtue of the whiff of prurient uncovering the book adopts both mockingly and with earnest affection for sexual expression. As noted in chapter 1, on Kominsky-Crumb, Barry told the *Comics Journal*, praising the cultural space provided by comics, "That's one thing about cartooning that you don't see a whole lot of in society: you don't see a fair picture of what it's like to be a woman. Usually, if you see a depiction of what it's like to be a woman, you see 'strength' and no sexual desire" (Powers, "Lynda Barry" 75). As with other authors *Graphic Women* examines, the explicitness in Barry's book—despite its obvious send-up of a title and the essential sweetness of its portrayals—was received by some as obscene.[18]

DEMYSTIFICATION AND DEBRIS: *ONE HUNDRED DEMONS*

In *One Hundred Demons*, as with Gloeckner and Satrapi's texts, the author-subject makes political, collective claims by testifying to the very *ordinariness* of her trauma. And, as with Gloeckner and Satrapi, Barry's autobiography in words and images swerves from the amusing to the appalling, insisting on both as the lived reality of girlhood. *One Hundred Demons* explores the rich weave, both violent and joyful, of the everyday lives of displaced, working-class children on the interracial streets of Seattle in the 1960s (Barry, as mentioned, is herself part Filipina and grew up in a primarily black neighborhood).[19]

Structured into nineteen discrete comic strips—as is Marjane Satrapi's *Persepolis*—each named for a "demon," *One Hundred Demons* is Barry's first explicitly autobiographical work. But *One Hundred Demons* is not a typical autobiography: it is "autobifictionalography." In Barry's handwritten print, the publication page offers the following proviso: "Please note: This is a work of autobifictionalography." The table of contents is bordered at the bottom by the same designation, floating in red cursive; and, to its left, the following phrase, in baby-blue print: "Are these stories true or false?" A red check mark affirms both terms. Barry inserts herself as a radically visible adult narrator in her autobifictionalography; in the introduction she paints herself at her desk, painting the book we read. (*One Hundred Demons* is entirely painted, not drawn; Barry explains in an interview that she switched from a pen to a brush in 1985, which changed the nature of her work, because a different voice is created by different writing implements: "there was something about using a brush that made it so I couldn't draw that same kind of strip").[20] "Is it autobiography if parts of it are not true?" the narration reads. "Is it fiction if parts of it are?" (figure 3.4). While this page's two panels are bisected by a very slim gutter—and at first glance look so

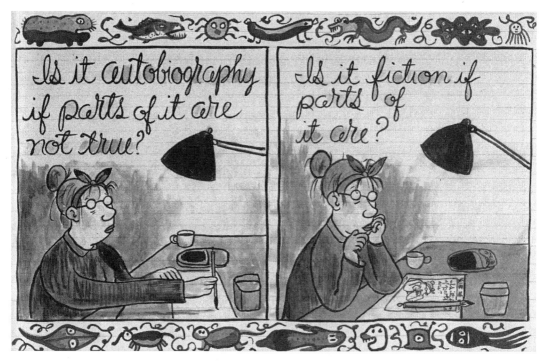

3.4 Lynda Barry, page from "Intro," *One Hundred Demons.* Sasquatch Books, 2002. *Used by permission of Lynda Barry.*

similar that one might take them to represent consecutive moments—a considerable amount of time passes from one to the next. In the first frame the paper in front of her is blank and she is just starting to paint; in the second, she has filled the space, finished the panel, and contemplates it—just as we too contemplate the same panel, twice: Barry's duplication of this frame within itself creates a mise en abyme. In pointing to this act of physical creation across the gutter, the sequence highlights the meaning of "fiction"—and also autobiography, too, she here implies—as the material process of making (from the Latin *fictio,* a nominal derivative from the verb *fingo,* whose definition is to make by shaping [from clay, wax, molten metal, etc.]). From the start, Barry embraces the discursive and generic fault lines of her work as productive, making that instability—that problematizing of taxonomy and reference—the basis upon which we approach her work.[21]

One Hundred Demons—in the spirit of its destabilizing claim to "autobifictionalography"—straddles the "high" and the "mass." The style and form of the book are influenced by a tradition of the historical avant-garde, as is also the case with Satrapi—but Barry demonstrates a different approach to self-visu-

alization. Whereas Satrapi embraces minimalism, Barry embraces lush collage (as did the Pattern and Decoration movement of the 1970s, in which artists like Miriam Schapiro and Joyce Kozloff mixed fabric and paint and explored the use of commonplace materials, putting pressure on mainstream concepts of art that devalued ornamentation and handicraft as "women's work").[22] In this full-color text, we see a piling on of commonly found, disposable, everyday objects. Describing her process, Barry explains, "I have tons of trash laying all over the floor and everywhere in bowls" in her studio (Interview). Each chapter of *One Hundred Demons* begins with a digital reproduction, a scan, of a two page multimedia collage, which preserves the three-dimensionality of the collage, what Barry terms its *bumpiness*.[23] Barry's collage interludes, which are unpaginated, are dense and accumulative, presenting a vibrant, thick, colorful surface texture. The rich visual volume and density of these collages offset the striking economy of each of the comics narratives they precede, which vary from only fourteen to twenty frames (and typically offer only two frames per page). These collages offer snippets of the subsequent strip, repeated handwritten words and phrases, original painted illustrations, and a piling on of sundry materials, including strips of brightly colored fabrics; cardboard; magazine pictures; tissue paper; the scalloped edge of a paper bag; photographs; the printed insides of bank envelopes; interior candy bar and gum wrapping; dried flowers; bits of doilies; glitter globs; Ric Rac; Chinese postage stamps; origami creatures; a stuffed animal; and pieces of old pajamas. At its conclusion, *One Hundred Demons* offers photographs of a pajama-clad Barry composing the book. Barry underlines the link between the scene of creation of the book and the actual materiality of the book by the fact that she incorporates pieces of pajamas into her collages. A diamond-pattern pair also frames the front and back inside covers of the book. What she wears on her body her book also wears. Additionally, each chapter's last page, which is always washed with color but otherwise pictorially empty, concludes with a small, echoing, punctuating collage that appears in its lower right-hand corner.

Barry's text also proliferates handwriting and typographies: it is more self-consciously handwritten than Gloeckner or Satrapi's uniformly hand-lettered text. Barry's handwriting changes color (in the book's prefatory pages and its collages) and changes stylization and size (everywhere throughout the text). It shifts—even in the physical, material space of one word—from cursive to print, from lower-case to upper-case letters. A sentence in the chapter "Dancing" reads, for example: "*And* THEN THERE *were* MY *teen*-AGE HULA DANCING *cousins who* BROUGHT THEIR HULA 45's AND DID *entire* DANCES THAT *trans*FIXED ME *totally*" (41). On first glance one might suspect that this shifting lends emphasis to the denotative meaning of a sentence or that it

works to imply its own spoken quality—a hallmark of Barry's writing is her ability to capture the way children speak to one another. Yet this shifting is enacted to "break up" the actual visual surface of the text. Barry creates the textural unevenness as a way of slowing down the experience of reading.[24] This ruffling of the visual surface of the book—this inscription of irregularity—slows one down and also works to establish an extrasemantic visual rhythm through the presentation of words. While a visual rhythm is sometimes established as regular in the text, it is just as often not; the intervals between regularity can be striking for their deviation from a measured flow, just as, in some cases, the very regularity established can stand apart as discrete.[25] The prose in the text signifies denotative meaning, but it also works at the visual level decoratively, containing a rhythm on its surface that is unconnected from the plot it establishes. Barry, who actually paints the words and does not follow any scripts, composes her work slowly, and she wants us to read and look slowly in turn.[26] (This is also her method for generating her novels: she painted the first draft of *Cruddy* in watercolors on construction and legal paper and is composing her forthcoming novel *Birdis* the same way.) Further, in this texture, this breaking up, Barry focuses attention in *every* aspect to the role of space in comics: her mix of upper and lower case letters also points, as she sees it, to "the very relationship between letters" in a handwritten text (Interview). Even the space between letters can contribute to the book's productively broken-up surface. In Barry's work, the printed surface itself has tension: Barry creates contrast even within the space of one word.

Barry is deeply focused on handwriting: the frontispiece to *One Hundred Demons* maps out the alphabet in its upper right-hand corner; in the book's epilogue, she notes, "I write the ALPHABET every day with a brush." Barry's material and intellectual foregrounding of handwriting calls attention to the visual rhythms that permeate comics. For her, the mixing up in her handwriting creates a rhythm, uppercase, lowercase; cursive, print, that ripples the visual surface. Barry's attraction to the form of comics indeed has to do with how it establishes rhythm: "I'm interested in comics because they remind me so much more of music than of anything else," she noted in a public event at NYU (Barry, Conversation). But while some cartoonists play heavily on the rhythm between word and image, and between presence (frame) and absence (gutter), Barry does this and additionally gives the visual surface of prose its own rhythm on the page and in the narrative. This is another central feature connecting her text to avant-garde experimentation, particularly to Dada, whose purveyors, as Johanna Drucker points out, made use of typographic innovations, as does Barry, by this very *mixing*: faces, sizes, and the use of "small graphic elements" such as pointing hands and arrows, are deployed in order to call "attention to the visual representation

of language as an element in the production of meaning" (*Alphabetic Labyrinth* 286).[27] Yet it is important that Barry's work—in contrast to many modernist experiments with typography, such as Bauhaus—does not seek the removal of the visible human hand from the style of letterforms.[28] Rather, she endeavors to the exact opposite: we may understand her shifting or irregularly stylized alphabet as a subjective, bodily ruffling of the smooth, objective, "perfect" surface of a printed page. Barry calls this "wrinkling" (Interview).[29] In addition to the piling of everyday materials, then, Barry's handwriting—which is carried out with the same brush as her images—itself "imparts a feeling of collage in its combination of typographic sizes, weights, and colors" (as Kimberly Elam writes about the work of Jean Tinguely).[30] In Barry's work, this element is in addition to the further element of typography introduced in her text in the assembled scraps of printed articles, labels, and advertisements in the collage pages.

One Hundred Demons references and is motivated by the high-art form of the artists' book; it is a *print reproduction* of an artists' book, a specifically populist, postmodernist rendering of that form.[31] This book is aware of its quality of tactility: its visible, overlapping layers, its pasted materials, in every corner appear three-dimensional—down to the white threads that fray loosely on either side of the sewn seam of the book on its title page, but belong to a purple and white diamond-patterned strip of fabric, photographed and snuggled in the crease of the double spread. (The three-dimensional aspect captured in *One Hundred Demons* evokes both artists' books and children's pop-up books, juxtaposing and rendering unstable, in this aspect as elsewhere, the discernable line between childhood and adulthood.)[32] The book demands to be understood in its entirety as a physical, aesthetic object; where the text begins and ends is not discernable in any definitive sense, as both the back and front covers are substantial works of collage—as is even a page as purportedly simply logistical and denotative as the publication page, which is here vividly collaged and handwritten by Barry.[33] There is literally no white (or black) space, as there is in Kominsky-Crumb, Gloeckner, Satrapi, and Bechdel, *anywhere* in Barry's book, which might either gesture at the space of reader projection or mark where one might anchor oneself in any differentiated, shifting "before" or "after" space of the story.[34] The endpapers, a dense profusion of painted black line art objects on rich purple-blue pages, are completely full.[35] Each section of the book—and, specifically, each chapter—presents a different background color. These colors alternate between different shades of yellow, peach, purple, green, pink, and blue; there is no pattern that might explain the choice of background color, and each color is slightly different, even from a shade that is ostensibly similar: Barry creates her specific colors anew for each chapter.

Yet, while *One Hundred Demons* showcases its composition as fine art and its unique, handcrafted creation as a high-art artists' book, it is a narrative powerfully invested in its own populism (literally and theoretically) and its accessibility. One immediately notices on the acknowledgments page that the strips contained within the book first appeared on the mainstream Salon.com and that the introduction is painted on yellow legal paper. As I will discuss further in my reading of the book's specific use of genre and otherwise everyday material, and its embrace of its "low" cultural status, the text does not enshrine or sanctify itself—either as a life narrative or as a work of art—but attempts to inspire the responsive, dialogic creation of narrative through its form. "Intro," whose eight frames all picture Lynda at her desk working on the book we are holding, ends with her hope that one will "dig these demons and then pick up a paintbrush and paint your own," which is underlined in a speech balloon that reads, "Sincerely! Pass it on!!" Seventeen demons later, "Outro," to which I will return, tells readers—precisely—how to do this.

STYLE AND TRAUMA: THE CHILD (PART ONE) —CREATING SPACE

Barry's printed surrealist collages show how *One Hundred Demons*, an adult recollection of childhood events, makes clear its process of interpretation as visualization, an aesthetic "working through." It is also centrally about the relationship of space, memory, and the past: one needs a sense of space for memories to come forward and take shape, and *One Hundred Demons* theorizes and creates that space materially on the page. Like its sibling text *What It Is*, *One Hundred Demons* is about capturing the structure of remembering. The layered space in Barry's book indicates that the past is not linear but all around us; we think of time, or the past, as moving from one point to another, Barry says, "[but] if you think of these images, they can move every which way, and you don't know when they're coming to you" (Chute, "Lynda Barry" 57). Barry's autobiographical work calls attention to itself as multilayered composition, the self as collage, in its rich, open layers of painting, words, and bits and pieces of ostensible debris: feathers, stamps, buttons, cotton balls, old labels, denim, felt, odds and ends from magazines. In that we can understand the visual work of *One Hundred Demons* as pastiche (drawing on the sense of pastiche as a "'stylistic medley' or blend of diverse ingredients"), Ingeborg Hoesterey's claim that "postmodern pastiche is about cultural memory and the merging of horizons past and present" makes much sense for this conspicuously multi-media autobiography (9, xi).[36] Barry's work is about process: of remembering, of reconstructing, of narrativ-

izing; in this sense it recalls Seyla Benhabib's concept of selfhood and the constitutive role of narrative in which "making sense" involves—in opposition to beginning, unfolding, ending—the "psychodynamic capacity to go on, to retell, to re-member, to reconfigure" (348). With its textured accretions of images and color, *One Hundred Demons* is about the process of accumulating and distilling memories as a visual practice.

One Hundred Demons, like much of Barry's earlier work, tackles the hidden and the traumatic. While it offers a subtle, wry humor, it expresses, as its title clearly would suggest, a certain *kind* of experience: difficult, "demonic." It repeats collage elements, piles on physical markers of memory, and counterposes spaciousness with heaps of ordinary, everyday material—a juxtaposition we see, for instance, on each chapter's final page. *One Hundred Demons*, in its collaged layers a literal re-collection, visualizes a process of recollection and renarrativization that well figures the assimilation of traumatizing experience.[37] We can see this, to name one example, in the book's sixth chapter, "Resilience." This story presents a central concern of Barry's work: the seeming paradox of traumatic memory, in which people "forget" trauma, but do not "forget" it enough (while these memories may no longer be verbal, they yet drive behavior).[38] Lenore Terr, a psychiatrist and researcher whose work is important to Barry, points out in *Unchained Memories*, her study of traumatic memory, both how repressed memory can be retrieved by visual cues, and how *place*, more than anything else, remains attached to highly emotional episodic memory (53, 73). Episodic memory works "like a movie"—"sometimes you can see only a few frames," Terr writes; this memory can go missing, except for fragments (81, 85). Traumatic memory tends to be more fragmentary and condensed than regular memory—a good description of the basic form of comics (203). And "we remember terrible events with a marked spatial sense" while temporal perspective (sequencing, causality) is often lost in trauma (199).[39] "Memories of our placement in space are among the best entry points we have to our old memories," Terr emphasizes. "We can literally map out on paper or mentally follow our childhood selves" (232). Comics is deeply relevant for this mapping: authors are able to put their child bodies in space on the page. The basic structural form of comics—which replicates the structure of traumatic memory with its fragmentation, condensation, and placement of elements in space—is able to express the movement of memory. It both evokes and provokes memory: placing themselves in space, authors may forcefully convey the shifting layers of memory and create a peculiar entry point for representing experience. In "Resilience" we see Barry map a process of memory—that is, make it material on the page—through the spatializing form of comics.

When the child Marlys creates her own comic about witnessing rape in Barry's *It's So Magic*, she scrawls, "Just forget it" over a blank panel: Marlys comes up against the unrepresentable. So does the child Lynda in "Resilience," who at age twelve "already knew too much about sex, found out about it in harsh ways" (65). Barry repeatedly inscribes, with different typographical hands, the phrases "Can't remember/Can't forget" in the two-page collage prefacing the story. In addition to varying how this pair of phrases appears by switching colors, handwriting, and use of upper- and lower-case letters, she emphasizes the problem of memory by stamping, in large, childish glitter, the words "FORGET" and "FORGOT" in the collage (figures 3.6 and 3.7). She also presents the twinned "can't"s in the chapter's punctuating, epilogic collage, in which the phrases stand in an architectural, perpendicular relation to each other: this, Barry shows us, is the situation of trauma and memory. As Cathy Caruth writes, "If traumatic experience, as Freud indicates suggestively, is an experience that is not fully assimilated as it occurs, then [texts of trauma] . . . ask what it means to transmit and to theorize around a crisis that is marked, not by simple knowledge, but by the ways it simultaneously defies and demands our witness" (5). The entire text of *One Hundred Demons* is a meditation on memory and the importance of remembering, as the chapter "Dogs," also about trauma, thematizes and states outright ("If we had been thinking, if we had been remembering, we'd have realized we were doing the wrong thing"), yet, as the swarming collages indicate, "remembering" is not a transparent state that is simply accessible (179).

"When I was still little, bad things had gone on, things too awful to remember but impossible to forget," Lynda reports (65). Crucially, Barry frames childhood sexual trauma as endemic: "I wasn't alone in my knowledge. Nearly every kid in my neighborhood knew too much too soon," the narrating Lynda writes.⁴⁰ "Resilience" represents not simply the devastating aftereffects of her experience but also critiques a broad, self-serving adult discourse about childhood trauma. In a panel that depicts the sleeping twelve year old, the adult Lynda narrates, in boxed text above the image, "I cringe when people talk about the resiliency of children. It's a hope adults have about the nature of a child's inner life" (66). In a later panel, again above the sleeping girl, she asserts, "This ability to exist in pieces is what some adults call resilience. And I suppose in some way it is a kind of resilience, a horrible resilience that makes adults believe children forget trauma" (70; figure 3.5). In this personal story Barry explicitly frames her experience collectively, evident in the way the strip speaks to the prevalence of abuse; she moves, on the last page, to the intimate second person, generalizing this experience outward to a public sphere, shifting away from the "I": "You can't

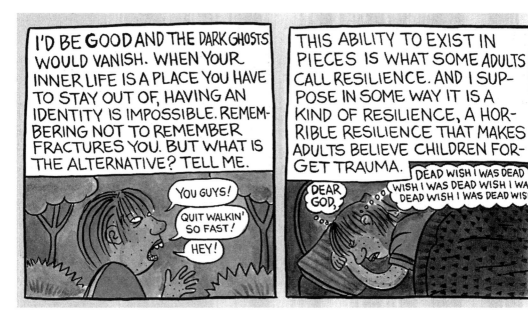

3.5 Lynda Barry, "Resilience," *One Hundred Demons*, p. 70. Sasquatch Books, 2002. *Used by permission of Lynda Barry.*

forget it but you do remember never to remember it . . . " (72). Echoing this complex, layered state of *not forgetting*, the strip recursively ends where the "plot" of trauma begins. The very last panel depicts a child sitting in the grass, while an adult man—cut off above the waist, as in "The Red Comb," and with his hand foregrounded, clutching a cigarette—asks, "Do you and your dolly want to go for a ride?" (72). This strip not only addresses traumatic memory's paradox but also enacts it—how it defies and demands our witness—in its narrative composition.[41]

This is suggested forcefully in the introductory collage. Here Barry presents a photograph of herself as a child with a translucent strip of orange pasted over her eyes, filtering our ability to see her—and also, at least graphically, filtering the subject's own outward gaze at us. The girl in the photograph is the same age as the girl in the story's last frame. Posed for a portrait, the child beams; her short red hair is coiffed, and one small chubby hand rests on her chin. An older, adolescent Lynda is painted facing this picture of her younger self: she stares blankly at the photograph, her hands on her chin, echoing the posture of the child: short red hair, short sleeves, elbows on the table in front of her. Instead of neat photo corners, blue pieces of tape, appearing haphazardly placed, as if floating instead of affixing, anchor the adolescent Lynda on the page. Between the two images of her—one photographic, one drawn; one toddler, one adolescent; one smiling, one gloomy—is a window, whose twinned panes proffer the

dilemma the story undertakes: "CAN'T remember can't FORGET." An upside-down stuffed toy also appears between the two images; its white blank eyes mark the center of the page. The childish toy upturned indicates upheaval for the child and is repeated by a black paper monster—a demon—also sporting white circular eyes, lurking upside down in the lower left corner; the two inverted creatures seem to diagonally enclose the child in the photograph, almost as a physical barrier. Above the small black demon is an upright figure, an alligator; buttons of glitter indicate a man's shirt, and a shiny glob of silver paper rests over his crotch. His body is turned to the left, legs locked stiffly, as the man who concludes the story also stands.

On the opposite, right-hand collage page, a large and prominent painted doll, which evokes the character Lynda with its red hair and childish purple dress, lies on its back with simple gaping holes for eyes. This doll also matches the doll that Lynda clutches in the story's very last frame, as we watch the child face the man we cannot see: both wear a dark dress, and sport a chopped bob. As in other prefatory collages, this page features a frame that looks like a stage of sorts: above the doll's prone body, legs apart, three demons hold a placard: "Today's DEMON: RESILIENCE." The rounded flowers behind and in front of the doll's body evoke the flowers among which the child Lynda sits at the story's conclusion. This doll of the collage, then, figures the character Lynda—bow in her hair, she is in what looks like a helpless and wounded position, supine on her back—and also the doll of the narrative: with her inanimate pose and vacated eyes, she is a figure for both dissociation and forgetting. The posture of physical helplessness ("on her back") works here as a postplot ending appearing as a kind of prologue: through our own projections and associations about what might happen to the Lynda character, this wounded figure stands in for her. "Resilience" is set up, then, so that the very end of the story circles back to the collage; it defies linearity. An origami creature, similar to a large insect, and with a phallic, pointed head, swoops into the frame over the space between the doll's legs; its three-dimensionality here, against the flat drawing of the panel, further implies a physical violation. Sight is a theme: while the doll has conspicuously emptied-out eyeballs, this contrasts with the demons hovering above her; one has a disproportionately large and blinking eye, while the other has two sets of eyes in a row. She sees little or nothing, while the demons see too much ("can't remember/can't forget"). A small black and white panel, dangling off the bottom left corner of the titular frame, pictures a teenaged girl, eyes obscured by glasses: she faces away.

The chapters of *One Hundred Demons*—the demons—run the gamut, from "Hate" to "San Francisco" to "Cicadas" to "Girlness." Barry does not adhere

3.6 Lynda Barry, "Resilience," *One Hundred Demons,* first page of double-spread collage preface. Sasquatch Books, 2002. *Used by permission of Lynda Barry.*

3.7 Lynda Barry, "Resilience," *One Hundred Demons,* second page of double-spread collage preface. Sasquatch Books, 2002. *Used by permission of Lynda Barry.*

to a chronological or otherwise stabilizing structure: throughout she moves back and forth between childhood, adulthood, and interim stages in the space of the book. Each individual chapter loops through different temporalities; the collection of temporal moments palimpsested in the opening collage pages indicates the book's overall approach to narrativizing a life. Unlike Kominsky-Crumb, whose *Love That Bunch* begins with youth and ends in middle age; Gloeckner, who follows her protagonist Minnie closely as she grows up bit by bit; and Satrapi, the subject of the next chapter, who presents a strictly linear account of her childhood, Barry's narrative of development is looped, retracked: "We think that we are going into the future, but actually what we're doing is going into the past," she claims about how images—memory—present themselves. "There's this feeling that there's a chronological order to things because there's an order to the years, and there is an order to our cell division from the time we're a little embryo until we're dust again. But I think the past has no order whatsoever" (Interview). In part the recursivity in her work indicates a temporal scrambling introduced by trauma, but more broadly its collection of nonsequential pieces—chapters—of visual and verbal narrative suggest how memory works as well as offering a view of narrative identity that eschews the notion of a fixed self persisting over time. Because her books are about remembering, they mimic, with their profusion of images "which move every which way," as she puts it, the process of how one remembers. And, as in Spiegelman's *Maus*, Barry destabilizes the ostensibly discrete categories of past and present, suggesting their porousness and fluidity.

In the circumstantial details of Lynda's upbringing, *One Hundred Demons* presents an opposite picture from *Persepolis*, a text also interrogating childhood trauma. While *Persepolis* is indisputably a book about class—its protagonist interrogating her class privilege in a fractured Iran—so too is *One Hundred Demons*, although from an inverse perspective: the character Lynda's family is decisively working class. And while *Persepolis* is about the power of family relationships, so too is *One Hundred Demons*, but as a negative proposition—particularly in the figure of Lynda's abusive mother, whose "very intense swearing in Tagalog" is characteristic of their interactions (119).[42] In the book's first chapter, "Head Lice and My Worst Boyfriend," an adult Lynda cannot figure out of whom her boyfriend reminds her; but when he screams at her, "You talk talk talk about asinine memories like they mean something! You're shallow! You're poison! Do you really think I'm interested?" she stares at him disbelievingly and says, "Mom?!" (21, 24).[43] It is significant that the accusation familiar to Lynda—"you

talk about asinine memories"—materializes in her autobiography's first chapter. Right away, the book establishes memory as its focus and "writes" against the verdict of Lynda's mother and Lynda's "worst boyfriend" (who gives himself the authority to gloss—and to denigrate and romanticize—a narrative of her life).[44] Barry explores her difficult and constitutive relationships with relatives, friends, and community, as well as with trauma, re-creation, and the very notion of creativity, visualizing and materializing memory as counter not only to those who would fix her identity (and believe identity fixable) but also to those who would diminish the political importance of the everyday.

ORDINARY MATERIAL: SELF, ADDRESS, AND GENRE

A story about genre, form, and narrative itself, *One Hundred Demons*'s final chapter, "Lost and Found," is a miniature *künstlerroman*, a narrative of Lynda's development as a cartoonist that has a decidedly populist beginning in the classifieds. Here a child Lynda, an adolescent Lynda, and an adult Lynda are all pictured protagonists (a "present-day" adult Lynda is narrating). "We didn't have books in the house, but the paper gave me plenty to work with," the story begins (208). We see a rapt Lynda, nine years old, with her trademark halo of spiky red hair, sprawled out on the floor of her home surrounded by the open classifieds section of the newspaper (figure 3.8). Unsurprisingly, Lynda is "fascinated" by the tiny narratives of the classified ads. These ads are, in many ways, evocative of the economical form of comics: "They gave me so many weird blanks to fill in," Lynda explains (after noting "each quarter-inch ad was like a chapter in a book"; 210, 209).

Barry then paints for us, in comics form—as a child would, with crooked lines and spelling errors—the stories that the child protagonist imagines explain the ads.[45] Here, Barry literally reimagines and re-creates her undervalued childhood "art" in the context of literary narrative. The "found" in the title "Lost and Found" is the exuberant mode of imaginative storytelling and self-expression that the genre material of the newspaper and its ilk—specifically the classifieds, the *Readers' Digest* series "Joe's Lung," and the newspaper homemaking advice column "Hints From Heloise"—provided Lynda as a child. Yet Lynda's love of genre material, as she narrates, marked her as unadvanced.

"My trouble ended when I started making comic strips. It's not something a person has to be very 'advanced' to do. At least not in the minds of literary types," Lynda writes (215). Barry argues for comics as populist art; "Lost and Found" is a critique of this visual form's elitist detractors: "Nobody feels the need to provide deep critical insight to something written by hand" (216). This comment

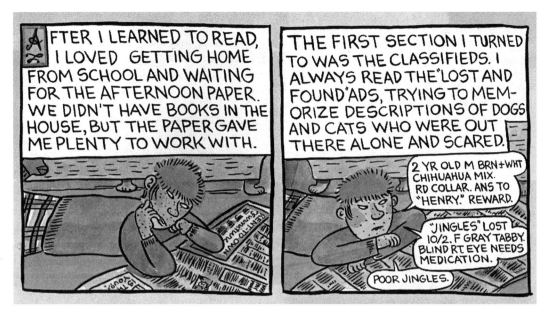

3.8 Lynda Barry, "Lost and Found," *One Hundred Demons*, p. 208. Sasquatch Books, 2002. *Used by permission of Lynda Barry.*

highlights the usefully unstable form of comics, which bridges mass and high culture because it is mass-produced and yet handwritten and artisanal. It also focuses attention on the generic strangeness of such a lush and beautiful *object* as Barry's book (suggesting correctly that critics who cannot easily categorize such work ignore it). Additionally, it calls attention to Barry's particular emphasis throughout *One Hundred Demons* on the presence of the hand in the text, both pictorially and in prose. Barry's work is very conspicuously *in* and *about* "handwriting"; she frequently depicts Lynda in the act of composing, hand on paper. In the book's "Intro" and "Outro," Barry portrays Lynda in the act of inscription; in "Lost and Found," an only eighteen-frame chapter, Barry draws Lynda in four frames—at different stages of her life and at different stages in the story—in the act of writing, her working hands visible (212, 214, 215, 216). This attention to the hand represents Barry's obvious respect for handcraft—and also a passionate project of demystification: she not only wants to call our attention to the body in the text as it writes, but she also wants to *show* us that act of writing.[46]

The last page of "Lost and Found" presents two frames (figure 3.9). The first is an address to the adult Barry's (female) readers, in the re-signified style of Heloise (it begins: "Gals, ever felt so intimidated . . . ") (216). The adult Lynda sits at her desk, framed by lamplight, brush poised to paper, foregrounding the enunciative situation of the book. This frame is followed by the nine-year-old Lynda again reading out loud from the classifieds, pictured as in the opening

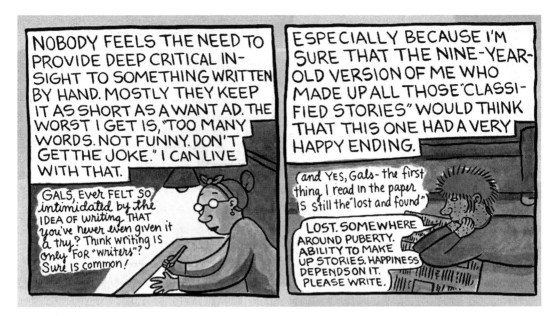

3.9 Lynda Barry, "Lost and Found," *One Hundred Demons*, p. 216. Sasquatch Books, 2002. *Used by permission of Lynda Barry.*

frames of the chapter: "Lost. Somewhere around puberty. Ability to make up stories. Happiness depends on it. Please write" (216). Here we see Barry, whose love of the classifieds inspired her as a child, in turn embedding her *own* life narrative *within* that form in the story. "Please write," of course, is both part of the classified advertisement's protocol and a wider, psychic injunction to artistic (self-) expression. This frame, which concludes *One Hundred Demons*'s last narrative chapter, represents a vital circling backward: the implication is that the young Lynda—as she has for other classified ads—will then imagine and narrate a story for that "ad" (which might be, of course, the very narrative we have just completed). Both bodies face left, against the direction of reading, back toward the beginning of the book (on the story's first page, Lynda faces right, with the narrative movement of reading).

The homage to the power of genre material of the everyday in "Lost and Found" extends into *One Hundred Demons*'s "Outro." Although it appears to be a postplot chapter (it is, like "Intro," unpaginated), "Outro" is as constitutive as any of the other chapters in building the autobiographical fabric of the text. Indeed, it is the most explicitly nonfictional portion of the book, in that it details—very precisely, including through eleven photographs—Barry's process of painting *One Hundred Demons*. "Outro," which explains how one would paint his or her own demons as Barry has done, best theorizes Barry's position on the political (and the physical) work of visual culture. W. J. T. Mitchell's sense of

visual culture as not only the socialization of the visual field but also, more importantly, *the visualization of the social*, is useful here (*What Do Pictures Want?* 345). Barry not only loves the classifieds, we learn, but she draws on and over them. The last page is an appropriately antiteleological closing to the book, for, in its citing of the classifieds in detailing its own production, it takes us backward to the previous chapter, "Lost and Found": "I like to PAINT on LEGAL paper or on the CLASSIFIED SECTION of the newspaper OR EVEN pages from OLD BOOKS! I will try ANY PAPER, typing paper, wrapping paper even PAPER BAGS!" We see this clearly in the yellow legal paper onto which "Intro" and "Outro" are painted and in the frontispiece to the book, which is a painting drawn over a page of an old novel whose table of contents is as follows: Introduction, Selfhood, Breed, Ethick (figure 3.10). By painting over—but incompletely—this schema, Barry at once invokes and rejects traditional narratives of self-development, materially and figuratively refiguring how a life narrative signifies.

The classifieds provide both an inspiration and a manifest practice for Barry; they are a figurative and actual foundation for her comic strips. Barry incorporates newspaper classifieds—what she calls "one of the things I enjoyed

3.10 Lynda Barry, frontispiece, *One Hundred Demons*. Sasquatch Books, 2002. *Used by permission of Lynda Barry.*

reading most" when little (209), which is still in her adult life "the first thing I read in the paper" (216)—*in* her work as a material foundation, literalizing the idea of "drawing on" genre material and offering, here, the idea of her own life narrative as a populist palimpsest.[47] Paying homage to the tiny narratives of the classifieds, Barry confirms their literal usability.

A full-page color photograph of Barry at her desk, in profile, opens "Outro": she is painting on yellow legal paper in her pajamas (figure 3.11). This image, which is demystifying in that it visually locates the precise materials with which she works, is not presented so as to referentially confirm the *autobiography* in "autobifictionalography"; Barry's refusal to look at readers in this image shifts the narrative emphasis, and readerly interpretation, away from an identification of an authentic individual self to a confirmation, rather, of the act of writing. She looks down at the page, not at readers, surrounded by writing implements: this page directly echoes the images that precede it in "Lost and Found" of the character Lynda, showing us the hand on and in the page; it is simply one more thread in that visual dialogue.

The next page offers the injunction "Paint Your Demon"—this is the image that Barry paints in the directly preceding photograph; and the next five pages explain in detail how one might do that. "Outro," composed mostly in text and photographs, lays bare its own procedure, not only showing a reader how *One Hundred Demons* is composed but even where one could purchase art supplies Barry uses (an "autobiographical" detail presented in the context of inspiring others to, presumably, their own autobiographical practice). The first two pages of these instructions detail necessary materials (such as an inkstone "at least 3 x 4 inches. You can get a good, simple one for under $20.00," and an inkstick "made of soot compressed into a hard stick—PERMANENT!! ARCHIVAL!! Really fantastic!!"). Barry devotes a whole page to brushes: "The one I used for this book," she writes—which she is presumably still using—"had a brush hair length of 1 inch and a base diameter of 1/4 inch." The subsequent three pages detail the mixing of ink and water; instructions on how to hold the brush; and, on the book's very last page, Barry's description of what she likes to paint on—which, as I have noted, circles us back to "Lost and Found" in citing the classifieds.

One Hundred Demons's final page, repeating "Paint Your Demon," also offers, in its center, a second photograph of Barry working on the original "Paint Your Demon" page that opens the chapter (figure 3.12). This is yet another move that, as in the final panel of "Lost and Found," implies a self-reflexive circling backward, a deliberately repetitive gesture indicating process. Facing us, Barry's face is yet cut off just below the eyes; we see the bottom rims of her glasses. As with figure 3.11, this photograph, presenting her face only partially, signals its

3.11 Lynda Barry, page from "Outro," *One Hundred Demons.* Sasquatch Books, 2002. *Used by permission of Lynda Barry.*

refusal to perform the role of "objective" correlate to her drawn self in order to authenticate the autobiographical subject. (Motifs here, such as the presentation of absented eyes and the truncating of a full view of the subject by the top panel border, also connect it to stories such as "Resilience," in which the painted doll haunting the prefatory collage has conspicuously absent eyes.) This final chapter materially emphasizes that the concept of the composition of the book itself, like the fabric of subjectivity, is a procedure rather than a product. It follows that its conclusion is open: *the process of making it*—"discovering the paintbrush, inkstone, inkstick and resulting demons," Lynda writes—"has been the most important thing to happen to me in years."

Relevant as feminist praxis, *One Hundred Demons* is a vital feminist work, resignifying the detritus of girlhood as productive collage by aesthetically re-visioning it. The recontextualization of cheap, common, or utilitarian paper (which also harkens back to the historical avant-garde) may be understood as a transvaluation of the idea of working on "waste"—a knowing, ironic acknowledgment on Barry's part that her life narrative, itself perhaps considered insignificant, is visualized in an accessible popular medium, comics, that is still largely viewed as "garbage." And, significantly, the use of genre and/or everyday

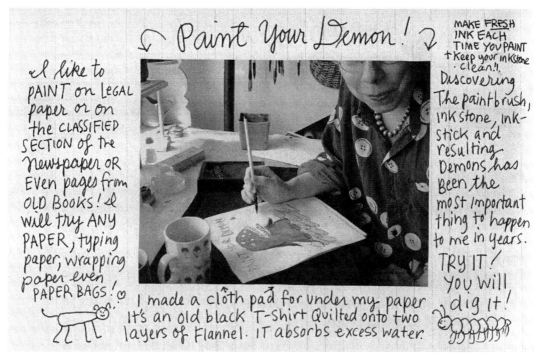

Paint Your Demon!

MAKE FRESH INK EACH TIME YOU PAINT + Keep your inkstone clean!!

I like to PAINT on LEGAL paper or on the CLASSIFIED SECTION of the newspaper OR EVEN pages from OLD BOOKS! I will try ANY PAPER, typing paper, wrapping paper even PAPER BAGS!

Discovering The paintbrush, ink stone, ink-stick and resulting Demons has Been the most important thing to happen to me in years. TRY IT! YOU will dig it!

I made a cloth pad for under my paper. It's an old black T-shirt Quilted onto two layers of Flannel. IT absorbs excess water.

3.12 Lynda Barry, last page from "Outro," *One Hundred Demons*. Sasquatch Books, 2002. *Used by permission of Lynda Barry.*

materials such as newspapers and paper bags as a foundation for drawing is consonant, materially and theoretically, with DIY (do-it-yourself) culture: the DIY ethic, so prominent in punk and youth subcultural practice and in contemporary grassroots feminism today, is not an abstraction in Barry's work but rather constitutes its explicit political context. Barry's feminist demystification—and feminist valuation—of the "writer" and "artist" in the figure of a genre material-obsessed cartoonist is a significant contribution to visual culture, as is her summary dispatching of any notion of a coherent self: the concept of a life narrative as "autobifictionalography" is a fine theorization of subject constitution, especially in light of Benhabib's persuasive narrative view of identity, which "regards individual as well as collective identities as woven out of tales and fragments belonging both to oneself and others" (351).[48] Further, the visual register of this "autobifictionalography" allows Barry to end her narrative showing—literally, through brushwork and photography—a female subject constituting herself, provisionally, through an address to others.

"A PIECE OF A FORMER NEIGHBORHOOD OF YOURS": IMAGES, MEMORY, AND COMICS

An intensification of the themes and formal concerns of *One Hundred Demons*, Barry's newest book, *What It Is*, sums up the central issues raised by her "autobifictionalography." It interlaces three different visual-verbal registers, all of which directly address the reader: narrative, collage, and "instruction." Michael Moon glosses it as "about human psychic functioning and its relation to the image," and avers that Barry's account of creativity is as "helpful and inspiring as [M.P.] Follett's, [Gertrude] Stein's, [Agnes] De Mille's, and [Martha] Graham's" (Review). Barry has long acknowledged her interest in the concept of play as proposed by British psychoanalyst D. W. Winnicott, the author of 1971's classic *Playing and Reality*. She aims to show, as with Winnicott, that "playing" is an essential activity, and should not be confused with fun; play involves conflict and anxiety.

Play is both the explicit theme, and the form, of *What It Is*, a book generated from at least twice as many collages as appear over its 210 pages, and which allows itself the space, both literal and metaphorical, to play with words and images, unfurling questions to which it does not know the answers.[49] *What It Is* makes legible the connection between childhood play—long fascinating to Barry—and the form of comics. Barry's interest in playing is, in part, located in how children animate inanimate objects, how they give them life. In *What It Is*, she makes clear her attempt to do the same thing with the material substance of words and images—that is, with marks. Comics is a kind of play—an animating play—with the mark. Barry tells Miriam Harris, "When I draw or write it is very much about trying to keep something alive, from the first living stroke of the paintbrush or pen. There has to be that risk of death, or the work itself is dead on arrival, dead from the beginning. Children do something similar when they play. There is always an element of danger and trouble when kids play" (143). Barry's focus on physical movement in the creation of her work underlines the broader notion of comics as play, in which she is playing with strokes and marks to give them life.

What It Is amplifies the formal instability, collective address, and use of everyday materials we see in *One Hundred Demons*, drawing on a wider range of voices—and marks—to make its collage pages. An even more experimental text than *One Hundred Demons*, it theorizes comics, memory, space, and the agency-activity of images. While Gloeckner's images propose agency in doing two things at once—professing their own ambivalent desires—Barry's images signal that they are both looked at and themselves looking. Barry paints or draws "I C

U 2" on images in *What It Is*; they project this message outward to readers. She also draws "Hello!" stamped over images: they are seeing us, addressing us; they are undead. "I didn't know there were different kinds of aliveness," Barry narrates of her younger self (11). Subsequently, a page tackles this subject explicitly: "What is an image?" asks a recurrent character—a creature with eyes dotting her face, head, and neck—who wields a microphone in the upper left corner. Barry paints herself painting this very character, Sea-Ma, at the bottom of the page: "Alive," she responds to the question, "in the way thinking is not, but experiencing is, made of both memory and imagination, this is the thing we mean by 'an image'" (14). The book also calls images "the formless THING which GIVES things form," suggesting that their aliveness is contingent upon us, whether we are looking with our eyes or in our "mind's eye": "there's an interaction," as Barry says (8; Interview). And if traumatic memory is the subject of *One Hundred Demons*, then it is the tacit subject animating the meditation on memory, images, and imagination that guides *What It Is*. "I always think of images as lowering the drawbridge where stuff can cross over—memory," Barry told me; she emphasizes that visualizing is its own form of reexperiencing (Interview).

Full color, swollen slightly larger than 8.5 by 11 inches, and composed on yellow legal paper, *What It Is* has thirteen narrative sections, which were written continuously as one autobiographical story but are broken up over the course of the book by intervals of collage pages. The narrative sections, which range from two to eleven pages, are in comics form, combining words and images in units that move the story temporally forward. The collages incorporate words and images of all different sorts, but are non-narrative. Each collage page functions as its own complete, discrete visual unit, a bounded artwork, and each strikes a questioning mode: What is the past? Why do we compose? The third part of the book begins in its second half, but is also interspersed: in beautiful, heavily collaged pages that reference workbooks, Barry suggests writing exercises and activities, and dispenses advice focused on retrieving memories in order to be able to write. (These exercises come from a workshop she teaches around the country, "Writing the Unthinkable.")[50] Each page of *What It Is* requires slowness and fresh concentration.

What It Is is filled with handwriting; it even has collage pages dedicated to probing handwriting ("HANDWRITING is an image LEFT BY A LIVING BEING IN MOTION it cannot be duplicated IN TIME OR SPACE" one offers; 109). But what differentiates *What It Is* from *One Hundred Demons* is that Barry's most recent book, while yet a memoir, is filled with handwriting that is not her own. To create the book, Barry used a personal archive that had belonged to a neighbor's aunt, Doris Mitchell—a schoolteacher whose career began in the

1920s—and been bound for the trash after her death: "She kept everything, and she kept all her school work that her kids did, but she kept it in the basement of this old farmhouse that was wet and full of rats . . . when they were clearing that out, I found all these pieces of paper with handwriting on them, and I'm crazy about handwriting, so a lot of *What It Is* are little pieces of paper that I was able to salvage. . . . [My neighbors] thought I was out of my mind because they were taking it to the dump, and I was like, 'Nooo!' I wouldn't let them throw anything away" (Barry, Conversation). Composing *What It Is*, Barry surrounded herself in her studio with bowls and baskets of the schoolchildren's work as well as with Mitchell's notes and letters. One wonders, for each collage page, Whose story is this? It is often unclear reading the book whose story is whose—to whom it "belongs." Are the handwritten statements, the comments, the doodles, the children's, Barry's, Mitchell's?

This unclearness, this porous boundary, constitutes the power of the book: its presentation as a "memoir" rooted in a collective (if fragmented) voice—a collectivity of voices. Many of the bits and pieces we get from the children look and sound dark, like Barry's own childhood story. But the book retains its unknowingness: it offers particularity *and* anonymity. It is a book about making marks, but it is filled with marks made by people who are not Lynda Barry. Barry does offer her own story in *What It Is*, but presents it as coming from only one (visual and verbal) voice among many. She recovers and reactivates words and images from the past in order to explore the concept of creativity, putting anonymous voices into play, valuing the subjective mark of other people's handwriting, and allowing these marks their own integrity within the collages (see, for instance, figure 3.13). It is often hard to tell what is made by an adult hand and what is made by a child hand (this mix of child and adult voices in the book reveals Barry's respect for child voices). The fragments belonging to others are not merely incorporated or assimilated to tell her story *for* her but rather expand the texture and the range of the questions at the book's center, which the combinations of words and images in the collages investigate. While *What It Is* is not precisely regularly patterned, Barry conceived, she told me, of the interspersed narrative portions of the book as the beat and the collages as the chorus (Interview).

Barry uses the term *chorus* in the sense of a popular song, but the notion of the collages as "chorus" is suggestive in a further aspect as well. Taking this metaphor seriously, it is possible to understand that *What It Is* replicates a recognizable structure from classical antiquity. *Chorus* is a term applied to popular song because of the way that popular song reproduces the structure of ancient tragedy. The history of tragedy is in a sense the story of the emergence of a self from a collectivity: the central tragic actor is originally a differentiated member of the cho-

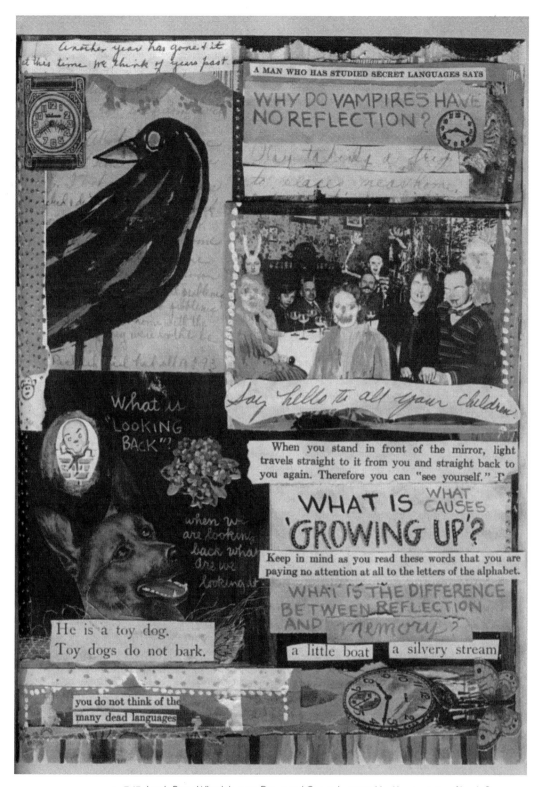

3.13 Lynda Barry, *What It Is*, p. 98. Drawn and Quarterly, 2008. *Used by permission of Lynda Barry.*

rus. The chorus—made up of many voices—performed a crucial, constitutive role, functioning as the interlocutor for this actor. Tragic performance represented a crucial moment in the emergence of the self as adult political subject, i.e., as citizen: the members of the chorus were preadult Athenians; performance in the chorus was considered to be a formative experience in their education as citizens to be. Barry's analogy implies a central premise of her work: it consistently demonstrates, to return to Benhabib—here using a phrase of Charles Taylor's—that "to be and become a self is to insert oneself into webs of interlocution" (344).

Barry does, on one level, re-present her own archive, as she does Mitchell's. In its narrative portions, *What It Is* offers a story parallel to *One Hundred Demons*'s "Lost and Found": it describes how a child from a neglectful-abusive family that did not value reading and drawing at some point realizes that art can transport her—"[a] pen is [a] kind of telephone," as one page suggests (108). The child Lynda, starting around age thirteen, begins a regimen of copying other people's art, particularly comics: *Peanuts, Nancy, Little Lulu, Boris and Natasha, Family Circus*; later on, in high school, she copies all of R. Crumb's underground comic book *Zap* no. 0. *What It Is* is thick with these images: the specific art that Lynda created at each phase in her life. However, Barry redrew these images— themselves copies of others' work—in the style of her young self for the book. She reinscribes her childhood visual preferences *and* her childhood hand into the book. As Barry explains, "I don't have anything from my childhood. I don't have a single scrap of paper, and my mom didn't save anything. There's nothing. There's nothing I could really call upon" (Interview). There is a similarity here with Alison Bechdel, who painstakingly redrew an extensive archive of materials belonging to herself and her family for *Fun Home*. The difference is that Bechdel has everything—diaries from her youth, comics magazines she drew when she was eight—in her possession. Reinhabiting them from an adult standpoint to re-create them for print is a way of reframing them, both identifying with an earlier version of self and taking control of it. In Barry, we see the same impulse, but coming from a different material circumstance: she re-creates a personal archive where none was valued enough to be allowed to remain—not because she wants to nostalgically resuscitate the past, but as a way of putting back into play discarded or ruined shards of memory. It is the same reason she uses the covers of Mitchell's mold-destroyed books in her collages. And it also lends pathos to the fact that she enters the many scraps of paper—the saved archives—of numerous children into her book. She redraws her own, but she gives others' originals their due, preserving them and activating them in a dialogue. Engaging her present-day drawings in conversation with diverse jottings, images, notes, and even school exercises from the past—the twenties, thirties, forties, fifties, sixties,

and seventies—in collage form also illustrates one of Barry's central points in *One Hundred Demons* and *What It Is*: that the way images move is contrary to linearity.

In *What It Is* we recognize many of Barry's materials from *One Hundred Demons*, such as stamps, the insides of envelopes, and painted-over clippings from magazines. Playing with surface and depth, flatness and texture, Barry again offers us both *pictures of things* and *actual things* themselves—say, a four-leaf clover belonging to Doris Mitchell.[51] There are additions, like embossed wallpaper, a proliferation of postmarks, old greeting cards, and photographs of families not Barry's own. (Unlike in *One Hundred Demons*, there are no photographs of Barry herself.) Mitchell's archive includes her letters and other documents; her class lists of students; endpapers and covers from her ruined books; bits from her students' own notebooks; and a vast array of student schoolwork including math problems, personal essays, and artwork. Barry conflates the public and private here—from school exercises to intimate correspondence, any mark is potentially part of her framework. The retransmission of this writing and drawing is joined by Barry's retransmission of parts of poems by Emily Dickinson and William Blake (credited), among others, as well as the incorporation of her own scribbled notes. As in *One Hundred Demons*, handwriting has at least two functions: it is denotative, communicating verbal information, and it fulfills an abstract visual function.[52]

Her strangest book object yet, adopting and refracting "high" and populist references and materials, *What It Is*—her first substantially non-narrative book—takes the themes and practices Barry establishes so strongly in *One Hundred Demons* and intensifies them. As the chorus of voices that emerge in drawing and writing demonstrate, this narrative of self establishes its self through visually staging a conversation among multiple selves, allowing others' marks and narrative fragments to assume a sort of center stage. Most pages have individualized borders, which Barry reveals are the first thing she creates on a page and seem to her "like awnings or like a stage curtain" (Interview). And *What It Is* appeals to the reader participation so crucially proposed by the form of comics: "Gaps are good / Leaving room for the reader."[53] While *One Hundred Demons* establishes a rhythm between accumulative presence (the colorful, layered collages) and gaps (stories that end in the space of the gutter, so to speak, forcing us to imagine causality), *What It Is* takes the theme of knowing/not-knowing that animates stories like "Resilience" and weaves it throughout into its entire structure. We are not sure what is "happening" on most of its pages, but our own associations and identifications are explicitly encouraged to generate the interpretation of

any given page. And, as its "activity book" portion suggests, *What It Is* is invested in provoking participation through its literal usability.

There is a peculiar connection between comics and memory, as the numerous accounts of lived childhoods, and, particularly, the number of traumatic accounts, would suggest. Placement within memory is also a placement within space. Barry's work reveals how a sense of space is crucial to experiencing and expressing memory. In comics people and events are positioned in space on the page. The most basic procedure of comics is that it expresses temporal development—or retracking—in spatial terms. Terr writes that "it may seem amazing that old traumatic memory should be so replete with postural and positional details"—both types of detail at which the form of comics excels—"but sense of position is one of the last things to leave in repressed traumatic memory and one of the first aspects of memory to return" (20). The sense of *position* that Terr describes in traumatic memory is related to the spatiality of comics and what it is able to evoke and capture. Certainly, positional and postural details can be expressed in comics, but, further, the location in space that Terr writes about suggests that the structure of traumatic memory is not unlike the spatial structure of comics. Barry theorizes that an image is a *location*. She enacts that in her book by offering her own experience—maps of images—and posing questions through arrangements of words and images and exercises designed to relocate us, should we wish, in the spatial dimensions of our own memory. *What It Is* alleges explicitly and implicitly throughout that "an image is a place. Not a picture of a place, but a place in and of itself" (88). Barry even proposes that an image is a *neighborhood*, and childhood—the subject of so much of her work—is a neighborhood of images. We may think of childhood, then, "as a place rather than a time" (159). And a memory is "a piece of a former neighborhood of yours" that may not be fully above the surface but can be expressed and provoked by images (160).

It is widely accepted that memory engages the senses. Michael Roddington and Anne Whitehead, for instance, open their recent volume *Theories of Memory* with that assertion. Immediately addressing the question of what memory is, they quote philosopher Mary Warnock, who claims that memory "inevitably brings in the physiological" and that the obstacle of dualism, the belief that mind and body are separate, needs to be removed: memory is "an aspect of the brain's behavior which necessarily is both mental and physical at the same time" (2). In his book *Momentous Events, Vivid Memories*, David Pillemer writes of two basic aspects of memory, to which comics is specially attuned as a mode of expression. First of all, while memory in general is sensory, personal event memories particularly have a core imagistic component; as Duke psychologist

D. C. Rubin asserts, "imagery is a central feature (as close to a defining feature as one can get) of what most people mean by the term autobiographical memory" (quoted in Pillemer 54). And for momentous, or traumatic events specifically, studies point to a pervasive underlying sensory component, above all one that is imagistic: "The memories are represented imagistically: 'intrusions in daily thoughts are typically visual memories and images of the traumatic event'" (53). In a very simple way, then, it becomes clear why comics, with its visual component, may lend itself to certain kinds of stories about events and about the memory of events. Second, Pillemer claims, "Just as autobiographical memory development cannot be adequately described as following a single, universal trajectory, so personal memories cannot be adequately described as occurring within a single level of mental representation or as involving a single mode of expression." He then describes the difficulty of a person who wishes to recount trauma and who then "must translate nonverbal, affect-laden, sensory images into an understandable . . . verbal narrative" (22). Lynda Barry does not need to "translate" the nonverbal, affect-laden, sensory images into verbal narrative to approach her past; rather, she *includes* them. She maintains the plural levels that Pillemer identifies in autobiographical memory; she engages multiple modes of expression and further demonstrates in her work, which plays with and off absence, the notion that "memories need not be expressed as explicit, conscious, fully-formed narratives in order to be influential" (23).

Images, as Gloeckner suggests, and Barry repeatedly theorizes, engage a physiological response—and comics, further, connects to the structures and shapes of memory with its rhythms of reading and looking. The spatial form of comics is adept at engaging the *subject* of memory and reproducing the *effects* of memory—gaps, fragments, positions, layers, circularities; it recognizes and plays on the notion of memory as located in mind and body and as, perhaps, shiftingly inaccessible and accessible. Barry's current biography, a sentence painted in red capital letters on the back cover of *What It Is*, reads: "Lynda Barry has worked as a painter, cartoonist, writer, illustrator, playwright, editor, commentator and teacher, and found they are very much alike." This biographical credo expresses that images generate structural energy motivating different forms both high and low—"they can raise the dead hours inside of us that nothing else can reach," Barry declares (*What It Is* 136). Yet Barry is largely a cartoonist, one who expands the boundaries of that category. What do comics offer? "I think comics have it all," Barry told an interviewer. "They're like music, where they have this same thing of having rhythm, and writing, and drawing. And I feel like that gets the whole part of your mind going. Not just one little part, but gets the whole part going" (Conan).

Graphic Narrative as Witness

MARJANE SATRAPI AND THE TEXTURE OF RETRACING

As with Lynda Barry's nonfiction, in Marjane Satrapi's *Persepolis: The Story of a Childhood*—an account of her childhood in Iran in which she endured the Islamic Revolution and the Iran-Iraq war—the author-subject makes political, collective claims by testifying to the very *ordinariness* of her trauma. In contemporary comics, there is a significant yet diverse body of nonfiction graphic work that engages with the subject either in extremis or facing brutal experience. As with Barry, Satrapi's autobiography in words and images swerves from the amusing to the appalling, insisting on both as the lived reality of girlhood. In much of the American women's work discussed so far, autobiographical investigations of childhood, the body, and (traumatic) sex—speciously understood as private, all-too-individual topoi—are a central focus. Yet, whether or not the exploration of extremity takes place on a world-historical stage (as in, say, the work of Joe Sacco and Art Spiegelman) or on a stage understood as the private sphere (as in the work of Phoebe Gloeckner and Lynda Barry) should not affect how we understand these graphic narratives as political: the representation of memory and testimony, for example, key issues here, function in similar ways across a range of nonfiction work through the expansivity of the graphic narrative form, which makes the snaking lines of history forcefully legible.

Persepolis is a book that bridges the wartime-focused testimonies of Sacco and Spiegelman and the child-oriented testimonies of many American women authors.[1] Barry's *One Hundred Demons*, composed on yellow legal paper and newspaper classified sections, but also referencing the high-art form of the artists' book, is a work of accretive collage. *Persepolis* is inspired by a different tradition of the avant-garde: it is expressionistic and minimalist. The stylization of *Persepolis* suggests that the historically traumatic does not have to be visually traumatic. And, while its content is keenly feminist, in *Persepolis*—as with all of

the works discussed in *Graphic Women*—we may understand the text as modeling a feminist methodology *in its form*, in the complex visual dimension of its author's narrating herself on the page as a multiple subject.[2]

Persepolis: The Story of a Childhood, which made its first appearance in the United States in an explicitly feminist, antiracist context in *Ms.* magazine in 2003, and was published as a book that same year, is a visual chronicle of childhood rooted in and articulated through momentous—and traumatic—historical events. *Ms.* excerpted *Persepolis* previous to the book's release in a section titled Writing of War and Its Consequences. In *Ms.*, the title of the work—*Persepolis: Tales from an Ordinary Iranian Girlhood*—differs from that of the final book version issued by Pantheon, which carries the subtitle *The Story of a Childhood*; the inclusion of *ordinary* in the original title underlines one of the central claims of this chapter. *Persepolis* is about the ethical visual and verbal practice of "not forgetting" and about the political confluence of the everyday and the historical: through its visual and verbal witnessing, it contests dominant images and narratives of history, debunking those that are incomplete and those that do the work of elision.

Born in 1969 in Rasht, Iran, to an engineer father and a dress designer mother, Satrapi is a trained artist with degrees from the School of Fine Arts in Tehran and the École Supiérieure des Arts Décoratifs in Strasbourg.[3] She joined the Parisian studio group Atelier des Vosges after leaving Strasbourg, and it was there that she started *Persepolis*, in 1999, after a friend had given her *Maus* as a birthday present and after numerous children's book projects she developed met with rejection. *Persepolis* was encouraged into existence, as she has explained, by French cartoonists in the L'Association comics publishing collective (particularly David B., of the autobiographical *Epileptic*), with whom she happened to share the Atelier des Vosges studio.[4] *Persepolis* originally came out in French in two separate volumes (*tomes*), in 2000 and 2001. The first seven pages of *Persepolis* had appeared in *Lapin*, a magazine published by L'Association; afterward Satrapi completed the first tome, which she then submitted to the same publisher—an outfit that does no PR, and no marketing, Satrapi explains (Hill 16–17). Interest in *Persepolis* grew through word of mouth; the first tome sold a record three hundred thousand copies in France. It is important to understand Satrapi in the context of Europe, where her book was not only a surprise bestseller but also what L'Association publisher Jean-Christophe Menu correctly terms a "phenomenon" (169).[5] Satrapi completed the third and fourth tomes of *Persepolis* in 2002 and 2003, respectively; these were published in the U.S. as *Persepolis 2: The Story of a Return* (2004).[6]

Its only apparent visual simplicity coupled with emotional and political complexity—and insisting on the connectivity of aesthetics and politics—*Persepolis* has earned the most international attention of any graphic narrative in the past ten years. Satrapi still lives in France, where she moved in 1994; she writes in French, her second language of six.[7] (While Satrapi's parents, who are featured heavily in the book, live in Tehran, she notes, "I no longer go to Iran, because the rule of law does not exist there" ["Persepolis"].) There are over a million copies of *Persepolis* in print. While *Persepolis* has already been translated into over 25 languages, because of the political situation in Iran it is unable to be officially translated into Farsi or published there—although Satrapi recently mentioned that there is a Persian version, which she has not seen or authorized, circulating on the black market. In the U.S. alone, *Persepolis* appears on about 250 university syllabi.[8] Further, after the book had already been an international bestseller, the awareness and reputation of *Persepolis* intensified when a black-and-white animated film version of the same name, cowritten and codirected by Satrapi herself, was released in 2007 to critical acclaim (it won the Jury Prize that year at the Cannes Film Festival and was France's official entry for Best Picture in the foreign film category of the Academy Awards).[9] But even before interest in the charismatic figure of Satrapi, and her story of growing up amidst intense political turbulence, developed through the visibility and popularity of the film, she had become a public intellectual of international proportions in a way very few cartoonists excepting Art Spiegelman ever have.[10] Recently, in June 2009, she and Iranian filmmaker Mohsen Makhmalbaf (*Kandahar*) spoke at the European Parliament in Brussels, where Satrapi, in English, and Makhmalbaf, in Farsi, declared that the June 12 Iranian presidential election is "not a fraud, it's a coup."[11]

Satrapi routinely contributes Op-Ed—or "Op-Art"—pieces in comics format for the *New York Times* and has weighed in on issues like the veil ban debate in France for venues such as the *Guardian*. While she expresses displeasure with the veil in *Persepolis*, she argued strongly against banning the veil in France, writing, in 2003, "I know what it felt like to be pushed into being religious, so I know what it must be like to be pushed into being secular. It is the same violence."[12] In the fall of 2005 Satrapi contributed a regular online feature for the Opinion section of the *New York Times* titled "An Iranian in Paris." In a combination of words and images, Satrapi expressed her views on topics like the 2005 Paris riots and President Ahmadinejad's statements about Israel.[13] All of her six entries subtly sound a similar theme: her experience as an Iranian exile now immersed in Western culture gives her a platform to identify and critique a Western tendency to overreaction and worry (she jokes of the Paris riots, disparaging the

sensationalism of the international press, "It seems that Paris is Beirut in 1982"). But, under a black and red portrait of herself with pointy teeth and horns, she writes that since President Bush had already identified Iran as a member of the "axis of evil," when she traveled to the U.S. for her first book tour in 2003, "I admit I was a little scared." The perspective broadly established in *Persepolis*—Satrapi as a translator of East to West—is evident across the different formats and venues in which she has become a sought-after voice.[14]

This perspective is indubitably part of the wide appeal and value of Satrapi's work, but has also been the basis for a broad strain of discourse around her work that champions it while yet glossing over its complexities and particularities. Reviews frequently applaud *Persepolis*, especially through the figure of the winsome child at its center, for being a universal story—an approach to the book that uncomfortably subsumes the exotic "other" into the "us," erasing the ethnic, cultural, and class specificity of the book's narrative.[15] This generalizing, didactic notion of *Persepolis*—that it presents a normalizing view of Iranians to the West through the necessarily nonthreatening figure of the charming female child— perhaps accounts for the inclusion of this very dark book on middle-school syllabi. Satrapi herself has stated her desire to demonstrate the diversity of the Iranian people to non-Iranians: we in the West may find the Satrapis and their experiences extraordinary, but her aim is in part to reveal that her family's experiences and their left-wing outlook are more common than the average Western reader would presume. "I wanted people in other countries to read *Persepolis*, to see that I grew up just as other children do," she says ("Why").[16] However, *Persepolis* is invested in elaborating what does and should count as ordinary—a theme we also see in much American women's graphic narrative—without negating Persian specificity, which the book foregrounds.[17] It is worth pointing out along these lines that among the commonplaces thus far established in academic criticism of Satrapi's series is its favorable comparison with Azar Nafisi's bestselling memoir *Reading Lolita in Tehran* (2003). As Gillian Whitlock writes, Nafisi's book "affirms the consensual community of Englishness that binds texts, traditions, and readers. Young Muslim women are trained to read for culture and morality in canonical texts the same way as their peers are trained to read English literature in London or Baltimore," whereas in *Persepolis* "a different mediation of cross-cultural relations occurs, drawing on the capacity of comics to free us to think and imagine differently" ("Autographics" 973).[18] *Persepolis* is a text that explores the boundaries of identity, destabilizing tropes of East and West—particularly as they bear on female experience—rather than reinforcing them.

If critics contrast *Persepolis* with *Reading Lolita in Tehran*, we should further understand its differences from the now abundant number of Iranian and

Iranian-American women's memoirs published since the 1979 revolution.[19] In a broadly conceived special issue of *MELUS* on Iranian American literature, Persis Karim accounts for the large body of such work by suggesting, "Memoir may have a particular resonance for Iranian and Iranian-American women writers because it confers a kind of self-authorization that women in Iran have typically been denied because of a male-dominated literary tradition that discouraged women's voices and self-revelation" (153). *Persepolis*, however, while part of this countertradition, stands apart from contemporary Iranian and Iranian disaporic life narrative because of its visual form. (Indeed, the 2006 collection *Let Me Tell You Where I've Been: New Writing by Women of the Iranian Diaspora*, edited by Karim, includes no visual-verbal work whatsoever.)[20] Although she had access to *Tintin* ("My cousins were reading *Tintin*, but in *Tintin* you don't have any female persons so I couldn't identify with any of it"), the only comics work Satrapi actively read as a child was a Russian-published comic book called *Dialectical Materialism*, pictured in the second chapter of *Persepolis* (Weich 4). While Shiva Balaghi points out that the relationship between word and image was a central concern to artists working in Iran the 1960s and 1970s, she argues the fruition of this interest was inventive political posters (31). Simply, there has not been a homegrown comics tradition in Iran. Hence Satrapi's autobiography in words and images is a major departure, not only because, as David B. suggests, she created what could be termed the first Iranian comics but also, more significantly, because of the expansive and yet inclusive form *Persepolis* takes in its visual-verbal narrativization of history.[21] The book, while shaped by Satrapi's voice, yet pushes outward to consistently visualize publics—collectivities of people—aside from herself and thus shifts the narrative attention to a broad public sphere.

Persepolis spans the years 1978–1984, a period in which Satrapi recounts protests against the Shah, the deposal of the Shah, the start of the Islamic revolution, and the beginning of the Iran-Iraq war—a war that is ongoing at that book's conclusion. *Persepolis 2* spans 1984–1994, during which time the protagonist, Marji, experiences her adolescence as an exile in Vienna and finally returns to Tehran in 1989, unsure of her direction; she attends school, marries, divorces, and leaves the country again in 1994. As Satrapi explains to an interviewer about the different emphases of the two volumes, in the first book "I lived the revolution and the war. My whole life and the life of a whole nation was upside down." On the political focus of the first volume, further, "When you are a child"—as she is throughout the first book—"you are very much concerned with the same things that your parents are" (Weich 1–2). *Persepolis 2*, in which the first half takes place in Vienna, and the second in Tehran, feels less anchored in the ex-

plicitly political because its focus is, on the surface, less collective. Satrapi notes, "[When] I came back . . . everything was settled down. The revolution was far behind, ten years before. The war was finished. So the second book is political, still—I talk a lot about the political prisoners—but Iran wasn't as political right after the war" (Weich 2).

In the extant body of *Persepolis* criticism, little work focuses specifically on how the two volumes, through their comics form, express traumatic histories.[22] While Satrapi implies that *Persepolis 2* is less political than the first volume because Iranians were less politically active in the early nineties than they had been in her youth, we may yet understand the political significance of the second volume in its move to make public—and visual—aspects of "private" experience, especially female experience.[23] In an essay on exilic cultural production in *Iranian Studies*, Amy Malek points out that Satrapi's presentation of homelessness, sex, depression, marital problems, and drug use—all events that are given shape in *Persepolis 2*—"is courageous and in the Iranian diaspora culture it is also somewhat unprecedented" (376). Nima Naghibi and Andrew O'Malley not only identify "the traditional Iranian bias against women's autobiographies" but also argue that *Persepolis 2* defies a cultural expectation for nondisclosure: "Marji discloses much of her private life, including her sexual experiences. This is particularly shocking in an Iranian cultural context; Satrapi ventures into territory that is still off limits to the growing field of diasporic Iranian women's autobiographies, texts which tend to skirt the issue of sexuality" (241). Therefore while we need not understand *Persepolis 2* as less political, we may understand that in also focusing on the intimate trials and tribulations of Marji's adolescence and young adulthood it integrates a deeply charged, additional mode of witnessing to the first book's witnessing on a world-historical stage. Since my focus is on how the *Persepolis* series envisions and expresses the traumatic, my discussion is weighted more toward the first book, which establishes the visual idiom of both. However, the attention to bodies we see in *Persepolis 2* is also an aspect of *Persepolis*, which is yet preoccupied with the representation of bodies (often corpses), and it also establishes a central focus of Satrapi's more recent works, a memoir-style story about sex and intergenerationality, *Embroideries* (2005), and a blow-by-blow account of the suicide of Satrapi's musician great-uncle, *Chicken with Plums* (2006).[24]

While Sacco and Spiegelman present themselves as visible narrators, embodied on the page, the testimonies that anchor their major works belong to others. Conversely, Satrapi's and Barry's work is driven by their own experiences—including their own traumas—and establishes a temporal structure in which multiple selves exist graphically: they visualize both their childhood

selves and their present-day narratorial selves on the page. This visualization of the ongoing procedure of self and subjectivity constructs "ordinary" experience as relevant and political, claiming a space in public discourse for resistance that is usually consigned to a privatized sphere. It also places the self in dialogue with a collectivity: Satrapi frames her text to address those, like herself, who are exiles from Iran, while Barry employs the intimate second person throughout, calling out to (female) readerships to "write" continuing versions of themselves.

PORTRAIT OF THE ARTIST AS A CHILD

Throughout Satrapi's narrative, the protagonist is a child (the young Marjane, called Marji). The issue of veiling opens the book (figure 4.1). Satrapi begins *Persepolis* with a row of only two frames. In the first panel, the narrator offers exposition. In a box above a drawing of an unsmiling, veiled girl, sitting with her arms crossed in the center of a frame, she situates the reader with the following information: "This is me when I was 10 years old. This was in 1980." The following panel depicts a line of four similarly composed girls, unsmiling and with crossed arms, and a *sliver* of a fifth on the reader's left: we are only able to infer a hand, a bent elbow, and a chest-length veil. The narrator writes, "And this is a class photo. I'm sitting on the far left so you don't see me. From left to right: Golnaz, Mahshid, Narine, Minna" (3).

Here Satrapi uses spacing within the pictorial frame as the disruption of her own characterological presence. We do in fact, clearly, "see" her—just not all of her—but her self-presentation as fragmented, cut, disembodied, and divided between frames indicates the psychological condition suggested by the chapter's title, "The Veil." An icon of a single eye, directly engaging the reader, dangles over the book's very first gutter, reminding readers at the outset that we are aligned with Satrapi's penetrating vision and enabling retracing of that vision: "I give myself this duty of witnessing," Satrapi explains about the book ("Address"). Satrapi defines *Persepolis* as a text of witness; the two-volume series concludes decisively in 1994 because that was when she left Iran for good. She will not write a third volume based on "second-hand information" (Leith 12). Here, her self-establishing ("this is me") and the immediate deestablishment of her person in the following frame ("you don't see me") not only creates disjuncture between narration and image (we do see her, even as she notes we do not; we know we are seeing a drawing, even as she announces the panel as a photograph) but also indicates how the visual form of the graphic narrative, in harnessing the possibilities of pictorial space, can create a complex autobiographical fabric. The comics form calls attention to what we as readers "see" and

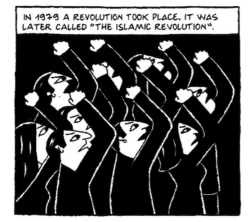

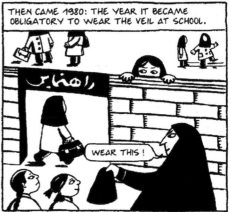

4.1 Panels from p. 3 (opening page), *Persepolis: The Story of a Childhood* by Marjane Satrapi, translated by Mattias Ripa and Blake Ferris, translation copyright © 2003 L'Association, Paris, France. *Used by permission of Pantheon Books, a division of Random House, Inc.*

do not see of the subject: the legibility of the subject as a literal—that is to say, readable—issue to encounter.

The first page also zooms from the ostensibly prosaic—a drawing of a class photo and list of the names of classmates pictured—to the explicitly political; the panel subsequent to the row of ten year olds throws us back a year: "In 1979 a revolution took place. It was later called the 'Islamic Revolution,'" reads text above the frame, which pictures an anonymous crowd of people throwing their fists into the air in front of a stark black background.[25] And then quickly enough,

we are back at school and 1980: "Then came 1980: the year it became obligatory to wear the veil at school." *Persepolis* literally moves back and forth across a momentous event. In the first four frames alone, we have crisscrossed from 1980 to 1979 and back to 1980; the chapter will then backtrack to 1975. Divided into nineteen chapters, *Persepolis* narrates the trials and tribulations of precocious Marji and her upper-class leftist parents: their protests against the Shah, and later against the Islamic regime; Marji's growing class consciousness; the torture and killing of family and friends; the havoc wreaked by the Iran-Iraq war; and Marji's fierce and dangerous outspokenness, which eventually leads her fearful parents to send her out of the country at age fourteen, after she hits one school principal and disputes politics with another.[26] The last page of the first volume shows her mother fainting at the airport as Marji leaves Iran.[27]

Satrapi's text is framed diegetically, and externally in her introduction, by injunctions to "never forget": it is the defining project of the text. Arguably the most moving narrative thread in the book is Marji's relationship with her charismatic uncle Anoosh, a Marxist who is ultimately executed for being a so-called Russian spy (70). He is allowed only one visitor in prison before his execution, and he requests Marji. Previous to this devastating political murder, which changes Marji's worldview decisively, Anoosh tells her: "Our family memory must not be lost. Even if it's not easy for you, even if you don't understand it all." Marji replies, "Don't worry, I'll never forget" (60). The phrases—"don't forget," "never forget"—recur again at significant moments in the text. In the brief introduction to *Persepolis*, Satrapi affirms that her book, visually and verbally, is indeed itself the product and act of "not forgetting" upon which Anoosh insisted. One hears an almost direct address to her uncle when Satrapi writes, "I . . . don't want those Iranians who lost their lives in prisons defending freedom, who died in the war against Iraq, who suffered under various repressive regimes, or who were forced to leave their families and flee their homeland to be forgotten." Standing alone, the last line of the introduction is "One can forgive but one should never forget." Satrapi echoes this language, in even more forceful terms, in an interview describing *Persepolis*: "I would have died of sadness if all these people had been forgotten" (Bahrampour). And one of those people who "were forced to leave their families and flee their homeland," of course, is Satrapi herself. In this way, Satrapi writes herself into the fabric of the wide net of persons to whom the book is addressed and whom it honors and commemorates.

Persepolis not only does not forget but also, more significant, shows us the process of "never forgetting" through its layers of verbal and visual narration: it presents the procedure, in addition to the object, of memory. *Persepolis* proliferates selves on the page. The graphic narrative form allows for a dialectical con-

versation of different voices to compose the position from which Satrapi writes, verbally and visually inscribing multiple autobiographical "I"s. Satrapi's older, recollective voice is most often registered in overarching narrative text, and her younger, directly experiencing voice is most often registered in dialogue, and in the discursive presentation of pictorial space—the "visual voice" of the book is one of its many narrative levels. (To allow these levels their distinct weight, I refer to *Persepolis*'s author as Satrapi, to the narrator in the text as Marjane, and to the child protagonist as Marji.) Satrapi's embrace of the perspective of youth for her narrative is a way for the author to return to and present the historical events of her childhood with a matter-of-factness that is neither "innocent" nor "cynical," but a constant negotiation of these as the character Marji's knowledge and experience increases and as the author, reaching back, engages the work of memory that requires a conversation between versions of self. Satrapi shows us the *state of being* of memory (as opposed to a singular act of recall) by triangulating between the different versions of herself represented on the page.[28] She shows us, then, the visual and discursive process of "never forgetting."

While one way that Satrapi unfolds the procedure of memory is through the spatializing form of comics, which visualizes and enmeshes an overlap of selves and their locations, the other crucial aspect is her style. As I have asserted, *Persepolis*'s presentation of pictorial space is discursive: Satrapi displays the political horror producing and marking her "ordinary" childhood by offering what seems to a reader to be a visual disjunction in her child's-eye rendition of trauma. This expressionism weaves the process of memory into the book's technique of visualization. Satrapi's stark style is monochromatic—there is no evident shading technique; she offers flat black and white. The condition of remembering, Kate Flint points out, "may be elicited by the depiction of deliberately empty spaces, inviting the projection of that which can only be seen in the mind's eye on to an inviting vacancy" (530). In *Persepolis*, while many of the backgrounds of panels are spare, a significant number of them are also entirely black. The visual emptiness of the simple, ungraded blackness in the frames shows not the scarcity of memory but rather its thickness, its depth; the "vacancy" represents the practice of memory for the author and possibly for the reader.

STYLE AND TRAUMA: THE CHILD (PART TWO)

Satrapi's technique also specifically references ancient Persian miniatures, murals, and friezes, especially in the frequent scenes in which public skirmishes appear as stylized and even symmetrical formations of bodies. Her style locates itself along a continuum of Persian art: Satrapi notes that in Persian miniatures, as

in her own text, "the drawing itself is very simple," eschewing perspective—and she describes this aspect of her style as "the Iranian side [that] will always be with me" ("Address").[29] Persian painting, historically, is widely understood to be characterized by its quality of being "shadowless and mostly flat" (Welch 13). Sheila Canby remarks that Persian painting "[favors] two-dimensionality and compositional harmony" and offers a "flat surface to form a rhythmic whole"—a quality we note throughout *Persepolis* that Canby asserts necessarily marks Persian paintings as exceeding mere mimetic representation (7). Additionally, while we may recognize this historically and culturally situated style of two-dimensional modeling in *Persepolis*—and see that both forms are physically "miniature"—it is also significant for understanding the work that *Persepolis* does to note that Persian miniature painting emerged as book illumination, in a cross-discursive context that we see continuing to be shaped and explored in contemporary graphic narrative.[30] Comparing its history against European book illumination, Basil Gray writes, "The Persian miniature"—as with images in graphic narrative—"does more than illustrate the text" (5).[31]

But while we may recognize traditions of Persian art in *Persepolis*, Satrapi's use of black and white specifically, as with the political underpinnings of her overall visual syntax, must also be understood as consonant with traditions of the historical avant-garde. Satrapi's insistence on black and white marks a difference from the color-rich classic tradition of Persian art.[32] The minimalist play of black and white is part of Satrapi's stated aim, as with avant-garde tradition, to present events with a pointed degree of abstraction in order to call attention to the horror of history, by re-representing endemic images, either imagined or reproduced, of violence. While Luc Sante suggests the expressionist Matisse as an inspiration, *Persepolis*'s sure, stronger stylistic inspiration is avant-garde, black-and-white cinema—especially expressionistic films such as Murnau's vampire fantasy *Nosferatu* (1922), whose "games" with black and white Satrapi has claimed as an influence ("Address"). Another inspiration for *Persepolis* is the black-and-white work of Swiss-born French artist Félix Vallotton (1865–1925), whose woodcut prints offer a high contrast style recognizable in Satrapi's work. Satrapi notes, "It was a revelation to me, his economy of line and decoration. It's the most simple and the most naïve at the same time. That took courage" (Gravett). Vallotton's images of war, especially from his 1916 woodcut album *C'est La Guerre!*, find a visual echo in *Persepolis*; the black-and-white abstraction of "The Trench," for example, has a visual analogue in the last page of *Persepolis*'s chapter "The Key," which depicts an exploding minefield (102).

On her particular use of black and white, Satrapi remarks, "I write a lot about the Middle East, so I write about violence. Violence today has become

something so normal, so banal—that is to say everybody thinks it's normal. But it's not normal. To draw it and put it in color—the color of flesh and the red of the blood, and so forth—reduces it by making it realistic" (Hajdu 35). Throughout, *Persepolis* is devastatingly truthful and yet stylized. The fact of style as a narrative choice—and not simply a default expression—is fundamental to understanding graphic narrative (as it is, of course, to understanding, say, prose, poetry, and painting).[33] Satrapi's choice of pared-down techniques of line and perspective—as with modernist painting such as Cézanne's, as with German Expressionism, and as with abstract expressionism, which justifies a flatness of composition to intensify affective content—is hardly a shortcoming of ability, as some critics have alleged.[34] It is rather a sophisticated, and historically cognizant, means of doing the work of seeing. In this it permits the "new seeing" of reality—instead of the mere "recognizing" or "acknowledging"—that Viktor Shklovsky defined as the fundamental device of art.[35]

Thus I would suggest that Tim O'Neil's declaration in the first sentence of his review of *Persepolis* in the *Comics Journal*—"Marjane Satrapi is not a very good cartoonist—I think I should say that up front so there's no confusion on the matter"—is a misreading of this conspicuously stylized work (37).[36] Just as Spiegelman, as I note in the introduction, explained to curators at the MoMA that it is only accidental if a comics work "makes a nice drawing," Satrapi rejects the idea of "masterpieces," telling interviewer David Hajdu, "Cartoonists shouldn't have to be too good. . . . The technical quality is not what matters" ("Art Spiegelman" 27; Hajdu 34–35). Proficiency in realistic drawing is not necessarily the goal of any given graphic narrative. Rather, graphic narrative is about the discursive presentation of time as space on the page.

Satrapi's autobiography is a "story of a childhood," and *Persepolis*'s style reflects this perspective: the narrative's force and bite come from the radical disjuncture between the often-gorgeous minimalism of Satrapi's drawings and the infinitely complicated traumatic events they depict: harassment, torture, execution, bombings, mass murder. *Persepolis* is about imagining and witnessing violence; more than half its chapters—which each commence with a black bar framing a white title drawn in block letters and preceded by a single, shifting icon—contain images of dead bodies and serious, mostly fatal, violence. Throughout, *Persepolis* is deeply invested in its own veracity, and yet it is also deeply stylized. It is formally beautiful, eschewing the *visually* traumatic even as it vigorously and painfully engages historical trauma.

A prominent example of what I have named its child's-eye rendition of trauma occurs early, in the book's second chapter, "The Bicycle." Here, in the text's first startling image of violence, Satrapi depicts a massacre that Marji first

hears about by eavesdropping on a discussion between her parents. The corresponding image we see represents the death of four hundred moviegoers deliberately trapped inside the burning Rex Cinema (whom the police willfully declined to rescue) (figure 4.2). In an almost full-page-sized panel, which is larger than any that precede it and seems to swallow up the page, the anonymous, stylized dead, their faces shown as hollow skulls, fly burning up from their seats as sizzling, screaming ghosts (15). This is clearly a child's image of fiery death, but it is also one that haunts the text because of its incommensurability—and yet its expressionistic consonance—with what we are provoked to imagine is the visual reality of this brutal murder. In size, syntax, and movement, which is to say, dead bodies flying upward, this panel has echoes in the last page of the later chapter "The Key," which offers one of *Persepolis*'s most abstract images, of young soldiers as black silhouettes soaring through the air in exploding minefields against bursting shards of light (102).[37] While Satrapi defines her text as one of witness—"I was born in a country in a certain time, and I was witness to many things. I was a witness to a revolution. I was a witness to war. I was witness to a huge emigration"—we see in *Persepolis* that witnessing is, in part, an inclusive, collective ethos. The author draws a scene of death not as a child perceives it empirically, but as she *imagines* it in a culture pervaded by fear of violence and retribution (Leith 12). In this sense *Persepolis*—ostensibly a text about growing up and the private sphere—blurs the line between private and public speech.[38] In a form keyed to structural gaps through the frame-gutter sequence, Satrapi further stresses the gap between our knowledge (or our own imagination) of what brute suffering looks like and that possessed by a child. The tension that is structural to pictorially depicting trauma in a visual idiom shaped by the discursive scaffolding of a child is one of *Persepolis*'s most moving and effective tactics supplied by the graphic narrative form.

In the two chapters following "The Bicycle," we see Marji's worldview growing to include torture and the politics of martyrdom in Iran: both show a puzzled child working slowly to understand the landscape that is commonplace to her parents. While "The Water Cell" commences as a happy detailing of family history, it ends, as its title would suggest, with Marji trying to come to terms with something she does not quite yet grasp. Describing the life of her communist grandfather one evening, her father tells her, "He was often sent to prison," while her mother chimes in, "Often they would put him in a cell filled with water for hours" (24). Satrapi here draws Marji, as at other points in the narrative, with a downturned, jagged squiggle for a mouth, indicating a certain kind of roiling shock: one mixed with fear and confusion. Revising her plan to play a board game, Marji decides instead to take "a really long bath": "that night I stayed a

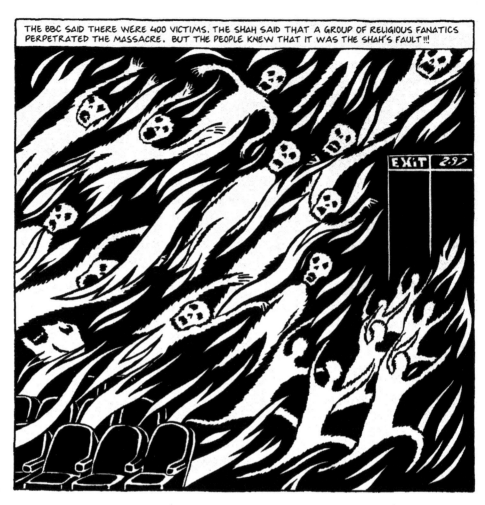

4.2 Panel from p. 15, *Persepolis: The Story of a Childhood* by Marjane Satrapi, translated by Mattias Ripa and Blake Ferris, translation copyright © 2003 by L'Association, Paris, France. *Used by permission of Pantheon Books, a division of Random House, Inc.*

very long time in the bath. I wanted to know what it felt like to be in a cell filled with water" (25). The accompanying image, dilated across the page, shows her up to her neck in water, still, eyes glazed. In the title chapter "Persepolis," her parents and grandmother, in momentary high spirits, amuse themselves over an anecdote of Marji's father: earlier in the day, he had witnessed the dead body of an elderly, cancer-stricken man snatched from a hospital stretcher as a martyr; the man's widow, despite her protestations, eventually joined the crowd carrying the body aloft to chant "The King is a Killer!" Marji then faces the reader head-on in a panel whose background is entirely black. "Something escaped me," the text box above the image reads. "Cadaver, cancer, death, murderer. . . . Laughter?"

Marji muses in a thought balloon, crossing her arms. The chapter ends with Marjane's explanation: "I realized then that I didn't understand anything" (32).

Persepolis continues to reflect Marji's growing awareness of turmoil, in that it offers further images of massacre. The ensuing chapters present mass death in a highly stylized fashion: indeed, they show her attempts to understand violence and death through attempts to visualize these occurrences and circumstances. As befits a child's understanding, the style is simple, expressionistic, even lovely in its visual symmetry: in the penultimate panel of "The Letter," Satrapi draws ten bodies—five on each side of the panel (39, figure 4.3). They are horizontally stretched out, abstractly stacked, configured to meet one another, as if linked in dying (the man in the foreground of the frame reaches his arm across its length, almost as if embracing the man who faces him). The bodies are stylized against a black background, filling up the frame, some open mouthed in horror, some appearing grimly asleep. In that mass death in Satrapi's work looks architectural, her representations both suggest a child's too-tidy conceptualization of "mass" death and tacitly suggest the disturbing, anonymous profusion of bodies in the Iranian landscape. In the opening panel of "The Party"—a celebratory title that is incongruous with the chapter's inaugural image—Satrapi draws rows of dead bodies; each face, while individually drawn, bears the same open-mouthed, wide-eyed expression (40; figure 4.4). There are eleven vertical rows, each four cadavers deep; the last of these, on the far right of the page, shows four faces cut off by the panel border just above the eyes, suggesting that the border drops arbitrarily and that the rows go on and on (the caption underscores this idea: "After Black Friday, there was one massacre after another. Many people were killed.") Satrapi draws stylized formations—lines, pyramids, symmetrical groups—to represent crowds; effective iconography often stands in for realism.

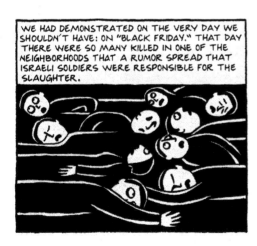

4.3 Panel from p. 39, *Persepolis: The Story of a Childhood* by Marjane Satrapi, translated by Mattias Ripa and Blake Ferris, translation copyright © 2003 by L'Association, Paris, France. *Used by permission of Pantheon Books, a division of Random House, Inc.*

4.4 Opening panel, p. 40, *Persepolis: The Story of a Childhood* by Marjane Satrapi, translated by Mattias Ripa and Blake Ferris, translation copyright © 2003 by L'Association, Paris, France. *Used by permission of Pantheon Books, a division of Random House, Inc.*

One of the most pivotal chapters in the book, "The Heroes," forcefully underlines the work that style performs in *Persepolis*. Here, Siamak Jari and Mohsen Shakiba, two political prisoners recently released from prison after the Shah's upending who are friends of the Satrapi family, visit their home and describe their experiences of torture to the Satrapis. (In the next chapter Satrapi draws Mohsen's eventual murder by drowning and Siamak's escape from the country after his sister is strangled when she answers the doorbell to face his persecutors.)

Satrapi draws Mohsen recalling, smiling, to Siamak, "You remember the day they pulled out my nails?" as Marji stands in between them, looking perplexed—emanata form a crown of surprise around her head—and small. "My parents were so shocked," Marjane reports—and here Marji wears her jagged mouth—"That they forgot to spare me this experience . . . " (51). Significantly, Siamak also describes how a guerrilla friend *did not* survive his time in prison. A panel, large and unbordered—its unboundedness evoking both the uncontainability of trauma and also the fleeting, uncategorizable images running through Marji's imagination as she listens to Siamak recount the fate of the guerrilla friend who "suffered the worst torture"—accompanies the narration (51).

A torturer urinates into open wounds on the man's back; brutally whips the man bound face down to a table; thrusts an iron into the center of the man's back, searing his flesh. Punctuating the last of these images, a slender box of text

reads—redundantly, since the image is clear—"They burned him with an iron" (51). While we are supposed to understand these depictions as the child Marji's envisionings, as narrated to her by the witness, they are plausible visualizations, consonant with the "real world" depicted in the text. The page's last tier is one single panel—connoting stillness in eliminating the passage of time between frames—in which Marji contemplates the household iron: "I never imagined that you could use that appliance for torture" (51). The open door in the exact center of this panel that graphically divides Marji from the iron at which she stares will never, it is suggested, be closed. For Marji, this is a distortion of the familiar: the location of horror is in the everyday.[39] While these images unsettle the reader, on the following page, Marji's imagining of Ahmadi's final, fatal torture is one of the text's most potent moments, suggesting the political point of Satrapi's expressionism.[40]

We learn from Siamak of Ahmadi that "in the end he was cut to pieces" (52). The accompanying, page-wide panel shows the limit—what Marji *cannot* yet realistically imagine (figure 4.5). The frame depicts a man in seven neat pieces, laid out horizontally as a dismembered doll on an operating table would appear (indeed, he appears hollow). His head is separated cleanly from the torso, precisely severed at the waist, shoulders, and above the knees. Referring to this panel in an interview, Satrapi theorizes her visual-verbal methodology in *Persepolis*, calling attention to the pitfalls of other, ostensibly transparent representational modes: "I cannot take the idea of a man cut into pieces and just write it. It would not be anything but cynical. That's why I drew it" (Bahrampour). By drawing this image from a child's (realistically erroneous but emotionally, expressionisti-

4.5 Panel from p. 52, *Persepolis: The Story of a Childhood* by Marjane Satrapi, translated by Mattias Ripa and Blake Ferris, translation copyright © 2003 by L'Association, Paris, France. *Used by permission of Pantheon Books, a division of Random House, Inc.*

cally informed) perspective, Satrapi shows us that certain modes of representation depict historical trauma more effectively, and more horrifically, than does realism (in part because they are able to do justice to the self-consciousness that traumatic representation demands).

The visual, *Persepolis* shows, can represent crucially important stories from a child's putatively "simple" perspective, because no perspective, however informed, can fully represent trauma.[41] The horror of "the idea of a man cut into pieces" cannot be adequately illustrated by words—or by pictures—from the perspective of either children or adults: it is in "excess of our frames of reference," as is testimony itself (Felman 5). Here the patently artificial containment of testimony, the act of bearing witness in comics frames, signals, but not despairingly, the text's awareness of this condition of representation. In *Persepolis* Marji's visualizing of a man cut into neat, hollow pieces provides what I have been calling a productive disjuncture: a way of seeing and showing that is deliberately estranging. It is a moment of defamiliarization (a child's imaging of torture) in which one recognizes not only the inadequacy of any representation to such traumatic history but also, more significant, the simultaneous power of the radically inadequate (the child's naive confusion).[42] The neat pieces of the cut body present an artificiality that is distinct from the terrifyingly organic actuality of the situation. The result is that while *Persepolis* at once comments on the insufficiency of any representation to "fully" represent trauma, an idea that has become commonplace, it also harnesses the power of the visual to represent an important emotional landscape (the child's), which is paradoxically moving because of its distance from and proximity to the realities it references. In the panel's emotional impact and its spareness, offering a disarticulated, white body floating on an all-black background, *Persepolis*'s style shows that the retracing work of historical graphic narrative—even when retracing trauma—does not have to be visually traumatic. The minimalist, two-tone, simplified schema of *Persepolis* at once speaks to the question of representation and also, in its accessible syntax, its visual ease, suggests the horrifying normalcy of violence in Iran.

VIOLENCE AND THE ORDINARY

Persepolis does not shy away from representing trauma, even as it stylizes it. Dead bodies litter the text, appearing consistently—and significantly—in pages that also casually situate readers in the everyday details of Marji's life. Throughout, *Persepolis* demonstrates the imbrication of the personal and the historical. We see this clearly in the chapter "The Cigarette." On its penultimate page—one of only five full-page panels in the book—Satrapi draws Marji walking down the

stairs of her family's home to the basement, and, as she hovers on a step in the top, left-hand corner, her staircase dissolves into the smoke of a battlefield strewn with the war dead, fighting soldiers, and dismembered, floating body parts. In the lower right-hand corner, Marji opens a door and exits the scene. The next page, the chapter's last, is composed in three tiers: the top tier is located in the family basement, the middle tier at an execution site, and the bottom tier back in the basement. Satrapi shows us—as if it is par for the course—a panel depicting five blindfolded prisoners about to be executed against a wall, directly above and below frames in which we view Marji in that prosaic, timeless rite of initiation: smoking her first cigarette (117; figure 4.6). Here Satrapi presents her experience as literally, graphically divided by historical trauma. This episode acquires further significance by breaking out of the book's established schema of narrative levels. Marji faces readers head-on, as if directly addressing us, and delivers frank summaries of historical and personal events. This retrospective mode of narratorial address to the audience from *within* the pictorial space of the frame and the child body of Marji is unusual in the text; the blurring of voices and registers here works with the blurring of the historical and "everyday" registers that is also part of the narrative suggestion of the page.

Satrapi shows us the execution of an eighteen-year-old known personally to Marji in the next chapter, "The Passport." Marji meets this woman, who has gone underground, when her family arranges a fake passport for a sick uncle. In text that unfurls over three frames, and becomes staccato, Satrapi writes: "Two days later, Niloufar, the eighteen-year-old communist, was spotted. Arrested . . . and executed" (125; ellipses in original). In the tier's last panel, execution wall behind her, Niloufar kneels, her hands tied behind her back, wearing a veil, spotted dress, and blindfold. Shadowing this narrative is a sequence of three panels directly below those summarizing Niloufar's fate: Khosro, the passport maker who had been hiding her, "found his house ransacked . . . fled across the mountains to Turkey . . . and sought asylum with his brother in Sweden" (125; ellipses in original). The last frame in this echoing sequence subtly resembles the one above it: while Niloufar, whose eyes we cannot see, is blindfolded, Khosro—for a moment—appears blindfolded also (figure 4.7). Yet his eyes are only covered by his jaunty, slouching winter hat. His arms, too, are behind his back: but he stands next to a snowman, not in front of an executioner.

Niloufar's execution is one of the reasons that the Satrapis decide to send Marji out of the country; the last chapter of the book, in which she leaves for Vienna, is titled "The Dowry"—a reference to Niloufar's death. After Marji publicly battles her religion teacher, a feat that both impresses and terrifies her parents, her mother explains in an emotional sequence that virgins are raped before

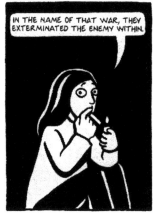
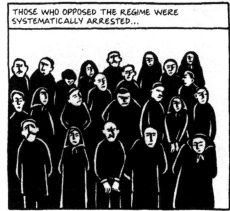
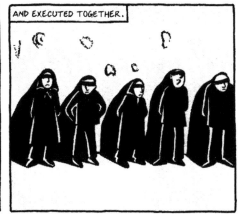
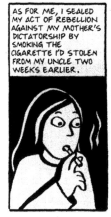
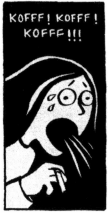
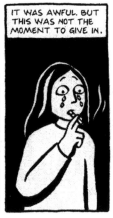
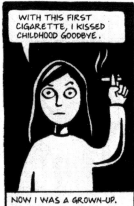

4.6 P. 117, *Persepolis: The Story of a Childhood* by Marjane Satrapi, translated by Mattias Ripa and Blake Ferris, translation copyright © 2003 by L'Association, Paris, France. *Used by permission of Pantheon Books, a division of Random House, Inc.*

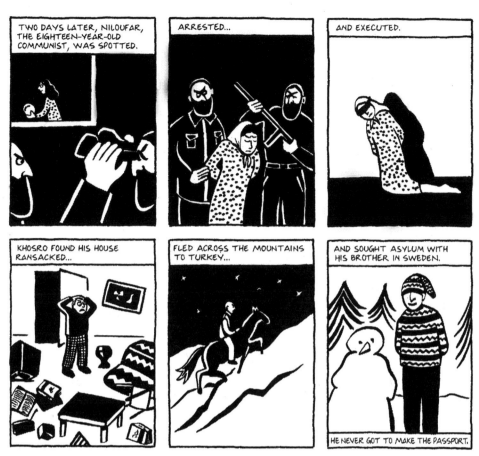

4.7 Panels from p. 125, *Persepolis: The Story of a Childhood* by Marjane Satrapi, translated by Mattias Ripa and Blake Ferris, translation copyright © 2003 by L'Association, Paris, France. *Used by permission of Pantheon Books, a division of Random House, Inc.*

execution: "You know what happened to Niloufar? . . . You know that it's against the law to kill a virgin. . . . So a guardian of the revolution marries her . . . and takes her virginity before executing her. Do you understand what that means??? If someone so much as touches a hair on your head, I'll kill him!" (145; first ellipses mine). Satrapi pictures Niloufar as a future projected double of Marji; Niloufar appears at the end of Marji's bed, smiling and wearing her spotted dress, after her death.

Through techniques such as combining on a page—with only apparent casualness—what constitutes the historical "routine" (execution) and the personal "routine" (sneaking cigarettes), and through subtle panel resemblances, Satrapi uses her understated graphic idiom to convey the horror of her "story of a childhood." *Persepolis* shows trauma as ordinary, both in the text's *form*, the understated, spatial correspondences *Persepolis* employs to narrative effect through

comics panelization, and in *style*, the understated quality of Satrapi's line that rejects the visually laborious in order to departicularize the singular witnessing of the author as well as open out the text to readers. In its simple style, *Persepolis* powerfully alludes to the ordinariness of trauma: one does not need, and in fact should reject, the virtuosic to tell this tale, it suggests.[43] The book's division into chapters with plain titles—all of which commence with the definite article, and are followed by a commonplace noun—denotes the ordinariness Satrapi is intent on underlining, even when the events depicted appear extraordinary.[44] And while *Persepolis* may show trauma as (unfortunately) ordinary, it rejects the idea that it is (or should ever be) normal, suggesting everywhere that the ethical visual and verbal practice of "not forgetting" is not merely about exposing and challenging the virulent machinations of "official histories" but is more specifically about examining and bearing witness to the intertwining of the everyday and the historical. Its polemical resonance lies in its rejection of the very idea that the visually virtuosic is required to represent the political trauma that plagues Marji's childhood.

PERSEPOLIS 2 AND THE IDIOM OF WITNESS

In *Persepolis 2*, as an exile in Vienna, a large part of what Marji struggles with is her indignant feeling that the people around her have trivial concerns (2). The book's first panel, in a chapter titled "The Soup," formally echoes that of the first book by situating us with a specific date: November 1984. Marji is sprawled across a bed, hands tucked under her head. Whereas in *Persepolis* she sat upright in the first panel, looking directly at us, and under an icon of an eye, here her gaze does not meet readers'; she is wide-eyed but despondent, staring off to the right. But while she is disgusted with Shirin, an Iranian girl her age who talks about lipstick "while people were dying in our country" (2), she is also, unexpectedly, romanticized by European friends at her Lycée Français high school for having "known war." *Knowing war*—in other words, Marji's status as a witness—becomes a major theme of *Persepolis 2*'s first half in Vienna. The book specifically emphasizes the visual aspect of this knowledge, as Marji, for the first time, experiences others' prurient fascination with death. When she is introduced by one acquaintance to another as, "This is Marjane. She's Iranian. She's known war," the enthusiastic response is "You've already seen lots of dead people?" to which Marji answers, honestly, eyes enlarged with bewilderment, "um . . . a few" (12).[45] This exchange, calling the reader's attention to the range of Marji's experiences and to the range of the *Persepolis* series's acts of seeing, points up Satrapi's strategy of visual witness.

Notably, in the first book, Satrapi makes central but does not visually elaborate a death that affects her and her family deeply. In *Persepolis*'s penultimate chapter, an Iraqi missile hits the Tavanir neighborhood—Marji's own. Rushing home from the market, Marji discovers it exploded on her street. As she struggles through the crowd, and through a police cordon, into a bombed-out area of broken glass near her home, her mother rushes toward her. While their building was not hit, the home of their neighbors, the Baba-Levys, was struck by the missile. The two pages in which Marji and her mother discuss the event and its damage, is, significantly, emptied out of almost any background whatsoever: there is simply space behind them in eleven panels across two pages as they talk (140–141). Atypically, this emptied-out background is largely white—clear of any mark, even the basic hand-drawn blacking-in so common to the series's frames. And when Marji and Taji Satrapi walk past the Baba-Levys's house, which was "completely destroyed," only the rubble of the house is depicted, to the right of the mother and daughter in an otherwise completely bare frame (142). (As is also the case with the last page of *Persepolis*'s chapter "The Key," the style in which Satrapi draws the rubble, which employs textured shading, is distinct from the rest of the book, marking the event's frame-breaking significance.) Any other details of the scene, it is implied, are irrelevant. This is an episode, formally and thematically distinct from the rest of the book, about Marji "knowing war" and, further, "seeing dead people"—and yet Satrapi does not show us the corpse she sees. Walking away from the wreckage, Marji spots a bracelet in the debris that she knows belongs to Neda Baba-Levy, her fourteen-year old friend. Turning back toward the rubble, her hand still firmly attached to her mother's, she looks with horror at a bracelet sticking out of the ruins. The next panel depicts only Marji's face, staring straight ahead, with her hand over her mouth and her eyes bubbling with tears; the text box above her reads, in its entirety, "The bracelet was still attached to . . . I don't know what . . . " (142). In the subsequent panel, from the same angle, we see Marji's face again, this time with both hands covering her eyes. There is no text. And the final panel of the page, and of the chapter, shows simply an entirely black frame. The small text box below this dark space declares, "No scream in the world could have relieved my suffering and my anger" (142).

This blacked-out frame, the only such frame in *Persepolis*, represents a moment of first-hand witnessing to the effects of the war—the death of a friend from an Iraqi bombing—and *Persepolis* chooses to not visually elaborate what Marji sees. The black-frame technique would seem an obvious choice for cartoonists: comics's fundamental pattern, of frames that *show*, can be disruptively broken to dramatic effect by displaying a frame that refuses to show.[46] This formal disruption is an example of comics' purchase on pointing up the common-

place of trauma's unrepresentability. However, I am less interested in how Satrapi inserts the blankness of unrepresentability into her text than in how the *Persepolis* volumes strive to express and represent: the visual witnessing they do enact. The *Persepolis* series is not invested in indiscriminate visual description of all the "dead people," to invoke Marji's Viennese friend Momo's phrase, that Marji witnessed in her life. Rather, it is invested in what I earlier called the collective ethos of witnessing. One of the most powerful scenes in *Persepolis 2*, then, occurs when Marji returns to Iran from Austria in 1989 and takes a walk through Tehran: as she strolls through the streets in the chapter "The Return," she notices that in her absence many streets had been renamed for martyrs (figure 4.8).[47] Taking in this new information over two small, standardized panels, the third in the tier then offers a one-sentence narration, "It was very unsettling," over an image of Marji, her emotional and physical disorientation represented by a breakdown of self in the form of confused self-proliferation. Five Marjis are actually shown, each looking at a different angle at a gaggle of (untranslated) Persian street signs that float up and down in the otherwise all-black frame (97).

The next panel is large, twice as tall and wide as the frames that precede it combined: "I felt," the narration reads, "as though I were walking through a cemetery" (97). Below, Satrapi draws Marji at the top of the frame as a tiny black silhouette figure, standing in the middle of the street, between clusters of buildings lining either side. But what is aboveground is dwarfed by what is below: underneath the street, Satrapi draws piles and piles of skulls, each one bigger than Marji's body, facing all different directions, massed on top of each other, drifting about with bits of scaffolding. Some are detached, floating; others appear atop lumpen bodies in various postures; some stick out of ruined window frames, as if trapped and trying to escape. The rudimentary features of the skulls—dark shaggy lines jotted in for the spaces of eyes, nose, and mouth—recall the Rex Cinema massacre victims from *Persepolis*, who bear the same vacant and yet jagged look. Coming just pages after Marji returns to Tehran at the book's midpoint, this horrifying scene of the martyred dead lurking uncomfortably under the cityscape is the first truly startling image in *Persepolis 2*. On a graphic level, it is also the most aesthetically interesting, and even lovely, image yet to appear in the book, turning on the dramatic force of the stark black and white contrasts—white skulls in the black earth—and the disproportions of expressionism.[48] Comics, in its power at once to stylize and to literalize, expresses the idea vividly: the skulls, Satrapi suggests, are supporting the city.

The subsequent frame—at the same small, standard size as in the first tier—appears to the right of the subterranean skulls. The narrator writes that she felt "surrounded by the victims of a war I had fled," as we see a dismayed Marji,

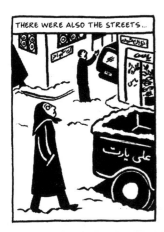

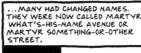

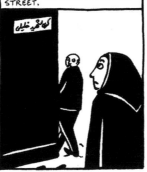

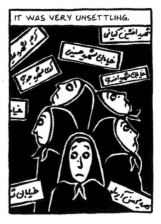

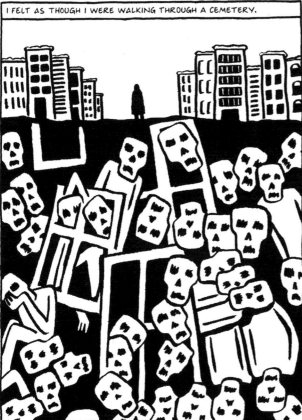

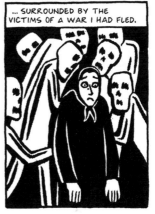

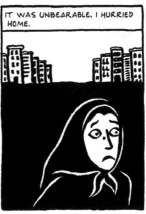

4.8 P. 97, *Persepolis 2: The Story of a Return* by Marjane Satrapi, translated by Anjali Singh, translation copyright © 2004 by Anjali Singh. *Used by permission of Pantheon Books, a division of Random House, Inc.*

159

clad in black, encircled by white skull-faced ghosts who lean in aggressively toward her from the edges of the frame, arms extended toward her body, almost as if pushing her down (97). Directly below, in the page's final panel, we see Marji trying to escape. "It was unbearable," reads the narration. "I hurried home" (97). However, while the words imply Marji's movement away from the scene, the perspective of the final frame visually proposes that Marji, too, is buried beneath the city. Compositionally, the page's concluding image is a visual echo, a small replica of its large and central frame. And here it is Marji who appears trapped in the deep black below the city street. The ghosts—the war victims—above her, it is suggested, have successfully pushed her down into their haunted space.

Across the *Persepolis* volumes, Satrapi's witnessing blends the collective and the personal: public and private speech, and spaces, are interwoven. In episodes like the one I have just discussed, the emotional investment of the image is in picturing death—even deaths that Satrapi can only pay belated witness to through the evidence of commemorative street signs. Other scenes in *Persepolis 2* also powerfully amplify the visual idiom of the first book's anonymous profusion of bodies, as when Satrapi draws a full-page image of political prisoners executed after the end of the Iran-Iraq war (figure 4.9, 102). This frame is evocative of the scenes from "The Letter" and "The Party" mentioned earlier, but significantly is extended to occupy one of only six full-page images in the 187-page *Persepolis 2*.

Unlike the panels from "The Letter" (39) and "The Party" (40), this rendition of mass death, while yet picturing anonymous revolutionaries being shot, shows us forty-nine figures, who, despite their blindfolds, have distinctive features; this image turns, more than its earlier analogues, on the tension between the anonymous and the particular. While this large, imposing image uses techniques we see in *Persepolis*—such as the cutting-off of dead bodies by the right-hand vertical border, a graphic suggestion of their profusion, since the frame is shown to be unable to contain their numbers—its figures also have more detailed features. While the first panel of "The Party" shows mass death as a stack of figures in rows, each with a similar abstracted face in which it is hard to read any markers of sex, here one may count, for instance, twelve women in the pile of bodies. Some men are clean-shaven, some have beards, some have heavy moustaches, some have skimpy ones, some are bald. Some of the figures cry out with open mouths; others have closed lips. While the images of the anonymous dead in *Persepolis*, which picture rows of corpses striking for their architectural neatness, are defamiliarizing, the execution of political prisoners in *Persepolis 2* is also displayed as an architectural configuration, producing a similarly odd graphic effect. Further, here, the temporality of the single-panel image produces a graphic strangeness that expresses the disorienting horror of the systematic executions

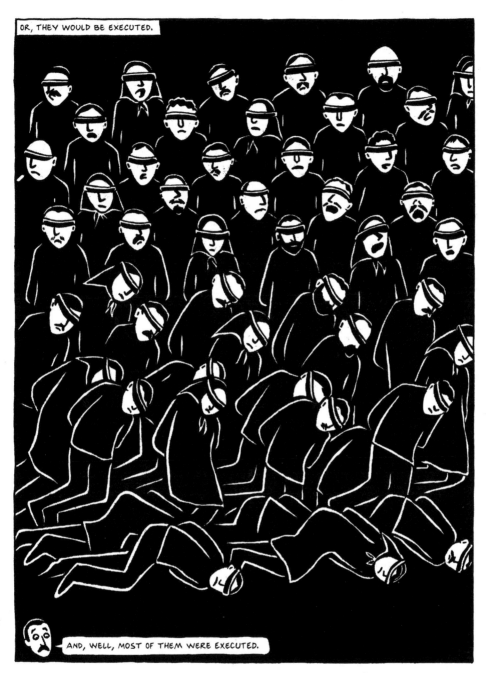

4.9 P. 102, *Persepolis 2: The Story of a Return* by Marjane Satrapi, translated by Anjali Singh, translation copyright © 2004 Anjali Singh. *Used by permission of Pantheon Books, a division of Random House, Inc.*

of "tens of thousands of people," as Marji's father reports (103). While they are heaped together in rows eight-people deep, making it logically impossible, the graphic suggestion, judging from the open, crying-out mouths of those in the back rows, is that the prisoners die all at once, their bodies falling on top of each other. Here, as elsewhere, the artificiality we recognize in the image's deliberately awkward spatiotemporal configuration does not tamp the power of the book's act of witness; rather, in Satrapi's construction of the *Persepolis* series around an ethic of collective witnessing, these aspects call attention to the very real physical suffering Satrapi aims to communicate.

Persepolis 2 deepens the range of the visual-verbal acts of witness established in the first book, imagining both anonymous collective death—trauma generated for Marji, one might say, from the public sphere—and also presenting episodes of crisis that Marji and those close to her experience directly: trauma that comes from the only ostensibly separate space of the private. If we see an expanded idiom of estrangement in *Persepolis 2*'s envisaging of groups of anonymous dead, we also see further experiments with the ability of the comics form to articulate traumatic personal events. Satrapi narrates the death of a friend, Farzad, who is killed at a party attended by Marji and others in "The Socks," a chapter that arrives close to the conclusion of the book. The three pages that detail the event itself are, except for the four words that open the episode, "And then one night," completely silent, unfolding in a series of panels without any verbal narration (153). On the first page, a patrol of Guardians of the Revolution stops in a car outside an apartment building, spies the party through binoculars, and rings the doorbell. From inside, the host of the party, a young woman, answers the phone; we are not presented with the conversation. Here, as throughout the episode, the background space of her home is white. In the page's last panel her body—as in Marji's out walking among the street signs in Tehran—is proliferated: like a mirror image of herself, she runs in two directions, arms akimbo. On the subsequent page she directs the male partygoers to run up the stairs of her building; as they flee, she pours liquor into the toilet in a frenzy (154). The Guardians enter her apartment to find six sheepish looking women. In the penultimate panel of the page, Satrapi depicts only the host and a Guardian of the Revolution, who points a gun directly at her face. Her hands are out in front of her, palms raised, a posture that here could either indicate protest—feigned ignorance—or acquiescence. It is never clear which, but in the next panel a guard motions others upward to the stairs.

The next page is one of the most graphically distinct in the book (155; figure 4.10). Playing heavily on the contrast between black and white, every body on the page (excepting three partygoers, including Marji, who press their faces

up worriedly to a window to watch the ensuing chase) is a silhouette, entirely black or entirely white. The first tier, unfolding in three frames, shows two guards racing up the stairs; we see them, boots tromping up the steps, first from the right, then from the left, and then from the right again; the panels create a jagged zigzag across the top of the page, evoking movement. In the second tier of two frames, as the partygoers watch in terror, the chase moves outside and across the rooftops of apartment buildings: the fleeing friends leap from building to building, across the space separating them, as do their pursuers. A slim storybook moon hangs in the upper-right corner.

Finally, the last tier—in four slim, rectangular, same-size fixed-perspective frames—shows Farzad first in the process of leaping; second in the process of falling, arms outstretched as if towards the moon; third tumbling head down into the black shaft of space at the center of the frame. The fourth and final panel, the last of the tier and the last of the page, simply shows, with the moon still hanging in the corner, the empty space of the buildings and the black gutter between them. The page temporally protracts; while it opens with speed, it somberly slows down at the conclusion, the four regular beats of the four final frames indicating duration as we witness Farzad's death. In this dramatic page, Satrapi relies on the visual language of comics to show the death: the page doubles its gutters, playing the steep black gutters between the buildings off of the white comics gutter that demarcates the page's temporal divisions. Replicating the gutter that exists outside her frames *within* her frames, Satrapi underscores the desolate horror of falling down into space: the cityscape's gutter mirrors and becomes the comics gutter. Farzad falls, essentially, into the unknown space of the page: his actual death—the moment of impact—is one we are left to imagine. Turning the page, we are back in interior space: a Guardian of the Revolution storms into the apartment announcing, "Your pal has gone to hell" (156). In the chapter's introductory image, Satrapi draws a pair of white socks, dangling down into the black title bar. The dangling feet that begin the chapter, then, invoke not only regime dress codes, the subject of its first few pages, but also gesture at its final image: the space vacated by a man whose feet also dangle into black space. This idiom of witness in *Persepolis 2* moves further than the blacked-out unrepresentability the book delivers after Marji beholds Neda Baba-Levy's body in the rubble of her bombed house; here, Satrapi develops the language of comics—its color contrasts, its temporal rhythm, its gutterspaces—over three pages to silently elaborate a death to which she was an eyewitness.

The *Persepolis* series is shaped by its acts of visual-verbal witnessing. The very last chapter, "The End," unlike every other chapter across the two books, has no icon preceding its title in the black title bar. The indication is clear: once

4.10 P. 155, *Persepolis 2: The Story of a Return* by Marjane Satrapi, translated by Anjali Singh, translation copyright © 2004 Anjali Singh. *Used by permission of Pantheon Books, a division of Random House, Inc.*

Marji leaves Iran for good, Satrapi's project of bearing witness—specifically, of giving voice to what she sees and knows from Tehran's political and personal landscape by *visualizing* these events and moments—is over. The conclusion of *Persepolis* is not the conclusion of Marji's story—in fact, her leaving Iran for France as a twenty-four-year old implies a new beginning full of stories—but it marks the conclusion of Satrapi's ability to witness events in her home country, and so the book ends. (*Persepolis 2* concludes with a set of ellipses after the statement "Freedom had a price"—the grim words here counterbalancing the vision of Marji cheerfully waving to her family and designating the *Persepolis* series a defiantly nontriumphalist narrative; 187).[49] Satrapi supplies a hard date for this ending, its day and year (September 9, 1994) exceeding the specificity of the date naming that opens *Persepolis* (1980) and thus precisely marking the end of her visual-verbal testimony.

In the *Persepolis* series, acts of witnessing take on added resonance, and poignancy, in the context of the legal situation in Iran, in which a woman's power of witness has less legal authority than a man's: in the last chapter Marji cites this decreased value of women's witness as one of the reasons she must leave the country.[50] Marji complains to a work colleague while driving through the city, just pages before the book's conclusion, "If a guy kills ten women in the presence of fifteen others, no one can condemn him because in a murder case, we women, we can't even testify!" (183). The act of bearing witness across the two *Persepolis* books, then, is framed, profoundly, by the demotion of women's testimonial worth in Iran: Satrapi's story is a charged act of countering, an assertion of (one woman's) witnessing power. Satrapi locates the profusion of Iranian memoirs in the fact of women's devalued power of witness:

> We come from a situation, all of us, we come from a situation that suddenly the government in our country decided we were worth half the men—my witness counts half of a mentally handicapped man just because he's the man. The basic culture is not that women are nothing. . . . So these women, when you tell them that their witness doesn't count as much as that of the guy who is going to wash the windows . . . it makes you have more reason to talk, actually, because you are repressed. Our men are in a better situation, they don't have any shouts, they don't need to be heard as much as we do.[51]

> (Root 151)

That she comes from a culture that does not treat women as "nothing," as she says here (and has repeatedly emphasized in other interviews), but rather specifically a political situation that fails to recognize the full force of a woman's

testimony, frames the *Persepolis* series as a counteractive artistic and political measure, a crucial laying claim—even while circulating outside the explicitly juridical realm—to the strength and influence of acts of witness. "I am not unsure about what I have seen with my own eyes," Satrapi affirmed at a 2009 lecture (Ruby Lecture). In this we may understand *Persepolis* not only as self-expression but also as public speech. "I wrote a book because I wanted there to be a witness account of the history of my country," Satrapi says simply (Hill 30). But further, unlike other Iranian and Iranian diasporic memoirs, the addition of *Persepolis*'s images profoundly shapes the consequence of this witness account. The *Persepolis* books are serious and experimental at once; they extend, in textured and rich ways, the range and idiom of witness with the device of their word-and-image form. They not only counteract Satrapi and other women's devaluation of authority as witnesses but enlarge as well the modality and ethos of the very idea of witnessing with their stylized envisionings of traumatic and censored scenarios in spaces of both the public and private.

"Beyond the desire to tell stories," Satrapi told an interviewer, "there's something extra when you position yourself as a witness: you also have to reorient your mind. . . . And this has always been the engine of my work" (Hill 19). We recognize this orientation in Satrapi's two books following the *Persepolis* volumes, although both have a looser approach to the nonfiction/fiction divide and operate on a register less evidently world-historical.[52] And while neither features Satrapi as a central character—although each is anchored in her specific family history—*Embroideries*, which came out in English in 2005, along with *Chicken with Plums*, which appeared in English the following year, both reflect on the central moves of the *Persepolis* series. They each dip backward into the past: the scene of *Embroideries* is dated to about 1991, when Satrapi was still living in Tehran before leaving for France, and *Chicken with Plums* is primarily located in the Tehran of the 1950s, sixties, and seventies.

Named for a cosmetic procedure of vaginal tightening, *Embroideries* features an intergenerational group of female relatives and neighbors discussing sex over tea—a group that includes Marji and her mother and is helmed by the spirited grandmother so prominent in *Persepolis*.[53] *Embroideries*'s content is strongly feminist, in that it is about the sexuality of older women (Satrapi explains in an interview that her grandmother was about seventy-eight at the time the book takes place), and because it is about women creating, through interlocution with other women, a level of sexual comfort with their past and future experiences.[54] Despite adopting a largely different framework than *Persepolis* in its strict focus on issues of sexuality, *Embroideries* significantly creates the same dynamic between the particular and the general and collective that makes so

many of *Persepolis*'s moments, especially those of witness, so profound.[55] (Satrapi wrote and drew *Embroideries* while working on *Persepolis*, in between the third and fourth tomes of the original French edition.) On its surface bounded to the private sphere, since its frame is a conversation that takes place entirely within the domestic, interior space of one living room, *Embroideries* in fact spreads outward through its flashback structure of many different women's recollections. With deft, inventive graphics, *Embroideries* elaborates the stories of women both present and absent.[56] The book names the protagonists who gather together— Parvine, Amineh, Azzi—but it also names and tells the story of many women who are not present, aiming to report and yet decenter individual stories and thus to address a wide net of women. *Embroideries* focuses intently on the faces of characters: the variable format of each page allows Satrapi to explore, often by substantially enlarging or multiplying many times on a single page, the particular faces of the women pictured in the book and their subtly mutating expressions as they speak and listen. Faces often emerge bursting large from the physical borders of the page, to powerful effect. However, *Embroideries* also presents a profusion of floating words—speech balloons untethered to a particular source—and disembodied body parts as well as undetailed silhouette figures, suggesting a nonparticularity in the visual fabric it presents. This mixture continues *Persepolis*'s focus on evoking the personal and the collective at once through the language of comics.

If *Embroideries* is about sexuality, *Chicken with Plums* is about sensuality and focuses closely on the actual corporeality of dying, an aspect that connects it with the *Persepolis* series' preoccupation with representing death and dying.[57] Tracking Satrapi's great-uncle Nasser Ali Khan's suicide, it begins with an eighteen-page prologue and subsequently offers a chapter for each of the eight days that Nasser Ali Khan, a famous musician, spent in bed starving himself. While the book looks carefully at the processes of dying, it also examines pleasure: both the sensuality of losing faculty and of the life that is worth living. Ultimately, *Chicken with Plums* is grim: as Nasser Ali declares at the outset (and the book does not contradict him): "To live, it's not enough to be alive" (7). In his case, his desire to die is based on two devastations inextricably bound up in his mind: the loss of the love of his life, who is not his wife; and the loss of his tar (Iranian lute), which is deliberately broken by his wife during an argument.

Yet *Chicken with Plums*, which despite numerous flashbacks is largely about Tehran from the fifties through the seventies, exhibits the same interweaving of the personal and political that is a hallmark of *Persepolis*.[58] The setting of the 1950s for its romance plot is not just a detail; *Chicken with Plums* presents the Tehran of that decade as a charged landscape in which personal disappoint-

ments and political ones braid together. Satrapi explains, "In the 50s, that is the moment that the Americans and British made a coup d'etat in our country. And that was in 53 and I mention it in the book. That was the end of our dream. And the end of Nasser Ali Khan's dream happened at the same time. It's somehow related in a way" (Mautner 5). Part of the book's weave of the political and personal, too, involves the only-incipient sexual revolution in Iran at the time its lovers meet. In addition to the backdrop of the 1953 coup d'état, in *Chicken with Plums* it is also evident that "there had been a coup d'état in the 70s," as Satrapi notes, and further, moving backward, "that in 1935 the veil was banned, and at the same time . . . that's the beginning of the sexual revolution in Iran where he loves the woman, but in the end he cannot marry [her]" (Zuarino, "An Interview" 2).[59] On his third day of dying, the narrative flashes backward to picture Nasser Ali meeting Irane, a glamorous, good-natured shopkeeper's daughter, who sports a dark bob and cat-eye makeup and is outfitted in a cloche hat and fur collar. Only panels after he chases her down on the street, they are kissing passionately. Her father later denies Nasser Ali Irane's hand in marriage: "How can an artist provide for his family??" (46).[60] The sense of authentic passion quashed in this narrative thread is not, *Chicken with Plums* suggests, remote from crushing, sudden shifts elsewhere: "two years of euphoria and wham!" a character exclaims of the 1953 coup d'état (8). The book seamlessly incorporates multiple discursive registers.[61] Crucially, *Chicken with Plums* also shows, as does *Embroideries*, a mode of autobiography that focuses on the transmission of family history through a personal lens, in which the author, the implied protagonist, is yet only a bit player within her presented narrative: "I think I have never been so much myself as when writing this book," Satrapi says of *Chicken with Plums* (Horgen 1).

Drawing what she sees and knows from the political and personal landscape of Tehran is the link in all Satrapi's work, and the formal and stylistic experimentation evident in each of her books of comics yet continues in the film of *Persepolis*, which presents several intriguing aspects relevant to this chapter's discussion of witnessing. (The film was released in the U.S. in French with English subtitles in 2007.) Most literary cartoonists resist and in fact often resent the frequency of questions about adaptation—when a book is going to be made into a movie—both because of the profound formal differences between comics and film that are so routinely overlooked and because the ubiquity of the question implies filmmaking as inevitably an ultimate goal, a notion with which few cartoonists would agree.[62] Satrapi is rare among her cohort, then, for even wanting to make a film out of her graphic narrative in the first place and perhaps rarer still for stating that she thought the result was better than the books. While Satrapi and I diverge on that assessment, what I would like point to here is how the suc-

cess of the film is due to its ability to work with what is essentially the language of comics. Against the odds, Satrapi maintains the visual idiom of the *Persepolis* books while reinventing the narrative fabric of her story for the medium of film. That Satrapi, a first-time director with no film experience, confidently declined to sell the rights (even when Hollywood money came calling) and demanded full creative control, demonstrates how one woman brought the auteur-driven model of the literary graphic narrative—and life narrative—to a different medium (one that happens to be the dominant representational idiom of our time).[63] As Satrapi herself points out, "People draw a relationship between cinema and comics, but it's not true" ("Persepolis"). Because they are both forms that use visual and verbal narration, comics and film are often compared, as if an organic connection exists between them, yet the temporal structure of each is decisively different.[64] When one reads a comics work, as Satrapi describes in many an interview, "you are very active as a reader because between two frames you have to imagine the movement yourself," whereas with film, a medium in which the viewer in the theater has no control over the temporal progression, "you are passive" (Axmaker 2).[65] While yet responsive to the fundamental difference between comics and film, for the movie version of *Persepolis* Satrapi replicates the aspects of comics that are pivotal to the method of witness she establishes in her books, such as abstract, iconic stylization and the effect of the gutter so basic to the activity of reading the *Persepolis* volumes.

One way that Satrapi translates the conceptual, epistemological concerns of her graphic narrative into the medium of film is through its process of creation. She insisted on an artisanal mode of production, so her team of roughly one hundred, working in Paris, hand-traced images on paper—an art that has long been obsolete in animation, replaced by computer technology. "All of the film is hand-drawn," Satrapi clarifies, "even the inking. . . . A machine makes things too perfect; we wanted to keep the shake in the line" (Galloway). She also insisted— as for the graphic narrative—on black and white, a rarity for contemporary animated films. In *Persepolis* the film, even the all-black backgrounds—and there are many, many black backgrounds, just as in the book version—are filled in by hand. The shaky line, the "vibration in the hand" that brings the drawings to life, as Satrapi puts it, and is so essential to comics life narrative, is one that is evident, then, on the big screen (Satrapi and Paronnaud 2008).[66] To draw and trace their lines, the animators working on the movie used the same implement (which Satrapi describes as "a very special marker you can find in Japan") that Satrapi used to make the books. On the production practices of *Persepolis*, Satrapi points out that as cartoonists, or "drawers," she and codirector Vincent Paronnaud, unlike computer animators, "have a whole new relationship with the pencil and the pa-

per and the ink" ("Capone" 5).[67] For a contemporary, feature-length film, *Persepolis* is unprecedented in its approach to animation, which extends the ethic and aesthetic of the comics underground to mainstream cinema. Satrapi's insistence that the film version resemble the book so closely points up just how crucial the question of style in the book really is. Both the film and the book do the work of witnessing by visually approaching trauma through the abstraction provided by minimalist black-and-white, hand-drawn lines.

While the body of the *Persepolis* film is black and white, it opens with a brief frame narrative in color. In all, it is ninety-two minutes of black-and-white flashback and four minutes of "present-tense" color, which locates us with Marji at the Orly Airport in Paris, where she has longingly traveled, without a ticket home, to sit, smoke, and remember her life in Iran. The "axis of the movie," Satrapi told an interviewer, is "the memory of an exiled person" ("Capone" 9). Although the film substantially condenses the sixteen years covered in the books, it sticks, broadly, to the narrative shape of the comics version.[68] (At the point of the interstice between the two book volumes of *Persepolis*—in other words, after the Mehrabad Airport scene that ends the first volume—the film returns to this color frame, as it also does at the conclusion of the story, after the narrative's second scene at the Mehrabad Airport, when Marji leaves Tehran for good.) At the outset, the film quickly moves backward from France to "Tehran, 1979" as black and white replaces the color and the familiar idiom of the *Persepolis* graphic narrative takes over. In an early scene, as Ebi Satrapi explains to his young daughter that the Shah is not chosen by God, as she learned in school, but in fact had a father, the first Shah, who was installed as Iran's emperor with British and American support, the scene moves from father and daughter at home to a set of stage curtains cranking open to reveal the historical figures as marionette puppets acting out the events Ebi recounts. This visual conceit does at least two things at once: in its further layer of remove/abstraction, it suggests that the film is self-consciously aware of its own acts of framing; it is a "performance" like the one on the stage, and its history is not transparent but is history *as a story that is being told*.[69] At the same time, it also suggests, through its puppet motif, the mechanical (and empty-headed) political maneuvering of the agents it depicts.[70]

The puppet theater interlude segues into one of the most visually and emotionally powerful sequences of the film—a large-scale protest against the Shah in which marchers spill down the street as army tanks ominously patrol the scene. Here Satrapi plays on the black and white contrasts of her graphic narrative with the added visual texturing afforded by the film's only slightly amplified level of visual detail: while the film version of *Persepolis* is fundamentally rooted in the stark, abstract black and white of its comics predecessor, it also adds more shad-

ing, more gray tones, to its black-and-white scenes than we see in the mono-chrome graphic narrative, in which the blacks and whites are flat. Satrapi and Paronnaud, fleshing out the style of the film, not only named Murnau as a visual reference to their animators (an already mentioned Satrapi influence) but also Fritz Lang, and the black-and-white shadow play in Charles Laughton's famous 1955 American film noir *Night of the Hunter*. As protestors—silhouette figures, entirely black—march down the street, the hazy, textured white light of Tehran behind them frames their dark bodies. The Shah's soldiers, also entirely black except for the glowing white eyes of their gas masks, look terrifyingly inhuman; they line up their rifles and shoot. The scene is bare of dialogue, lending suspense to the unfolding of its visual narrative effects.

A young man, shot, crumples on the shaded pavement, his all-black body stark against the ground. The perspective of the film stays close on his body as masses of hands, also entirely black, reach toward him (see figure 4.11) and the screen, enveloped by bodies, turns all black. The man is next lifted up above the heads of protestors; his arms and legs drape downward, encasing the group. Here, the bodies look, as in the graphic narrative, like an architectural structure. While each figure, both dead and alive, remains pitch black against the shaded fog of the chaotic street, the young man's eye gleams white as he is carried off, marking him, suddenly, as particular and also implying, on a graphic level, his connection with the soldiers—presumably young, scared men themselves. Deploying the abstraction of comics, this scene inverts the dominant visual idiom of *Persepolis*, which often presents all-black backgrounds, and shifts it onto a mass of anonymous bodies, making soldiers and protestors black shapes against the murky, sinister political and physical environment of Tehran. As in the books, the emotional force comes from this stylized abstraction, and the film establishes early, then, its investment in crafting an expressive visual modality of witness.

The film also reproduces comics' gutter effect, as we see in the chase scene in which Marji's friend Farzad, here called Nima, falls into the space between buildings as Guardians of the Revolution pursue him. In this scene, as in the book, viewers never see the dead body, but while the book keeps a fixed perspective on the space into which the friend falls, which merges with the white space of the page's gutter, in the film, after Nima's failed leap across the rooftop, the camera yanks upward: it cuts from the gulf in between the edifices up to the moon and stalls in that space. For several beats—accentuated by a slow, repetitive guitar twang—we simply watch the space in the sky above where his body was. We never actually see Nima *not* make it to the other side, but the implication is clear; by lingering above, the film lets us know what is below. It manages, then, to convey the horror of the space of absence, as the graphic narrative does

4.11 Marjane Satrapi and Vincent Paronnaud, frame from *Persepolis*, 2007. *Used by permission of 2.4.7. Films.*

by proliferating gutters on the page; it keeps us in this actionless but replete space of absence for a painful duration. And at the conclusion of the film, after Marji finally leaves Orly Airport in a taxi, telling the driver, as they motor into Paris, that she is coming from Iran, the film adopts a gutter effect for a postplot ending: the screen is entirely black, with no images whatsoever. With a black screen in front of us, we hear the child Marji and her grandmother converse about how the older woman places jasmine in her brassiere every morning. In this scene, *Persepolis* the film invokes the activity Satrapi understands as a defining aspect of comics. This is clearly one of her most cherished memories, and the blank screen in front of us calls attention to the procedure of memory—the black blank spaces that suddenly assume a shape in our recollections, out of chronological order. By providing no visual correlate—and hence presenting a disjunct that is constitutive of the fundamental language of comics—this episode also turns outward, to the space of the viewer's own recollections.

Strikingly, the film *Persepolis*, as with the book, insists in its mode of production on what I call the texture of retracing and underlines the power and risk of reproducing and making visible the site of one's inscriptional effacement (as critique, as a narrative of development, as a positing of the collectivity of self). As with Alison Bechdel—who posed, for her own visual reference, for every person in every frame of her graphic memoir *Fun Home*, the subject of the next chapter—Satrapi acted out the physical gestures for each scene of the film to give her

animators a physical reference ("I play all the roles. Even the dog," she told the *New York Times* [Hohenadel 18]). *Persepolis* is a work of reimagination and literal reconstruction that retraces the growing child body in space, reinscribing that body by hand to generate a framework in which to put versions of self—some stripped of agency, some possessing it—in productive conversation. *Persepolis* the film is, in a sense, a repetition of this primary act of repetition. Satrapi, in the expanded field of production afforded by film, yet inserts her literal, physical body into each frame of the film through her own physical act of repetition.

Graphic narratives that bear witness to authors' own traumas and to those of others materially retrace inscriptional effacement; they reconstruct and repeat in order to counteract. It is useful to understand the retracing work of graphic narratives as ethical repetitions (of censored scenarios). Both the comics and the film version of *Persepolis* present the censored and the censured by creating a visual language that is stark and capacious at once, that is abstract and motivated by accuracy. The grammar of the *Persepolis* project, in both media, is a complex visualization of what was for Satrapi an ordinary childhood yet pocked by terror; her interpretation of this history requires a rethinking of the tropes of unspeakability, invisibility, and inaudibility typical to trauma theory—as well as a censorship-driven culture at large. Iran, which, as noted earlier, has not allowed the graphic narrative to be published there, decried the film version of *Persepolis*; the day after it won the Cannes Jury Prize, Medhi Kalhor, cultural adviser to President Mahmoud Ahmadinejad, released a statement to the Iranian press calling the film "anti-Iranian" and accusing it of trying to "sabotage Iranian culture" (Satrapi does not see her film as anti-Iranian and, accepting her Cannes prize, dedicated her award "to all Iranians" [iafrica.com]). Kalhor further alleged, "The Cannes Film Festival, in an unconventional and unsuitable act, has chosen a movie about Iran that has presented an unrealistic picture of the achievements and results of the glorious Islamic Revolution in some of its parts" (PressTV).[71] Protesting the prize, the culture bureau demonstrates both the enormous impact and the risk of representation that Satrapi forces us to confront, offering us texts that suggest the importance of cultural invention and visual-verbal mapping in the ongoing project of grasping history.

Animating an Archive

REPETITION AND REGENERATION IN ALISON BECHDEL'S *FUN HOME*

*I finally sat down to write the book when I was forty, right at that weird
midpoint in my life where my father had been dead for the same number of years
he'd been alive. . . . That meant confronting my father's artist fixation head-on.
I had to dismantle his inhibiting critical power over me before I could tell the story.
But telling the story was the only way to do the dismantling.*
—Bechdel, "Talking"

It's like learning a new syntax, a new way of ordering ideas.
—Bechdel on comics in "Life Drawing"

While Marjane Satrapi's *Persepolis* aims to be productively alienating
and to suggest the devastating normalcy and profusion of violence in
Iran with its minimalist, two-tone visual schema and de-particular-
ized faces, Alison Bechdel's *Fun Home: A Family Tragicomic* (2006)
works in reverse.[1] Focusing on the most particular aspects of the Bechdel family,
Fun Home recuperates an archive of family documents—which Bechdel labori-
ously re-creates in her own hand—in order to seek out the specificities of a man
who felt abstract to his daughter, and also to propose the embodiment of the car-
toonist's link to the past (and hence to her father). In works like Phoebe Gloeck-
ner's *A Child's Life,* the author composes comics as a way of interacting with and
actually touching a younger version of self, as is made explicit in the picture titled
"A Child's Life." *Fun Home* explores the legibility of the father figure at its center,
allowing the author the intimacy of touching her father through drawing him,
while suggesting that the form of comics crucially retains the insolvable gaps
of family history. *Fun Home*'s narrative structure, as in Satrapi's text, features a
female child as its main character, with an older, recollective narratorial voice

framing the story in overarching text and in overlaying boxes. Both *Persepolis* and *Fun Home* are stories about trauma—but whereas Satrapi's is about a loving intellectual family facing crisis together in the violent, war-torn urban landscape of Tehran, Bechdel's is about an icy intellectual family facing deep internal divisions that result in her father's death, in the calm town of Beech Creek, Pennsylvania.[2]

It is the imbrication of her own development with her forbidding father's sudden demise that constitutes the core of crisis in *Fun Home*. The book is structured by its exploration of Bechdel's relationship with her father, who stepped in front of a Sunbeam Bread truck on the Pennsylvania highway when she was nineteen, just a few months after she came out to her family as a lesbian. *Fun Home*'s title refers to Bruce Bechdel's work space; it is short for "funeral home." In a wry sense the title also refers to the elaborately decorated home in which Alison Bechdel grew up, which often felt mausoleumlike and significantly less than fun to its inhabitants. The first American graphic narrative since Spiegelman's *Maus* to earn such vast audiences and accolades, *Fun Home* bears structural, if not stylistic, similarities to *Maus* (see Chute, "An Interview" 1013). Both are father books, functioning at once as biographies and autobiographies. Both authors end their books with a scene that figures the death of their father; in fact, both authors have figured their books *themselves* as funerals for fathers.[3] Further, both concentrate deeply on identification and concomitant *disidentification* with fathers, proposing that this dynamic is the foundation for the narrator-protagonist becoming the artist—and, specifically, the *cartoonist*—who created the book we read. In both books the child's specific investment in the expansivity of visual narrative marks their difference from their fathers; both books are ultimately as much about the comics form itself as they are about the narrative content proffered in each. While *Fun Home* evidently investigates the life and death of Bruce Bechdel—a closeted gay man, high school English teacher, obsessive restorer of the family's Victorian Gothic Revival home, part-time undertaker, and a suicide at age forty-four—Bechdel has also said that the book's "real story is about [her] becoming an artist" (Address).

Fun Home, then, needs to be understood in the context of Bechdel's career, throughout which, at every stage, she has innovated the shape of the contemporary comics field. Released in 2006, *Fun Home* is Bechdel's first long-form work and the first graphic narrative to be published by Houghton Mifflin (later that year Houghton Mifflin followed up on the book's success with the publication of its first *Best American Comics* volume, adding comics to its stalwart *Best American* series). Previously, Bechdel was best known for her *Dykes to Watch Out For* comic strip, a series she began in 1983 and which she describes as "an uneasy hy-

brid of soap opera and editorial cartoon" that turns on the line between "domestic microcosm and political macrocosm" (Address).[4] Featuring a cast of recurring characters, friends who live in an unnamed midsize American city, *Dykes to Watch Out For* is the first ongoing lesbian comic strip—the book *Dyke Strippers: Lesbian Cartoonists A to Z* is even dedicated to Bechdel.[5] *Dykes to Watch Out For* launched Bechdel's career as a cartoonist; while it first appeared in the New York feminist monthly *Womanews*, eventually *Dykes* earned a national audience in the alternative press as a biweekly feature, and it has now been collected into twelve successful book anthologies.[6] These carry titles such as *Post Dykes to Watch Out For*, *Dykes and Sundry Other Carbon-Based Life Forms to Watch Out For*, and, most recently, the compendium *The Essential Dykes to Watch Out For*.[7] The strip renders the daily texture of a range of lesbian (and some straight and bisexual) lives with humor, a sharp attention to detail, and an insightful integration of political issues into the fabric of the personal experiences it depicts.[8]

Both *Dykes* and *Fun Home* turn on a characteristically feminist stress on the division between the private and the public. "That interplay between the personal and the political is an enduring fixation of mine," Bechdel comments, noting, "I look back now at the genesis of *Dykes* and I see it very much as a reaction to what happened with my father. I felt that to a certain extent he killed himself because he couldn't come out, so I was determined to be utterly and completely out in my own life" ("Talking" 8–9). One may understand both works as feminist not only in how they claim a space for openly sexual female bodies—especially queer bodies that have been marginalized and pathologized—but also specifically in how they explore subject constitution in mutually inflected private and public spheres.

Yet *Dykes to Watch Out For* and *Fun Home* are different endeavors, existing in separate discursive registers. While technically fictional, *Dykes* carries what Bechdel calls a "journalistic" quality—an appraisal that indicates a certain mode of communication and a descriptive project of representation: translating the everyday realities of a certain slice of gay life to the page (Address). The strip originated in Bechdel's desire "as a young lesbian just out of college to see reflections of myself in the culture. I was very hungry to see visual images of people like me" ("Life Drawing" 41). While in Bechdel's hands this project of representation is sophisticated, it is yet qualitatively different from *Fun Home*: *Dykes* is motivated by observing the details of lived life as they unfold, whereas *Fun Home* captures and expresses years of intellectual introspection about one father-daughter relationship within a family Bechdel describes as "autistic" (*Fun Home* 139).[9] And as an ongoing comic strip serial, *Dykes* has a narrative that is potentially endless. *Fun Home*, on the other hand, is *about* a certain kind of endlessness, or timeless-

ness, as I suggest in this chapter, but its narrative edges are bounded by its exploration of Bruce Bechdel's life and death. The result is a deeply crafted, intensely structured object—like a map, or a key, of the relationship it examines. Dense with visual and verbal information, yet profoundly distilled and economical, *Fun Home* presents a reverse puzzle: its many pieces set perfectly in place—or, to use the language of comics, *fit in space*—it asks the reader to figure out the logic of its rigorous design over its gaps and elisions. "I went over and over and over it, tweaking the connections between what had happened and what was still coming," Bechdel states. "Everything in the book is so carefully linked to everything else, that removing one word would be like pulling on a thread that unravels the whole sweater" (Chute, "An Interview" 1008). Bechdel says she did not start thinking of herself as an artist until she was forty, when she started working on the book (Address). If the book's shadow narrative or "real story" is about the protagonist Alison becoming an artist, *Fun Home* instantiates that development.

So while *Dykes to Watch Out For* is celebrated and popular—there are a quarter-million copies in print of the *Dykes* books, which Houghton Mifflin points out elevates a title well beyond "cult" (read: niche gay) status— *Fun Home*, which took seven years to complete, represents a departure, both for Bechdel and for American literature. It is not only an important reference point in discourse on graphic narrative but also on the possibilities and reach of contemporary literature in general.[10] Indeed, *Fun Home*'s wide success bodes an institutional change; it is a prime example of how the form of comics expands what "literature" is in a way that puts productive pressure on the academy, the publishing industry, and literary journalism.[11] *Fun Home* immediately garnered conspicuous critical and popular acclaim, even making the *New York Times* bestseller list, a rarity for any literary graphic narrative.[12] The *Times* wrote in their review, "If the theoretical value of a picture is still holding steady at a thousand words, then Alison Bechdel's slim yet Proustian graphic memoir, 'Fun Home,' must be the most ingeniously compact, hyper-verbose example of autobiography to have been produced" (Wilsey 9). *Fun Home* also, strikingly, has had a wide impact with more mainstream venues; most remarkably, among its mainstream accolades, it was voted *Time* magazine's number one book of the year, in *any* category.[13] It went on to be nominated for a National Book Critics Circle Award in autobiography/memoir (the winner was Daniel Mendelsohn's *The Lost: A Search for Six of Six Million*).[14] With *Fun Home*, Bechdel established herself as one of the innovators of nonfiction comics—if not the form's currently most recognizable public face. In the short period since *Fun Home*'s release she has not only entered public consciousness to a degree not typical for literary cartoonists (with profiles in venues like *People* and glowing reviews in outlets like *USA*

Today), but she has further expanded the boundaries of what nonfiction comics can do: for instance, she published the *Times Book Review*'s first book review in the form of comics in March 2009.[15]

EMBODIMENT AND THE COMPLEXITY OF LOSS

A tightly compact, condensed, and patterned narrative object, *Fun Home* has a very intricate narrative fabric, both verbally and visually. It uses two different visual representational styles: one that is heavily crosshatched, which is used for drawing photographs, and one that has crisper black line art.[16] *Fun Home* also employs color: there is a gray-green ink wash throughout that Bechdel describes as "sort of a grieving color . . . [with] a bleak, elegiac quality to it" ("Life Drawing" 48). Each of *Fun Home*'s chapters, however, begin with a black-and-white title page for which the author draws a life-size photograph that floats alone in white space at its center (see figure 5.1).[17] Each of these photographs is accompanied by a varying number of photo corners stuck to its edges, indicating *Fun Home*'s interest in depicting photographs as used, worn, studied archival objects as opposed to presenting them as windows into reality.

Like many graphic narratives, *Fun Home* calls attention to itself as a material object, but it constructs itself, further, *as* a house. Bechdel depicts the exterior of the Victorian Gothic on its cover: when one removes the dust jacket of the hardcover edition, the exterior of the house, with circular cutaway views of the family members inside it, is evident. Bechdel's replication of the wallpaper in her family home serves as the book's endpapers. This pattern encloses the space her comics panels create, much as it did the interior living space of her girlhood. The pattern, Bechdel told me, is William Morris's "Chrysanthemums": "Recreating that wallpaper was insane. . . . One thing my mother did say about the book was that I didn't get the wallpaper pattern right. And she's right, I didn't get enough contrast in it. I've since learned that there are eleven shades of green in the original—and I was only using five different shades" (Chute, "An Interview" 1008).[18] The book is a creation, then, that doubles for Bechdel's actual childhood home. The whole interior of *Fun Home* is washed in a color derived from the interior of her house, but the book builds its narrative as an alternate location of family history—a differential typology that is here a differential architecture built on the elements of the comics form.

How Bechdel creates her house, the book object for which she is both architect and master builder, is profoundly significant in making legible the different attitudes toward history and preservation shared by father and daughter. On every page of Bechdel's text comics builds a certain kind of space that counters

the methodology of her father and the modality of the family home he shaped. As the massive profusion of ornamental objects in his Victorian home reveals, Bruce Bechdel is obsessed with presence. The narrator asks in the book's first chapter, "What function was served by the scrolls, tassels, and bric-a-brac that infested our house?" and, a few pages later, she concludes of her father, "His shame inhabited our house as pervasively and invisibly as the aromatic musk of aging mahogany" (16, 20). Bruce Bechdel needs to reaffirm the presence of things—protuberant, decorative things—in order to cover over the gaps, to concoct a family space whose proliferative material aspect stands in and covers for its dearth of transparency and emotional connection. Alison Bechdel, on the other hand, is preoccupied with absence and loss, investigating her father's death, but she makes loss and absence *present* throughout the book. Father and daughter recuperate loss differently: he covers absence with presence; she invokes presence, but this is counterbalanced by the white, emptied-out gutter spaces of comics. The profusion of ornamental detail in Bruce Bechdel's house—evident in the characteristically Victorian William Morris wallpaper pattern, which is completely filled in—is an aesthetic, or an ontology, in contradistinction to the book itself, which both captures presence, and also activates blank spaces as part of its architecture. The contrast, or the paradox, of presence and absence limns the book; it is the form, and theme, that most fundamentally constitutes *Fun Home*.

Fun Home is not a book about "what happened" to Bechdel's father. Rather, it is a book about ideas about what happened to Bruce Bechdel, and arriving at a collection of ideas through an intense engagement with archival materials. Its seven chapters do not progress linearly, but are rather thematically structured; *Fun Home* eschews the straightforward chronological march of works like *Persepolis*, unfolding a layered, recursive narrative in which events and images overlap and repeat.[19] At the level of form *Fun Home* stages its own central preoccupation with the nature of revisiting the past, embodying through its word and image composition the fissures and contradictions that are the focus of its plotline. In its comics form we see the *materialization* of epistemological problems. The book does not seek to preserve the past as it was, as its archival obsession might suggest, but rather to circulate ideas about the past with gaps fully intact.[20]

The awkwardness between word and image is both the actual subject— and, powerfully, the form—of *Fun Home*.[21] Many critics have identified *Fun Home* as a "literary" text because it is thick with references to famous works of literature—specifically, the mostly high modernist books Bechdel's father loved. My sense of the book as "literary," on the other hand, has to do with how the page composition, through panel size and panel shape and arrangement, gestures at a certain rhythm that is connected with "the complex relation between

CHAPTER 1

OLD FATHER, OLD ARTIFICER

knowing and not knowing" that Cathy Caruth identifies as the premise of both literature and psychoanalysis (*Unclaimed Experience* 3). As one comics scholar puts it, the history of comics is itself partly "a history of the refinement of elliptic and fragmented storytelling" (Lefèvre 5). Because of its flexible page architecture, its structural threading of presence and absence, and its sometimes consonant, sometimes dissonant visual and verbal narratives, comics is suited to articulate the dynamic of knowing and not knowing that motivates *Fun Home*: just how much can Bechdel know about her often remote, often tyrannical, and always secretive father, whose suicide she suspects is linked to her own coming out? And what is there to conclude about their truncated relationship?

Fun Home, which expresses and indeed embodies profound contradictions in its form, in several places verbally names its ultimate rejection of binary

structures. For instance, in a description apposite to the relationship between Bechdel and her father, the narrator—her prose stretched out across three separate frames, none attached to an image containing any reference to Proust—writes:

> In one of Proust's sweeping metaphors, the two directions in which the narrator's family can opt for a walk—Swann's way and the Guermantes way—are initially presented as diametrically opposed. Bourgeois vs. aristocratic, homo vs. hetero, city vs. country, eros vs. art, private vs. public. But at the end of the novel the two ways are revealed to converge—to have always converged—through a vast "network of transversals."

> (102)

Fun Home is itself a map of the network of transversals for the two "directions" embodied by Alison and Bruce Bechdel; it tracks both their divergence and convergence (lesbian-child-artist, gay man-father-dilettante). *Fun Home* actually *enacts* what Bechdel calls "this nonduality," beyond simply naming it, in its spatial and semantic gaps, which express a critical unknowability or undecidability—as well as a quality of time that confuses categories like past and present (116).

These gaps, however, do not ultimately overtake the narrative. *Fun Home*'s engagement with trauma is powerful precisely because it neither makes insufficient claims to fully represent trauma, nor does it wrap itself in an ethic of the inconsolable, the unrepresentable. In his most recent book, among many, on trauma, *History and Its Limits*, Dominick LaCapra warns of the indiscriminate valuation of the negative sublime that is a tendency of trauma theory—an "extreme, at times exclusive or intransigent, investment in the aesthetic of the sublime and the melancholic (with the aporia as a sublime textual trauma or *mise en abîme*)" (65). I argue throughout this book that graphic narrative puts pressure on dominant conceptions of trauma's unrepresentability. Particularly, in *Fun Home* we recognize the "ethic of response" that LaCapra identifies as reasonable: "an ethic . . . mindful of, but not fixated on, the paradoxes and aporias of representation" (67). *Fun Home* is a book about trauma, but it is not about the impassable or the ineffable. It is rather about hermeneutics; specifically, on every level, *Fun Home* is about the procedure of close reading and close looking.

The narration of the book is rooted in *acts of looking at archives*. Trauma is often understood as repetition, and this is something one sees—as I will discuss further—in the force of comics' acts of visual repetition.[22] But further, in *Fun Home*, repetition is a kind of obsessive embodiment. By *embodiment,* I mean

to point to what is both peculiar to comics—a traditionally hand-drawn form that registers the subjective bodily mark on the page—and what is specific to Bechdel's text.[23] In *Fun Home*, I treat Bechdel's drawing and, in some cases, redrawing of archival materials as an embodied repetition.[24] By embodied I mean not simply *concrete*, but that everything Bechdel represents—from letters to diaries to photographs—is drawn by hand. Nothing was scanned for *Fun Home*; instead, documents were repeated—imitated—by Bechdel's own hand in the production of the book.[25] The text is invested in offering up the archival documents on which it meditates to readers. But instead of merely reprinting these materials, Bechdel re-creates them. She inhabits the past not only, in a general way, by giving it visual form, but further by the embodied process of reinscribing archival documents.[26]

The idea of replication—of generation, of reproduction, of repetition-only-maybe-with-a-difference—haunts *Fun Home*. *Fun Home* enacts repetition at every level: in its preoccupation with individual images; in its narrative conceit of telling and showing a private story through "great books"; in its re-creating of paper archives; in the author's creative process, in which she physically reinhabits scenes of the past in order to draw them; and in its overall narrative structure. *Fun Home*'s narrative, as mentioned, is not linear and chronological; instead, it has a circling, "labyrinthine" structure.[27] The structure of the book reflects a labyrinth, in Bechdel's words, because it spirals in to the double-spread center of Roy posing in his underwear on the bed—that is, in to the redrawn photograph of her childhood babysitter with whom her father was having an affair—and then spirals out ("A Conversation").[28] And it is recursive—it returns again and again to picture and repicture central, traumatic events. The recursivity it reflects at the structural level of the story rhymes with the recursivity suggested by the comics page itself, which, by virtue of its sequential order of panels *and* its immediate visual "all-at-onceness," often demands rereading and relooking.

The operation of the image in *Fun Home* connects with a notion Caruth discusses that is useful for thinking about why there are so many graphic narratives about trauma; she writes, as I have noted, "to be traumatized is precisely to be possessed by an image or an event" (*Trauma* 4–5). Here, the notion of being possessed by an image is one that the book enacts over and over. The phone conversation in which Alison's mother reveals that her father slept with Roy, and Alison listens stretched out on the floor, repeats, significantly, three times across the text, as does the phone conversation in which Alison talks to her father about her own gayness a few months before his death. And Bechdel returns, over and over, to an imagined scene of the moment with the truck before her father's death: it weaves in and out throughout the text. This image is, in fact, on

the last page of the book, closing the story: its impact is to leave us with an ending that emphasizes its own ceaselessness.

However, despite its psychic and material drive to repeat, *Fun Home* is a book obsessed, in a way, with *not* repeating. This is revealed at a key moment in which Bechdel establishes her divergence from her parents. Alison, at age six, realizes on a family trip to Europe that "my parents felt their own dwindling." The narrator declares, "perhaps this was when I cemented the unspoken compact with them that I would never get married, that I would carry on the artist's life they each had abdicated" (73). One can understand *married*—as it functions in this episode as the antithesis of "an artist's life"—to stand in for Alison's potential act of creating, through marriage or reproduction or both, her own family.[29] (For the adult Bechdel, this idea remains: "I've never had the remotest desire to reproduce," she remarked on family in 2007; further, "I kind of like being my own husband and wife.")[30] At six, however opaquely, Alison conceives of herself as an artist, defined in opposition to her merely "artistic" parents. This "compact" indicates the force of the child's difference, which speaks to her self-possession and also carries traces of self-erasure: the progeny is going to make good on the life her parents had each really desired for themselves by having no progeny (the progeny will be a book, not children—but a book about progeny). It is both competitive—she rejects the psychic dwindling they each have settled for—and a tribute to their own stifled creativity. She will make good on their lost lives. And if Alison senses her parents' own dwindling, they too perhaps sense in her, in turn, that what she calls her "intoxicating" "freedom from convention" on that trip is her own creative increase (73). The narrative of the book is about establishing her difference from her parents; the book itself represents, as a work of art, the conclusion that she has succeeded in doing so.

But the book is also about contradiction—and what Bechdel calls "the complexity of loss"—and in it we see that Bechdel in fact repeats a lot (120). There is a structural repetition at work in the narrative method of *Fun Home*. Alison's parents, she lets us know, were emotionally distant people who refracted their own experience through literature. It is hard to overstate the fascination with books that the Bechdel family exhibits; reading in their household is valued above all else. (Indeed, when Alison's parents are shown fighting, Bruce Bechdel retaliates by abusing books: in one scene he knocks a stack of books off a desk, and then starts ripping pages out of books in front of his wife: "Take **that** back to the fucking library" [70]. His sexual frustration manifests itself in deconstituting the body of the book, which is a stand-in for his own erotic sense of self, his own body.) Reading is the site where almost everything happens in *Fun Home*. It is, significantly, the basis for Alison's most substantial, although itself tenu-

ous, bond with her father, which begins when she becomes a student in his high school English class. Not surprisingly, Alison's sexuality becomes articulate to her through her own physical activity of reading—an activity validated above all others by her family, but particularly by her father, for whom reading provides a cathexis related to his own sexuality.[31] And in typical Bruce Bechdel fashion, his only mode of encouraging Alison's sexuality is by praising her choice of reading matter.[32] Her father is depicted reading *Anna Karenina* on *Fun Home*'s very first page, and he goes on, within the space of the text, to be shown reading or discussing an additional twenty-one different books (Alison, for her part, is shown reading or discussing over fifty separate titles).[33] As she puts it in the book, "the line that Dad drew between reality and fiction was indeed a blurry one" (59). Examples run throughout the text. Bruce Bechdel notes, of F. Scott Fitzgerald, "He reminds me much of myself" (62). Of the protagonist of Fitzgerald's story "Winter Dreams": "He is me" (63). Bruce Bechdel writes in a letter to Alison: "Faulkner is Beech Creek. The Bundrens ARE Bechdels" (200). Later, when Alison first reads Joyce's *Portrait of the Artist as a Young Man*, he tells her: "You damn well better identify with every page" (201).

As I noted, one of the reasons that *Fun Home* may have been so quickly accepted as serious literature is that it is explicitly "literary": it discusses, and cites, many famous, mostly modernist, works of literature at length. But it does not only do this to explain the pervasive chill and preoccupation in the Bechdel household. Rather, Bechdel unfolds her story about her family through the lens of the literature with which her father identified. Each chapter in *Fun Home* adopts a particular text or figure, and sometimes several, as a thematic and narrative filter. The book engages most prominently with Joyce, but *Fun Home* also takes on works by Camus, James, Stevens, Proust, Wilde, and Colette, among others, in order to frame its meditations and its central events. It is a riveting narrative conceit, in part because it appears, at least on the surface, to cede to the kind of emotional distance that Bechdel critiques in her own family. As the cartoonist Howard Cruse points out, "It's both a way of standing back from and contemplating the family dynamics, and also, it itself *is* the family dynamics" (Chute, "Gothic Revival" 36).

We also see an urge to repeat in the book's obsessional drawing—and in some cases, such as with Bechdel's former diaries, redrawing—of the archival elements that drive its story. (Indeed, in the three short pieces Bechdel published after *Fun Home*, all show her returning to and re-creating private archives.)[34] Bechdel draws public and private photographs; her own diary entries; numerous maps; newspapers; many different kinds of books, including typeset pages from novels and dictionaries; childhood and adolescent drawings; poems; old

cartoons; passports; police records; court orders; course catalogs; typed letters from her father and mother, and handwritten letters *between* her parents (see 63; see figure 5.2). She re-created absolutely everything in the book, reinhabiting the elements of her past to re-present them—and to preserve them, to publically rearchive them. But the difference in her process of rearchiving is that the documents are reinflected with her own hand. Bechdel suggested to me, when I pressed her on her oft-quoted statement "I always felt like there was something inherently autobiographical about cartooning," that a page's marks "inevitably resemble, or are a manifestation of, the person making them" ("Life Drawing" 37; Interview 2008). The pathos that itself underwrites the project of painstakingly learning to copy a dead father's handwriting is striking, as is her effort to pin it down correctly and reproduce it visually in her narrative. This embodiment also lets the reader recognize how the archival is by definition in *Fun Home* refracted through Bechdel's experience and her body. While Julia Watson argues that *Fun Home* asks us "to weigh the authority of archival evidence against the erotic truth of a repertoire of experiences," in my reading the text does not even propose this dichotomy to undermine it: by redrawing the archive, Bechdel circumvents this opposition entirely (53).

THE GAP BETWEEN SENTENCE AND SYMBOL: DIARIES AND EPISTEMOLOGICAL CRISIS ("I THINK")

That both daughter and father are deeply engrossed in aesthetic discrimination and hold divergent judgment is established early on: Alison is "Spartan to his Athenian . . . modern to his Victorian . . . butch to his nelly . . . utilitarian to his aesthete" (15). But, more significantly, their difference is in how they are invested in forms of representation doing the work of documentation—delivering versions of the elusive real. Bechdel, at a 2007 event, described her family as one "where there was a real disjuncture between appearance and reality" ("PEN/Faulkner" 1). Bruce Bechdel's investment, since he hides the secret of his parallel life, is in appearance, in artifice. A key scene in the book depicts Bruce Bechdel taking a photograph of his wife, sons, and daughter, gathered together stiffly in formal attire on the front porch of their Victorian house. The image is crisp, crosshatched; the view is behind Bruce, aligned with his gaze, showing us what he sees. "He used his skillful artifice not to make things, but to make things appear to be what they were not," reads the text above the image. "That is to say, impeccable" (16). The framing device of photography is important to both father and daughter; but while for Alison Bechdel it is generative in being suggestive, as we can recognize in the book's relationship to the photograph of Roy, for

IT COULD NOT HAVE ESCAPED MY FATHER'S NOTICE THAT DURING SCOTT'S OWN STINT IN THE ARMY HE WROTE HIS FIRST NOVEL AND BEGAN COURTING ZELDA.

DAD'S LETTERS TO MOM, WHICH HAD NOT BEEN PARTICULARLY DEMONSTRATIVE UP TO THIS POINT, BEGAN TO GROW LUSH WITH FITZGERALDESQUE SENTIMENT.

AFTER THE BIOGRAPHY, HE TORE THROUGH FITZGERALD'S STORIES, SEEING HIMSELF IN VARIOUS CHARACTERS.

DAD DOES NOT MENTION IDENTIFYING WITH THE CHARACTER OF JIMMY GATZ, BUT THE PARALLELS ARE UNAVOIDABLE.

GATSBY'S SELF-WILLED METAMORPHOSIS FROM FARM BOY TO PRINCE IS IN MANY WAYS IDENTICAL TO MY FATHER'S.

5.2 P. 63, *Fun Home: A Family Tragicomic* by Alison Bechdel. Copyright © 2006 by Alison Bechdel.
Reprinted by permission of Houghton Mifflin Harcourt Publishing Company. All rights reserved.

Bruce Bechdel it is decisive; surface stands in as evidence of depth. In crafting and maintaining the artifice, he jettisons "an elasticity, a margin for error" in his methodology; hence his admonishment of his seven year old for her not-literal-enough interpretation of her coloring book (18). And while Alison Bechdel's contrapuntal energy allows for more of what is actually *creativity*—ultimately, she is the artist, not her father, who always longed to be one—both her child self and her adult self are obsessed with representing the truth.

Fun Home registers its concern with the nature of representing truth in its unusual attention to the archive; it is physically, materially saturated in the sensuality of the archive, as well as structurally constituted by archival research, and we recognize its archival drive in both the child protagonist character and the adult author. (Eventually, at the very end of the book, the two merge.) The first sentence, indeed, of *Fun Home*'s author biography identifies Alison Bechdel as "a careful archivist of her own life" who "began keeping a journal when she was ten." Alison's child and adolescent diaries are key to *Fun Home* materially and conceptually. The book tracks the shifting shape of the protagonist Alison's diaries over several of its chapters. The movement, eventually, seamlessly folds itself into the form of the book we are reading, as the form of comics itself comes to absorb the epistemological quandaries that Alison mulls over in various modes of diary keeping in her youth.

"The Canary-Colored Caravan of Death," *Fun Home*'s fifth chapter, explores the foundation of Bechdel's fascination with the form of her book; Bechdel identifies this chapter as "my cartooning manifesto," even though it makes no explicit reference to comics ("Life Drawing" 49). In 1971, at age ten, Alison's father gives her a calendar-diary from a burial vault company, instructing her to "just write down what's happening" (140). As everywhere else in *Fun Home*, life—creativity, writing—is here limned by death ("death is the mother of beauty," as Alison cites her mother's favorite poem earlier in the chapter [129]).[35] Another seeming paradox of this primal episode, arriving just pages after Bechdel reveals artistic tussles between her child self and her father over a poem (129–130) and coloring book (130–131), is how Bruce Bechdel inaugurates, and collaborates with his daughter in the project of recording her life, a paradox that, writ large, is *Fun Home* itself. Bechdel offers a panel in this scene whose structure recurs throughout the book: an object—usually a text—is passed between father and daughter, and both conspicuously grasp it, so that the object links their hands; they touch each other, it seems, through the object.[36] Bruce Bechdel writes the first sentence in the diary, "Dad is reading." Soon Alison has moved onto recording her life in an insurance company datebook, but, a few months later, Bechdel

narrates, in overarching text, that "the minutely-lettered phrase *I think* begins to crop up between my comments," above a panel in which she redraws an excerpt from April 2, 1971: "I finished [I think] "The Cabin Island Mystery." Dad ordered ten reams of paper! [I think] We watched The Brady Bunch. I made popcorn. [I think]" (141; see figure 5.3). "It was a sort of epistemological crisis," the adult narrator explains over an image of the child making popcorn. "How did I know that the things I was writing were absolutely, objectively true? All I could speak for was my own perceptions, and perhaps not even those" (141). The last panel of the page returns to April 2, this time offering us, at life-size, the child fingers gripping the pen in the middle of writing her disclaimer about the popcorn. By May the "I think" has become even less stable: "My *I thinks* were gossamer sutures in that gaping rift between signifier and signified," writes Bechdel above her scratchy May 6 entry. "To fortify them, I perseverated until they were blots" (142). Gradually the layered "I think"s give way to a "shorthand version" Alison creates to "save time": a symbol that Bechdel calls "a curvy circumflex," something like an expressive upside-down V, or a caret (142). The phrase has become an image. She first draws it at the end of sentences, then *over* entire words, then additionally over the entire diary entry, "for even more protection" ("PEN/Faulkner" 2). Words are unstable so she protects herself with the visual.

Bechdel's childhood diaries link up with *Fun Home* not only because their excerpts constitute a part of its visual-verbal composition, and their shape-shifting from prose to protocomics occupies part of the book's reflective plotline, but also because they register the desire to record, to inscribe, and also the difficulty of doing so—the problem Bechdel will return to as an adult writing and drawing *Fun Home*. In *Fun Home* this difficulty is poised at the gap between the sentence and the symbol, even at the place where word and image are *contiguous*, as when the circumflex is marked over a word. In an interview for a 2006 feature about Bechdel in the *Village Voice*, she told me, as we looked over her re-created childhood handwriting, "I have the weird tic where I would *obliterate* words, just fixate on that little graphic gesture. I know I have said that the book is just an expansion of my freshman English paper [on *Portrait of the Artist as a Young Man*]. But in another way, the book is an expansion of my childhood diary, in that it's this perseveration on detail" (Chute, "Gothic Revival" 36). In the narrative of development from obsessional childhood diarist to obsessional cartoonist that Bechdel implies—despite and even through her obsession with archives—*Fun Home* charts a process of recognizing the unsolvability of the gap between word and image and approaching the aporetic through comics. Discussing her childhood diaries and their procedure of obliterative symbols in a talk, Bechdel

THE ENTRIES PROCEED BLANDLY ENOUGH. SOON I SWITCHED TO A DATE BOOK FROM AN INSURANCE AGENCY, WHICH AFFORDED MORE SPACE.

> Friday MARCH 26
>
> It was pretty warm out. I got out a Hardy Boy Book. Christian threw sand in John's face. He started to cry. I took him in. We went

BUT IN APRIL, THE MINUTELY-LETTERED PHRASE *I THINK* BEGINS TO CROP UP BETWEEN MY COMMENTS.

> I finished *I think* "The Cabin Island Mystery." Dad ordered 10 reams of paper! *I think* We watched The Brady Bunch. I made popcorn. *I think* There is popcorn left over

IT WAS A SORT OF EPISTEMOLOGICAL CRISIS. HOW DID I KNOW THAT THE THINGS I WAS WRITING WERE ABSOLUTELY, OBJECTIVELY TRUE?

ALL I COULD SPEAK FOR WAS MY OWN PERCEPTIONS, AND PERHAPS NOT EVEN THOSE.

MY SIMPLE, DECLARATIVE SENTENCES BEGAN TO STRIKE ME AS HUBRISTIC AT BEST, UTTER LIES AT WORST.

THE MOST STURDY NOUNS FADED TO FAINT APPROXIMATIONS UNDER MY PEN.

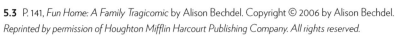

5.3 P. 141, *Fun Home: A Family Tragicomic* by Alison Bechdel. Copyright © 2006 by Alison Bechdel. *Reprinted by permission of Houghton Mifflin Harcourt Publishing Company. All rights reserved.*

suggests that they have something to do with why she became a cartoonist. "I do think I sensed on some level that if language was unreliable, and appearances were deceiving, then maybe somehow by *triangulating* between them, you could manage to get a little closer to the truth," she said, also noting that "the space between the image and words was a powerful thing if you could figure out how to work with it" ("PEN/Faulkner" 2). Ultimately, in *Fun Home*—which retains its gaps, the complex unbridgability between word and image—this is not "truth" in any elusive empirical sense, but an analytic texture, an emotional, experiential accuracy. In an anecdote about her father sinking into fields of mud as a toddler, she draws the rescuer as a milkman, even as she tells us she knows he was a mailman (41).

Comics is a procedure of *mapping*: mapping time into space.[37] "Cartoons are like maps to me," Bechdel has said, and the book "is a fairly accurate map of my life" ("PEN/Faulkner" 4). Bechdel follows her meditation on her childhood diaries with a meditation on mapping. (The diaries and maps of the book both chart information spatially, combining word and image.) In a two-tier page that eliminates any vertical gutters, she draws her favorite page from *The Wind in the Willows* coloring book—a map—above a map of the part of Beech Creek, Pennsylvania, where she grew up (146; figure 5.4). "The endless slippage between signifier and signified that was troubling to me in my diary entries seemed somehow to come to rest here—or at least pause," Bechdel has explained ("PEN/Faulkner" 4). In both maps we see representations of what Bechdel calls "the symbolic and the real . . . the label and the thing itself"—in other words, of word and image (*Fun Home* 147). Yet the narrator knows that *the real* is not delivered by the image, just as *Fun Home* knows it can never actually preserve the past.[38] While the interaction between what Bechdel calls the symbolic and the real describes one version of comics's map, another set of terms, which indicates what comics's formal proportions can put into play—the unresolvable interplay of elements of absence and presence—is a Lacanian map: the linked triad of the Symbolic, the Imaginary, and the Real (*le réel*). The last is a psychic order that exists outside possible symbolization and that we may understand is suggested by the absent spaces of the gutter. In language that aptly describes the work of the gutter, Alan Sheridan describes the Lacanian real as "the ineliminable residue of all articulation, the foreclosed element, which may be approached, but never grasped" (280).[39]

It is "triangulating between" words and images—or providing what Bechdel calls "the space between the image and words"—that enables *Fun Home* to present the story of her relationship with her father, a story that is ultimately

IN OUR *WIND IN THE WILLOWS* COLORING BOOK, MY FAVORITE PAGE WAS THE MAP.

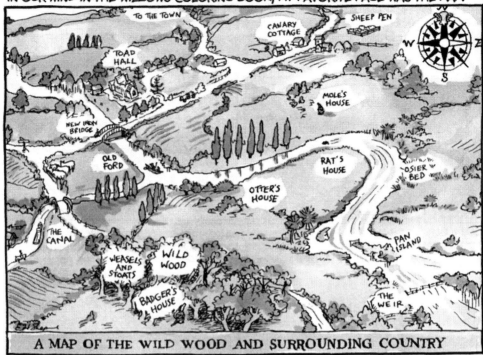

A MAP OF THE WILD WOOD AND SURROUNDING COUNTRY

I TOOK FOR GRANTED THE PARALLELS BETWEEN THIS LANDSCAPE AND MY OWN. OUR CREEK FLOWED IN THE SAME DIRECTION AS RATTY'S RIVER.

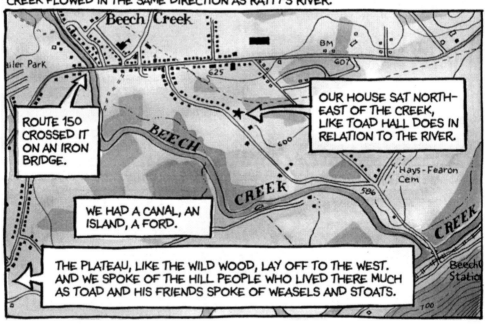

ROUTE 150 CROSSED IT ON AN IRON BRIDGE.

OUR HOUSE SAT NORTHEAST OF THE CREEK, LIKE TOAD HALL DOES IN RELATION TO THE RIVER.

WE HAD A CANAL, AN ISLAND, A FORD.

THE PLATEAU, LIKE THE WILD WOOD, LAY OFF TO THE WEST. AND WE SPOKE OF THE HILL PEOPLE WHO LIVED THERE MUCH AS TOAD AND HIS FRIENDS SPOKE OF WEASELS AND STOATS.

5.4 P. 146, *Fun Home: A Family Tragicomic* by Alison Bechdel. Copyright © 2006 by Alison Bechdel. *Reprinted by permission of Houghton Mifflin Harcourt Publishing Company. All rights reserved.*

about two registers existing at once: her father is her collaborator *and* her biggest inhibitor; *Fun Home* is a funeral that marks his death, and yet its inscriptions resist the epitaphic. And, while the book is occupied with repetition, it is also regenerative: with its conspicuous gaps, it marks its difference from her father's dead-end goal of trying to capture and preserve impeccable surfaces that we see in his own obsessive documentation both of the family house and of what Bechdel, in a biting appraisal of his paternity, calls his "exhibit," his own "still life with children" (13). As against this, Bechdel asserts her own necessarily messy, unembalmed, live body.

Bechdel's redrawn archive, then, says more about comics as *a procedure of what I am calling embodiment*, and the instantiation of handwriting as a gripping index of a material, subjective, situated body, than it does about the status of the archival as a stable register of truth.[40] In a dramatic scene indicative of *Fun Home*'s investment in embodiment, when Bechdel returns to her childhood diaries, immediately after reflecting on the procedure of mapping, the resultant page splits its two images equally, juxtaposing the dead body of a child at the fun home ("still life") on the top tier with a panel that demonstrates both the materiality of Alison's childhood diaries (which are here drawn larger than life size) as well as the rough, messy marks of two implied live bodies: the childhood Alison and the adult re-creator. The big, scrawled, inverted *V* symbols of Alison's twinned "I think"s over her writing are here echoed by the inverted *V* shape created by the sheet Bruce Bechdel pulls back from the corpse he prompts his children to see (figure 5.5). The still, dead boy mirrors Alison: he is a distant cousin exactly her age. The contrast of the dead body (a possible dead self, tended to by her father) with the energetic bodily marks of the inscribing body below points up the animated corporeality of writing and drawing.[41] The diary entry reports, "Dad showed us the dead people. They were cut up and stuff" (148). In its anxious, forcefully marked combination of words and images, it is already a form of protocomics, but this entry further registers the first appearance in Alison's diaries of an actual established language of comics: without any comment from the diarist, a smiley face simply appears, punctuating a very grim report.[42] In the face of death, Bechdel counters with an image, which despite its banality carries for her the weight of the unknown. While Jared Gardner calls the smiley face "pathetic"—and one can see how it might appear a bit wan, floating beside the vigorously inscribed circumflexes—in my reading it is rather a register of exhilaration: the exhilaration of cartooning as a practice of embodiment that runs counter to death ("Autography's" 4).

DAD EXPLAINED THAT HE HAD DIED FROM A BROKEN NECK.

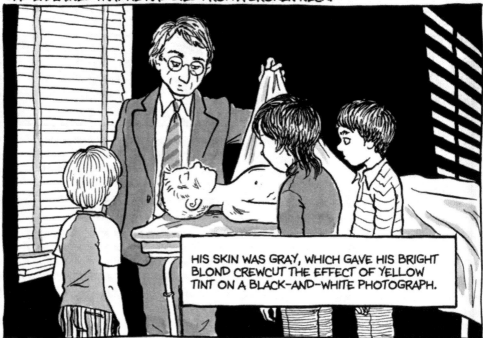

HIS SKIN WAS GRAY, WHICH GAVE HIS BRIGHT BLOND CREWCUT THE EFFECT OF YELLOW TINT ON A BLACK-AND-WHITE PHOTOGRAPH.

MY DIARY ENTRIES FOR THAT WEEKEND ARE ALMOST COMPLETELY OBSCURED.

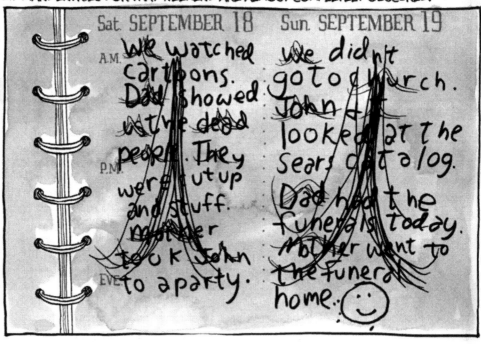

5.5 P. 148, *Fun Home: A Family Tragicomic* by Alison Bechdel. Copyright © 2006 by Alison Bechdel.
Reprinted by permission of Houghton Mifflin Harcourt Publishing Company. All rights reserved.

GAPING

Fun Home is drenched in death. It is, after all, not only about suicide but also about the suicide of a mortician. And yet the embodiment its every page proposes serves as a contrast to the pervasiveness of death and the many dead bodies—chief among them, Bruce Bechdel's—the book presents. *Fun Home* is a profoundly bodily book, but in a much different way than we see in Gloeckner's work, in which she renders sexually engaged and engorged bodies that leap confrontationally off the page. Bechdel's book is about sexuality, but its most shocking bodies are dead (its sexually involved bodies are earnest and sweet).[43] And *Fun Home*'s handwriting, including its retranslation of archival documents through the body of the author-daughter at its center, inscribes its paradox onto its pages: "The book is about my father's suicide, but it's also about the opposite of suicide" ("PEN/Faulkner" 3).

An emotional and physical confrontation between Alison and her father at a site of death in chapter 2 makes lucid the book's central suggestion, which is shaped by the specific way death moves between them, about its project and form. While this chapter, titled "A Happy Death," after Camus's first novel, the book Bruce Bechdel was reading before he died, is heavily weighted, graphically, with dead bodies—five of *Fun Home*'s seven, including Bruce Bechdel himself, in a casket—the detailed father-daughter-corpse scene in the fun home's embalming room is the most striking. Alison, thirteen, is vacuuming the fun home when her father, unusually, calls her into the embalming room where he is working.

If, in "The Canary-Colored Caravan of Death" (whose chapter title, in the echo of its last word, indicates just how explicitly preoccupied the book is with loss), Bechdel shows us how her father displays to Alison the gray-skinned boy her own age, in this event he forces her to look at a young man about his own age. The man was, in Bechdel's narration, "jarringly unlike Dad's usual traffic of dessicated old people"—which appears to be, as in the episode with the broken-neck boy, Bruce's reason for soliciting his daughter's attention (44; figure 5.6). In the central page of this episode, its first sentence, which travels across the full horizontal length of the page at its top, splits off after "Dad's," graphically suggesting, in its lineation, the contrast between the dead man and the live father: the first line of text looks to propose how the corpse is "jarringly unlike Dad." But the comparison of the two men introduced in the presentation of the sentence, even as a negative proposition, in fact indicates their propinquity. The entire chapter suggests the presence of Bruce Bechdel's death during his life; in the aforementioned incident in which the three-year-old Bruce wanders off away from home into fields of mud, an event in which he almost died, Bechdel draws,

THE MAN ON THE PREP TABLE WAS BEARDED AND FLESHY, JARRINGLY UNLIKE DAD'S USUAL TRAFFIC OF DESSICATED OLD PEOPLE.

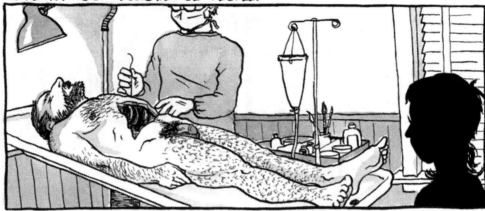

THE STRANGE PILE OF HIS GENITALS WAS SHOCKING, BUT WHAT REALLY GOT MY ATTENTION WAS HIS CHEST, SPLIT OPEN TO A DARK RED CAVE.

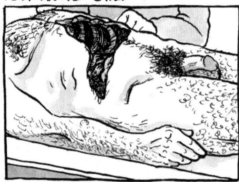

IT FELT LIKE A TEST. MAYBE THIS WAS THE SAME OFFHANDED WAY HIS OWN NOTORIOUSLY COLD FATHER HAD SHOWN HIM **HIS** FIRST CADAVER.

THERE WAS SOME PRACTICAL EXCHANGE WITH MY FATHER DURING WHICH I STUDIOUSLY BETRAYED NO EMOTION.

HAND ME THOSE SCISSORS OVER BY THE SINK.

OR MAYBE HE FELT THAT HE'D BECOME TOO INURED TO DEATH, AND WAS HOPING TO ELICIT FROM ME AN EXPRESSION OF THE NATURAL HORROR HE WAS NO LONGER CAPABLE OF.

5.6 P. 44, *Fun Home: A Family Tragicomic* by Alison Bechdel. Copyright © 2006 by Alison Bechdel. *Reprinted by permission of Houghton Mifflin Harcourt Publishing Company. All rights reserved.*

in a large bird's-eye view panel, a truck that drives in his direction, quietly chugging toward him (41).[44]

In the embalming room scene, below the opening sentence, the page begins with a long, rectangular panel that accommodates a full view of the man's body, laid out on the embalming table; Alison lurks at the bottom right edge of the frame, monochromatically blackened and in silhouette—a graphic technique Bechdel uses to highlight certain acts of looking—while the man's body tilts down toward her, as if he might actually slide onto her.[45] His penis faces her directly, as if in confrontation. Her father pulls a thread through the side of the man's ribcage, a thread that connects the two men literally and figuratively. In the second tier, the book calls further attention to Alison's protracted act of looking. The first panel in the tier, an echo of the opening image above it, homes in closely on the man's chest, "split open to a dark red cave," while the following panel reverses the perspective to absent the cadaver from the frame and to offer a view of Alison staring from the doorway and her father's face (almost as if from the perspective of the dead man himself). The third tier repeats this pattern: in the first panel we see the dead man, and in the second the view returns to picture Alison looking at the body while Bruce—this time with his face turned away—occupies the foreground. In the first Bruce and Alison's hands, which is all we see of either of them, enter the panel from opposite sides of the frame, conspicuously not quite meeting each other in the handoff of medical scissors directly above the corpse.

The compositional focus on the space of absence *between* the two hands reaching out one for the other and almost touching is reminiscent of perhaps the most famous scene in art: Michelangelo's iconic image of the hand of God giving life to Adam, in the Sistine Chapel, in which there is a visible space of absence between the grasping forefingers of God and Adam, who just barely do not make physical contact. Visually, Bechdel figures Alison in the God position, hand stretching in slightly below from the right (the extended scissors approximating Michelangelo's God's stretched-forward index finger); the more languid-looking posture of her father's waiting hand and wrist figures Adam's. He, then, is waiting to be animated, to be given life, by her (the daughter to whom he gave life), even as Bechdel twists the notion of the life-giving scene by drawing it within an explicit scene of death, over a pictured dead body who represents her father's bodily fate. While her father ultimately dies—his other hand in this panel still holds the thread that connects him to the corpse—this scene makes legible how she animates him, in the book, through her own physical, haptic act of bearing witness to his life and death.

While most of *Fun Home*'s pages read left-to-right horizontally, the "gaping cadaver" page also suggests a vertical graphic structure (much as the Roy page gestures at unconventional or multiple reading patterns; 45).[46] The opening panel shows both the body and the protagonist's act of looking at the body—the man on the left, Alison on the right in the tier-wide bordered rectangle. Moving vertically downward, images of the corpse continue on the left, while images of Alison looking continue on the right. Death is on one side of the page; Alison is on the other, watching intently. And Bruce is in the middle, mediating: the only place in which his face is actually visible is close to the very center of the page. (Traveling through the page conventionally, left to right, one might say the movement of the panels signifies the same contrast: dead→looking, dead→looking, dead→looking.) The narration concludes that Bruce is either testing Alison's composure or attempting to access emotion ("the natural horror") that he has become inured to, through his presumably shocked daughter (44). But Bechdel's prose narration does not suggest the most obvious motive— Bruce Bechdel is showing her his own death: his possible dead self, nominally tended to by his daughter or at least witnessed by her. She will, in fact, be a close reader/close looker of that death; that is the project of *Fun Home* itself. Here her own close reading of the body of the man, and her father's tacit insistence that she be a witness to this deconstituted person, establishes the dynamic the book itself instantiates.

Bechdel identifies the most terrifying aspect of the body as not the penis but its split-open chest (this "cave" creates a wobbly triangular shape evocative of Alison's curvy circumflex symbol). The absence at the center of the body—its *gapingness*—is what shocks. And this bodily gap is underscored by, and itself amplifies, the conspicuous gap between father and daughter appearing exactly over (and, in effect, doubling) this space of fleshly absence as their hands reach toward one another across the corpse and freeze in the frame without touching. If Alison is surrounded by death in the daily texture of her life, it is not just because she is a mortician's daughter but also because her father is on the other side of an unspoken psychic divide: he has already, in a sense, begun dying; the coherence, the shape, of his life and person are riddled with insurmountable gaps. This is literalized in the gross figure of the cadaver he makes his daughter witness.[47] On the very next page, fast-forwarding seven years, Alison gets the phone call that her father has died.[48] And while the scene implies through its cold surrogate body that Bruce Bechdel winds up "saying 'no' to his own life," as Bechdel puts it later, it also implies how Alison's role as a witness to the intricacies of her father's life is formed by both emotional detachment—the feat she pulls off in the embalming room—and the careful *close looking* we see her perform in this

scene and with this book (228).[49] The close looking and close reading of *Fun Home*, however, is not without its own gaps: the page of comics—the body of the page—produces its own necessary absences. *Fun Home* does not stitch up the gap at its center—Bruce Bechdel's death—so much as give a substance to loss; in its form, it actually *caresses* the loss. And, if in addressing his particularity so profoundly, the text can be seen to resurrect or reconstitute Bruce Bechdel's body, it is a body, a history, that remains riddled with gaps.

Despite and because of the gap in hands between father and daughter, *Fun Home* is immersed in verbal and visual languages of touching. Unlike with prose, wherein its creator does not have to touch it—today, one can write a book and never physically *touch* one's own prose at all—the spatialized form of comics, which "has to look like what it is," as Bechdel explains, mandates a baseline manual sensuality.[50] In order to make the book, Bechdel says, "I had to touch every millimeter of all of the pages" ("A Conversation"). Further, as W. J. T. Mitchell reminds us, vision itself is a form of touch: in the installation procedure for the human visual system, "One must learn to use and understand the visual impressions by coordinating them with tactile impressions. Thus, normal seeing is, in a very real sense, a form of extended, highly flexible *touch*" ("Visual Literacy" 13).[51] While we may consider, then, vision a form of touching (not "purely" optical but rather optical and tactile), the *re*-visioning required to draw history and memory in *Fun Home* is also a form of touch. "Certainly drawing this about my family, it felt like I was—and all the pictures of my dad, with close-ups of his face—it was really like touching him," Bechdel told me in an interview. For her next book, *Love Life*, she wants to make even clearer "that drawing is a form of touch, and paper is like a kind of skin" (Interview 2008).

There are many layers of touch, then, in this book that so heavily thematizes acts of looking and touching. Exploring the idea that her own coming out triggered her closeted father's suicide, *Fun Home*'s narrator concludes, "Causality implies connection, contact of some kind. And however convincing they might be, you can't lay hands on a fictional character" (84). (Alison is pictured from behind, peering hesitatingly into her father's library, calling out "Dad?") The haptic language of "contact" and "laying hands" is deeply significant here. *Fun Home* is everywhere about interpellating Bechdel's father as real—as *non-fictional*—through the process of drawing him; the book struggles against the conclusion that he is "a fictional character" through its intense attention to the particularities of his person, a project of close reading and looking glued together by the intimacy of (retroactive; posthumous) touching. Comics is not only a way to mark her own body onto the page (the stillness of the corpse versus the frenzied circumflex) but also a way to intimately touch the subjects, even and

especially the dead subjects, on whom her work focuses, to *lay hands* on them through drawing, as the language of chapter 3 suggests.[52]

I have said that *Fun Home*'s narration is rooted in acts of looking at archives. But in *Fun Home* the re-generation of archives is about asserting the power of comics as a form to include and also to fruitfully *repurpose* archives, not about solving any epistemological crisis. In fact, the archive of photographs Bechdel draws, for instance, is compelling but tells us little as "evidence"; as windows onto the past the photographs remain ambiguous, blurry. This is especially the case with the found document that was the seed for the book itself, the photograph of the semiclad babysitter with whom Bruce Bechdel was having an affair (100–101).[53] If we see a kind of compulsive reproduction of particular textual objects like letters and photos—a going back into the past to *re-mark* archival documents with her own body—we can also note a literal reenactment in production. Bechdel did five or six successive sketches for each panel in the book. In addition, for every pose of every panel in the entire book—which comes out to roughly one thousand panels—Bechdel, as I noted in the last chapter, created a reference shot by posing herself for each person in the frame with her digital camera (see figures 5.7 and 5.8). In the cases where she already had a photographic reference shot from her parents' collection, she yet posed herself in a new photo. In one panel, say, depicting a classroom of children sitting at desks, Bechdel posed for every child. In this way, Bechdel created for *Fun Home* a shadow archive of the archive of photographs and other documents at the book's center. Even at this fundamental level of process, what she generates in the process of examining her parents mimics or doubles. The book is about a family archive: she re-creates that archive with her pen on the book's pages and she also generates a counter, phantom archive of her own that exists on discs and computer files.[54] On a promotional DVD that came with the press copy of the book, Bechdel remarks, setting up a pose, "The really interesting thing is when I have to act out my parents having a fight and I have to be both of them."[55] Bechdel's cartooning practice clarifies what runs throughout *Fun Home* in theme and form at every level: embodiment. The notion of embodiment as corporeal habitation, to draw on language from the OED, is particularly relevant here. Bechdel repeats her parents' role, both at a figurative level and at a literal visual level—a physical level in space. And in her re-creation, her body is never separate from their bodies: she performs their postures, remakes the marks they made. "I'm kind of a method cartoonist," she describes in an interview. "In one of my more vivid research efforts, I stood beside the road at the spot where my dad died, photographing trucks as they approached and passed. It seemed important not just to know what that looked like, but what it felt like" ("Talking" 7). In the act of

5.7a (*top*) Panel from p. 197 of *Fun Home: A Family Tragicomic* by Alison Bechdel. Copyright © 2006 by Alison Bechdel. *Reprinted by permission of Houghton Mifflin Harcourt Publishing Company. All rights reserved.*

5.7b (*bottom*) Alison Bechdel, photograph of the author posing as her father. Photograph copyright © 2005 Alison Bechdel. *Reprinted with permission.*

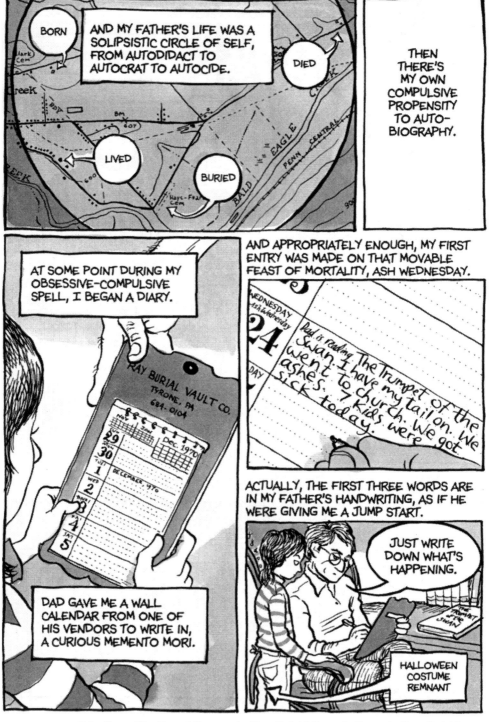

5.8a P. 140 of *Fun Home: A Tragicomic* by Alison Bechdel. Copyright © 2006 by Alison Bechdel. *Reprinted by permission of Houghton Mifflin Harcourt Publishing Company. All rights reserved.*

5.8b Alison Bechdel, photograph of the author posing as her ten-year-old self, holding the actual wall calendar her father gave her when she was ten. Photograph copyright © 2005 Alison Bechdel. *Reprinted with permission.*

creating *Fun Home*, Bechdel inhabits the contradiction of being *of* her parents and yet separate from them.

WROUGHT

The generative space in the gaps between comics's words and images is made especially clear as the book picks up momentum at its close, where it explicitly stakes out Bechdel's difference from her father. Here the book converges with *Ulysses*, which becomes—along with Joyce himself—a central focus for what we might think of as *Fun Home*'s working out of its archival drive. Here, Bruce Bechdel's copy of *Ulysses*—the copy he himself used in college, which in *Fun Home* has archival status—figures prominently as a thematic and a literal foundation for Bechdel's own verbal and visual narration. While each of *Fun Home*'s seven chapters takes on at least one, and often several, literary figures and their works, the book is engaged in its first and last chapters with Joyce. In fact, the first words of the book—presented graphically, dramatically—are Joyce's, from *Portrait*: underneath a drawn photograph of a seductive Bruce Bechdel, which floats in white space and is missing one photo corner, are the bold words of

the chapter title: "Old Father, Old Artificer" (see figure 5.1).[56] The last chapter, too, titled "The Antihero's Journey," takes up Joyce as framework. While Michael Moon argues that Colette "wins the battle for the soul of Bechdel's *Fun Home*"—in part because Bechdel does twice draw the scene of her father handing off *Earthly Paradise* to her, in which both their hands are contiguous with the book—neither the figure of Colette nor *Earthly Paradise* has the visual presence in *Fun Home* that Joyce and *Ulysses* do.[57] Through its treatment of *Ulysses*, *Fun Home* makes clear the expansiveness and the inclusivity of the spatial aesthetics of comics. *Fun Home* is a book, even at a basic denotative level, about form— and modernist writing is one part of that, but it is really about, as Bechdel says, not only becoming an artist, but more specifically "why I became a *cartoonist*": instead of *replicating* her father's interest in writing, she incorporates it into an expanded form that includes both writing and drawing ("PEN/Faulkner" 3).

We see this most forcefully in the book's last chapter. Alison depicts herself in a college seminar on *Ulysses*; earlier her father had bestowed her his personal copy of the book, and she sits with it in her lap (209). But we can observe that she is unengaged with the prose, refusing her father and her professor's exegetical enthusiasm, instead making her own literal mark all over the text, a sort of intergenerational palimpsest. Bechdel shows this scene first from a distance, then in the second panel the frame focuses close up: she is rejecting the text, drawing pictures over it (figure 5.9). In my interview with her for the *Voice*, she said, "It was sort of like *fuck you*. A *fuck you* to my dad and to James Joyce. . . . I would draw pictures over the page" ("Gothic Revival" 39). As the book draws to a close, *Ulysses* forcefully threads back in.[58] As a way of indicating the ability of comics to put multiple discourses into play on a single page, I will turn my attention to a reading of *Fun Home*'s third to last page (230).

The page has four narrative levels (figure 5.10). It starts with the adult narrator, in a vertically elongated, detached text box, musing on "erotic truth"—her own and her father's. The page immediately sets up instability, gaps: "I shouldn't pretend to know what my father's was," Bechdel proclaims. The second panel continues this first-person narration, in unbordered overarching text, and pairs it with a nonsynchronous, silent visual narrative: the child Alison, perhaps five or six, clad in a dark striped swimsuit, riding on her father's back, arms clutching his neck, as he swims toward the right, in the direction of reading. Alison's mother sits frozen in a chair on the edge of the pool. The text declares, "Perhaps my eagerness to claim him as 'gay' in the way that I am 'gay' . . . is just a way of keeping him to myself, a sort of inverted Oedipal complex." The image makes this legible: Bruce Bechdel looks desiring, contentedly heavy-lidded, but he is looking away and swimming away from his wife, toward something or someone

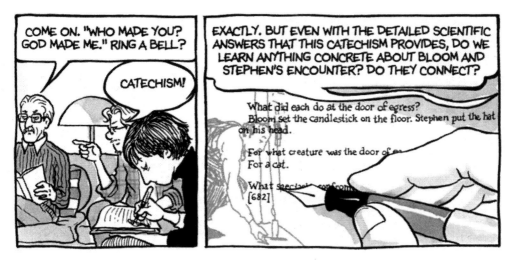

5.9 Panels from p. 209, *Fun Home: A Family Tragicomic* by Alison Bechdel. Copyright © 2006 by Alison Bechdel. *Reprinted by permission of Houghton Mifflin Harcourt Publishing Company. All rights reserved.*

else; Alison smiles, tightly on his back, looking and moving in the same direction. Both of their expressions are desiring, happy. They are together in the foreground; the two of them are the unit, tandem in the ("inverted") direction of their desires.[59] Alison and her mother, in another scene from the previous chapter, conspicuously face opposite directions as they swim laps together in a pool (173). Here the father and daughter bodies are marked by their distinction from the normativity represented by the heterosexual mother they leave in their wake.

The next narratorial sentence is spaced out across the entire horizontal length of the second tier: "I think of his letter, the one where he does and doesn't come out to me." Below, in a pagewide panel—its lack of gutter, where time passes in comics, connoting the stillness of its archival status—Bechdel draws a typed letter from Bruce Bechdel, visually highlighting his line "I am not a hero."[60] "It's exactly the disavowal Stephen Dedalus makes at the beginning of *Ulysses*," the narrator notes below, and then Bechdel reproduces the typeset chunk of *Ulysses*—a dialogue, here—highlighting Stephen's matching phrase from the Telemachus chapter. The two rectangular panels of re-created type are twinned—her father's prose and Joyce's prose. The last tier then begins, like the first, with a detached text box: "In the end, Joyce broke his contract with Beach and sold *Ulysses* to Random House for a tidy sum." And it ends, as in the first, with a silent visual narrative: Alison and her father, again, her arms still around his neck, but slipping back, creating a space between them, as the two move through the water without speaking. This time the mother is gone. The overarching narration: "He did not offer to repay her for the financial sacrifices she'd made for his book."

"EROTIC TRUTH" IS A RATHER SWEEPING CONCEPT.

I SHOULDN'T PRETEND TO KNOW WHAT MY FATHER'S WAS.

PERHAPS MY EAGERNESS TO CLAIM HIM AS "GAY" IN THE WAY I AM "GAY," AS OPPOSED TO BISEXUAL OR SOME OTHER CATEGORY, IS JUST A WAY OF KEEPING HIM TO MYSELF--A SORT OF INVERTED OEDIPAL COMPLEX.

I THINK OF HIS LETTER, THE ONE WHERE HE DOES AND DOESN'T COME OUT TO ME.

Helen just seems to be suggesting that you keep your options open. I tend to go along with that but probably for different reasons. Of course, it seems like a cop out. But then, who are cop outs for? Taking sides is rather heroic, and I am not a hero. What is really worth it?

IT'S EXACTLY THE DISAVOWAL STEPHEN DEDALUS MAKES AT THE BEGINNING OF ULYSSES--JOYCE'S NOD TO THE NOVEL'S MOCK-HEROIC METHOD.

— A woeful lunatic, Mulligan said. Were you in a funk?
— I was, Stephen said with energy and growing fear. Out here in the dark with a man I don't know raving and moaning to himself about shooting a black panther. You saved men from drowning. I'm not a hero, however. If he stays on here I am off.
Buck Mulligan frowned at the lather on his razorblade. He hopped down from his perch and began to search his trousers

IN THE END, JOYCE BROKE HIS CONTRACT WITH BEACH AND SOLD ULYSSES TO RANDOM HOUSE FOR A TIDY SUM.

HE DID NOT OFFER TO REPAY HER FOR THE FINANCIAL SACRIFICES SHE'D MADE FOR HIS BOOK.

5.10 P. 230, *Fun Home: A Family Tragicomic* by Alison Bechdel. Copyright © 2006 by Alison Bechdel. *Reprinted by permission of Houghton Mifflin Harcourt Publishing Company. All rights reserved.*

Bruce does not look desiring anymore; Alison looks startled. Her father, an "absent husband," breaks his contract (vows) with his wife by virtue of both his gay affairs and not repaying Helen Bechdel for her decades of sacrifice ("I'm sick of cooking for him and I'm sick of cleaning this museum"); instead, he kills himself two weeks after she asks for a divorce (216). And he also breaks his contract with Alison—the spurned lesbian figure, like Beach—by killing himself, not offering to repay her for the sacrifices she had made for his book; in other words, for *her* book, the one we read. (This page points up how much *Fun Home* is, in fact, in its search for his particularity, *his* book: he is finally, as he always wanted, a character in a literary narrative, famous and commemorated.) Here, in this punctuating panel, Bruce and Alison swim in the opposite direction than they did before, moving against the direction of reading, as if pointing us back toward the narrative we have been reading. On this page Bechdel proposes, and resolves, a kind of war of media: her father's prose, mirrored by her father's favorite prose, literally occupies center stage, and she frames this with her own visual frames: her own silent but full visual narrative at the top and bottom. Instead of writing over *Ulysses*, as her adolescent character had done on the earlier page, Bechdel incorporates *Ulysses into* the fabric of her comics narrative, no longer rejecting it but weaving it in, juxtaposing both the status of prose and the status of visual narrative, and staging their confrontation, in order to point to the capacities of the comics page.

If, in its windup to the end, *Fun Home* stages the conversations comics fashions across media and documents, in its *very* last pages it proposes two repetitive (but ultimately productive) acts that both reflect the trauma at the book's core. One of the book's most haunting visual repetitions, which encloses the entire narrative, underscores its central suggestion: that Bechdel's father, as cruel and petty as he was, was both a disabling and *enabling* force. The first page of *Fun Home* opens with the father and daughter playing the child's game "airplane" (3; figure 5.11). Alison is balanced on her father's legs; he holds her up, physically supporting her. In an overlaid text box, at the bottom of the page, Bechdel writes, "In the circus, acrobatics where one person lies on the floor balancing another are called Icarian games." The next page makes reference to the fate of Icarus, who flouted his father's advice and flew too close to the sun, and then, stamping a panel that depicts Alison tumbling down—and even intruding on a full view of her head—is a text box that reads: "In our particular reenactment of this mythic relationship, it was not me but my father who was to plummet from the sky" (4; figure 5.12).

On the first page Alison is Icarus, the child figure, and her father is Daedalus. Almost immediately after establishing this relationship, Bechdel reverses

it. This shifting of child and parent roles back and forth between Alison and her father occurs throughout the text, but most powerfully at the book's beginning and end. In the last chapter of the book, Bechdel maps—but unstably—herself and her father onto Odysseus and Telemachus and onto related characters from Joyce's *Ulysses*; there is slippage between father and daughter as they get compared to a range of characters. For the conversation in which Bruce Bechdel first talks openly to Alison about being gay, we get a rare "democratic" page—meaning the panels are completely uniform (221). The perspective of each panel is the same, and each panel underlines the stark division between father and daughter: they are each aligned with a separate car window; a black bar of sorts lies between them. The text reads, "It was not the sobbing, joyous reunion of Odysseus and Telemachus," and then, referring to Joyce's *Ulysses*, "it was more like fatherless Stephen and sonless Bloom." "But which one of us was the father?" Bechdel asks. Next, Alison is shown as Bloom, whose own father was a suicide. Then, Bruce Bechdel is figured as both Joyce's Stephen—he lifts his line, "I am not a hero," in his letter to Alison—and also as Joyce himself, in his less palatable moments. When Bechdel has finished narrating a publication history of *Ulysses*, her book also ends: The end of *Ulysses* becomes the end of Bruce Bechdel. Concluding, in a penultimate page that *repeats* the postures of the very first page, Bechdel asks, with her father below her, looking up at her, "What if Icarus hadn't hurtled into the sea? What if he'd inherited his father's inventive bent? What might he have wrought?" The answer, of course, is the book itself.

On its last page, then, *Fun Home* visually presents the devastating sadness at the heart of the book: Bechdel, in outliving her father and becoming the artist he always wanted to be, finally *surpasses* her father; *he* is Icarus. (Bechdel's recent essay in *Granta* about making *Fun Home* picks up the answer to her question: it is simply titled "Wrought.") *Fun Home* ends by implying two movements—the speeding truck, the jumping girl—for an effect that is fluid and frozen at once. Underscoring the iconic nature of the traumatic image, it concludes here by repeating, as elsewhere, the visual image that most haunts Alison—the imagined moment before her father's suicide. We see the truck, on the last page, from the full-on perspective of someone, perhaps, about to be hit by it. The text centered over the grill of the truck reads, "He did hurtle into the sea, of course." But ultimately, "in the tricky reverse narration that impels our entwined stories, he was there to catch me when I leapt" (232). Below the truck, the child Alison jumps into the water—not balanced precariously on her father's legs, as in the beginning, as if a bodily extension, but rather poised above him moving into his outstretched arms. (Her movement of jumping forward into his arms contrasts with the movement we do not see: Bruce Bechdel jumping backward into the

LIKE MANY FATHERS, MINE COULD OCCASIONALLY BE PREVAILED ON FOR A SPOT OF "AIRPLANE."

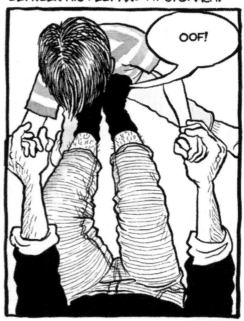

AS HE LAUNCHED ME, MY FULL WEIGHT WOULD FALL ON THE PIVOT POINT BETWEEN HIS FEET AND MY STOMACH.

OOF!

IT WAS A DISCOMFORT WELL WORTH THE RARE PHYSICAL CONTACT, AND CERTAINLY WORTH THE MOMENT OF PERFECT BALANCE WHEN I SOARED ABOVE HIM.

IN THE CIRCUS, ACROBATICS WHERE ONE PERSON LIES ON THE FLOOR BALANCING ANOTHER ARE CALLED "ICARIAN GAMES."

5.11 P. 3 (opening page of chapter 1), *Fun Home: A Family Tragicomic* by Alison Bechdel. Copyright © 2006 by Alison Bechdel. *Reprinted by permission of Houghton Mifflin Harcourt Publishing Company. All rights reserved.*

CONSIDERING THE FATE OF ICARUS AFTER HE FLOUTED HIS FATHER'S ADVICE AND FLEW SO CLOSE TO THE SUN HIS WINGS MELTED, PERHAPS SOME DARK HUMOR IS INTENDED.

BUT BEFORE HE DID SO, HE MANAGED TO GET QUITE A LOT DONE.

HIS GREATEST ACHIEVEMENT, ARGUABLY, WAS HIS MONOMANIACAL RESTORATION OF OUR OLD HOUSE.

5.12 P. 4, *Fun Home: A Family Tragicomic* by Alison Bechdel. Copyright © 2006 by Alison Bechdel. *Reprinted by permission of Houghton Mifflin Harcourt Publishing Company. All rights reserved.*

road in front of the truck.) Here, at the end, she is the one made graphically distinct by the dark outfit he wears in the book's opening. This image captures both the graceful *space between* their bodies as they move toward one another and yet their imbrication: the text box appearing *over* the bodies of the father and daughter also jangles their limbs and fully bisects Bruce Bechdel's body. The child body of Alison and the text of the adult daughter fully encompass him: her arm spreads out over his head; the text box contains him from below. Catching her, he is an ideal version of paternal Daedalus; but, in the top right of the panel, the patterned back of a pool chair, almost graphically contiguous with the grill of the truck across the slim gutter, lines up with his body, bearing down on him, reminding us that although she jumps, he was the one to "hurtle."

Alison Bechdel becomes the father of the dyad in the space between *Fun Home*'s penultimate and ultimate page. When Alison starts to slip off of Bruce's back, as we see at the conclusion of the twinned-prose page, she does not hang on tighter; neither does she fall. Instead, Alison separates from him. (figure 5.13) In the first image of the penultimate page, she climbs up onto the diving board to jump. She is active; her father, immersed in the water, waits for her and watches her.[61] The perspective of the panel, significantly—especially following those panels in which father and daughter match gazes in a shared direction—is down below Alison, looking up at the girl ascending. The composition shows up Bruce's act of looking, prominently displaying the back of his head as he turns directly toward her. The verbal narration, crucially, begins by unpacking valences of the concept of *generation*, suggesting through Sylvia Beach that books, in fact, are children. "Beach put a good face on it, writing, 'A baby belongs to its mother, not its midwife, doesn't it?'" reads the overarching text (231). And then, over a rendered photograph of Nora, Lucia, and Giorgio Joyce, Bechdel continues the theme: *Ulysses* "fared much better than Joyce's actual children." The page opens out into the huge panel of Bruce looking up intently at his daughter; the perspective has switched and is now behind Alison, picturing the striking expression on his face, and his daughter's legs, poised to leap. Her jumping is a very slow, protracted movement at *Fun Home*'s conclusion, and it literally, on the page, crosses over James Joyce (in the visual form of his family). "But I suppose that this is consistent with the book's theme that spiritual, not consubstantial, paternity is the important thing," reads the narration. Bruce Bechdel's unprecedently open, unguarded, even vulnerable face registers awe, curiosity, reverence. It is strewn with light; dappled with sun. He is perhaps dazed by sun: the text box about Icarus is placed within the frame; it appears to be a platform on which Alison stands. Bruce, looking up at the sun/son, but himself now in the child role, is dazzled; in the Icarian sense of losing faculty—what happens before he plummets—and also

BEACH PUT A GOOD FACE ON IT, WRITING "A BABY BELONGS TO ITS MOTHER, NOT TO THE MIDWIFE, DOESN'T IT?"

AND AS LONG AS WE'RE LIKENING *ULYSSES* TO A CHILD, IT FARED MUCH BETTER THAN JOYCE'S ACTUAL CHILDREN.

BUT I SUPPOSE THIS IS CONSISTENT WITH THE BOOK'S THEME THAT SPIRITUAL, NOT CONSUBSTANTIAL, PATERNITY IS THE IMPORTANT THING.

in the sense of admiration: Alison will succeed him, as the artist. "Is it so unusual for the two things to coincide?" asks a text box that floats over him.

There is spiritual—that is, here, *textual*—and consubstantial paternity between Bruce and Alison, but it is *on the site of the book*, his paternity to her as an artist. The dual slippages of the last pages of *Fun Home* suggest a contrast between the children of two moody self-absorbed men: Joyce's kids ("Went mad"; "Became an alcoholic," Bechdel glosses the pair in paratextual arrow boxes) and Bruce Bechdel's kids (231). If we think of it as his book, in a sense, Bruce's relationship to *Fun Home*, like Joyce's to *Ulysses*, is as mother, and midwife, to the book, at the expense of his children. But Bechdel does not go mad or become an alcoholic; as with Joyce, with whom she is ultimately more aligned than is her father, a book becomes her child too, and the repetition compulsion she enacts through making the book becomes literally productive, procreative.[62] The trajectory from *Portrait of the Artist as a Young Man* to *Ulysses* establishes that Stephen Dedalus becomes an artist; in the first book he claims he will be, at the end ("I go . . . to forge in the smithy of my soul the uncreated conscience of my race"), and in the second he proves that he is actually doing so (276). *Fun Home*, opening with *Portrait* and ending with *Ulysses*, carries this structure within it, and "The Antihero's Journey" itself, by far the book's longest chapter at forty-seven pages, charts this movement within its pages too; the book, then, doubles in weight at its close.

It was only while working on this last chapter Bechdel started realizing *Fun Home* was about her becoming an artist. The book's ending, too, was a surprise: her father catching her was, she said, "not what I expected" (Address).[63] "The Antihero's Journey," in so many ways explicitly engaged with *Ulysses*, is also the fruition of the implicit claim *Fun Home* makes in opening with "Old Father, Old Artificer," the chapter so intensely involved with *Portrait*—a book in which the child figure vows to become an artist both despite his father and with the support of his father: "Old father, old artificer, stand me now and ever in good stead" is its very last line (276). *Stand me in good stead*: as Seamus Deane points out, one can read this line as "an Icarus asking that Daedalus stand in his place— i.e., that the son will become like the father and survive to create the labyrinth" (329). In Bechdel's case, as their postures on the page indicate so forcefully, she is reversing places with the father; she survives him to create the "labyrinthine" book we read. The powerful unfolding of frames at the conclusion of *Fun Home* makes legible how the daughter, while giving credence to her father's status as artificer, his "inventive bent," yet separates from him and takes this inheritance to become the father, the progenitor: the artist he never was and will never be. Bechdel honors (but flatters) her father's prose by twinning it with Joyce's; the

constant movement of the last chapter from *Ulysses* to her father, using the former to elucidate the latter, elevates Bruce Bechdel's writing, confirms his aesthetic sensibilities. But, while Bruce Bechdel loves *Ulysses*, Alison becomes the one to use it. He hands her his copy from the deadened space of his glassed-in bookcase in his library; she animates *Ulysses* with her body and her pen, re-creating its portions and palimpsesting it with her own text and images, rendering it dynamic through the form of comics. Earlier in "The Antihero's Journey," in a panel in which her text box overlays a reproduced page from *Ulysses*' penultimate "Ithaca" chapter, complete with her own handwritten college-era note hanging in the margin (*"obtunding?"*), Bechdel writes of herself and her father, "We had had our Ithaca moment" (222). The moment, as is Stephen and Bloom's convergence in *Ulysses*' Ithaca, is "equivocal."[64] As the chapter that most closely addresses *Ulysses*' exploration of filiation, Ithaca is often cited and thematized in Bechdel's last chapter. It is also, like *Fun Home* itself, inclusive of archival elements and graphic symbols: the chapter ends with a large period or dot, the ostensible answer to the question "Where?" (607).[65] *Fun Home*'s last page provides a graphic echo, but, in this instance, there are two dots, which appear just outside the book's last horizontal border in the center of the page. The dot that appears in *Ulysses* is a conventional sign for QED (*quod erat demonstrandum*; "which was to be proved"). In *Fun Home* the two dots, its tiny final/filial marks, suggest, perhaps, not that something has been demonstrated, precisely, in the symbol's traditional valence, but rather, echoing Ithaca's examination of paternity but doubling its last graphic mark, the imbrication of the father and daughter that produces the daughter as artificer.

In its graphic configuration, *Fun Home*'s last page suggests that when he dies she leaps, or when she leaps he dies (figure 5.14). The *situation* of the last page is both timeless and instantaneous. The two panels appear as two frozen moments connected in time that happen at once: Bechdel succeeds him literally—in his implied death—and figuratively: her coherent body leaping gracefully; his body, distorted by immersion in water, more vulnerable, as if already decomposing. (Bechdel's favorite image connected to Icarus and Daedalus, by Bruegel, depicts a tiny fallen Icarus in its lower-right corner, with only his legs visible, sticking up from the sea. In her version, while she inverts the graphic paradigm, the panel's focus on Bruce's legs immersed in water yet suggests his figuration as the fallen son.)[66] The effect of the last page is to leave one with a sense of the timelessness of his death; the page insinuates the question: When did Bruce Bechdel *start* committing suicide? In the stunning, scrambled temporality of *Fun Home*'s last page, he has always been committing suicide, and she has always been the artist succeeding him (leaping above him).

5.14 P. 232, *Fun Home: A Family Tragicomic* by Alison Bechdel. Copyright © 2006 by Alison Bechdel.
Reprinted by permission of Houghton Mifflin Harcourt Publishing Company. All rights reserved.

It is possible to identify events in *Fun Home* that link the two moments of its last page across the gap between them.[67] But just as the confusion of past and present is constitutive of psychic life, *Fun Home*—a map of psychic life—is insistently recursive. "Dad's death was not a new catastrophe but an old one that had been unfolding slowly for a long time," Bechdel writes in the chapter "That Old Catastrophe" (83). A form able to maintain absence and presence, the confusion of past, present, and future temporalities in the space of a page or panel, comics expresses the conundrum of this death—its pervasiveness, ubiquity, and its instant. Ultimately, *Fun Home* is not as interested in fixing and preserving death through a narrative of causality as it is in *releasing* death into timelessness through the open spaces and gaps of its word and image form. Its vision of the past locates death, but puts death *into play* as opposed to fixing it, pinning it down. Bruce Bechdel wants the past to be whole; Alison Bechdel makes it free-floating. We see this in the way she animates the past in a book that is, as I suggested earlier, a counterarchitecture to the stifling, shame-filled house in which she grew up: she animates and releases its histories, circulating them and giving them life even when they devolve on death. She brings a static dead house to life through the bodily contact of drawing it. A striking 2006 photograph of Bechdel published in the *New York Times* when her family home was up for sale suggests this powerfully. In an empty living room still decorated with her father's William Morris wallpaper and Victorian light fixtures, she reaches out toward the wall, extending her arm and hand, and *almost* touching it (figure 5.15). But a gap remains: a gap between her hand and the green "Chrysanthemums" wallpaper that encloses her home and her book. In this image of her, underlining the proximity and yet the space between her hand and the wall, one recognizes again echoes of Michelangelo's Creation of Adam scene: she is animating the house, animating its histories, activating the stagnant space. The gap between hand and wall is also the gutter of the comics page, where time passes, highlighting the irrecoverable break of history, the chasm between the present—her adult body—and the past: her childhood home, now vacant. The space between author and house, like the space between frames on the pages of her narrative, is the space both of animation and of loss.

On *Fun Home*'s last page, death happens in the white space: the first panel, personless, depicts the moment before death; the second panel moves backward (as Bruce Bechdel himself jumps backward into the road) to a moment of father and daughter moving together; we jump backward from the moment before impact, back into the past, and the death we know is coming happens not within the frame but extrinsically in the white space that ends the book. The rhythm of knowing and not knowing that Caruth discusses for trauma and that I earlier linked with the patterning of comics' architecture is never resolved: this is an

5.15 Nicole Bengiveno/*The New York Times*/Redux.

endless rhythm in comics' modality of representation. Bruce Bechdel's death in the spaces of comics frames resonates backward and forward.[68] Bechdel's narrative not only names absence but also gestures at readers to perform the movement of presence to absence across and over the space of the gutter, moving outward from the framed image.

Fun Home maps the confluence of death and artistry. But it maps that not in one figure but across the (filiate and affiliate) bodies of father and daughter, calling attention, as in the profound "I am not a hero" page, to the daughter's almost virtuosic act of artistry.[69] And it inscribes the psychodynamics of a father-daughter relationship into its word-and-image form. As we see in *Fun Home*'s moving last page, which in a jarring yet oddly elegant rhythm jumps the eye from a 1980s barreling truck to swimming, flying bodies in a pool of the 1960s, presence and plenitude are always framed by interstice and interval. Comics accommodates the *interaction* between the seeable and the sayable without, crucially, trying to overcome the gap. And while Bruce Bechdel—a preserver of dead bodies, a preserver of the family home—seeks to always keep the past whole, to keep it the same, Alison Bechdel, a preserver but also a reanimator of archives, inhabits a form, comics, that demands the crafted arrangement of objects in space in order to propose the difference her very body suggests: repetition as regeneration.

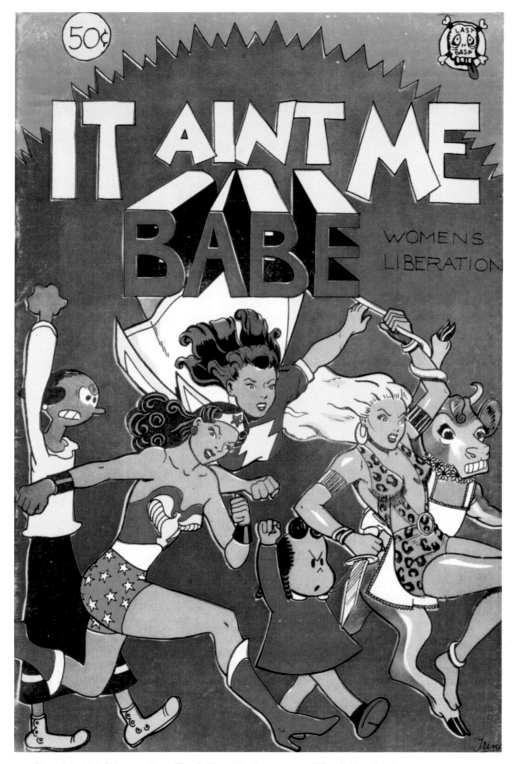

0.2 Cover, *It Ain't Me Babe*, 1970. Artist: Trina Robbins. *Used by permission of Trina Robbins.* (*p. 22*)

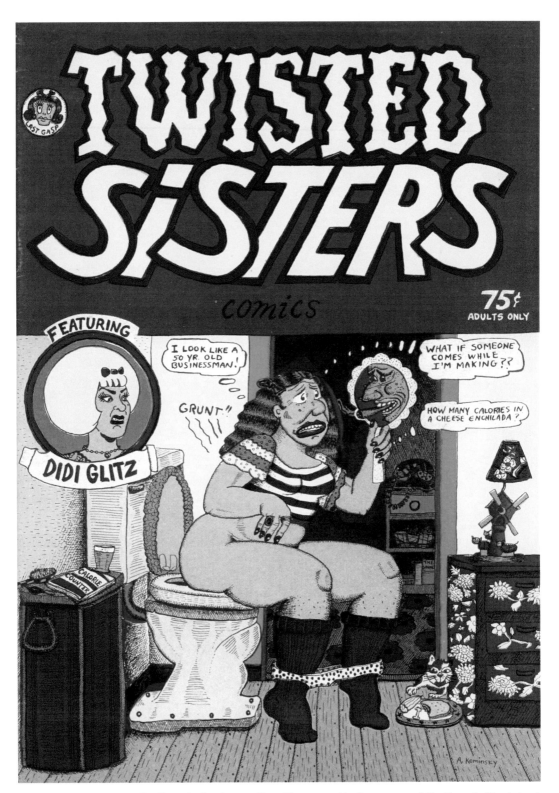

0.4 Aline Kominsky-Crumb, cover, *Twisted Sisters*, 1976. *Used by permission of Aline Kominsky-Crumb.* (*p. 25*)

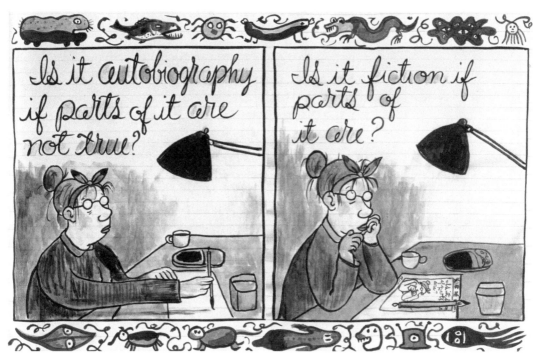

3.4 Lynda Barry, page from "Intro," *One Hundred Demons*. Sasquatch Books, 2002. *Used by permission of Lynda Barry.* (*p. 109*)

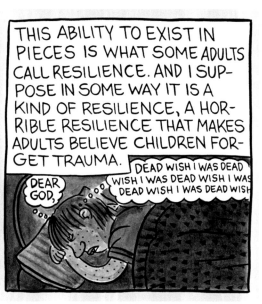

3.5 Lynda Barry, "Resilience," *One Hundred Demons*, p. 70. Sasquatch Books, 2002.
Used by permission of Lynda Barry. (p. 116)

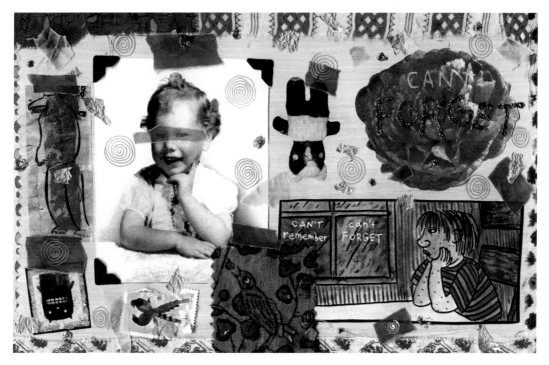

3.6 Lynda Barry, "Resilience," *One Hundred Demons*, first page of double-spread collage preface. Sasquatch Books, 2002. *Used by permission of Lynda Barry.* (*p. 118*)

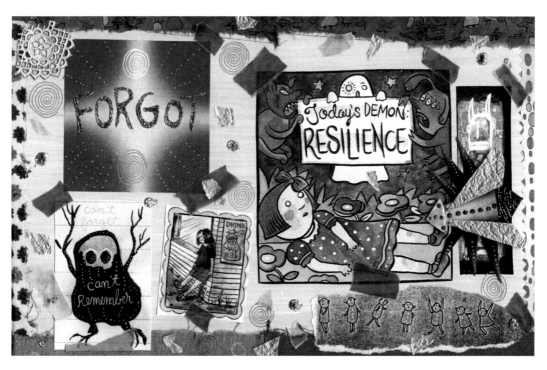

3.7 Lynda Barry, "Resilience," *One Hundred Demons*, second page of double-spread collage preface. Sasquatch Books, 2002. *Used by permission of Lynda Barry.* (*p. 118*)

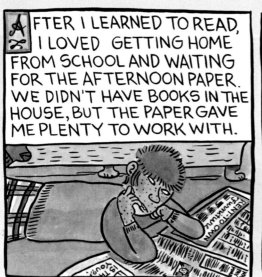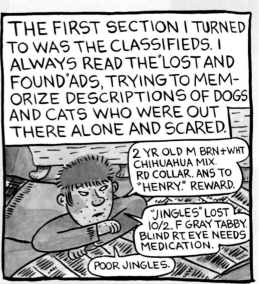

3.8 Lynda Barry, "Lost and Found," *One Hundred Demons*, p. 208. Sasquatch Books, 2002. *Used by permission of Lynda Barry.* (*p. 121*)

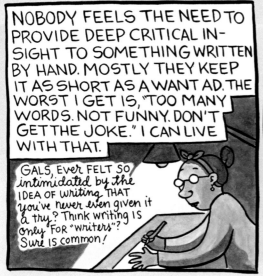

NOBODY FEELS THE NEED TO PROVIDE DEEP CRITICAL INSIGHT TO SOMETHING WRITTEN BY HAND. MOSTLY THEY KEEP IT AS SHORT AS A WANT AD. THE WORST I GET IS, "TOO MANY WORDS. NOT FUNNY. DON'T GET THE JOKE." I CAN LIVE WITH THAT.

GALS, EVER FELT SO *intimidated by the* IDEA OF *writing* THAT *you've never even given it a try?* Think writing IS *only* FOR "*writers*"? *Sure* IS common!

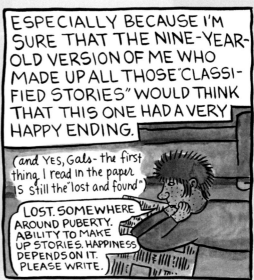

ESPECIALLY BECAUSE I'M SURE THAT THE NINE-YEAR-OLD VERSION OF ME WHO MADE UP ALL THOSE "CLASSIFIED STORIES" WOULD THINK THAT THIS ONE HAD A VERY HAPPY ENDING.

(and YES, Gals- the first thing I read in the paper IS still the "lost and found")

LOST. SOMEWHERE AROUND PUBERTY. ABILITY TO MAKE UP STORIES. HAPPINESS DEPENDS ON IT. PLEASE WRITE.

3.9 Lynda Barry, "Lost and Found," *One Hundred Demons*, p. 216. Sasquatch Books, 2002. *Used by permission of Lynda Barry.* (*p. 122*)

3.10 Lynda Barry, frontispiece, *One Hundred Demons*. Sasquatch Books, 2002. *Used by permission of Lynda Barry.* (*p. 123*)

3.11 Lynda Barry, page from "Outro," *One Hundred Demons.* Sasquatch Books, 2002.
Used by permission of Lynda Barry. (*p. 125*)

↶ Paint Your Demon! ↷

I like to PAINT ON LEGAL paper or on the CLASSIFIED SECTION of the newspaper OR Even pages from OLD BOOKS! I will try ANY PAPER, typing paper, wrapping paper even PAPER BAGS! ♡

MAKE FRESH INK EACH TIME YOU PAINT + Keep your inkstone clean.!!.

Discovering The paintbrush, ink stone, ink-stick and resulting Demons has Been the most Important thing to happen to me In years.

TRY IT! YOU WILL dig it!

I made a cloth pad for under my paper. It's an old black T-Shirt Quilted onto two layers of Flannel. IT absorbs excess water.

3.12 Lynda Barry, last page from "Outro," *One Hundred Demons*. Sasquatch Books, 2002. *Used by permission of Lynda Barry.* (p.126)

3.13 Lynda Barry, *What It Is*, p. 98. Drawn and Quarterly, 2008. *Used by permission of Lynda Barry.* (*p. 130*)

IT COULD NOT HAVE ESCAPED MY FATHER'S NOTICE THAT DURING SCOTT'S OWN STINT IN THE ARMY HE WROTE HIS FIRST NOVEL AND BEGAN COURTING ZELDA.

DAD'S LETTERS TO MOM, WHICH HAD NOT BEEN PARTICULARLY DEMONSTRATIVE UP TO THIS POINT, BEGAN TO GROW LUSH WITH FITZGERALDESQUE SENTIMENT.

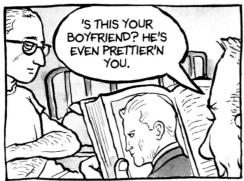

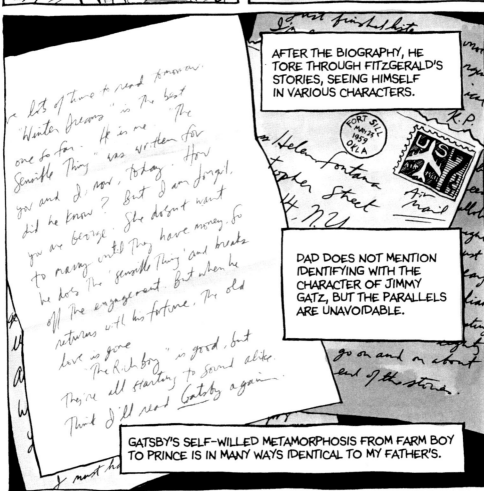

AFTER THE BIOGRAPHY, HE TORE THROUGH FITZGERALD'S STORIES, SEEING HIMSELF IN VARIOUS CHARACTERS.

DAD DOES NOT MENTION IDENTIFYING WITH THE CHARACTER OF JIMMY GATZ, BUT THE PARALLELS ARE UNAVOIDABLE.

GATSBY'S SELF-WILLED METAMORPHOSIS FROM FARM BOY TO PRINCE IS IN MANY WAYS IDENTICAL TO MY FATHER'S.

THE ENTRIES PROCEED BLANDLY ENOUGH. SOON I SWITCHED TO A DATE BOOK FROM AN INSURANCE AGENCY, WHICH AFFORDED MORE SPACE.

Friday MARCH 26

It was pretty warm out.
I got out a Hardy Boy
Book. Christian threw
sand in John's face.
He started to cry. I
took him in. We went

BUT IN APRIL, THE MINUTELY-LETTERED PHRASE *I THINK* BEGINS TO CROP UP BETWEEN MY COMMENTS.

I finished ʳᵃⁿᵏ "The Cabin
Island Mystery."
Dad ordered 10 reams
of paper! ɪ ᴛʜɪɴᵏ We watched
The Brady Bunch.
I made popcorn. ɪ ᴛʜɪɴᵏ There
is popcorn left over

IT WAS A SORT OF EPISTEMOLOGICAL CRISIS. HOW DID I KNOW THAT THE THINGS I WAS WRITING WERE ABSOLUTELY, OBJECTIVELY TRUE?

MY SIMPLE, DECLARATIVE SENTENCES BEGAN TO STRIKE ME AS HUBRISTIC AT BEST, UTTER LIES AT WORST.

ALL I COULD SPEAK FOR WAS MY OWN PERCEPTIONS, AND PERHAPS NOT EVEN THOSE.

THE MOST STURDY NOUNS FADED TO FAINT APPROXIMATIONS UNDER MY PEN.

5.3 P. 141, *Fun Home: A Family Tragicomic* by Alison Bechdel. Copyright © 2006 by Alison Bechdel.
Reprinted by permission of Houghton Mifflin Harcourt Publishing Company. All rights reserved. (p. 190)

IN OUR *WIND IN THE WILLOWS* COLORING BOOK, MY FAVORITE PAGE WAS THE MAP.

I TOOK FOR GRANTED THE PARALLELS BETWEEN THIS LANDSCAPE AND MY OWN. OUR CREEK FLOWED IN THE SAME DIRECTION AS RATTY'S RIVER.

5.4 P. 146, *Fun Home: A Family Tragicomic* by Alison Bechdel. Copyright © 2006 by Alison Bechdel.
Reprinted by permission of Houghton Mifflin Harcourt Publishing Company. All rights reserved. (*p. 192*)

DAD EXPLAINED THAT HE HAD DIED FROM A BROKEN NECK.

HIS SKIN WAS GRAY, WHICH GAVE HIS BRIGHT BLOND CREWCUT THE EFFECT OF YELLOW TINT ON A BLACK-AND-WHITE PHOTOGRAPH.

MY DIARY ENTRIES FOR THAT WEEKEND ARE ALMOST COMPLETELY OBSCURED.

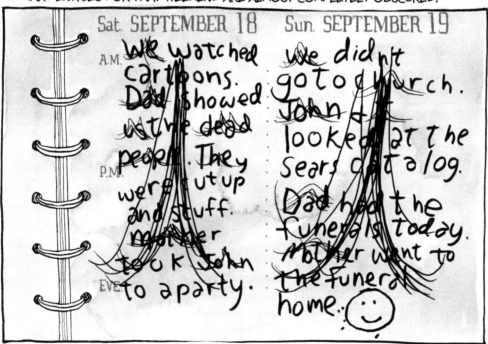

Sat. SEPTEMBER 18 Sun. SEPTEMBER 19

A.M. We watched cartoons. Dad showed us the dead people. They were cut up and stuff. Mother took John to a party.

We didn't go to church. John looked at the Sears catalog. Dad had the funeral today. Mother went to the funeral home.

5.5 P. 148, *Fun Home: A Family Tragicomic* by Alison Bechdel. Copyright © 2006 by Alison Bechdel. *Reprinted by permission of Houghton Mifflin Harcourt Publishing Company. All rights reserved.* (*p. 194*)

THE MAN ON THE PREP TABLE WAS BEARDED AND FLESHY, JARRINGLY UNLIKE DAD'S USUAL TRAFFIC OF DESSICATED OLD PEOPLE.

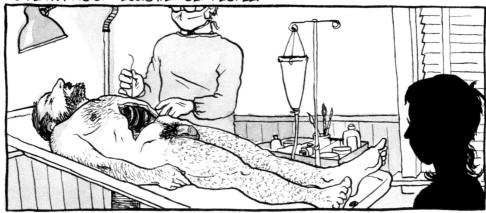

THE STRANGE PILE OF HIS GENITALS WAS SHOCKING, BUT WHAT REALLY GOT MY ATTENTION WAS HIS CHEST, SPLIT OPEN TO A DARK RED CAVE.

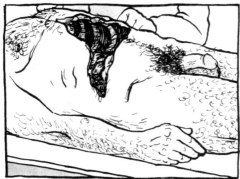

THERE WAS SOME PRACTICAL EXCHANGE WITH MY FATHER DURING WHICH I STUDIOUSLY BETRAYED NO EMOTION.

HAND ME THOSE SCISSORS OVER BY THE SINK.

IT FELT LIKE A TEST. MAYBE THIS WAS THE SAME OFFHANDED WAY HIS OWN NOTORIOUSLY COLD FATHER HAD SHOWN HIM **HIS** FIRST CADAVER.

OR MAYBE HE FELT THAT HE'D BECOME TOO INURED TO DEATH, AND WAS HOPING TO ELICIT FROM ME AN EXPRESSION OF THE NATURAL HORROR HE WAS NO LONGER CAPABLE OF.

5.6 P. 44, *Fun Home: A Family Tragicomic* by Alison Bechdel. Copyright © 2006 by Alison Bechdel.

Reprinted by permission of Houghton Mifflin Harcourt Publishing Company. All rights reserved. (*p. 196*)

5.7a (*top*) Panel from p. 197 of *Fun Home: A Family Tragicomic* by Alison Bechdel. Copyright © 2006 by Alison Bechdel. *Reprinted by permission of Houghton Mifflin Harcourt Publishing Company. All rights reserved.* (*p. 201*)

5.7b (*bottom*) Alison Bechdel, photograph of the author posing as her father. Photograph copyright © 2005 Alison Bechdel. *Reprinted with permission.* (*p. 201*)

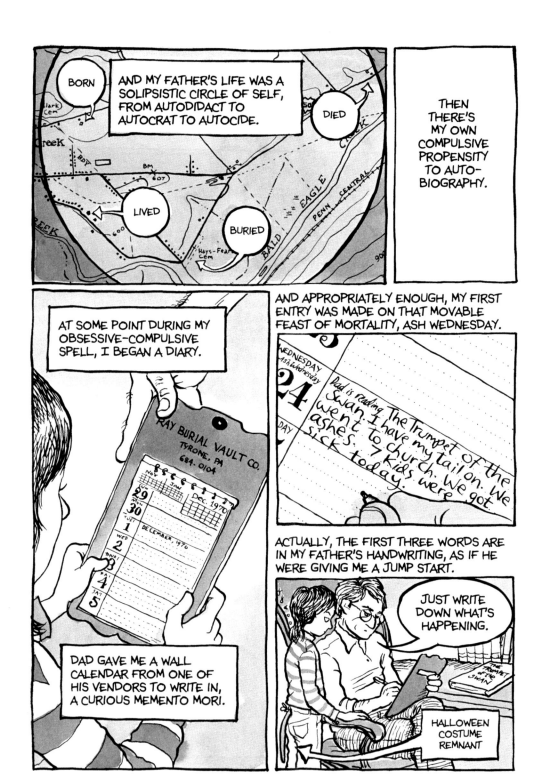

5.8a P. 140, *Fun Home: A Family Tragicomic* by Alison Bechdel. Copyright © 2006 by Alison Bechdel.
Reprinted by permission of Houghton Mifflin Harcourt Publishing Company. All rights reserved. (*p. 202*)

5.8b Alison Bechdel, photograph of the author posing as her ten-year-old self, holding the actual wall calendar her father gave her when she was ten. Photograph copyright © 2005 Alison Bechdel. *Reprinted with permission* (*p. 203*)

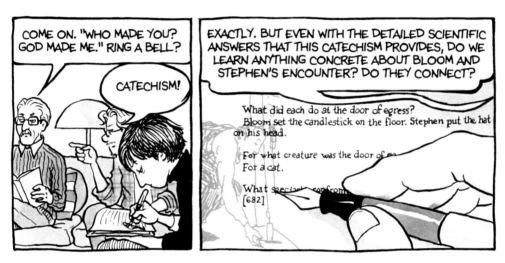

5.9 Panels from p. 209, *Fun Home: A Family Tragicomic* by Alison Bechdel. Copyright © 2006 by Alison Bechdel. *Reprinted by permission of Houghton Mifflin Harcourt Publishing Company. All rights reserved.* (*p. 205*)

"EROTIC TRUTH" IS A RATHER SWEEPING CONCEPT.

I SHOULDN'T PRETEND TO KNOW WHAT MY FATHER'S WAS.

PERHAPS MY EAGERNESS TO CLAIM HIM AS "GAY" IN THE WAY I AM "GAY," AS OPPOSED TO BISEXUAL OR SOME OTHER CATEGORY, IS JUST A WAY OF KEEPING HIM TO MYSELF--A SORT OF INVERTED OEDIPAL COMPLEX.

I THINK OF HIS LETTER, THE ONE WHERE HE DOES AND DOESN'T COME OUT TO ME.

> Helen just seems to be suggesting that you keep your options open. I tend to go along with that but probably for different reasons. Of course, it seems like a cop out. But then, who are cop outs for? Taking sides is rakther heroic, and I am not a hero. What is really worth it?

IT'S EXACTLY THE DISAVOWAL STEPHEN DEDALUS MAKES AT THE BEGINNING OF *ULYSSES*--JOYCE'S NOD TO THE NOVEL'S MOCK-HEROIC METHOD.

> — A woeful lunatic, Mulligan said. Were you in a funk?
> — I was, Stephen said with energy and growing fear. Out here in the dark with a man I don't know raving and moaning to himself about shooting a black panther. You saved men from drowning. I'm not a hero, however. If he stays on here I am off.
> Buck Mulligan frowned at the lather on his razorblade. He hopped down from his perch and began to search his trousers

IN THE END, JOYCE BROKE HIS CONTRACT WITH BEACH AND SOLD *ULYSSES* TO RANDOM HOUSE FOR A TIDY SUM.

HE DID NOT OFFER TO REPAY HER FOR THE FINANCIAL SACRIFICES SHE'D MADE FOR HIS BOOK.

5.10 P. 230, *Fun Home: A Family Tragicomic* by Alison Bechdel. Copyright © by 2006 Alison Bechdel. *Reprinted by permission of Houghton Mifflin Harcourt Publishing Company. All rights reserved. (p. 206)*

LIKE MANY FATHERS, MINE COULD OCCASIONALLY BE PREVAILED ON FOR A SPOT OF "AIRPLANE."

AS HE LAUNCHED ME, MY FULL WEIGHT WOULD FALL ON THE PIVOT POINT BETWEEN HIS FEET AND MY STOMACH.

OOF!

IT WAS A DISCOMFORT WELL WORTH THE RARE PHYSICAL CONTACT, AND CERTAINLY WORTH THE MOMENT OF PERFECT BALANCE WHEN I SOARED ABOVE HIM.

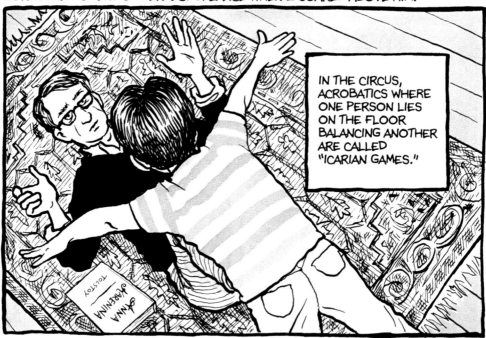

IN THE CIRCUS, ACROBATICS WHERE ONE PERSON LIES ON THE FLOOR BALANCING ANOTHER ARE CALLED "ICARIAN GAMES."

5.11 P. 3 (opening page of chapter 1), *Fun Home: A Family Tragicomic* by Alison Bechdel. Copyright © 2006 by Alison Bechdel. *Reprinted by permission of Houghton Mifflin Harcourt Publishing Company. All rights reserved. (p. 209)*

CONSIDERING THE FATE OF ICARUS AFTER HE FLOUTED HIS FATHER'S ADVICE AND FLEW
SO CLOSE TO THE SUN HIS WINGS MELTED, PERHAPS SOME DARK HUMOR IS INTENDED.

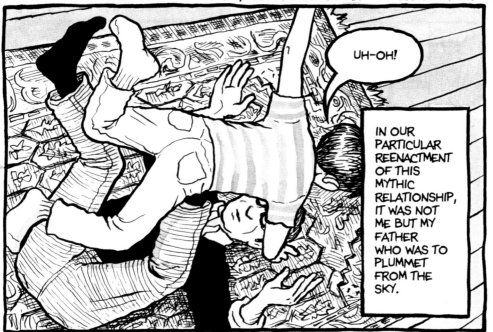

BUT BEFORE HE DID SO, HE MANAGED TO
GET QUITE A LOT DONE.

HIS GREATEST ACHIEVEMENT, ARGUABLY,
WAS HIS MONOMANIACAL RESTORATION
OF OUR OLD HOUSE.

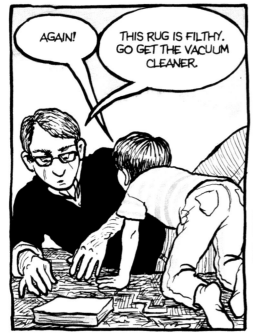

BEACH PUT A GOOD FACE ON IT, WRITING "A BABY BELONGS TO ITS MOTHER, NOT TO THE MIDWIFE, DOESN'T IT?"

AND AS LONG AS WE'RE LIKENING *ULYSSES* TO A CHILD, IT FARED MUCH BETTER THAN JOYCE'S ACTUAL CHILDREN.

BUT I SUPPOSE THIS IS CONSISTENT WITH THE BOOK'S THEME THAT SPIRITUAL, NOT CONSUBSTANTIAL, PATERNITY IS THE IMPORTANT THING.

5.14 P. 232, *Fun Home: A Family Tragicomic* by Alison Bechdel. Copyright © 2006 by Alison Bechdel. *Reprinted by permission of Houghton Mifflin Harcourt Publishing Company. All rights reserved.* (*p. 215*)

5.15 Nicole Bengiveno / *The New York Times* / Redux. (*p. 217*)

Notes

INTRODUCTION

1. Dori Seda died in 1988, but her book *Dori Stories* continues to be influential; Trina Robbins, a cartoonist and women's comics historian, whose most recent books have been written histories, is also an important figure (see Kaplan, "Trina Robbins"). This list is a sampling, hardly exhaustive of the female peers of the authors I treat here; nor are the titles mentioned after the names exhaustive of each person's body of work. Cartoonist Diane Noomin's two *Twisted Sisters* book collections (1991 and 1995), as well the *Comics Journal* issue on women cartoonists, "Comics Gal-ore" (2001), are good resources for exploring women's work in the field, as is the 2004 women's anthology edited by Kelso, *Scheherazade*. In addition, see the resources-oriented Web site for Friends of Lulu, a national organization designed to promote the readership and participation of women in comics: http://friendsoflulu.wordpress.com. The webzine *Sequential Tart* works toward raising awareness of women's influence in comics: http://www.sequentialtart.com. "Women and Cartooning: A Global Symposium," a recent issue of the *International Journal of Comic Art*, offers a valuable international perspective.

2. I agree, for example, with journalist Peggy Orenstein, who asserts in a lengthy profile of cartoonist Phoebe Gloeckner—which, ironically, ran in the *New York Times Magazine* in 2001—that "a small cadre" of women cartoonists "is creating some of the edgiest work about young women's lives in any medium." Orenstein makes an important point: "Perversely, even their marginalization—as cartoonists, as literary cartoonists, as *female* literary cartoonists—works in these artists' favor. Free from the pressures of the marketplace, they can explore taboo aspects of girls' lives with the illusion of safety" (28).

3. Female cartoonists themselves have long been vocal proponents and theorists of the value of their work in a male-dominated medium. The noncommercial American "underground comix revolution" of the late 1960s and 1970s—which established the mode of serious, artistic work for adults that we now recognize in the term *graphic novel*—saw numerous and heterogeneous feminist comic books, as I will discuss.

4. See, for example, in addition to the five authors I discuss here, Ho Che Anderson (*King*), David B. (*Epileptic*), Chester Brown (*Louis Riel: A Comic-Strip Biography*),

Coe, Doucet, Dreschler, Guy Delisle (*Pyongyang, Shenzhen, The Burma Chronicles*), Berenice Eisenstein (*I Was a Child of Holocaust Survivors*), Katin, Stan Mack (*Janet and Me*), Marisa Acocella Marchetto (*Cancer Vixen*), Keiji Nakazawa (*Barefoot Gen*), Harvey Pekar and Joyce Brabner (*Our Cancer Year*), Sharon Rudahl (*A Dangerous Woman: A Graphic Biography of Emma Goldman*), Joe Sacco (*Palestine, Safe Area Goražde, The Fixer, War's End: Profiles from Bosnia 1995–1996, Footnotes In Gaza*), Schrag, Spiegelman (*Maus, In the Shadow of No Towers, Breakdowns*), Tyler.

5. In a statement relevant to the work I discuss here, Spiegelman observes, speaking of his Pulitzer Prize–winning graphic narrative, "I think anybody who liked what I did in *Maus* had to acknowledge that it couldn't have happened in any other idiom" (quoted in Gussow, E6).

6. There is a dual repetition in comics texts that speaks to what Cathy Caruth calls the "repetition at the heart of catastrophe": there is the repetition involved in redrawing the scene of or around trauma, and the literal repetition of certain visual images within the text, as we see in a book like Bechdel's *Fun Home*, which repeats its centrally traumatic images over and over (Caruth, *Unclaimed* 2).

7. Once, asked if creating *Maus* was cathartic, Spiegelman responded, "It would be like the catharsis of making a 100-faceted wooden jewel box" ("Art Spiegelman" 12).

8. This book is centrally concerned with the ethics of representation, and Caruth's formulation of ethics well illustrates the way I use the term here: she writes, discussing *Hiroshima Mon Amour*, of "a betrayal precisely in the act of telling, in the very transmission of an understanding that erases the specificity of death. The possibility of knowing history, in this film, is thus also raised as a deeply ethical dilemma: the unremitting problem of *how not to betray the past*" (*Unclaimed* 27). This book throughout is interested in the ethical dilemma of knowing history and how not to betray the past. That involves, as Caruth indicates, the transmission of history that does not erase the specificity of the other (whether in death or other circumstances).

9. As I will detail further in forthcoming chapters, book printers rejected Kominsky-Crumb's *Love That Bunch* as pornography; Gloeckner's work was seized as pornography by customs officials in Britain and France; Barry's gallery exhibit and book called *Naked Ladies* faced community censorship; Bechdel's *Fun Home* was removed from library shelves in Missouri; and Satrapi's *Persepolis* is unable to be translated into Farsi or published in her native Iran, which also prohibits the movie version of the book from being released there.

10. See Chute, "Comics as Literature?" and "The Texture of Retracing"; and also Chute and DeKoven, "Introduction."

11. If James Olney writes that the autobiographical practice he calls "the autobiography of memory" is composed "simultaneously of narration and commentary, past experience and present vision, and a fusion of the two in the double 'I' of the book," graphic narratives meet and *exceed* Olney's criteria in displaying the autobiographer's shaping "vision" (240, 248).

12. "The emotional intensity of trauma produces fragmented, imagistic memories," as Marian MacCurdy writes in *The Mind's Eye* (33).

13. Felski, among others, has written on the notion of "feminist aesthetics" and posed the

problem of how an aesthetics-driven feminism can be both politically valuable and accessible. See *Doing Time* and *Beyond Feminist Aesthetics*.

14. *Comix* is an alternate spelling of *comics* that originated in the 1960s and emphasizes its ex-centricity and intended adult audience.

15. See, for instance, Michael Shnayerson's 1997 *Vanity Fair* article "Women Behaving Badly," which identifies a "new wave of female memoirists" and devalues their work and their motivations in clearly gendered terms (54).

16. Comics differs from the only proximate medium of film, also a visual, sequential art form, in that it is generally created from start to finish by a single author. Every work analyzed in this book is attributable to one author who both writes and draws the narrative. While not every contemporary graphic narrative is created by a single author, most "literary" book-length comics are single authored (one notable exception would be the work of Harvey Pekar).

17. For a key critique of experience as "uncontestable evidence and as an originary point of explanation"—and an important discussion of Samuel Delany, who has now written a graphic narrative memoir—see Scott, "Experience."

18. The field of visual studies needs to grow to include analyses of comics. Comics is absent from prominent texts examining visual culture—and feminist visual culture specifically—that discuss a range of media forms. We also see this absence, for instance, in the introduction to the *Signs* special issue "New Feminist Theories of Visual Culture" (2006), in which Doyle and Jones address the multiple subjects of visual studies without including comics, even as their issue offers an essay on a genre of Japanese girls' comics called *shôjo manga* ("Introduction"). One exception, although his analysis is brief, is Mirzoeff's *Watching Babylon*. I am interested in visual culture, as I note in my chapter on Lynda Barry, to the extent that, in Mitchell's formulation, it is not only concerned with "the social construction of the visual field" but also with *the visual construction of the social field* (*What Do Pictures Want?* 345).

19. Academic criticism of comics in any applicable literary-cultural or literary-historical sense did not exist as such until the 1970s, when full-length books began to appear (e.g., Dorfman and Mattelart, Kunzle). Up until then, except for a very few general-audience exceptions (e.g., Seldes, Waugh), writing about comics had either been sociological and psychological—as in the writings of psychologist Fredric Wertham—or had merely existed in small isolated pieces, in introductions and short essays written by critics and luminaries (much of this, including work by e. e. cummings, Thomas Mann, Delmore Schwartz, Robert Warshow, Marshall McLuhan, and Clement Greenberg, is collected in *Arguing Comics*).

20. The prioritizing of sequence allows for a rich history of forms, some of them ancient, such as cave paintings, to be understood as applicable to the history of comics.

21. McCloud, conversely, states, "I firmly believe that if you did a series of bas-relief sculptures on a wall in a museum that tell a story, then you'd be making comics" (Chute, "Scott McCloud" 83).

22. See Chute, "'The Shadow of a Past Time.'"

23. As Rocco Versaci puts it, "We read comics 'dually'—one panel at a time in succession but also as an entire page" (124).

24. See Chute, "Comics as Literature?" for further explanation of this claim.

25. See Rose's *Sexuality in the Field of Vision* for a crucial version of the psychoanalytic relationship between sexuality and seeing, especially in light of the important issue of dis/identification with images.

26. Blake, from *A Vision of the Last Judgment*, quoted in Mitchell, *Iconology* 95.

27. "If you have a novel that runs to three hundred pages, and you decide to reprint it at a smaller trim size or at a bigger font size, that text is going to reflow however it wants, and it's still the same book. . . . There's no reflow in comics, though" (Chute, "Scott McCloud" 83). In this sense, comics, as is often pointed out, is like concrete poetry. Johanna Drucker writes, "The specific quality of presence in such a [performative] work depends upon visual means—typefaces, format, spatial distribution of the elements of the page or through the book, physical form, or space. These visual means perform the work . . . [so that it] can't be translated into any other form" ("Visual Performance" 131).

28. Some novels are also performative in this sense; contemporary examples include Kathy Acker's *Blood and Guts in High School*, which intersperses type with drawings; Mark Danielewski's *House of Leaves*, which experiments with typography; and Jonathan Safran Foer's *Extremely Loud and Incredibly Close*, which incorporates visual elements.

29. A phrase from the *New York Times* magazine cover story on the growing visibility of the form (McGrath, "Not Funnies" 24).

30. While there is an unprecedented level of acceptance for comics right now in mainstream literary culture, one may yet note a lingering discomfort with the designation *cartoonist*. For instance, in the contributor's note to her comics-format review of Jane Vandenburgh's 2009 memoir, the *New York Times Book Review* awkwardly describes Alison Bechdel, as if allergic to the word *cartoonist*, as "the author and illustrator of a graphic memoir, 'Fun Home'" ("Scenes from a Family" 7).

31. A recent and pertinent meditation on the form of the cartoon is Spiegelman and Sacco's "Only Pictures?" interview in the *Nation*.

32. Harrison points out that while *cartoon* and *caricature* are often used interchangeably, caricature usually suggests a representation of a specific person (*The Cartoon* 54).

33. Tebbel recounts this process and reports that the name the Yellow Kid was also applied to Hearst himself (120–121).

34. This cited rule is item 6 in General Standards—Part A in the Code for Editorial Matter. The Comics Code of 1954 is widely available on the Web; see also Nyberg.

35. While I discuss the underground as the movement responsible for creating today's nonfiction work, Witek usefully suggests that, while sensational, war comics, especially the company EC's titles edited by *Mad* creator Harvey Kurtzman, were serious works "committed to historical veracity" and thus they provide an interesting model for nonfiction comics work (15). However, as Witek notes, in the mid-1950s, when these titles were active, "an adult comic-book audience had not yet developed" (93). That would happen with the creation of the underground.

36. For more on Ward, see the Library of America's new collection *Lynd Ward: Six Novels in Woodcuts*, with a long introduction by Spiegelman.

37. Benton 114; Hoberman 38. Kurtzman left the magazine in 1956. For a useful history of *Mad*, see Maria Reidelbach's *Completely Mad*.

38. Indeed, from 1957–1971 there were thirty-six FBI files on *Mad*, Paul Buhle reports (195). Mitchell analyzes the keen cultural force of *Mad* in *Picture Theory*.

39. Campus publications, including humor magazines that featured comics, became serious outlets for students in the 1960s as they became politicized and focused on counterculture. Often at odds with university administration, Rosenkranz observes, "College humor magazines became precursors to the underground press, and were often the center of academic and social agitation on American campuses" (20). In particular, cartoonists for the *Texas Ranger* at the University of Texas at Austin later became active in the underground scene. Frank Stack, a former *Ranger* editor, clandestinely published a comic book, *The Adventures of Jesus* (by "Foolbert Sturgeon") in 1964 on a UT Austin photocopier, while Jack Jackson, also under a pseudonym, self-published *God Nose: Adult Comix* in the same year. Coming out of the college magazine scene, these titles had print runs of about fifty and one thousand, respectively, and are sometimes considered the inaugural underground comix.

40. As Rosenkranz's *Rebel Visions*—a thorough study of the underground that yet places very little emphasis on the contributions of women—makes clear, while some underground papers, such as the *East Village Other*, appreciated comics, others were sometimes seen by cartoonists as placing too much emphasis on political correctness (56).

41. The difference between presenting racist and sexist content to explore or point up a stereotype and between tacitly underwriting such content by giving it central presence can sometimes feel blurry in the case of Crumb and other cartoonists. Publisher Ron Turner, who is white, remembers black students in San Francisco enjoying white cartoonist Gilbert Shelton's comics story that stars a black character in *Radical America*, an SDS magazine: "They thought Watermelon Jones was the funniest thing they had seen in their lives," Turner recalls. "Gilbert had lampooned it perfectly. That taught me a lot about what the images were. Were they racist or were they lampooning the racism?" (quoted in Rosenkranz, *Rebel Visions* 127). Yet, more recently, in reference to particular pieces of Crumb's on blacks and Jews, Spiegelman, who was influenced by Crumb, critiqued the idea that translating one's unconscious is enough: "Once you take it on as a subject, you're responsible to do more than just give in to it. . . . He's responsible to dig deeper into what it means to mess with this particular brand of dynamite" ("Spiegelman on Crumb"). For more on racism and the underground, see Rifas.

42. Gloeckner describes seeing Crumb's *Zap* work around age twelve, particularly the controversial "Joe Blow," a 1969 satire featuring father-daughter and mother-son incest, and "loving the drawings, how soft they looked and rounded" (Groth, "Interview" 79). She told NPR: "I literally found out about how sex was done by looking at a comic by R. Crumb," and, in a description of what could also be her own work, she elaborates, "What was interesting is that you really see the anatomy. You see what goes where and how it fits together" (Andersen). Barry also saw Crumb at age twelve: "It was the first time I realized that you could write about *anything*. It seems like such an easy idea that you could write about anything, but when you're a seventh grader, the idea that you could write about *anything*, even *bad* things, about what was happening in real life—I saw stuff in *Zap* that, even though it wasn't my life that was represented, it seemed closer to real life than any novel I had read, and anything I'd ever seen in comic strips or

in any movie. It just seemed how people were, and that was so thrilling to me" (Chute, "Lynda Barry" 62).

43. One example proffered by Spiegelman is Roy Lichtenstein, who appropriated images from the comics as a way out of abstract expressionism—a way to make representational images again ("Comics").

44. With the new deluxe hardcover edition of *Binky* (slightly larger than 10 by 14 inches) published in 2009 by McSweeney's, however, the book may become more widely known.

45. While my interest here is in contemporary literary comics by women, which date from the 1970s onward, Trina Robbins's four studies of women cartoonists (three of which are fairly similar) fill out a picture of women's work moving back farther into the early part of the twentieth century. See *A Century of Women Cartoonists* (1993), *The Great Women Superheroes* (1996), *From Girls to Grrrlz: A History of Women's Comics from Teens to Zines* (1999), and *The Great Women Cartoonists* (2001). Nancy Goldstein's study *Jackie Ormes: The First African American Woman Cartoonist*, about a cartoonist who published in the thirties, forties, and fifties, details one socially significant case history.

46. The year 1973 also saw the groundbreaking *Abortion Eve* comic book, which focuses on five fictional pregnant women. For more on the obscenity charge, see the "Tits & Clits" entry in *Erotic Comics*, which reports that editors Farmer and Chevely hid the forty thousand copies of the first issue with friends and lived for two years under the threat of a year's imprisonment, fines of up to four hundred thousand dollars, and the loss of their homes and children (Pilcher, with Kannenberg, *Erotic Comics* 167). Issue no. 2's cover shows a woman menstruating on the American flag.

47. Many of the contributors to *Twisted Sisters*—both the comic books and two subsequent book volumes—are discussed in a 2001 issue of the *Comics Journal* called "Comics Gal-ore," whose wraparound cover features self-portraits by sixty women cartoonists—as well as an index of their work within the magazine.

48. Significant comix publishers included Print Mint, Last Gasp, Rip Off Press, Kitchen Sink Press, and Apex Novelties. While many underground comix publishers have gone out of business or now deal largely in the collectibles market, a few, such as Last Gasp and Kitchen Sink Press (now Denis Kitchen Publishing) continue to have an important, if reduced, presence in the contemporary nonmainstream comics scene.

1. SCRATCHING THE SURFACE

1. Gloeckner traces a direct line from Kominsky-Crumb's 1970s work to her own. Of Kominsky-Crumb's 1976 comic book *Twisted Sisters*, she explains, "I was so incredibly influenced by it. First of all, it was about women, and second, Aline's story was autobiographical. It was about her life as a teenager. It occurred to me that I could do the same thing. Here I am" ("Phoebe Gloeckner" 150).

2. The language of aesthetics and "different ways of being" with sexuality is drawn from Cornell, *Beyond Accommodation* xxviii.

3. See Sedgwick and Frank, *Shame and Its Sisters*. Probyn's *Blush* takes after Tomkins in viewing shame as productive; see particularly her chapter "Writing Shame."

4. That is, there is no academic criticism that offers any sustained analysis of Kominsky-Crumb's work. Brief discussions appear in only two sources: Jared Gardner's "Autography's Biography," which devotes a page to her story "Goldie," and Andrea Most's "Re-Imagining the Jew's Body," which discusses how Kominsky-Crumb and Spiegelman present Jewish bodies on the comics page, but is primarily concerned with cartoonist Ben Katchor's *The Jew of New York*. It is particularly surprising that Kominsky-Crumb's work is not addressed in Baskind and Omer-Sherman's *The Jewish Graphic Novel* (2008), even though she is mentioned in that collection's opening essay "Contemporary American Jewish Comic Books" as contributing to the "boom" (3). The same applies to Kaplan's (nonacademic) *From Krakow to Krypton*, which mentions Kominsky-Crumb only in passing. Kominsky-Crumb's Jewish identity figures substantially in her own work and in her collaborative work with her non-Jewish husband; see, for example, "A Couple a' Nasty, Raunchy Old Things," in *Self-Loathing* no. 2, and "Euro Dirty Laundry" in *Dirty Laundry*.

5. While Crumb and Kominsky-Crumb have recently coauthored comics for the *New Yorker*, these charming, sanitized strips are not representative of each author's body of work—and they largely revolve around the cult of personality that the iconoclastic Robert Crumb inspires. Both Crumb and Kominsky-Crumb note that while they each write and draw their own stuff on the page, "almost like a George Burns and Gracie Allen routine," as she explains, and the stories are co-signed, many readers believe that Crumb draws and writes the entirety of each story (Interview). They have published ten collaborative autobiographical stories in the *New Yorker* since 1995. More representative is their recent collaborative title *Self-Loathing Comics*, which so far has two issues (1995, 1997).

6. When I taught Kominsky-Crumb in a course called "Contemporary Graphic Narratives" in 2005, I asked students to each jot down several adjectives describing her style. I was surprised that my class generated eighty different adjectives, ranging from *bumpy* to *cluttered* to *frantic* and *traumatizing*. Only sixteen adjectives overlapped, among them *exaggerated, grotesque, vulgar,* and *unpredictable*.

7. While rooted in a different context, Jacqueline Rose's analysis of political film in "Sexuality and Vision" is yet applicable: she describes a film by Sankofa that refuses to "settle" the question of representation because it intermixes "the surreal and *vérité*," representing "their incommensurability *and* their relation" (125).

8. In this chapter I will focus on *Love That Bunch* (1990) and *The Complete Dirty Laundry Comics* (1993, with Robert Crumb). While *Need More Love* (2007), Kominsky-Crumb's memoir that combines prose sections, photography, comics, testimonials from friends and family, reproductions of paintings, and interviews, is a fascinating formal object and deserves a separate analysis as a boundary-shifting life narrative, it contains very few original comics narratives—the comics it excerpts have largely been previously published at least once. Here, then, I will restrict myself to an analysis of Kominsky-Crumb's earlier comics collections. For more on *Need More Love*, see Chute, Review of Aline Kominsky-Crumb. *Need More Love*'s publisher, MQ Publications, went bankrupt the night the book was released; the rights reverted back to Kominsky-Crumb. See Reid, "The Crumbs Move to Norton." Although she has offers to republish *Need More Love*, Kominsky-Crumb will not, claiming it "exists on its own

terms, in its own way": "It's like a guerrilla art statement that you put out there and it's in the Twilight Zone. But as a result, I've gotten more feedback on that book than I've ever gotten from anything else I've ever done. It seems to go around in these weird ways, and people really like it and I've gotten so much feedback on that book, which I never made a cent on, [and has] never been officially distributed" (Interview).

9. More than any other author discussed in this book, Kominsky-Crumb has been involved with editing underground/independent comic books, and thus has played a substantial role in contemporary comics as a tastemaker, especially as editor of *Weirdo*, during which, as she explains, "I was able to publish many women for the first time," including Julie Doucet, Krystine Kryttre, and Dori Seda ("Aline" 168). Kominsky-Crumb, who also published Phoebe Gloeckner's work, edited *Weirdo* from 1986 to 1993, when it ceased publication.

10. Kominsky-Crumb explains that a group of cartoonists who called themselves the Air Pirates defended her work: "Dan [O'Neill], Gary [Halgren], and Willy [Murphy] stood up for me—they told the publisher that my work was funny and should be published. . . . A fight between men to decide the fate of my story" ("Aline" 164).

11. I will no longer use [*sic*] when quoting from Kominsky-Crumb's work. With the goal of maintaining the rhythm established by the text in her work, I will preserve her spellings.

12. Arnold Goldsmith, Kominsky-Crumb's father, was called "Goldie." While "he made me feel so repulsive, and so full of self-hatred, and so ugly that that character really came out of that," her adoption of her father's nickname in her autobiographical strip also indicates moving through and beyond the feeling of being inalterably marked by family dynamics. Kominsky-Crumb resignifies, then, a name that, she told me, "I sort of hated" (Chute, "Aline Kominsky-Crumb" 62).

13. For more of Robbins's view on Crumb, see Terry Zwigoff's documentary *Crumb*, in which she is interviewed, and her entry in *The Life and Times of R. Crumb: Comments from Contemporaries*. Kominsky-Crumb recounts she was horrified when she and Diane Noomin, another *Wimmen's Comix* contributor, who dated (and is now married to) underground cartoonist Bill Griffith (*Zippy the Pinhead*), were accused of selling out their ideals and named camp followers—i.e., prostitutes who follow soldiers from camp to camp—by Robbins and writer Sally Harms in an article in the *Berkeley Barb*.

14. In fact, in her foreword to *Erotic Comics*, Kominsky-Crumb notes, mentioning one of Crumb's characters, "I never think Robert goes far enough in his sadistic exploration of the Obnoxious Amazon's body" (7).

15. *Twisted Sisters: A Collection of Bad Girl Art* (1991); and *Twisted Sisters 2: Drawing the Line* (1995), both of which include work by Kominsky-Crumb and Gloeckner. Notably, the first collects Julie Doucet's famous "Heavy Flow," in which the Julie character morphs into a Godzilla-like monster, crushing buildings and bleeding all over the city in search of Tampax. The second carries Gloeckner's story "Minnie's 3rd Love," which started a censorship battle, as well as a rare autobiographical piece from Noomin, "Baby Talk," about her four miscarriages. Most of the artists congregated in these volumes were published by Kominsky-Crumb when she was the editor of *Weirdo*.

16. *Twisted Sisters* was resurrected for four issues in the mid-nineties with publisher Kitchen Sink, after the success of the first book volume.

17. In that this description tacitly invokes the common experience of women—while Kominsky-Crumb's work yet disrupts unitary identity—we may understand Williams's assertion in *Hard Core* that "women's resistance must therefore continue to rely on the fiction of the unity 'woman' insofar as oppression continues to make that unity felt" to be useful here (56).

18. In describing the organizing units of the book, I will use *comic strip, story,* and *chapter* interchangeably.

19. While Kominsky-Crumb's mother's name is Annette, she appears in her daughter's stories as Blabette. Kominsky-Crumb often notes her mother's lack of interest in her work and the fact that she has seen very little of it.

20. Of the dominant culture of this period, Kominsky-Crumb notes, "For most of my generation, growing up in the 1950s in the U.S., and perhaps more so on Long Island, was a horrible nightmare. The bizarre visual and cultural world of the 1950s"—which she captures so well in her comics—"added a surreal aura to the atmosphere" (*Need More Love* 14).

21. This is part of the animating tension of her work. While all of the authors I discuss offer texts with funny, wry moments, Kominsky-Crumb is the most comedic, or satirical, of all of them: her work mixes a focus on trauma with a kind of physical comedy and rigorous satire. Lynda Barry comes closest to this wide tonal range, although her work is not satirical.

22. See Mundy, *Surrealism,* especially her chapter "Letters of *Desire,*" for an apt characterization of sexuality and surrealism. The protruding, red, swollen organ of Joan Miró's 1925 "Love," for instance, appears as high-art analogue to Kominsky-Crumb's depictions of "love" and sexuality (see Mundy 35). For a comics autobiography even more explicitly surrealist than Kominsky-Crumb's, see Wojnarowicz.

23. The alter-ego living inside one's body is a particularly interesting figure for disgust, which, as Susan Miller points out, is fundamentally about self-boundarying and protecting the barrier between inside and outside. See also Menninghaus, *Disgust,* for a history of theories of disgust from a literary-philosophical standpoint, and Miller, *Anatomy of Disgust,* which posits two types of disgust, both of which we see in Kominsky-Crumb's work: the Freudian disgust that exists to prevent the activation of unconscious desire (109) and the disgust that has its origins in the notion of surfeit (110)—what Susan Miller calls "the too muchness of the disgusting" (100).

24. See Kominsky-Crumb, *Need More Love* 135, 136, and "Kominsky-Crumb Interview" 52, 70.

25. "It's a nice blend . . . very pleasing to the eye . . . besides, it's innovative . . . nobody's ever done a comic like this before! It's a historic break-through!" Crumb enthuses about *Dirty Laundry* in its premier issue (7). *The Complete Dirty Laundry Comics* reprints the two issues of the comic book—*Dirty Laundry* no. 1 (1974) and *Dirty Laundry* no. 2 (1977), as well the subsequent collaborative pieces Kominsky-Crumb and Crumb published in *Weirdo* and several other underground venues, in addition to a shorter collaborative newspaper-style comic strip, "The Crumb Family," which was commis-

sioned for but never appeared in the *San Francisco Examiner*. A forthcoming title to be published by Norton will collect all of the couple's collaborative work, including all of their *Dirty Laundry* and *New Yorker* comics, along with a long new piece titled "Total Immersion."

26. For relevant recent approaches to gaze theory, see Jones, *The Feminism and Visual Culture Reader*.

27. "Branded for life" is a phrase Robert Crumb uses in *Dirty Laundry* in which he worries about the damaging effects of the couple's sexual self-representation (72). Cornell's notion of the "imaginary" is as follows: "The imaginary, if it is 'there' at all, is only indicated as it is written and lived in protest, and in the process of transformation. Our 'sex,' in other words, is irreducible to the definitions of established gender hierarchy, once we deconstruct the logic of gender hierarchy that seems to define us" (*Beyond Accommodation* 17).

28. Multiple entries from the 1983 ordinance, officially titled the Antipornography Civil Rights Ordinance, are relevant to Kominsky-Crumb's work: "Women are presented as sexual objects tied up or cut up or mutilated or bruised or physically hurt"; "women are presented in postures or positions of sexual submission, servility, or display"; "women are presented as being penetrated by objects or animals" (quoted in Cornell, "Introduction," 3).

29. However, Kominsky-Crumb reports that Bagge, along with the Hernandez brothers (*Love and Rockets*), encouraged Fantagraphics editor Gary Groth to publish *Love That Bunch* (Chute, "Aline Kominsky-Crumb" 64).

30. See Cornell, *Feminism and Pornography*, for a thorough sampling of the debates that includes important work by Dworkin and MacKinnon as well as by anticensorship feminists. See also the crucial texts Vance, *Pleasure and Danger*, and Williams, *Hard Core,* as well as Williams's recent collection *Porn Studies*.

31. In an interview, Kominsky-Crumb explained to me that Fantagraphics had been using a Christian printer because "they just wanted the cheapest printer. You know, a lot of printers were Christian. [Fantagraphics] went to the cheapest printer they could go to, I guess, and these guys refused to print it. They went to a couple of printers, actually. And to their credit, they kept persisting until they found someone that would do it" (Chute, "Aline Kominsky-Crumb" 64).

32. Specifically, Kominsky-Crumb explains, "I grew up going to the Borscht Belt hotels in the Catskills and hearing famous comedians like Joey Bishop and Alan King and Jackie Mason" (Arazie 49). Vincent Brook describes this tradition as the "perpetually adolescent, self-hating, id-revealing Jewish stand-up tradition" (253). See Donald Weber's "Genealogies of Jewish Stand-up" in Brook. Applying this tradition to the visual-verbal printed form of comics, Kominsky-Crumb suggests, is a unique feature of her work (*Need More Love* 333). Unfortunately, Paul Buhle mentions Kominsky-Crumb only briefly, in a chapter on "Reflexive Jews," in a book on American Jewish popular culture that yet devotes considerable attention to underground comics.

33. It is important that women authors have been able to re-signify what it means to be "cruddy." Lynda Barry's first "illustrated novel" is called *Cruddy*. The book begins, "The cruddy girl named Roberta was writing the cruddy book of her cruddy life" (3).

34. Instead of claiming that her style masks her intelligence, Harvey Pekar, in his surprising introduction to *Love That Bunch*, essentially ignores her style, after noting in his first sentence that her work is "loaded with ugliness" (iii). He asserts that the stories in *Love That Bunch* "are valuable—to me, anyway—primarily because of Aline's perceptive psychological and social insights" (iv). In this damning-with-faint-praise introduction, he conspicuously avoids addressing the fact that her work exists at all in the verbal *and visual* form of comics, except to briefly point out, in an appraisal that demonstrates a lack of understanding, "Her drawing's improved technically over the years, and generally has a more open, sunny quality than it once did" (iv).

35. Indeed, in a 1980 interview, Robert Crumb emphasizes the value of nonprofessional work: "I think the whole 'underground' comic medium will stay interesting and dynamic as long as non-professional artists are somehow able to get their work printed, distributed, and sold. . . . The medium itself will still be viable as long as it stays loose" (Duncan, "A Joint Interview" 132).

36. "Aline Kominsky Crumb: Need More Love: Drawings and Other Works, 1971–2006," Adam Baumgold Gallery, New York City, February 15–March 17, 2007.

37. The amateurish "ugly" in Kominsky-Crumb's work also represents a populist politics, much like Lynda Barry's: she has analogized her work as "meatloaf" and others' as "sushi" ("Aline" 168).

38. See also *Need More Love* for a discussion of how Kominsky-Crumb's work "shows how much I am struggling with the medium," as she views it (135).

39. Barthes explains "the grain" in this essay using the theoretical opposition between pheno-text and geno-text established by Julia Kristeva. In Barthes's analysis, the pheno-text (or, here, pheno-song), is one in which "the rules of genre . . . the style of interpretation . . . [are] in the service of communication," while the geno-text (or geno-song) is "the space where significations germinate 'from within language and its very materiality'" ("Grain" 182). In music, if "the various manners of playing are all flattened out *into perfection*," nothing is left but the pheno-text (189).

40. This dominant stylistic methodology emphasizes mastery—if not of linework, then of such visual qualities as page architecture.

2. "FOR ALL THE GIRLS WHEN THEY HAVE GROWN"

1. See Foster, "Postmodernism in Parallax" (13–20). Foster borrows the term from Catherine Clément. He writes on the "problematic of distance," in terms of identification with the cultural other; my use of this term specifically aligns with his later discussion of Debord and Benjamin on the image: the "critical distance" produced due to its "dialectic of distance and closeness" (18).

2. In her 1995 essay "Not Outside the Range," Brown disputes the American Psychiatric Association's *Diagnostic and Statistical Manual*, which had defined a traumatized individual as having experienced "an event that is outside of the range of human experience." How can this be the operative definition, Brown asks, when as many as a third of girls are sexually abused prior to the age of sixteen? Brown argues, then, that "a feminist perspective, which draws our attention to the lives of girls and women, to the secret,

private, hidden experiences of everyday pain, reminds us that traumatic events do lie within the range of normal human experience" (110).

3. Even and especially in the realm of nonfiction, the spectrum of visual style in comics is wide. On one end is "cartoony" work, which tends to be both simplified and exaggerated. On the other end is Gloeckner's work, which we may understand as realistic in its attention to detail and its ability to approach photorealism (the OED suggests that in photorealism one may discern the "exactness of a sharply focused photograph"). Yet Gloeckner, as I will further discuss, mixes this realistic register, which carries an evidential quality, with what I here identify as a nonrealism: obvious and deliberate disproportion, for example, that projects the emotional/psychic state of the narrator/subject.

4. A slightly revised edition of *A Child's Life*—which collects two additional short pieces—was published in 2000.

5. "Self-Portrait with Pemphigus Vulgaris," accompanying Gloeckner's foreword, is actually the second portrait of Gloeckner to appear in the book, although it is the first drawn by her. In a move that speaks directly to the book's doubled attitude toward the objectified female body, Gloeckner's self-portrait and foreword are directly preceded by a portrait titled "Phoebe" and an introduction by R. Crumb. "Phoebe" dates from 1977, when Gloeckner was seventeen, and while it depicts her in the act of drawing, the center of the image is, lasciviously, the space between her legs. Crumb praises her work and also writes about how he "used to lust after" Gloeckner ("Introduction" 5). The sexualization of young women by adult men, then, is a topic of the book that is yet inscribed in its very structure.

6. As a rule, images cannot be ambivalent; only people can. The OED definition of ambivalence is "the coexistence in one person of contradictory emotions or attitudes (as love and hatred) towards a person or thing." Here, then, in assigning ambivalence to images, I hope to underscore the agency of images themselves (which is separate from that of their creators).

7. Medical illustrators have both artistic ability and detailed knowledge of human anatomy; they create graphic representations of medical or biological subjects for use in textbooks, pamphlets, exhibits, instructional films, civil/criminal legal procedures, and teaching models ("Medical Illustrator"). The Association of Medical Illustrators—www.ami.org—describes the field at length.

8. While earning her living as a medical illustrator throughout the 1990s, Gloeckner also illustrated sex manuals such as *The Encyclopedia of Unusual Sex Practices* and *The Good Vibrations Guide to Sex*. (The visual difference with her work as a comics auteur is that while both her commercial and noncommercial work offers a detailed realistic register, the illustration projects do not present the disproportionate physical features so notable in *A Child's Life* and *Diary*.) Gloeckner riffs on this work in "Sexual Memory Game," published in the *Comics Journal*, in which she draws, in a checkerboard-style layout thirty-two, "rare, or not very usual" sexual practices in small color panels; she multiplies images and asks readers to find the matches (112–113). Gloeckner's focus on naming and illustrating sexual non-normativity here (the player matches the practice, such as *Axillism*, *Klismaphilia*, and *Capnolagnia*, with a corresponding visual) dem-

onstrates her concern with sexual *knowing* and *not knowing*, a theme that applies in a particular way to children. This project exhibits her interest in both destigmatizing complicated sexuality by frankly showing it and also in pointing up the dark aspect of adult sexuality, which we see in the tension produced by slotting such adult content into a childish "game." One of the rules of the game is "children enjoy this game and through it they can learn how to recognize identical shapes and patterns though they will not fully understand the acts depicted" (112). The most basic kind of learning for children, she suggests, is sexualized.

9. Gloeckner's view of her experience also identifies it as incest: "There's something perverse about having sex with a woman and her daughter. It's like incest, whether or not you're related to these people by blood. It's breaking a family. The mother and the daughter become rivals. The mother is no longer protecting the daughter" (Joiner).

10. One standard definition of hardcore pornography is the external "cum shot"; pornography in this schema is *only* pornography if the *evidential* status of sexuality is made visible for viewers. This is why a softcore publication like *Playgirl* does not allow erections: erections—unlike a vagina photographed in almost any manner possible—are seen to register the evidential.

11. This lack of expression of female sexuality is a cultural norm. Not one of my sixteen students in a feminist literary study seminar in 2006 could come up with an example of a current cultural representation of positive female sexuality.

12. Significantly for my discussion of Gloeckner, Krauss's reading of the beat unites the experience of being both inside and outside; as we know from texts like *The Atrocity Exhibition*, Gloeckner's work is riveted to externalizing interiors.

13. The only extant academic article on Gloeckner, although *International Journal of Comic Art* is not peer reviewed, discusses *Diary*'s "multimodality." It schematically presents four broad categories of multimodality (e.g., "representational multimodality") that overlap so substantially they would be better discussed through the lens of their interrelation. See Rosenberg.

14. These in-text illustrations include seven excerpted from other comics artists—Gloeckner's own father, Aline Kominsky-Crumb, and Robert Crumb among them. Gloeckner was strongly influenced by San Francisco's underground comix scene, particularly the comic book *Twisted Sisters* (1976), co-edited by Noomin and Kominsky-Crumb, whose cover pictures Aline on the toilet, and which Gloeckner discovered hidden under her mother's bed. *Diary*'s full-page illustrations and comics portions, unlike the rest of the book, are unpaginated.

15. *Diary*'s verbal form alone accommodates postcards from boyfriends; letters from ex-stepfathers; letters (both sent and unsent) to lovers, to best friends; letters written from admirers to the protagonist's mother; diary entries peppered with a host of different addressees and sign-offs; poems by many authors, some historical and others possibly not; Tammy Wynette lyrics; fake police reports; formal letters to self.

16. See Felman and Laub, among others, for a discussion of trauma and "breaking the frame" (of form). In Felman's analysis of a course she taught on trauma, it was with the introduction of a visual element (videotapes of testifying Holocaust survivors) that the sensible framework of the class broke.

17. For an excellent discussion of rationality and knowledge, see Lubiano; she writes, for instance, in a comment directly relevant to feminist graphic narratives: "Within the terms of [Western rationality's] hegemony, what isn't considered rational—anger, desire, pleasure, and pain, for example, becomes a site of disciplinary action" (18).

18. Monroe tells Minnie she is boring and depressing, yet offers validation of her as a sexual object. In particularly horrifying episode, as they look at cars, he tells Minnie, "*You have such shitty taste!*" and punches her in the stomach: "I was pulling on his arm and he turned around and suddenly punched me in the stomach, right on the street" (Gloeckner, *Diary* 24).

19. Art Spiegelman writes "it is not exactly Justin [Green]'s fault that there is . . . comix by a new generation of women cartoonists giving blow-by-blowjob accounts of their unsatisfactory relationships" ("Symptoms" 4). There *are* a lot of blowjobs in the work of Aline Kominsky-Crumb and Phoebe Gloeckner, and the context is not simply that of "unsatisfactory relationships" but abusive ones. We may yet understand that Spiegelman's pun points to an important aspect of the form of comics. The *blow* in his comment refers to the frame or panel, the punctual moment in which comics traffics. *Blow-by-blowjob,* then, references the temporality of the frame, denotes fellatio, and also registers the violence—endemic in feminist work—of presenting disturbing, affective images that *feel* like jolts or blows.

20. "Memoir need not be confessional . . . in the sense that it need not promote a victimized identity as its subject," Gilmore writes, noting that the subject of such a memoir may be a subject "coming to terms more with the mystery of her agency than her injury" ("Jurisdictions" 710).

21. Crumb, as noted, wrote the introduction to *A Child's Life,* in which he praised "Minnie's 3rd Love" as "one of the comic book masterpieces of all time" (5).

22. Yet it is unsurprising that pornographers buy Gloeckner's artwork: Al Goldstein, publisher of the pornographic magazine *Screw,* and Nina Hartley—a registered nurse and the feminist porn star and director who is now an unofficial spokesperson for pornography—bought Gloeckner paintings of cross-sections of fellatio.

23. In the case of the Stockton library, Gloeckner addressed Mayor Podesto on her live journal, noting that "I understand your anxiety to a point," but the solution is not to deaccession or destroy the book, but rather to shelve it in such a way so that it is not "in sections used typically by very young children" (quoted in Brubaker).

24. Gloeckner was angered by the show and on her blog challenged Andersen, Medved, and Gurstein to a live discussion about her work and "what is valid fodder for 'art' and indeed, what they feel the role of art and the artist is in our society" ("Well").

25. See Cornell, *Feminism and Pornography,* and Williams's chapter "Speaking Sex" in her important *Hard Core* for a history of definitions of pornography. Most recently, in *Porn Studies,* Williams, who proposes that the Latin meaning of *obscene* is literally "off-stage," posits a methodological idiom that is productive for graphic narrative work like Gloeckner's: "If obscenity is the term given to those sexually explicit acts that once seemed unspeakable, and were thus permanently kept off-scene, *on/scenity* is the more conflicted term with which we can mark the tension between the speakable and unspeakable which animates so many of our contemporary discourses of sexuality" ("Introduction" 4).

26. Gloeckner says, "There is that element [of arousal] in my work. I do have pictures of people getting blowjobs. I think it's fine if a normal human being sees a picture like that and gets aroused. . . . I'm aware of that effect, but that's not my full intent. I'm just showing something that happened" (Martin).

27. Gloeckner's work has been greeted with censure even at the level of interpersonal relationships. Gloeckner's mother has threatened to sue her over her work (see Gloeckner's interviews with Chute, Groth, Juno, and Zeisler); her husband felt it was "unseemly." (see her interview with Juno 159).

28. See Joiner for Gloeckner's discussion of incest. See also Frost, "After Lot's Daughters," which is consonant with this project in emphasizing *The Kiss*'s refusal to subscribe to genre values as a register of traumatic memory.

29. As Gilmore reminds us, this act sets in motion the interpenetration of the ostensibly discrete realms of the private and public: trauma is "never exclusively personal" because "remembering trauma entails contextualizing it within history" (*Limits* 31). This "entails situating a personal agony within a spreading network of connections" (32).

30. Gloeckner told her mother about her affair with her mother's boyfriend when she turned eighteen because "I believed that since I was 18, my mother's boyfriend could no longer get in trouble for being involved with me" ("Phoebe Gloeckner" 153).

31. *Diary*, as I have suggested, is like both *Bastard Out of Carolina* and *The Kiss*, all texts that stage the longing for maternal intervention in child-father affairs. It exists somewhere in between, pondering both victimization and complicity (at fifteen, Minnie is both older than Allison's single-digit Bone and younger than Harrison's twentysomething).

32. In this, Gloeckner also plays on nineteenth-century images of nude women, such as Manet's *Le Déjeuner sur l'herbe* and *Olympia,* in which—under different circumstances—female subjects engage the look of the viewer.

33. As is also the case in the book with Minnie, Gloeckner reports that she was "fantasizing about how [my mother] would make him go to hell. I thought once she knew, everything would be all right, finally, with my life. . . . She remained friends with him after that. It was very confusing to me. . . . I was hoping that she'd defend me or punish him in some way" ("Phoebe Gloeckner" 154). For more on Gloeckner's relationship with her mother, see Sapienza's "The Two Phoebes: Diary of an Artist and Her Mother," which features interviews with both women. Gloeckner's mother presents herself as remarkably unsympathetic to her daughter, urging that the time in Gloeckner's life depicted in *Diary* "has to be forgotten." "I love Phoebe," she says, "but why do we need to hear this stuff? What does it add to our lives?" (Sapienza 48).

34. Howard Hampton's phrase from the *Believer* ("Flannel-Swaddled" 71). Hampton's excellent piece—on Gloeckner, Cat Power, Lora Logic, and Daniel Clowes's Enid Coleslaw—is collected in his book *Born in Flames*.

35. An overview of the Juárez "femicides" is Rodriguez, *Daughters of Juárez*. Elizabeth Malkin's 2009 *New York Times* piece, "As Mexican Killings Rise," provides a recent summary of circumstances in Juárez. The number of murders of young women in Juárez began rising drastically in 1993. While Amnesty International, in a 2003 article, identified the murders as "serial sex killings," and the phenomenon is often referred to as such, Gloeckner points out that there is little proof that the crimes were and are com-

mitted by one or even several "serial killers," although many of them seem calculated to appear so (Personal communication). Juárez, especially since 2008, has been plagued by enormous violence relating to its drug cartels. Multiple media venues, including the local *El Diario* in Juárez, put the number of murders there in 2009 at approximately 2,660, making it one of the most violent cities in the world. See Garvin, "Life in 'Murder City,'" and Chung, "The World's Most Dangerous Place?" both published in the spring of 2010, for more on statistics. The Frontera list, managed by a Border and Latin American Specialist at the New Mexico State University Library, logs information on the number of killings from newspapers and other sources (see http://groups.google .com/group/frontera-list/about?hl=en). Frontera reported that in 2009, 163 of the people killed in Juárez were women. Eliabeth Malkin's 2009 *New York Times* piece, "As Mexican Killings Rise," provides a recent summary of the women's murders in the context of other political developments in the city; see also Rodriguez, *Daughters of Juárez*, for an overview of the Juárez "femicides."

36. Gloeckner's forthcoming book, for which she has returned to Juárez over a dozen times, will specifically focus on a girl named Maria Elena Chávez Caldera, who disappeared in 2000 at age fifteen. Gloeckner wanted to write about this specific girl because "there's almost nothing left of her. Her parents had just one photograph, which they gave to the police" (Roberts). Here we can understand how Gloeckner's word-and-image work is one of reconstruction—building scenes and objects for absent histories where there are no documents and no answers.

37. *La Tristeza*, then, blurs the boundaries of different stylistic registers (different forms that code as "real" and "fake" on one pictured body), which is consonant with its overall focus on borders. Gloeckner suggests that the work is "about borders, not just between the United States and Mexico, although that is a big issue, but between the living and the dead, between memory and those who are forgotten" (Roberts). On the aspect of the photographic faces, too, Gloeckner told me that there distortion plays a big role in the overall aesthetic: "If [they're] not distorted, it doesn't look good, because the image doesn't have that kind of unreal thing. I don't know if it's always obvious that they're changed, but they are changed a lot. Sometimes I even use eyes from one person, and a nose from another person" (Chute, "Phoebe Gloeckner" 49).

38. The issue of pacing in narrative forms that seek to impart the traumatic is key. The fact that in comics one consumes the narrative at one's own pace establishes an active relationship with the text that is essential to avoiding the manipulative and the sensational. Discussing *La Tristeza*, Gloeckner explains, "In film, the pictures go by very fast. With a book you can linger over things, you can make connections to things so you have many more opportunities to build levels of meaning. . . . Because you know the reader will be able to flip the pages back and forth and try to make sense of the story themselves" (Johnson).

39. The trope of "visibility" has needlessly suffered in recent critical theory; I disagree with the romanticized and politically unviable antivisual arguments in, for instance, Phelan's *Unmarked*, and Weston's *Gender in Real Time*. For a helpful gloss on debates that (re)situate the female body in visual representation as against an antivisualism, see McDonald, *Erotic Ambiguities*. See also Haraway, who writes in "The Persistence of Vision" that vision has been "maligned" in feminist discourse.

40. What some have called a feminine imaginary could simply be conceptualized as a space for the development of a subjectivity and personhood that is not proscribed by overdetermined structures.

41. The aesthetic nature of knowledge of sexual difference, for example, while it does not stand in for material struggle, is neither "just" about artists and "feminine expressivity." As Cornell argues, "the ways our sexual difference is represented is a crucial component of how we understand what changing the material conditions of the world means" (*Beyond Accommodation* xxxii).

42. The phrase is from Caws 1313.

3. MATERIALIZING MEMORY

1. WAVES were "Women Accepted for Volunteer Emergency Service" in the Navy starting in WWII; the corps was founded in 1942. Barry writes in a contributor's note to *The Best American Comics 2006* that she was born in 1956 "to a woman who came from the Philippines on a military transport plane and a navy man who drank and bowled," adding, "They didn't like each other and they didn't like their kids" (277).

2. In Kip Fulbeck's exhibit *part asian, 100% hapa*, which features photographs and testimonials from mixed people of various ages, Barry—unnamed in the piece—writes: "I'm also half Irish—from both sides—my mom and dad are both half Irish. I seriously think that's all they had in common. I grew up in a very filipino household. In family portraits with all my cousins and uncles and aunts my two brothers and I look like we're some neighbors who just dropped by for some really good food and San Miguel beer."

3. Today many self-distributing comics authors create what are called mini-comics. The term indicates that the author controls the printing process with whatever technology she has on hand, e.g. Xerox machines and silk screening setups, scissors and glue and staplers. In this way, mini-comics and zines are similar; the two can overlap. For more on the intersection of comics and zines, see Sabin and Triggs, *Below Critical Radar*.

4. Printed Matter's mission is "to foster the appreciation, dissemination, and understanding of artists' publications, which we define as books or other editioned publications conceived by artists as art works, or, more succinctly, as 'artwork for the page.'" See http://printedmatter.org/about/index.cfm.

5. Barry and close friend Matt Groening, creator of the comics series *Life in Hell* and the animated television program *The Simpsons*, vocally supported each other's comics after graduating from Evergreen and did book signings together when they started publishing. Barry explains that she was not deterred by the asymmetrical response their work elicited: "Matt's stuff and my stuff was really different, and if you're gonna have a book that's very clever and really funny and talking about people's difficult situation at work, or you're going to have a book that's about horrible things that happen in childhood, there's gonna be one that has a long line, and another one that has a shorter line" (Chute, "Lynda Barry" 54).

6. In October 2008, Barry stopped drawing *Ernie Pook's Comeek*. A decade ago, as Christopher Borrelli reports, *Ernie Pook's Comeek* was syndicated in seventy papers; before she discontinued syndication in the fall of 2008, it remained in only four, a sign of

the decline of the once-robust "alternative weekly" newspaper culture (Borrelli, "Being Lynda Barry").

7. Barry exhibited two additional drawings, increasing the pool of "Jokers" from two to four (as in the book's own color foldout section). The Linda Farris Gallery operated from 1970–1995. It was the first Northwest exhibitor of Robert Rauschenberg in 1978 and featured exhibits such as 1987's "Self-Portrait," with works by Eric Fischl, Alex Katz, Chuck Close, Alice Neel, Robert Mapplethorpe, and Andy Warhol, among others. See Hackett, "Linda Farris."

8. I interviewed Barry over two days in New York City in June 2008, following a public interview I conducted with her for a symposium cosponsored by NYU and the New York Institute of the Humanities (as Barry, Conversation). A portion of my interview with Barry appeared in the *Believer*'s 2008 art issue (as Chute, "Lynda Barry").

9. Barry understands her gallerist's concern in the following way: "Rich people, they need [art] to be this sort of deep *experience*, and they're sort of buying the talisman of the experience, so the idea that you're watching Phil Donahue [while you are making the work]" is unacceptable (Interview).

10. See Barry, *Come Over* 55, *It's So Magic* 71. *Cruddy*, which takes the form of a suicide note, love letter, and diary at once, is not "illustrated" to the same extent as Gloeckner's *The Diary of a Teenage Girl*, although they share crucial features. Both are presented as the diaries of adolescent girls struggling with father figures and both address readers directly (the opening "Dear Anyone Who Finds This" in *Cruddy* is similar to "A Note of Caution to the Reader" in *Diary*). Both also strikingly combine typeset text with the handwritten signature of the diarist in a signal page. In Gloeckner's work the images often move large parts of the narrative forward independently, whereas in *Cruddy*, while it has a painted cover, endpapers, frontispiece, and chapter headings, the images feel secondary to the text. Like *Diary*, *Cruddy* mixes fact and fiction; unlike *Diary*, it plays explicitly with genre expectations, mixing established elements of adventure, gothic, thriller, comedy, and "road-trip" stories. Barry recently called it a "murder fiesta"; the *Times* called it "a work of terrible beauty" (Chute, "Lynda Barry" 50; Nash, "Bad Trip").

11. Although her work is not aimed at a young audience, Barry does not object when it lands in a YA category or on lists for "reluctant readers," where it also sometimes appears. She explains, "It's very nice for me, because I feel like I could have found it that way," and she maintains that she would rather be in the YA section than in the more constricted "graphic novel" section of bookstores (Chute, "Lynda Barry" 54).

12. In two reviews the *New York Times* has also emphasized this economy: while Dave Eggers particularly sees it in how Barry's narratives begin ("she is, not surprisingly, a master of the opening line"), Nick Hornby recognizes it in how they end ("these stories all contain little grenades of meaning that tend to explode just after you've read the last line") (Eggers 10; Hornby 11).

13. Seashells, in Botticelli as elsewhere, have long functioned as metaphors for women's vulvas. See, for instance, Blackledge, *The Story of V* 49–50.

14. Some, however, have their eyes closed—for instance, while masturbating.

15. Barry does not choose her visual self-insertion as the location for text and image to meet. Significantly, the segment of story that appears with the self-portrait, while it

retains the first-person voice of the prose, is focused on describing a friend of the narrator.

16. *Naked Ladies* could by all means be used as an actual and not simply figurative coloring book; its sense of play and of utilitarian purpose is underlined by the fact that at its center it offers a color foldout of the complete deck of "cards" of the women, with the shell, fish, and dagger motif printed on the other side of each, so that one could plausibly cut them out for use. This attention to the book as functional object resurfaces in other works, including *What It Is*, in which Barry prints multiple pages of "word cards" that she recommends cutting out and using for writing exercises.

17. While Berger treats *naked* and *nude* differently, Barry does not appear to; I take his comments on nudity to be applicable to her naked ladies schema. To Berger, while a "nude" is seen to be a form of art, it is a conventionalized form of art in which one is "seen naked by others and yet not recognized for oneself" (54).

18. Barry's then-publisher Cathy Hillenbrand explained the exhibit caused a stir: "a lot of people thought the imagery was disgusting; offensive"; the *Ms.* magazine article that quotes her also reports Hillenbrand had to shop the book to fifteen printers until two finally agreed. A few bookstores sent the book back; surprisingly for Barry, the artist-run bookstore in Seattle refused to carry it, accusing Barry of producing a "sexist" work (Interview). Barry explains she was "furious at the fine arts community and at the artists who run that bookstore" (Powers, "Lynda Barry" 65).

19. The first academic essay on *One Hundred Demons*—also the first academic essay on Barry—was published recently, focusing specifically on Barry's contributions to Filipina American feminist writing: "Barry's comix reach far more mainstream readers than any other Filipino American artist today" (de Jesús, "Liminality" 247). The author, Melinda de Jesús, published a similar article in the same year focusing on Filipina American identity and motherhood in *One Hundred Demons* ("Of Monsters and Mothers").

20. See Powers's interview in the *Comics Journal* (66). "One Hundred Demons" is a painting exercise; the example that inspired Barry was a hand-scroll painted by a Zen monk named Hakuin Ekaku in sixteenth-century Japan. In "Intro" Barry paints a frame depicting Lynda viewing this example in the book *The Art of Zen* by Stephen Addiss.

21. Whereas Spiegelman draws himself at his desk, explicitly foregrounding *Maus*'s enunciative situation ("I started working on this page at the very end of February 1987") well into the second volume of *Maus* (*Maus II*:41), Barry does it immediately.

22. On collage and the avant-garde, see, for instance, Cottington, *Cubism in the Shadow of War,* especially the chapter "Collage and Counter-Discourse: Aestheticism and the 'Popular,'"; Gopnik and Varnedoe, *High and Low.* For the Pattern and Decoration movement—and Miriam Schapiro's concept of "femmage," a specific collage technique that highlights the connection with women's domestic crafts, see Broude, "The Pattern and Decoration Movement." Like Barry's work, Pattern and Decoration sought to dissolve dichotomies governing artistic valuation. Sider sees that the "pluralist exuberance" of today's American art can be traced to P&D (42). But while Schapiro used material that had been gendered female, such as fabric, with paint to call into question the divide between decorative and "fine" art, she generally combined these *on canvas,* whereas Barry works strictly on common paper.

23. Barry would flatten the collage with the scanner, getting "as close to the work as possible" to preserve the texture. Describing her preference for the scanner, Barry explains, "If you've ever just put your hand on a scanner and scanned it, you'll see that it won't just do the surface, it'll do it up another eighth of an inch around it, so you will get 3-D stuff, and it's low tech" (Interview). Although Barry's collages, as made objects, contain both representations of things, such as cutout magazine photographs, and three-dimensional things themselves, such as flowers, they come to us as scanned and printed representations, offering a kind of trompe l'oeil collage.

24. In his introduction to comics journalist Joe Sacco's book *Palestine*, Edward Said praised how Sacco's visually and verbally dense pages slow a reader down; Said called this the text's "power to detain" (v). With Barry's decorative and deliberately irregular handwriting, we see another technique for provoking a slowed-down experience of reading.

25. My understanding of rhythm in comics is connected to concepts anchored in both poetics and music—such as pacing, tempo, phrasing, stress, insistence (Gertrude Stein's term), and alteration. For more on "insistence," see DeKoven, *A Different Language*.

26. Barry rejected the stage commonly known in comics as penciling. Discussing her process for *One Hundred Demons* and *What It Is*, Barry clarifies, "When I'm painting [words], they're coming to me as I paint them, and I try really hard to just do one word at a time.... I didn't write any of it beforehand. I just did it slowly enough" (Interview).

27. See also Drucker, *The Visible Word*.

28. *What It Is* specifically addresses the importance of the structural spontaneity in handwriting, in the inscription of a body's movement on the page. Recently, sophisticated critical attention has been given to contemporary design and typographical experiment, such as in Hayles's *Writing Machines*, which analyzes Mark Danielewski's novel *House of Leaves*, along with an artists' book and other texts. The director of MIT's Media Pamphlet series, the publisher of *Writing Machines*, asserts that the book "makes the case that thinking about literature without thinking about materiality isn't really thinking at all"—an apt statement (138). Yet, while it focuses on materiality, "spatial writing," and printed surface, Hayles's book ignores handwriting completely.

29. "Wrinkling" also applies to Barry's decision to allow her mistakes to remain evident in the final printing of *What It Is*. When she misspelled a word, her subsequent correction—blotting out or pasting over—is clear to the reader's eye. She had a chance when her publisher scanned the images during production to erase these mistakes digitally, but did not. That words present residues of past words behind them brings a layering to her sentences that works in tandem with the layers of her collages.

30. See Elam 35. Her *Expressive Typography*, especially the chapters "Handwritten Typography" and "Collage and Typography," provides an historical context for typography that is useful for understanding the role of handwriting in comics. Particularly, her discussion of mid-century artists' self-designed posters for their own exhibitions, "in which the style of the [handwritten] typography harmonized with the style of the image," presents a useful precursor to comics form (see 32).

31. For an analysis of the artists' book, see Drucker's discussion of the "hybrid nature" of the historical avant-garde in her tracking of the history of the artists' book—a history applicable to graphic narratives (*The Century of Artists' Books* 45). See also Klima.

32. Barry's forthcoming project *Picture This: The Near-Sighted Monkey Book*, whose titular

character is a stand-in for the author, plays with this boundary and how books are generically shaped by their intended audiences. There will be a tension in the look of the book and its content; it could be either for children or adults. Barry explains, "It is for adults but it is a kid's book." It will look, she says, "like a Dick and Jane book" and yet "I want it to be a kids' book but about a character that has a drinking problem, and is kind of a bad [character]" (Interview).

33. Barry says in a recent interview, "Sometimes I was at the computer, sometimes I was kneeling on the floor over scattered pages of the collage introductions with an Elmer's glue bottle in my hand. It took three months to do all the designing and my studio looked like a tipped-over ransacked aquarium when we were finished. . . . I do have to say it took a lot of crying, screaming, Mick Jagger-style posturing, James Brown-style begging, arm twisting, smoke-blowing and flaming e-mails to get the publisher to agree to the book looking the way it does" (*Independent Publisher*). In addition to Elmer's Glue, Barry used commonly available and inexpensive tools like Scotch tape to affix her images to the page.

34. This filling in also emphasizes Barry's treatment of *One Hundred Demons* as an artists' book—a series of paintings/collages rather than a transparent narrative vehicle, with the mark of the hand working the surface evident in the brushstrokes. Here, the "never leave a canvas bare" dictum of painting is applied to paper.

35. Barry paints, for instance, in the front papers, a dancing child, boots, a cat, a frozen TV dinner, a clock striking nine, a ghost smoking a cigarette, patent-leather Mary Janes, a piggy bank, a cake, a letter, platform shoes, a television, a fly swatter, a kitten inside a snowglobe, an eight-eyed demon, a dog, a purse, a knife, bugs, a cigarette in an ashtray, and a squid with the word YES between its eyes.

36. Hoesterey writes that postmodern pastiche can "[attain] the status of critical art that could legitimately claim to represent an emancipatory aesthetics [as this term was understood in the discursive climate of the Frankfurt School], i.e., art that fosters critical thinking" (xi–xii).

37. Caruth, in *Unclaimed Experience*, and Felman and Laub, in *Testimony*, for instance, emphasize how an unknowingness is part of how one understands trauma, which remains, to a certain degree, outside of standard categories of comprehension.

38. As Freud and many later analysts and theorists of trauma and memory have pointed out, behavior linked to trauma gets repeated.

39. "Physical placement . . . is very exact in memory, especially memory formed under terrifying circumstances [in childhood]," Terr writes (144).

40. As with all of the autobiographical texts I discuss here, I will refer to the author by her last name (Barry), to the narrator in the text by her first name (Lynda), and to the pictured protagonist by her first name and/or childhood nickname (in this case also Lynda). In *One Hundred Demons* the narrator usually narrates outside or overlaying the frame's pictorial content; the protagonist, pictured within the frame, speaks in speech balloons.

41. Unlike "The Red Comb," which strongly suggests sex without naming it, "Resilience" plainly identifies its subject as sexual abuse ("I already knew too much about sex"). However, the circumstances of the abuse, described here as "harsh," "bad," "too awful to remember," remain, crucially, opaque in the story. In a recent interview, Barry

explained that she glosses *One Hundred Demons* to parents who buy the book for children in the following way: "'Well, just to let you know, there's incest and suicide, and drug taking'" (Chute, "Lynda Barry" 54). Suicide is the topic of the story "Cicadas," and drug taking is the topic of "The Visitor." As "Resilience" is the only story to address sexual abuse, we might deduce that the abuse at its center is incestuous. The story does not offer any information on the perpetrator(s) until the last panel and keeps the identity of the man who appears vague. This vagueness prompted my reading of the man as a stranger; knowing that the man could potentially be known to her, but is presented with such distance, amplifies the dramatic effect of the story, which leaves us at the very moment that the trauma begins. It also underscores that "Resilience" is about traumatic memory, not about describing the situation of the abuse itself (as it is, for example, in Gloeckner's work).

42. Of her parents, Barry told me: "I haven't seen or talked to them in probably sixteen years, and it's been absolutely mutual, and they've never come looking for me either, so it's been the best sixteen years of my life" (Interview). However, Barry's relationship with her mother's mother is portrayed positively in *One Hundred Demons*, and the 1993 documentary film *Grandma's Way-Out Party*, about a road trip Barry took from Minneapolis to get to her grandmother's eighty-fifth birthday party in her Seattle hometown, offers footage of their reunion that attests to their strong relationship. *Grandma's Way-Out Party*, which initially aired on public television in eight segments, is currently available online in full (57:28) at the Minnesota Video Vault. See http://www.mnvideovault.org/index.php?id=15597&select_index=8&popup=yes. Accessed September 22, 2009.

43. Barry is most explicit, as an adult narrator, on her relationship with her mother in the chapters "Dogs" and "Girlness": in the former, she tells us: "I grew up in a violent house"; in the latter, she discusses her mother's abusive behavior as stemming, in part, from her traumatic experiences in the Philippines after the Japanese invasion during the war. See also the spoken-word piece "Wartime" on *The Lynda Barry Experience*.

44. The boyfriend, who calls her "little ghetto girl," thinks he can sum up Lynda's history: "My mother thinks you're lying about your age. She thinks you're older. I told her about your history. How it's like war. The foot soldiers always age faster than the officers" (*One Hundred Demons* 21).

45. Lynda stars in the stories that she creates in conversation with the classifieds: "I'd imagine the whole story: the freaked-out people, the freaked-out animals, and me, always coming to the rescue and never accepting the reward," we learn, for instance, about ads placed for lost pets (*One Hundred Demons* 209). She paints the stories that accompany the following classified ads: "Crypt in mausoleum. Prime loc. Eye-level. Best offer. Evenings"; "Sz. 12 wedding dress. Never worn. Must sacrifice"; "Fill dirt, very clean"; "Party pianist. My piano or yours" (209). Of these heroic mininarratives, Barry tells us: "Mostly I died in my classified stories. Even then I loved tragic endings. People would be crying so hard. They'd cover my coffin with fill dirt, very clean. The party pianist would play" (211).

46. This interest in and respect for making the situation of the book's own production evident is also clear in Barry's desire for "the wrinkling to show"—to show her "mistakes" instead of eliding them (Interview).

47. *One Hundred Demons* is closest, among memoirs, to Adrienne Kennedy's *People Who Led to My Plays*, which presents not a literal palimpsest, as Barry's collaged self-representation does, but, democratically, a huge range of persons, texts, and events that formed the author. Kennedy's book is composed entirely of lists of identifications. Her work, like Barry's, is feminist in its methodology: its disruption of linearity, its fluid unfixed sense of self, and its merging of the private and the public—how Kennedy productively identifies and disidentifies with public culture, both high and low—is given the same value in the book as her personal, intimate identifications. As with Barry, Kennedy weights the ordinary and everyday in her narrative of self-formation, including one-line entries such as "People: Those I saw walking in the snow on my street one Christmas afternoon" (46).

48. In this model of subjectivity, importantly, "to be 'constituted' by narrative is not to be 'determined' by it; situatedness does not preclude critical distantiation and reflexivity" (Benhabib n. 354).

49. The "non-purposive" state of play described by Winnicott matches the tenor of Barry's collages and the undefined shape of her *What It Is*, both of which offer a sense of provisionality (55). Winnicott defines playing as an experience that is the location of creativity: it is satisfying, even when leading to anxiety, and it is precarious because it "is always on the theoretical line between the subjective and that which is objectively perceived"—it is not an inner psychic reality, because it exists *outside*, but neither does it entirely belong to the external world (50). He emphasizes the spatiality of play: "Playing and cultural experience—link the past, present, and the future; *they take up time and space*" (109). In *What It Is,* Barry acknowledges the ideas of Winnicott, along with psychoanalyst Marion Milner, among others. Milner's *On Not Being Able to Paint*, relevant to all the autobiographical comics discussed in this book, theorizes how the imagined body in painting does "feel like a body" because it is essentially spatial. She writes of "this sense of extension in space" and how space conveys an intensity of feeling (36).

50. Because so much of Barry's work focuses on childhood trauma, I initially took the "unthinkable" of the title as unimaginable, unrepresentable; her course is, after all, about unloosing memory. After reading *What It Is*, it struck me that *unthinkable* in this context might mean taking seriously *seemingly* banal, everyday details and occurrences; these details appear unthinkable because too ordinary as a subject for writing. In her own reading of her title, the unthinkable is the truly spontaneous, which is play: "not knowing what you're about to do" (Barry, Conversation). All three interpretations, however, are connected in *What It Is*, which focuses on how playing with images, which is a way of taking images seriously, including seemingly inconsequential or confusing details of images, allows memories to resurface in creative work. The unthinkable as *not knowing* is the subject of the episode "Two Questions," which was first published in *McSweeney's*.

51. This play with flatness/texture can also be seen in how Barry mixes type and handwriting in the space of one word (see *What It Is* 23).

52. Barry includes handwritten bits in which one cannot "read" the handwriting. She includes a scrawled note of her own, for example, on page 96, in which what it "says" is unclear. When I pointed it out to her, she responded, "I don't even know what it

says"—but she values the visual form it makes (Interview). She also integrates collage bits that feature Mitchell's handwriting when she had palsy, in which it is almost impossible—in many cases, I could not do it—to decipher the words Mitchell writes.

53. This statement appears on one of many notecards that are laid out, the arrangement mimicking comics frames, on the front endpapers (they also appear on the back endpapers). The statement is made on a page that develops the very idea, then, in its composition.

4. GRAPHIC NARRATIVE AS WITNESS

1. As previously noted, Satrapi widely cites *Maus* as the primary inspiration for her project of representing her life in Iran in a revolutionary and wartime period. She calls it "a bomb in my head," explaining, simply, "when I read *Maus* . . . I saw that it was possible to talk about a war in the comic format" (Wood 56). She read Joe Sacco's work, which she often praises, along with a range of American literary cartoonists, after she developed *Persepolis* (see Hill).

2. The feminist content of *Persepolis* is clear: the protagonist, at age six, is roundly sure that she is the "last prophet"; she imagines herself standing at the forefront of a line of previous prophets, all men, who collectively wonder "A woman?" as she smiles, enveloped in light (6). Wholly confident, Satrapi stands apart from many graphic narrative authors in that she is never self-deprecating. While there is gentle self-critique of childish notions in *Persepolis*, it never becomes a harsh motif, as it can in work by Spiegelman, Sacco, and Kominsky-Crumb, for instance. As the revolution reduces women to "ideological signs," the protagonist Marji's parents urge her, at age eleven, to publicly protest; her mother, who had previously barred her from dangerous street demonstrations, implores: "She should start learning to defend her rights as a woman right now!" (76). For more on *Persepolis* and feminism, see Miller, "Out of the Family," focusing on feminist generations, and Friedman, "Cosmopolitanism, Women, and War," which analyzes Satrapi's "fully situated cosmofeminism" (4). Satrapi herself prefers to be called a humanist rather than a feminist (see Hill, Solomon, and Tully).

3. The name under which she publishes her work, Marjane Satrapi, is different from the name on her passport, in part to protect her family.

4. The cartoonist David B. (Beauchard), a founding member of L'Association, is best known for *Epileptic,* which was originally published by L'Association in six volumes as *L'Ascension du Haut-Mal* from 1996–2004. An early champion of Satrapi's work, he wrote the introduction to the first French volume of *Persepolis* (2000). Much has been made of the similarities between B.'s and Satrapi's style (see, for instance, O'Neil, Sullivan) and, in fact, too much: Douglas Wolk, for example, goes so far as to deem Satrapi David B.'s "former student," whereas they never had that connection. Responding to a question about B.'s support, Satrapi clarifies, referencing other French cartoonists: "It's true that David helped me for the first two, three chapters of [the first French volume of] *Persepolis*. He taught me a lot of things. I also benefited from the support of Émile Bravo. I also had the support of Christophe Blain. All in all, there were many people. It wasn't just David" (Hill 17). In Satrapi's interview with Hill—the most useful interview on the early publication history of *Persepolis*—when asked directly about

B.'s influence, she explains, "*Epileptic* was one among others. I read other books too" (17). While there is certainly a visual consonance in the black and white monochrome palette of B. and Satrapi's comics, supporters of B.'s work appear, in the face of Satrapi's enormous international success, invested in demonstrating the indebtedness of her style to B., whereas his is actually denser and more decorative.

5. For more on the European comics field, see Beaty. L'Association, France's premier independent publisher of comics, was formed in 1990 by a group of six artists. L'Association set itself apart from the mainstream French comics market by publishing mostly black and white books, largely in paperback, with variable length and format dictated by the artists themselves, in contradistinction to the standard format for comics in France—the forty-eight-page, full-color, hardcover album (see Wolk). The four original French *Persepolis tomes*, for instance, are unpaginated, softcover books, slightly larger (9.5 x 6.5) than the hardcover American editions; each volume increases in length (*Persepolis 1* is 76 pages, *Persepolis 2* 88, *Persepolis 3* 96, *Persepolis 4* 104).

6. Pantheon issued *Persepolis: The Story of a Childhood* and *Persepolis 2: The Story of a Return* together as *The Complete Persepolis* in 2007. Pantheon had earlier done the same with *Maus*, publishing it in two volumes and then releasing *The Complete Maus*.

7. Satrapi, who is married to a Swede, speaks Farsi, French, German, English, Swedish, and Italian.

8. Notably, *Persepolis* is required reading at West Point. Satrapi was invited to give a talk there in 2005 and published an "Op-Art" piece in the *Times* afterward contrasting her low expectations with her actual experience, in which she describes the cadets as open to her antiwar viewpoint.

9. Satrapi cowrote and codirected the film with Vincent Paronnaud, a fellow comic book author who also had no feature-length film experience (the film is in French). The two shared the Jury Prize, a tie, with *Silent Light*'s Carlos Reygadas.

10. Fittingly, it was Satrapi who wrote (and drew) the entry on Spiegelman when he was named one of the world's one hundred most influential people in *Time* magazine in 2005.

11. An edited version of the video appears on the *New York Times*'s blog The Lede, and a longer, unedited version appears on YouTube.

12. Noting in the *Guardian*, "Everywhere I go the first thing anyone wants to talk to me about is the veil," Satrapi criticizes France for being "simply scared of Islam, and of talking about Islam," and specifically criticizes French feminists who campaigned for the ban: "The western woman is so entranced by the idea that her emancipation comes from the miniskirt that she is convinced if you have something on your head you are nothing." She asserts, "anything that uses the language of banning is wrong" ("Veiled Threat"). A sampling of other opinion pieces published in English includes "I Must Go Home to Iran Again" (Op-Ed, *New York Times*), "Diary of a Nobelist" (Op-Art, *New York Times*), "Iranian-Americans: An Informal Poll" (*New Yorker*), and "Home Sweet Home" (*New Yorker*).

13. In its mixture of overtly political (e.g., the entry "Iran and Israel") and personal foci (e.g., "I Don't Want to Stop Smoking"), Satrapi's brief but rich blog, receiving no critical mention of which I am aware, is a confluence of material that resembles the structures of her graphic narratives. Further, its use of color and multiple styles and

media demonstrates Satrapi's visual range apart from the black-and-white stylization for which she is best known. In one entry Satrapi fruitfully analyzes a reprinted page of her own passport. As in Lynda Barry's *Naked Ladies*, Satrapi often matches drawings of anonymous others to her first-person verbal narration, visually reinforcing her position as only one voice among many. See http://satrapi.blogs.nytimes.com.

14. On the question of spokesmanship, Satrapi clarifies, "I never positioned myself as a politician, as a historian. . . . [But] it has never bothered me, on the contrary. People can ask me what they want." She adds, "We're also letting me talk to present another version of history. All of this is very upbeat" (Hill 30–31).

15. The best review of Satrapi's work by far—and one that explicitly puts pressure on the "universal" angle—is Jennifer Camper's brilliant take on *Persepolis 2* in *The Women's Review of Books*, which itself could be the subject of a critical article. Camper's essay in comics form is a feminist, decentered review that claims no single judging authorial voice but features a wide cast of characters, at home, in cafés, on park benches, or in the space of bookstores, discussing either *Persepolis* volume or related political and aesthetic issues. (In the opening scene, two veiled women stand over a book display; one sighs, "I see we're still flavor of the month"; in a later scene, two cartoonists wonder, "Do you think she uses a pen or a brush?" [8].) The strip itself, which is transnational, multiethnic, and intergenerational, and features many differently positioned Iranian women characters, commingles the public and the private, much as the book itself does. It also presents an international culture of comics, highlighting the bigger comics cultures in Europe, South America, and Asia, and pairs a sophisticated critique of condescending American attitudes about Eastern and/or Muslim women with a critique of ignorant American attitudes about comics. Camper is the founder and editor of the comics anthology *Juicy Mother*, which includes work by Alison Bechdel and focuses on the perspectives of "women, people of color, and queers" ("Introduction" 7). Camper, who is Lebanese-American, explores the identity of "an Arab Muslim dyke" in the *Juicy Mother* piece "Ramadan" (7).

16. Malek makes the strong case that *Persepolis*, while written at least in part for non-Iranians, also speaks to young diasporic Iranians as an important dispatch from an older generation—the generation that witnessed the revolution and the Iran-Iraq war. The validity of Malek's argument is clear in the fact that two Iranians, under the names Sina and Payman, recently launched *Persepolis 2.0*, an online project that uses images, with Satrapi's permission, from the *Persepolis* volumes but substitutes new text that comments on the June 2009 Iranian election fraud and protests. Sina explains to the *Guardian*, "Her cartoon[s] are about her life but to my generation of Iranians (at least in the West) they have become more than that, they have become iconic. The fact that images [depicting] 30 years ago can tell a story about what is happening now makes them all the more powerful" (Weaver). Only weeks after launching, according to Sina, visitors from 120 different countries had visited the site. See www.spreadpersepolis.com.

17. Naghibi and O'Malley are right to argue that *Persepolis* intervenes against two scripts, Iran as oppressive and the West as enlightened/liberal, and, further, that in *Persepolis* "the assumption of recognition and familiarity experienced by a Western reader are

constantly undermined by the interjection of culturally specific and unfamiliar references" (231). While they aptly analyze the evocation of difference on the book's cover, in which the image of the child body is contained by a decorative frame that includes an upside-down tulip—a flower that in Iran is a potent symbol of martyrdom—I would add that the untranslated Farsi present in *Persepolis* and *Persepolis 2* also functions as a significant marker of difference and particularity. See, for example, *Persepolis* 33, 86, 87, 115, 138 and *Persepolis 2* 21, 24, 52, 67, 96, 97, 122, 149, 153, 174, and 186. (There are also a small number of translated Farsi sentences, as when Marji is shown commenting on her landlord in a speech balloon in Farsi to her mother, which is translated below as "She's so fat!" [*Persepolis 2* 51]).

18. See also Malek, Naghibi and O'Malley, and Ramazani. Whitlock discusses *Persepolis* further at the end of her book *Soft Weapons: Autobiography in Transit*.

19. The best known of these Iranian and Iranian diaspora memoirs includes Gelareh Assayeh's *Saffron Sky: A Life Between Iran and America* (1999); Tara Bahrampour's *To See and See Again: A Life in Iran and America* (1999); Firoozeh Dumas's *Funny in Farsi: A Memoir of Growing Up Iranian in America* (2003); Nobel Peace Prize-winner Shirin Ebadi's *Iran Awakening: A Memoir of Revolution and Hope* (2006); Susha Guppy's *The Blindfold Horse: Memories of a Persian Childhood* (1988); Roya Hakakian's *Journey from the Land of No: A Girlhood Caught in Revolutionary Iran* (2004); Azadeh Moaveni's *Lipstick Jihad: A Memoir of Growing Up Iranian in America and American in Iran* (2005) and *Honeymoon in Tehran: Two Years of Love and Danger in Iran* (2009); Azar Nafisi's *Reading Lolita in Tehran*; and Nahid Rachlin's *Persian Girls* (2006).

20. This is particularly strange considering *Let Me Tell You Where I've Been*'s own emphasis on the importance of visual images. In the foreword, Al Young writes, glossing the all-poetry and prose work in the volume, "Images and icons roll up, no matter who's doing the telling" (xiv). In the introduction, Karim asserts, "Poets and writers . . . use their work to counteract the barrage of visual images that has simultaneously been part of the Islamic Republic's campaign . . . and Western media's fixation on veiled women and women's repression" (xx–xxi). Why not counteract images with images? Satrapi's work is, however, included in the collections edited by Zanganeh, a book for which she also contributed the cover, and Heath, which excerpts not only the first few pages of *Persepolis* but also includes other comics work—Sarah C. Bell's piece "Nubo: The Wedding Veil."

21. B. writes, "Elle a réalisé le premier album de bandes dessinées iranien" in the introduction to the first tome of *Persepolis*.

22. While a thread of criticism identifies *Persepolis*'s "liminal" or "hybrid" form as appropriate to expressing or performing the author-protagonist's liminal position/identity (Davis, Friedman, Worth), these do not specifically analyze *Persepolis*'s approach to historical trauma. A recent exception is Segall. She takes the opposite approach from mine—and one that is common to criticism of graphic narratives about trauma. As with many critics of *Maus*, Segall, who offers very little visual analysis, understands that the visual layer of the graphic narrative, instead of engaging the complexity and horror of trauma, rather acts as a buffer, a sugar coating that makes trauma bearable for the artist and reader: "Since it is difficult to bear loss, the caricatures, with their

cartoon-like faces, offer a measure of detachment. Even as the cartoon visual detaches from traumatic events, the narrative depicts a tangled sense of individual and familial, literal and ideological, loss" (40).

23. Naghibi and O'Malley point out that in Iran, where the use of the autobiographical genre has been discouraged, especially for women, "autobiographical stories have been perceived as a form of metaphorical unveiling as indecorous as physical unveiling" (224).

24. *Embroideries* was first published in France as *Broderies* by L'Association in 2003; *Chicken with Plums* was first published as *Poulet aux prunes*, also by L'Association in 2003.

25. For more on the genre of the class photo in *Persepolis*, see Hirsch and Spitzer, "About Class Photos."

26. Friedman's discussion of the horizontal, rather than vertical, logic of cosmopoetics well describes Satrapi's position vis-à-vis her life in Iran, in which she is privileged in terms of class, a subject the *Persepolis* series openly explores, and deprivileged, after the revolution, as a woman. Friedman writes, "Cosmopoetics suggests a transnational framework for understanding the production, reception, and textuality of writing that is not proscribed by the boundaries of single nations, ethnicities, religions, or genders; and it recognizes the contradictory subject positions that writers often occupy—privileged in some ways, outsiders in others; seldom fully one or the other" (4).

27. As Patricia Storace points out, this final page—which concludes *Persepolis* unhappily, as *Maus I* also ends, but for an inverse reason—is "unmistakably based on the Pietà," with Taji Satrapi in the figure of Christ and Ebi Satrapi portrayed as the "sustaining mourner" (42).

28. In "Painting Memory," Kate Flint tracks the shifting perceptions of Victorian artists in the process of representing the invisible operations of memory; in a discussion of Henri Bergson's *Matter and Memory*, she points out that "memory, in part because of the way in which it is bound in with the operation of the senses, had come to be seen as something different from simple recall" (530).

29. Pope highlights lucidity as a historical ideal of Persian art, noting that Persian designers "showed special skill in the reduction of an image to its simplest terms" (4).

30. Maslenitsyna points out that "Persian miniature painting emerged as book illumination; it continued as such up to the 16th century, being inseparably linked with the manuscript leaves and with the text" (118). In the middle of the sixteenth century, when there was a separate demand for the images, they were carried out in the same miniature technique and usually bound in albums. The first extant artifacts date from the eleventh century, but there is evidence that miniature painting dates back even further (118).

31. "In Europe manuscript illumination has served either to illustrate, or to decorate the book. It has been either didactic or decorative" (Gray 5).

32. Gray writes of what we may think of as "an established, classic, Persian style" that its "most striking and peculiar gift is its use of colour. [The paintings'] colours are of singular purity, mostly prepared from metallic bases, and applied flat. . . . [Colours] are not used in a tonal scheme, as in most western painting, but as a chord; they do not foil one another but sing together" (10).

33. However, critics have misread graphic narrative: Storace, for example, comments that

Persepolis is "a book in which it is almost impossible to find an image distinguished enough to consider an important piece of visual art" (40). As I hope to make clear, those who produce graphic narrative are not interested in creating images as independent artworks but rather in what Spiegelman calls picture-writing and Satrapi calls narrative drawing.

34. The merit of *Persepolis*'s style has been a subject of debate in the United States as well as in Europe (see Beaty 246–248). One common strain of criticism identifies the book's political topicality as its reason for success but devalues its aesthetics. Beaty surveys negative assessments of Satrapi's visual style, including those by Romain Brethes in *Beaux Arts Magazine*, Christopher Theokas in *USA Today*, and Rebecca Vadnie in the *Orlando Sentinel*, which termed the art in *Embroideries* "sloppy" (Beaty 248). Adam Kirsch, writing in the *New York Sun*, states "'Persepolis' and its sequel cannot do justice to subjects that are not cartoonish" (24).

35. I would like to thank Jurij Striedter for suggesting the relevance of Shklovsky's "new seeing" to *Persepolis*. See Striedter, *Literary Structure, Evolution, and Value*, and Shklovsky, *Theory of Prose*, especially "Art as Device," in which he puts forth the concept of defamiliarization that I use in this chapter.

36. O'Neil's assumption that Satrapi's straightforward lines indicate the extent of her abilities, as if the style of *Persepolis* is "natural" and nondiscursive, is a misunderstanding, I believe, with which most male authors rarely now contend. Joseph Witek argues of *Maus* in his seminal *Comic Books as History*—surely a text of which any comics critic would be aware—that "Spiegelman's visual style is a narrative choice, as constitutive of meaning as the words of the story" (100).

37. As with the Rex Cinema page, this image of death marks itself discursively as belonging to the child's perspective. Further, it marks its significance within the narrative by its distinct, unusual rendering, in which there is shading and texture. The episode visually weighs the death of thousands of young underprivileged Iranian men and boys, who wear "keys to paradise" around their necks, against the recreational activities of the privileged twelve-year-old Marji, who attends her first party on the same page. Below Satrapi's image of the exploding minefields, we see the dancing bodies of Marji and her friends. *Persepolis*'s attention to bodies is striking, as it contrasts dead and joyous bodies on the page. Marji looks directly at us, while the dead bodies are undetailed and eyeless, soaring through the air.

38. I use *speech* in the manner of Leigh Gilmore's assertions about the "nexus of trauma and gender as the terrain of political speech, even when that speech explicitly draws on a rhetoric of private life and elaborates a space of privacy" ("Jurisdictions" 715).

39. Three years later, Marji will echo this upsetting knowledge back to a group of Guardians of the Revolution who want to detain her, lying and pleading that her family will "burn [her] with the clothes iron" if she fails to return home right away (*Persepolis* 134). For an account of how domestic objects are *unmade* by being turned into weapons, as torture itself uncreates the structure of making, see Scarry 38–45.

40. Visually, this panel has an echo in the chapter "The Cigarette," in which Marji again tries to imagine something she cannot, which is then visualized for us by Satrapi. Mulling over slogans, Marjane narrates, inset above an image, "The one that struck me the most by its gory imagery was 'To die a martyr is to inject blood into the veins of soci-

ety.'" We see a spare portrait of a grimacing man, head on a small pillow, with four long spouts of blood flowing from each arm, out into the borders of the panel (*Persepolis* 115).

41. However, in keeping with my focus on what I think of as the "risk of representation" of trauma in visual-verbal texts, there is significant critical attention to the role of the visual in the presentation of traumatic experience. See, for example, Saltzman and Rosenberg, *Trauma and Visuality in Modernity*; Bennett, *Empathic Vision*.

42. I use *imaging* in de Lauretis's sense as that which binds affect and meaning to images by establishing the terms of identification, orienting the movement of desire, and positioning the spectator in relation to them (135).

43. Thus the *Village Voice*, pointing out that *Persepolis* "conveys neither the emotional depth of *Maus*" nor "the virtuosity of Joe Sacco's journalistic comics," misunderstands how its ostensibly simple style is part of the book's political project (Press, "Veil of Tears"). Sacco's ethical undertaking is to remedy the underrepresentation of victims of war, and he is well known for his dense, swarming, photorealistic style; as a journalist, he works at the level of detail where he consults forensics experts, for instance, in order to more accurately draw dead bodies.

44. The two exceptions are a place name—"Moscow"—and a proper name, that of a popular American singer, "Kim Wilde."

45. The fact of "knowing war" is central to how her cohort in Vienna understand her: while she is exoticized, on one hand, she is also accused of lying, on the other: "She lies when she says she's known war. It's all to make herself seem interesting," Marji overhears a classmate describe her in a café (*Persepolis 2* 42).

46. We see this, for instance, in Barry's *It's So Magic*. In the (fictional) strip "If You Want to Know Teenagers," the narrative conceit is that the child protagonist Marlys draws the story, and she ends by offering a blank frame: "Sorry for no picture. I saw something I can't even draw it" (71).

47. This key episode in *Persepolis 2* revolves entirely around acts of looking as Marji observes the visual culture of Tehran's Islamic regime that has sprouted since she left for Vienna. On the page preceding the renamed street signs, she gazes up at a "sixty-five-foot-high" mural presenting a veiled woman cradling the body of a martyred man, surrounded by a decorative tulip motif (96). Later, in the chapter "The Exam," Satrapi calls attention to her facility in adopting the codes of this visual culture as she presents an image common to graphic narratives but unique to *Persepolis*: her hand on the page, in the act of composing a drawing qualification exam for Tehran's College of Art (127). Satrapi draws herself drawing Michelangelo's *La Pietà*, reconfigured with an Islamic regime theme: Mary in a black chador, an army uniform on Jesus, and four tulips framing the figures. A footnote in the book explains the slogan: red tulips grow from the blood of martyrs. The image could represent either the young Marji drawing during the exam, the older Satrapi redrawing it for the purposes of her book, or both—the hand that fills in the white space is not marked by either time period. In highlighting this image through its ambiguous and atypical composition, Satrapi demonstrates Marji's and the book's awareness and inversion of established visual codes. As well as the visual similarities between the martyr murals and the exam composition, the prominent tulips in Marji's drawing echo the upside-down tulips on the cover of *Persepolis* and *Persepolis 2*, and the image also invokes the previously mentioned conclusion of

Persepolis, in which Ebi Satrapi carries Taji Satrapi away from the airport after she's fainted in a posture evocative of "La Pietà."

48. In *Persepolis 2*'s penultimate chapter, "The Satellite," Satrapi uses the same visual motif, with twenty skulls representing regime protesters lurking in the earth below trees and sun, floating together and fitted underneath the ground as if puzzle pieces (169).

49. In declaring at the end of her series that "freedom had a price," Satrapi refers to the death of her beloved grandmother, whom she saw only one more time after this goodbye before her death in 1996.

50. For more on women's legal testimony in Iran, see Kusha, *The Sacred Law of Islam*, especially the section "Witness Rights and Responsibilities of Women" (99–102). Analyzing the relevant verse from the Qur'an, Kusha argues that while "the verse could and should be taken in its historical context and not as reflecting heaven's endorsement that women are less valued than men in the eyes of God, [t]his said, there is no doubt, however, that this verse has been interpreted to equate two women's testimonial worth (whether educated or not) to one man's testimonial worth" (101).

51. In this quotation, in which she mentions the frustration, specifically, of a male window washer having full power of witness while women have half, Satrapi betrays, perhaps, a distinctly upper-class attitude; she is a descendant of Iranian royals, and her grandfather was a prince (one among many others) who at one point was prime minister under Reza Shah. The window washer reference, though, may also be linked to Satrapi's specific experience: *Persepolis* presents a devastating scene in which Marji's aunt seeks a passport authorization for her ill husband and finds her former window washer installed as the new director of the hospital under the Islamic regime (121). He defers the request; Marji's uncle dies.

52. Of the stories in *Embroideries*, Satrapi told *Nerve.com*, "I really loved the stories the women told me. I don't know if they are made up or true. I don't think it matters." Of *Chicken with Plums*, she clarifies, "The facts are true. . . . I changed the name and I changed the figures. . . . The person [Nasser Ali Khan] is really the mixture of a couple of stories who belong to different people. All of them are true, but at the same time, the mixing of it are [*sic*] not true" (Mautner 5).

53. For more on the centrality of the grandmother figure in *Persepolis and Embroideries*, see Pulda, who compares Satrapi's work with Mary McCarthy's and Michael Ondaatje's.

54. Speaking to *Nerve.com* about *Embroideries*, Satrapi asserts, "The day we [humans] can say we are civilized is the day when women can have the same relationship to their sexuality that men can" (Thrupkaew).

55. *Embroideries* extends the theme of sexuality present in *Persepolis 2*. After a female classmate accuses her of indecency for taking the pill, the openly sexual Marji publicly declares, "Can you explain to me what's indecent about making love with your boyfriend? . . . My body is my own! I give it to whomever I want!" (149). While Naghibi and O'Malley praise *Persepolis* for its presentation of intimate details—an act generally considered taboo in Iranian culture, as previously mentioned—they dislike *Embroideries*, it seems, for going too far in this direction, assigning it a quality of "voyeurism" with which I disagree: the book, they write, "implicates itself in [the] impulse to repackage women's resistance as women's sexual promiscuity. . . . Although the text challenges the stereotype of the obedient and repressed Iranian female subject in main-

stream Western discourse, it also risks affirming the claims of emancipation through sexual liberation popular in certain Western feminist models" (238). Actually, the book clearly puts pressure on Western lifestyle models, as when Marji's grandmother critiques MTV as "the one with all the assholes who sing half naked" (np). Yet, just as in *Persepolis*, *Embroideries* has a textured take on "Eastern" and "Western" models; a text about Iranian specificity, it critiques both homegrown and Western attitudes and practices, and is clearly ambivalent about how Western culture, broadly, conceives of female sexuality (Satrapi's interview with Solomon, while brief, provides a good gloss on her views). And, unlike what Naghibi and O'Malley imply, not all the women whose stories are presented in *Embroideries* are "promiscuous"; further, Satrapi is, as the quotation from her I cite indicates, a believer in the notion of emancipation through sexual liberation, but neither the book nor Satrapi herself claim this is the only component of what Naghibi and O'Malley call resistance.

56. A physically small book (6"x 8") and entirely unpaginated, *Embroideries* is definitely a work of narrative drawing—the words and images each present a separate narrative track that together create the meaning—but it is not gridded. The format of *Embroideries* itself mimics a conversation, as Satrapi explains: "A conversation is something small without any frame that you can enter and leave whenever you want" (Zuarino, "An Interview" 2).

57. Satrapi explains, "I got attracted by this idea of death because death is part of life" (Mautner 3). For a more detailed account of *Chicken with Plums*, see Chute, Review.

58. *Chicken with Plums* is purportedly the second work in a trilogy that starts with the *Persepolis* volumes and moves backward into Iranian history: "*Persepolis* is [about] Iran between the '70s and the '90s, and *Chicken with Plums* is the '50s until the '70s. I want to make a book that is around the '20s until the '60s. It's really like a backwards trilogy, a family saga," Satrapi reports (Zuarino, "An Interview" 2).

59. In a different interview, Satrapi frames the sexual revolution as failed: "The story with this woman Irane is that she's not veiled anymore because the veil was banned by Reza Shah. It was the beginning of a sexual revolution that never actually took place" (Sundberg 1).

60. The book's last scene is of Irane crying at Nasser Ali's funeral, after an episode in which she fails to recognize him on the street, precipitating his suicide.

61. Satrapi explains that she wanted *Chicken with Plums* "to look like eight days of life, which is extremely short. But it's extremely dense at the same time. . . . I want my book to look like what I'm talking about"—a notion of graphic narrative format and style evident in all of her work, from *Persepolis*'s shifting black and white spaces to *Embroideries*'s visual diffusion to the compact pages of the story of a slow suicide (Zuarino, "An Interview" 2).

62. For instance, when I prepared a public interview with Art Spiegelman and Chris Ware for the Jewish Community Center of San Francisco in 2008, they both expressed their lack of interest in, as well as the constant querying about, adapting their graphic narratives for film.

63. Satrapi is currently working with her *Persepolis* collaborator Vincent Paronnaud on a feature-length, live-action film. The film is reportedly an adaptation of *Chicken with Plums* that will be titled *Waiting for Azrael* (Azrael, the Angel of Death, is featured in the book).

64. Harrison, reviewing *Embroideries* in the *Times*, is peculiarly inattentive to the formal differences between the two, such as the narratologically basic one of film being in time, when she writes, "Graphic novels mean . . . having to admire the wonderful fresh cleverness of putting words and pictures alongside each other, as if films haven't been doing the same thing, modestly and painlessly, for about a hundred years" ("Dreams of Trespass" 33).

65. See also Russell; Root.

66. Satrapi's cowriter and codirector Paronnaud, who draws comics under the name Winshluss (an appellation that comes from the French underground comics community), explains of the process of making the film that "we were doing something that was like an underground piece but now it's come out above ground" (Guillén).

67. Insisting on hand-drawn animation was not so much "a battle against the tri-dimensional" as an aesthetic issue: "We tried to make some scenes, like the scene with the car. We tried to make it on the computer. The result was disgusting" (Satrapi, "Capone" 5).

68. At this strict level of story, the film version, in contradistinction to the comics version, is anchored so tightly around the character of Marji that it sometimes lacks the breadth of the books. I agree with Kate Stables's measured criticism of the film; Stables writes that, when located in Vienna, "the film narrows, in interest rather than pace" and that "the film's darker moments range wider" (75).

69. The theme of remediation runs throughout the film, as *Persepolis* focuses on multiple films within the film, including *Godzilla*, *Beauty and the Beast*, and *Terminator*, as well as numerous television shows (such as *Columbo* and a Japanese soap opera), briefly making each of these re-created narratives its own.

70. Satrapi describes the puppet theater scene as signaling "this [film] is not a primer on the history of Iran" (Russell 7).

71. After pressure from the Iranian embassy, the film was pulled from Thailand's Bangkok International Film Festival. The film was also briefly denied a release in Lebanon; the head of the general security department at the interior ministry approved the ban after Shiite officials expressed concern. In Beirut the production manager of the film's distribution company called the decision "ridiculous" and noted it was also ineffective: he reports that he purchased pirated copies of the film from the suburbs and from the Sabra and Shatila Palestinian refugee camps (Moussaoui). While *Persepolis* did not have an Iranian release, it was yet screened at two cultural centers in Tehran early in 2008 (Jaafar). In the *Middle East Times* Satrapi is quoted as saying, "I certainly don't think the film is going to be coming out on screens in Iran. But like all things forbidden in Iran, it gives people even more desire to see it." She notes that in Iran people watched the film on illicit DVDs, some of which were created by taping the movie overseas with cell phones. Iran's culture bureau also denounced the 2007 American film *300* as anti-Iranian, and, as Satrapi reports, "It's an awful, vulgar film and one week after its release it's in Tehran and even dubbed into Persian" (*Middle East Times*).

5. ANIMATING AN ARCHIVE

1. The flap copy of *Fun Home*'s first edition declares, "Like Marjane Satrapi's *Persepolis*, it's a story exhilaratingly suited to graphic memoir form." I have never liked this sentence, in part because it is so enthusiastic and yet so vague. In this chapter I aim to

clarify how the comics form suits the two in fact quite different projects of representation we see in Satrapi and Bechdel's work.

2. Beech Creek has a population of roughly eight hundred.

3. While Bechdel has said outright that *Fun Home* "feels like a proper funeral for my father," Spiegelman figures *Maus*'s work of commemoration as a yahrzeit candle: "When I finished it I realized that I had made like a thirteen-year-long Yahrzeit candle, a memorial candle of some kind" (Chute, "Gothic Revival" 34; Kannenberg, "A Conversation" 246).

4. *Dykes* started off in the form of single-panel cartoons; Bechdel switched to a strip format in 1984 with her four-panel story "Perils of a Midtown Dyke." In 1987 Bechdel introduced regular characters with an ongoing story line.

5. *Dykes*, which made its first appearance in *Womanews* in its July–August 1983 issue, was close to being the first ongoing queer strip, period: the first installment of Howard Cruse's *Wendel* strip appeared only months earlier, in the January 20, 1983, issue of the *Advocate*.

6. The first collection, the eponymous *Dykes to Watch Out For*, was released in 1986 by the feminist independent publisher Firebrand, which subsequently published an additional eight *Dykes* titles (the publisher Alyson Books, which specializes in LGBT titles, took over in 2003). At one point *Dykes* appeared in about forty papers across the U.S., Canada, and the U.K. Bechdel was offered the chance to develop a strip for the mainstream Universal Press Syndicate in 1994, which she turned down (Warren 19).

7. Houghton Mifflin published *The Essential Dykes to Watch Out For* in 2008, which includes a substantial "Cartoonist's Introduction" by Bechdel explaining the strip's origins and early history. Recently Bechdel instituted an "official sabbatical" from producing *Dykes*. She announced the decision in a May 10, 2008, post on her highly active blog *dykestowatchoutfor.com:* "I'm going to take an unspecified amount of time off from the strip so I can get my next memoir [*Love Life: A Case Study*] written and drawn by the fall 2009 deadline. It's absolutely terrifying to me to consider this—I've been doing DTWOF at regular intervals since I was 23, and it's become a sort of autonomic bodily function, always going on." http://dykestowatchoutfor.com/winds-of-change#more-580. Accessed April 29, 2009.

8. *Dykes* is not an autobiographical strip, although the "anxious, judgmental" Mo, arguably the central protagonist of the group of friends the strip spotlights, is the character closest to Bechdel herself ("Mo is this young white middle-class dyke. . . . For all practical purposes she is me" [Warren 21]). On Bechdel's relationship to Mo, see "An Interview with Alison Bechdel," in Warren, and Bechdel's chapter "Character Development," in Bechdel, *The Indelible Alison Bechdel*, a nonfiction book that explores the making of the strip.

9. Bechdel uses *autistic* in the sense of its definition as a condition in a which a person is "morbidly self-absorbed" (OED); in her family of five, each person had his or her own obsessive creative pursuit—an idea conveyed graphically on the cover of the hardback edition by the circular cutaways depicting each family member within the house, locked into a particular activity (this image also appears within the book on page 134). "In this isolation, our creativity took on an aspect of compulsion," Bechdel writes (134). "Indeed, if our family was a sort of artists' colony, could it not be even more accurately described as a mildly autistic colony?" (139).

10. For instance, Chip Kidd—a novelist, graphic designer, and the editorial director of the graphic novel imprint at Pantheon—wrote in his blurb for *Fun Home,* "Alison Bechdel's mesmerizing feat of familial resurrection *is a rare, primal example of why graphic novels have taken over the conversation about American literature,*" continuing, "The details—visual and verbal, emotional and elusive—are devastatingly captured by an artist in total control of her craft" (my emphasis).

11. Within academia, among appearances in other journals across disciplinary boundaries, *Fun Home* occupies a central place in two recent refereed special issues: it is the subject of two essays each in *Biography*'s issue on "Autographics" and *Women's Studies Quarterly*'s issue on "Witness."

12. *Fun Home* made the *New York Times* nonfiction bestseller list in July 2006, a significant feat, as no literary graphic narrative since Spiegelman's *Maus* had made the list, including Satrapi's *Persepolis*, an international bestseller. *Fun Home* has already been translated into over ten languages, including Hungarian, Finnish, Korean, and, most recently, Chinese. A private publisher called Beijing Zito copublished the book with Shaanxi Normal Universal Press, an official government publisher; the nudity in the book is censored (see Yi-Sheng).

13. *Time* wrote: "The unlikeliest success of 2006 is a stunning memoir about a girl growing up in a small town with her cryptic, perfectionist dad and slowly realizing that a) she is gay and b) he is too. Oh, and it's a comic book: Bechdel's breathtakingly smart commentary duets with eloquent line drawings. Forget genre and sexual orientation: this is a masterpiece about two people who live in the same house but different worlds, and their mysterious debts to each other" (Grossman).

14. The first volume of Spiegelman's *Maus* (1986), nominated for the same award in the category of Biography, caused a stir for its inclusion there as a serious nonfiction title. Twenty years later, *Fun Home*, as crafted and as profound, joins *Maus* in reminding audiences, perhaps now more receptive to innovation within contemporary narrative forms, just how moving and complex nonfiction comics can be.

15. The "Up Front" column written every week by the editors was devoted to Bechdel in the issue in which her review—of Jane Vandenburgh's nongraphic memoir—appeared. Calling it a "graphic review," they declared it "a happy departure for us" (2). Bechdel's success in expanding the form of the graphic essay can also be seen in pieces such as "Compulsory Reading," a four-page essay on the topic of reading that *Entertainment Weekly* commissioned for their 2008 special issue "The New Classics," which listed the one hundred best books of the past twenty-five years. *Fun Home* was listed at no. 68; other graphic narratives included *Maus* at no. 7, Alan Moore and Dave Gibbons's *Watchmen* at no. 13, and *Persepolis* at no. 37.

16. While both *Dykes* and *Fun Home* offer a visual style that codes, broadly, as "realistic" in the spectrum of style in comics, the rendering in *Dykes* differs from the rendering in *Fun Home*, in that the former employs a different kind of shading: its images tend to be more crosshatched than we generally see in *Fun Home*.

17. *Maus*'s chapter divisions inspired *Fun Home*'s (Chute, "An Interview" 1013). Both are markers or stand-ins for a separate level of reality, but whereas Spiegelman's are more graphically decorative than the pages they demarcate, Bechdel's, with their heavily detailed photorealistic rendering, function in an opposite stylistic register. Bechdel's title pages are stark black and white; they conspicuously lack the color that infuses the rest

of the book. For more on the role of the drawn photographs within *Fun Home*, see Bechdel's "Wrought," a comics essay in which she discusses how her drawings are a "crude schema" of the color photographs that inspire them, which are themselves a crude schema of the life they purport to capture (np [54]).

18. I first interviewed Bechdel in New York City in June 2006. There are three separate citations attached to this interview: "Gothic Revival," in the *Village Voice*; "An Interview with Alison Bechdel," in *Mfs*; and "Interview June 21, 2006"—I use the last to cite parts of that interview that were not published. I interviewed Bechdel a second time, for the purposes of this book, at her studio in Vermont in May 2008; that conversation is cited here as Interview 2008. A follow-up telephone interview conducted in April 2009 is cited as Interview 2009.

19. "There's really not much dramatic action," Bechdel says about the book's narrative shape. "If you don't count the subplot of my coming out story, the sole dramatic incident in the book is that my dad dies"—an event we learn about at *Fun Home*'s beginning (Chute, "An Interview" 1008). Bechdel published the autobiographical twelve-page black and white "Coming Out Story" in a 1993 special issue of the underground serial *Gay Comics* devoted entirely to her work (no. 19). "Coming Out Story" has substantial overlap with *Fun Home* in its presentation of the narrative of Alison's coming out, especially as regards the significance of scenes of reading in a college setting, but it completely absents her parents: it mentions nothing about the sexuality of either parent or their reaction to her coming out. The piece is reprinted in *The Indelible Alison Bechdel* and is available online. See http://www.oberlinlgbt.org/bechdel/bechdel-1.html.

20. While Watson and another critic, Lemberg, suggest that *Fun Home* aims to ultimately "close" the gap—referencing comics theorist Scott McCloud's term, *closure,* for what a reader enacts in the white spaces between frames—I argue the contrary: that the text's investment is not in closing gaps, but rather in rendering the tension between word and image productive, dynamic, and dramatic. See Watson 50 and Lemberg 133, 139.

21. My investment in "word and image" as a useful analytic marks my difference from scholars such as Robyn Warhol. In her paper on *Fun Home* at the 2008 MLA annual convention, Warhol proposed that the dual model I suggested for comics in *PMLA*—words and images as unsynthesized narrative tracks—was a "default" position Bechdel and I both take that could be replaced with a more narratologically correct tripartite model (consisting of extradiegetic, intradiegetic, and images). The *imprecision*, the *gap* set up by thinking about comics's "word and image" form is actually exactly what interests me.

22. Repetition compulsion is at the center of Freud's *Beyond the Pleasure Principle* (1920); LaPlanche and Pontalis define it as when the subject "[repeats] an old experience, but he does not recall this prototype; on the contrary, he has the strong impression that the situation is fully determined by the circumstances of the moment" (78). In her classic *Trauma and Recovery*, Herman points out that "traumatized people find themselves reenacting some aspect of the trauma scene in disguised form, without realizing what they are doing," and further that "even when [reenactments] are consciously chosen, they have a feeling of involuntariness" (40–41). Yet, Herman writes, "not all reenactments are dangerous. Some, in fact, are adaptive" (40). See LaPlanche and Pontalis for

an explanation of theoretical debates of the concept among psychoanalysts. For opposing readings of *Beyond the Pleasure Principle*, see Caruth, *Unclaimed Experience*; and Leys.

23. Handwriting is a central theme as well as constitutive of the process of *Fun Home*. While Bechdel, as I will discuss further, rewrote and redrew *Fun Home*'s archival documents by hand and drew the book by hand, the lettering used for dialogue and for the book's overarching prose narration is a computer font based on her own hand lettering. To create the font, she wrote out each letter of the alphabet for a studio, Blambot, which then generated the font through a program called Fontographer.

24. Jared Gardner has written on "the archival turn in contemporary graphic narrative," naming a slew of texts from Clowes's *Ghost World* to Katchor's *The Jew of New York* that meditate, in a fashion Gardner identifies as Benjaminian, on the importance of valuing both major and minor collections and histories ("Archives" 788). Yet while Gardner suggests that there are positive formal similarities, broadly theorized, between comics and archives—particularly a nonsynthesizable excess that refuses cause and effect argument—he does not focus on how comics can actually incorporate archives formally and visually, as *Fun Home* does, instead of just referring to them.

25. The sole exception in the text is on page 143: Alison's diary entry for Saturday, August 14, 1971 is a scan of her actual handwriting from her childhood diary. "There's one little bit of actual childhood drawing that I just scanned because I was feeling lazy," Bechdel told me (Interview June 21, 2006). When I suggested in a later interview that in general she could have simply scanned in the documents, especially since *Fun Home* is so preoccupied with accuracy, she replied, "That's not even a really philosophical issue. It's just that it is purely aesthetic. It wouldn't be a comic to me if I did that" (Interview 2008).

26. Ann Cvetkovich and Valerie Rohy, in essays on *Fun Home*, have lauded *Fun Home*'s "archival mode of witness" that constitutes a "queer witnessing" (Cvetkovich, "Drawing the Archive" 114, 126) and its "queer archive" (Rohy 3). Cvetkovich praises its archival component for blurring what counts as private and public history, and, along the lines of recent work on the political potential of shame, providing "a compelling challenge to celebratory queer histories" (126). Rohy argues that *Fun Home* represents and embodies Derrida's concept of "archive fever," in that both have a paradox at their center: inscription *and* effacement, progress *and* repetition. But both authors are primarily interested in *time*—a productively antihistoricist "queer temporality" and "queer time" in *Fun Home*. I want to suggest that *Fun Home*'s comics form is also engaged with *space* to a crucial degree these critics overlook. Neither Cvetkovich nor Rohy address the actual redrawing of the archive in *Fun Home* as its own kind of visual, spatial recursivity on the page. For more on concept of queer archives, see Cvetkovich, *An Archive of Feelings*.

27. Bechdel used this term to describe the book both in her public appearance at Rutgers University and in my 2008 interview with her.

28. The photograph depicts Roy, then seventeen, posing in his underwear. *Fun Home* performs a close reading of the "low-contrast and out of focus" photograph it renders for readers, which was taken in a hotel room on the Jersey Shore adjacent to the room Alison slept in with her two younger brothers on an August 1969 family trip (for which

her mother was not present; *Fun Home* 100). Bechdel discovered the snapshot of Roy about a year after her father died, in 1980, in an envelope marked "Family." And while she did not start working on *Fun Home* for almost twenty more years, this snapshot introduced the idea for the book (Chute, "An Interview" 1005). The photograph of Roy occupies "literally the core of the book, the centerfold," she explains, appearing in the middle of *Fun Home*'s central chapter, "In the Shadow of Young Girls in Flower" (1006).

29. The trip to Europe was also the time, Bechdel told me, when her parents would "do this funny thing of explaining psychoanalytic concepts explicitly to me"; citing Oedipus/ Electra complexes, they encouraged her, as a girl, to be interested in her father. Bechdel explains, "I was forced to be with my dad. I really wanted to be with my mom." She suspects that she was aligned with her father because "I guess no one liked him. He was such a bastard" (Interview 2008). Her family was foisting a traditional Oedipal complex and she wanted an "inverted" one (as we see in the last chapter, in an episode in which she is pictured with her father at the same age).

30. See Michael Dean's box of follow-up questions with Bechdel in Lynn Emmert's interview titled "Life Drawing" (52).

31. Alison is standing in the college campus bookstore glancing through *Word Is Out,* a 1978 collection of oral histories of gay lives, when she realizes she is a lesbian. This crucial scene appears twice in *Fun Home,* on page 74 and page 103. Reading together—even from the dictionary—becomes an explicitly erotic pastime for Alison and her first girlfriend. In *Fun Home* Bruce Bechdel often projects his gayness, the "nonconventional" pitch of his life, onto the subversive texts and alternative lifestyles of the modernist elite. In a significant letter to Alison in the last chapter, he reinforces the implied collapse of *gay* and *artist* by proposing a tripartite scheme, in which *artist-intellectual* exists outside conventions of class and sexuality (224).

32. When Alison returns to college after an equivocal conversation with her father about their homosexuality, he writes to her about a book, Kate Millett's *Flying* (the 1974 lesbian-focused autobiography) she had left for him to return to the library, praising its lesbian—and specifically, nonprocreative—positionality (Bechdel, *Fun Home* 224).

33. In picturing *Anna Karenina* on its first page, *Fun Home* surely implies the relevance of that book's opening line: "All happy families resemble one another; each unhappy family is unhappy in its own way."

34. See the twelve-page "Cartoonist's Introduction" in *The Essential Dykes to Watch Out For,* "Compulsory Reading," and "Wrought."

35. Bechdel here quotes Wallace Stevens's "Sunday Morning" (from *Harmonium*). The Stevens line circles the text back to the earlier chapter 3, "That Old Catastrophe," named after another line from the poem. The line in a literal valence refers to the book itself, a work of beauty born/borne from the death of the parent.

36. This is consonant with how Bechdel suggests she touches her father in drawing him— that is, she touches him through the pen.

37. Scott McCloud has identified comics as a "temporal map." "All comics," he says, "from *Peanuts* to *The Incredible Hulk* to *Persepolis,* are drawing a map of time" (McCloud, Interview with Hillary Chute).

38. As Rohy and Bechdel herself also point out, in Ferdinand de Saussure's *Course in General Linguistics,* to explain the signified (concept) and signifier (sound-image), he shows an image of an arbor and then the word *arbor:* the image here stands in for the thing itself. He does not actually present a signifier and signified, but rather two signifiers. See Bechdel, Interview 2008.

39. Tom Mitchell passed along the idea of the gutter as the Lacanian real. Ragland-Sullivan's language of the Real as an "ir-regulatory principle" and one that appears "in whatever concerns the radical nature of loss at the centre of words and being" is also relevant (375).

40. For a brief explanation of recent debates on the notion of archival truth, see Mansour's "The Violence of the Archive" in *ELN*'s 2007 special issue "The Specter of the Archive," ed. John-Michael Rivera, whose title article also usefully frames current arguments.

41. This contrast is amplified by the fact that Bechdel describes the dead boy as looking like a photograph (*Fun Home* 148).

42. Jared Gardner's essay "Autography's Biography" calls attention to this important instance of cartooning in Alison's diary (4). Gardner correctly points out that the smiley face is significantly "untouched by text or circumflex," but while he sees that in this entry "image and text . . . are at war for the page and the memories of the dead boy," I see the circumflexes and prose as working together, generating awkward, if unknown or unresolvable, spaces or slices of knowledge (4).

43. However, *Fun Home* has faced censorship because of its depiction of sex. In October 2006, after a patron of Marshall, Missouri's public library filed a request to remove *Fun Home* and Craig Thompson's graphic narrative *Blankets* (2003) from the library because she found them "inappropriate," the books were temporarily removed from library shelves while the library developed a "material selection policy" (the library board of trustees voted to remove the books during this period). In an op-ed column, Chuck Mason, the editor of the *Marshall Democrat-News*, argued against removing the books while debating the policy, suggesting that the Bible "contains sex, violence, adultery, lust" but unlike the texts in question, "just doesn't have pictures." The books were not returned to the shelves until March 2007. *Blankets* was moved from the teen section to the adult fiction section; *Fun Home* was returned to the adult fiction section. (Neither Bechdel nor Thompson's book is fiction; the classification of both as adult fiction is indicative, perhaps, of a widespread inability to view graphic narrative work as "nonfictional" as prose.) In a related episode, at the University of Utah, in March 2008 students protested the assignment of *Fun Home* in a mid-level English class; one student approached the group "No More Pornography," which started an online petition in protest of the book (Dallof). On the local reporting Web site *ksl. com,* there are over three hundred responses, mostly from students, in the "Community Comment Board" about the issue. See http://www.ksl.com/index.php?nid=148&sid=2952660&comments=true.

44. This truck, which, while smaller, suggests the truck that kills Bruce when he ends his life, has an important visual echo on chapter 2's last page. Here Bechdel, musing, "Stuck in the mud for good this time," and adopting a similar bird's-eye perspective, pictures

Alison in the cemetery lying down by her father's headstone (*Fun Home* 54). As in the earlier scene, a truck is present, and drives across the panel from the upper right-hand corner, linking the two scenes decisively and suggesting that Bruce Bechdel's life was always marked by death.

45. This panel also appears to refer to Rembrandt's masterpiece *The Anatomy Lesson* of *Dr. Nicolaes Tulp* (1632): how the corpse is framed here, its position and angle, and even the beard, is remarkably similar. Unlike in *The Anatomy Lesson*, here Alison is, conspicuously, the only onlooker—and in the frame, significantly, she occupies the lower right-hand corner space where in the painting we see a large, open text facing the dead man. Bruce Bechdel, while in the lowlier position of gutting, cleaning, and decorating the body, unlike the professor demonstrating the finger-flexors, yet evokes Tulp in his physical posture, and the page's later focus on the arrangement of his hands and fingers, as well as the prominent appearance of an anatomy poster, underscore the connection. The intense focus on and valuation of the hand as an organ above all others in Rembrandt's painting has an analogue in *Fun Home*. See Heckscher, *Rembrandt's*; and Schupbach, *The Paradox* on *The Anatomy Lesson*.

46. While the image of Roy traverses the two pages—the seam of the book bisects him just below the navel—the text boxes themselves read most sensibly up and down each side of the spread, instead of across the body of the image itself (although, in this case, both vertical and horizontal modes of reading could in fact plausibly move the narrative forward). See *Fun Home* 100–101.

47. The corpse on the table is feminized by virtue of its uncanny "dark red cave," a vaginal gap (44). Later, Bechdel writes of perceiving the inadequacy of her father's masculinity: "I sensed . . . an undefended gap in the circle of our wagons" (*Fun Home* 95).

48. The scene of Alison on the phone as her father's death is reported to her is repeated on page 81, one of several traumatic scenes recurring in the book.

49. There is another striking scene of Bruce tending to a cadaver in *Fun Home*—a local doctor who commits suicide only a few months before Bruce's own death. Bechdel draws a terrifying image of her father working beside the man's upper body and bagged head. Although this scene is evocative of the earlier cadaver, it is imagined, not witnessed, by Alison and appears in only one panel (49). Her father does not mention it in his correspondence with his daughter, who was then at college.

50. Bechdel's full statement is "[Comics is] like concrete poetry—it has to look like what it is." Comics is a site-specific medium, whereas "prose is literally one-dimensional—it doesn't exist in space the way a graphic narrative does" ("A Conversation").

51. Mitchell is glossing philosopher Bishop George Berkeley (1685–1753): "The installation procedure for the visual system, Berkeley notes, is similar to that of language acquisition in that it is what linguists would call *doubly articulated*: that is, it is not enough to have light impressions fall on the retina and stimulate the visual cortex. . . . There is no 'pure' visuality, or, as Gombrich pointed out long ago, '[T]he innocent eye is blind.' And *innocent* here means, quite precisely, *un*touched" ("Visual Literacy" 13). Mitchell also makes this point in his earlier, influential essay "Word and Image," in which he cites Berkeley's *An Essay Towards a New Theory of Vision* (1709) in support of the idea that eyesight involves visual and tactile sensations (47–48).

52. This is not only a way to grasp the past, but also a form of countering the lack of touch

in the Bechdel household. The lack of parental touch is clear in *Fun Home*, established early in a chapter 1 scene in which Alison is "unaccountably moved" to kiss her father goodnight and both are awkward and ashamed: "we were not a physically expressive family, to say the least" (19). In her childhood, Bechdel's mother was physically affectionate with her two brothers, but not with her: "She made my last diaper and never laid a hand on me," Bechdel told me (Interview 2008).

53. Despite her recognition of the powerful aesthetics of the scene of homosexual desire proposed by the existence of the photograph—"I felt this sort of posthumous bond with my father," Bechdel told me—it is, in fact, dim proof; it cannot deliver an incontrovertible truth about her father, nor can it clarify Alison's ambivalence, actually shift the axis of dis/identification ("An Interview" 1006). The photograph's evidence—like her father himself—is "simultaneously hidden and revealed" (*Fun Home* [101]). It is blurry evidence and literally blurry (and for all its detail of light and tone, Roy's eyes appear curiously elided). In this core of the book, Bechdel makes the photograph of Roy a double spread as if to elevate her father's desire and his art as aesthetic, beautiful, the book's own centerfold. But Bechdel destabilizes the power of the babysitter's photograph—the artistic product of her father—with the grammar of comics that is her own artistic product: the overlaying, irregular text boxes. The double spread of Roy is the least regulated of all of the pages of *Fun Home*.

54. Bechdel explained to me that her digital archive for *Fun Home* is currently on multiple discs and in "a huge iPhoto file" (Interview 2009).

55. This video is now available on YouTube at http://www.youtube.com/watch?v=_CB-dhxVFEGc.

56. This photograph is the subject of a comics essay by Bechdel in the Winter 2008 "Fathers" issue of *Granta*, which functions like a précis of *Fun Home*.

57. The Colette hand-off appears on 205 and 229. While there are, as with *Ulysses*, multiple scenes of Alison reading *Earthly Paradise*, and, as with *Ulysses*, Bechdel reproduces multiple textual excerpts from the book as her own comics panels, *Ulysses* is yet the greater material and emotional presence in the book. Alison's interaction with Colette's text is expansive, though. She masturbates to Colette, for instance—and, most importantly, the book becomes the site of her ability to broach her shared homosexuality with her father: "I wondered if you knew what you were doing when you gave me that Colette book" (220).

58. *Ulysses* is present throughout the chapter; Bechdel compares scenes, themes, and lines from *Ulysses* and *The Odyssey* to her and her father's lives and interactions; but *Ulysses'* presence, not only in the narration but also within the frames of the comics panels themselves, powerfully, conspicuously increases in the last ten pages of the book.

59. In the "inverted Oedipal complex" she has with her father, she does not want to have sex with him, but the desire for togetherness implied in an Oedipal complex is yet present, here evident in her wish for the two of them to reject heterosexuality together and hence to side with each other over and against the mother.

60. The line is from Bruce's response to Alison's letter, which she sends to both parents, announcing her homosexuality. The panel on page 231 is an excerpt that also appears on page 211.

61. A water theme emerges in this chapter; at one point Alison imagines herself "un-

moored" by her queerness, then floating on the ocean in a "small craft" swamped by her parents' "broadside," and then the narration notes a letter from her father the next day left her "more awash" (211). The sense of the child adrift or awash in water reverses with Bruce Bechdel's immersion in the water.

62. Bechdel has often discussed the seven-year period of making *Fun Home* as the time she needed for it to "gestate properly" (Emmert, "Life Drawing" 36; "A Conversation").

63. "I realized eventually," Bechdel says in an interview, "that what the book was really about was not his suicide, or our shared homosexuality, or the books we read. It was about my creative apprenticeship to my father" ("Talking" 7).

64. Bechdel identifies her conversation with her father in the car in which they discuss homosexuality as like Bloom and Stephen "having their equivocal late-night cocoa at 7 Eccles Street," an event from the Ithaca chapter (*Fun Home* 221).

65. The Ithaca chapter is structured by questions and answers, as in catechism or Socratic dialogue. On this chapter's inclusion of archival materials, see, for instance, a budget for June 16, 1904, in different-size type (584); the musical score for an oral legend, with handwritten lyrics under the bars (566–567). See Gifford 579.

66. Pieter Bruegel, *Landscape with the Fall of Icarus* (ca. 1558), Musées Royaux des Beaux-Arts de Belgique, Brussels.

67. For instance, Alison is six in the last scene and also when she makes the "unspoken compact" with her parents that she would carry on to live the artist's life they each had abdicated; what is in effect her father's suicide note to her, a handwritten letter reproduced in the text, identifies himself, incongruously, as "the dumbest about the intellectual" and posits the daughter as the artist: "I see you fitting the mold of this better" (*Fun Home* 224).

68. At the end of chapter 1, which also, as with the beginning of chapter 1, directly echoes *Fun Home*'s conclusion, Bechdel writes, "It was true that he didn't kill himself until I was nearly twenty. But his absence resonated retroactively, echoing back through all the time I knew him." And then, above a tier-long image of Alison driving a tractor toward her father while he looks away, Bechdel writes, "Maybe it was the converse of the way amputees feel pain in a missing limb. He really was there all those years, a-flesh-and-blood presence steaming off the wallpaper, digging up the dogwoods, polishing the finials . . . smelling of sawdust and sweat and designer cologne." The tractor approaches Bruce; his back is turned. "But I ached," reads the narration above a bird's-eye frame in which she then drives away from him, "as if he were already gone" (23). The child Alison physically anticipates his *goneness* even when he is present; the amputee analogy suggests that she figures his presence to be as integral to her as one of her own limbs, and she feels, profoundly, his present/future absence.

69. Discussing the thematically structured chapters of *Fun Home*, Bechdel listed death, creativity, and sexuality as rubrics, before noting, "All these things are the same, aren't they? That's what the book is about" ("A Conversation").

Works Cited

Abel, Jessica. *La Perdida*. New York: Pantheon, 2006.

——*Mirror, Window (An Artbabe Collection)*. Seattle: Fantagraphics, 2000.

Agence France-Presse. "Cannes Winner Says Iran's Disapproval Boosts Film." *Middle East Times,* October 18, 2007. http://www.metimes.com/International/2007/10/18/cannes_winner_says_irans_disapproval_boosts_film/5894/. Accessed June 4, 2009.

Allison, Dorothy. *Bastard Out of Carolina*. New York: Dutton, 1992.

Andersen, Kurt. "Decency." *Studio 360*. Show 073005. Public Radio International, 2005.

Anderson, Ho Che. *King: A Comic Book Biography*. Intro. Stanley Crouch. Seattle: Fantagraphics, 2005.

Arazie, Ilana. "Drawn Together: R. Crumb's Beloved Aline Kominsky." *Heeb* 12 (Spring 2007): 48–51.

Asayesh, Gelareh. *Saffron Sky: A Life Between Iran and America*. Boston: Beacon, 1999.

Axmaker, Sean. "The Exile: An Interview with Marjane Satrapi." http://www.seanax.com/2008/01/27/the-exile-an-interview-with-marjane-satrapi/. Accessed June 4, 2009.

B., David. *Epileptic*. Trans. Kim Thompson. New York: Pantheon, 2005.

——"Introduction." *Persepolis 1*. Paris: L'Association, 2000.

Bahrampour, Tara. "Tempering Rage by Drawing Comics," *New York Times*, May 21, 2003.

——*To See and See Again: A Life in Iran and America*. New York: Farrar, Straus, and Giroux, 1999.

Balaghi, Shiva. "Iranian Visual Arts in 'The Century of Machinery, Speed, and the Atom': Rethinking Modernity." In Shiva Balaghi and Lynn Gumpert, eds., *Picturing Iran: A Society and Revolution*, pp. 21–37. New York: I.B Tauris, 2002.

Ballard, J. G. *The Atrocity Exhibition*. Illustrations by Phoebe Gloeckner. Rev. ed. San Francisco: Re/Search, 1990.

Barry, Lynda. *Big Ideas*. Seattle: Real Comet, 1983.

——*Come Over, Come Over*. New York: HarperPerennial, 1990.

——Contributor's Note. In Harvey Pekar, ed., *The Best American Comics 2006*, p. 277. Boston: Houghton Mifflin, 2006.

——Conversation with Hillary Chute. *Post-Bang: Comics Ten Minutes After the Big Bang*. New York Institute for the Humanities and the MoCCA Festival. NYU Cantor Center, New York City, June 6, 2008.

——*Cruddy: An Illustrated Novel*. New York: Simon and Schuster, 1999.

——Down the Street. New York: Harper and Row, 1988.

——— *Everything in the World*. New York: Harper and Row, 1986.

——— *The Freddie Stories*. Seattle: Sasquatch, 1999.

——— *The Fun House*. New York: Harper and Row, 1987.

——— *Girls and Boys*. Seattle: Real Comet, 1981; rpt. New York: HarperPerennial, 1993.

——— *The Good Times Are Killing Me*. Seattle: Real Comet, 1988; rpt. New York: HarperPerennial, 1991.

——— Interview with Hillary Chute. New York City. June 7, 2008 and June 8, 2008.

——— *It's So Magic*. New York: HarperPerennial, 1994.

——— *The Lynda Barry Experience*. Larkspur, CA: Gang of Seven, 1993. My Perfect Life. New York: HarperPerennial, 1992.

——— *Naked Ladies! Naked Ladies! Naked Ladies! Coloring Book*. Seattle: Real Comet, 1984.

——— *Picture This: The Near-Sighted Monkey Book*. Montreal: Drawn and Quarterly, 2010.

——— *One Hundred Demons*. Seattle: Sasquatch, 2002.

——— *The! Greatest! of! Marlys!* Seattle: Sasquatch, 2000.

——— "The Red Comb." *Down the Street*, pp. 100–101. New York: Harper and Row, 1988.

——— "Two Questions." *McSweeney's* 13 (2004): 60–65.

——— *Two Sisters*. Seattle, Self-published, 1979.

——— *What It Is*. Montreal: Drawn and Quarterly, 2008.

Barthes, Roland. "The Grain of the Voice." *Image-Music-Text*, pp. 179–189. Trans. Stephen Heath. New York: Hill and Wang, 1977.

——— *The Pleasure of the Text*. Trans. Richard Miller. New York: Hill and Wang, 1975.

Baskind, Samantha, and Ranen Omer-Sherman. *The Jewish Graphic Novel: Critical Approaches*. New Brunswick, NJ: Rutgers University Press, 2008.

Beaty, Bart. *Unpopular Culture: Transforming the European Comic Book in the 1990s*. Toronto: University of Toronto Press, 2007.

Bechdel, Alison. Address. Museum of Contemporary Cartoon Art (MoCCA) Annual Convention. June 23, 2007, New York City.

——— "Cartoonist's Introduction." *The Essential Dykes to Watch Out For*, pp. xii–xviii. Boston: Houghton Mifflin, 2008.

——— "Compulsory Reading." *Entertainment Weekly*, June 27 and July 4, 2008, pp. 110–113.

——— "A Conversation with Alison Bechdel." Writers at Rutgers Conversation Series. Rutgers University, New Brunswick, NJ, March 5, 2008.

——— *Fun Home: A Family Tragicomic*. Boston: Houghton Mifflin, 2006.

——— *The Indelible Alison Bechdel: Confessions, Comix, and Miscellaneous Dykes to Watch Out For*. Ithaca: Firebrand, 1998.

——— Interview with Hillary Chute. Jericho, VT, May 18, 2008.

——— Interview with Hillary Chute. Telephone. April 6, 2009.

——— Interview with Hillary Chute. New York City, June 21, 2006.

——— "PEN/Faulkner Event with Lynda Barry and Chris Ware." Washington, D.C., November 9, 2007.

——— www.dykestowatchoutfor.com.

——— "Scenes from a Family." Review of *A Pocket History of Sex in the Twentieth Century* by Jane Vandenburgh. *New York Times Book Review,* March 29, 2009, p. 7.

——— "Talking with Alison Bechdel." Houghton Mifflin press release, June 2006, pp. 7–9.

——— "Wrought." *Granta* 104 ("Fathers": Winter 2008): 54–55.

Bell, Gabrielle. *Cecil and Jordan in New York: Stories*. Montreal: Drawn and Quarterly, 2009.

———*Lucky*. Montreal: Drawn and Quarterly, 2006.

Bell, Sarah C. "Nubo: *The Wedding Veil*." In Jennifer Heath, ed., *The Veil: Women Writers on Its History, Lore, and Politics*, pp. 171–173. Berkeley: University of California Press, 2008.

Bellafante, Ginia. "Twenty Years Later, the Walls Still Talk." *New York Times,* August 3, 2006, D7.

Benhabib, Seyla. "Sexual Difference and Collective Identities: The New Global Constellation" *Signs: Journal of Women in Culture and Society* 24.2 (1999): 335–361.

Bennett, Jill. *Empathic Vision: Affect, Trauma, and Contemporary Art*. Stanford: Stanford University Press, 2005.

Benton, Mike. *The Comic Book in America*. Dallas: Taylor, 1989.

Berger, John. *Ways of Seeing*. London: BBC and Penguin, 1977.

Bilger, Audrey. "The! Great! Lynda! Barry!" *Bitch* 13 (2001): 33–41.

Blackledge, Catherine. *The Story of V: A Natural History of Female Sexuality*. New Brunswick, NJ: Rutgers University Press, 2004.

Bongco, Mila. *Reading Comics: Language, Culture, and the Concept of the Superhero in Comic Books*. New York: Garland, 2000.

Borrelli, Christopher. "Being Lynda Barry." *Chicago Tribune,* March 8, 2009. http://www.chicagotribune.com/entertainment/chi-mxa0308magazinebarrypg13–22mar08,0,5941014.story. Accessed September 21, 2009.

Bright, Susie. "Introduction." In Diane Noomin, ed., *Twisted Sisters 2: Drawing the Line*, p. 7. Northampton: Kitchen Sink, 1995.

Brook, Vincent. *You Should See Yourself: Jewish Identity in Postmodern American Culture*. New Brunswick, NJ: Rutgers University Press, 2006.

Broude, Norma. "The Pattern and Decoration Movement." In Norma Broude and Mary D. Garrard, eds., *The Power of Feminist Art: The American Movement of the 1970s, History and Impact*, pp. 208–225. New York: Abrams, 1994.

Brown, Chester. *Louis Riel: A Comic-Strip Biography*. Montreal: Drawn and Quarterly, 2003.

Brown, Joshua. "Of Mice and Memory." *Oral History Review* 16.1 (Spring 1988): 91–109.

Brown, Laura. "Not Outside the Range: One Feminist Perspective on Psychic Trauma." In Cathy Caruth, ed., *Trauma: Explorations in Memory*, pp. 100–112. Baltimore: Johns Hopkins University Press, 1995.

Brubaker, Elijah. "Phoebe G and the library of doom." October 15, 2004. Accessed April 18, 2008. http://elijahbrubaker.com/blog/?p=88.

Buhle, Paul. *From the Lower East Side to Hollywood: Jews in American Popular Culture*. London: Verso, 2004.

Camper, Jennifer. "Introduction." In Jennifer Camper, ed., *Juicy Mother*, p. 7. New York: Soft Skull, 2005.

———"Review of *Persepolis 2: The Story of a Return* by Marjane Satrapi." *Women's Review of Books* 21.12 (September 2004): 8–9.

Canby, Sheila R. *Persian Painting*. London: Thames and Hudson, 1993.

Carré, Lilli. *The Lagoon*. Seattle: Fantagraphics, 2008.

Caruth, Cathy. "Trauma and Experience: Introduction." In Cathy Caruth, ed., *Trauma: Explorations in Memory*, pp. 3–12. Baltimore: Johns Hopkins University Press, 1995.

———— *Unclaimed Experience: Trauma, Narrative, and History*. Baltimore: Johns Hopkins University Press, 1996.

Caws, Mary Ann. "Looking: Literature's Other." *PMLA* 119.5 (October 2004): 1293–1314.

Chun, Kimberly. "Cartoonist Pens Life on Mean Streets." *San Francisco Chronicle,* November 13, 1998.

Chung, Andrew. "Ciudad Juárez, Mexico: The World's Most Dangerous Place?" *The Toronto Star*, May 21, 2010. http://www.thestar.com/news/world/article/812757—the-world's-most-dangerous-place. Accessed May 22, 2010.

Chute, Hillary. "Aline Kominsky-Crumb." *Believer*, November/December 2009, pp. 57–59, 62–68.

———— "Comics as Literature? Reading Graphic Narrative." *PMLA* 123.2 (March 2008): 452–465.

————"Decoding Comics." *Mfs: Modern Fiction Studies* 52.4 (Winter 2006): 1014–1027.

————"Gothic Revival: Old Father, Old Artificer: Tracing the Roots of Alison Bechdel's Exhilarating New 'Tragicomic,' *Fun Home*." *Village Voice*, July 12, 2006, pp. 34–39.

————"An Interview with Alison Bechdel." *Mfs: Modern Fiction Studies* 52.4 (Winter 2006): 1004–1013.

————"Lynda Barry." *Believer,* November/December 2008, pp. 47–58.

————"Phoebe Gloeckner." *Believer,* June 2019, pp. 41–50.

———— Review of Aline Kominsky-Crumb, *Need More Love. Guttergeek*: *The Discontinuous Review of Graphic Narrative.* February 2007. http://www.guttergeek.com/2007/February2007/morelove/morelove.html. Accessed June 26, 2009.

————Review of *Marjane Satrapi, Chicken with Plums. Guttergeek*: *The Discontinuous Review of Graphic Narrative.* September 2006. http://guttergeek.com/2006/September2006/chicken/chicken.html. Accessed June 8, 2009.

————"Scott McCloud." *Believer,* March 2007, pp. 80–86.

————"'The Shadow of a Past Time': History and Graphic Representation in *Maus*." *Twentieth-Century Literature* 52.2 (Summer 2006): 199–230.

———— "The Texture of Retracing in Marjane Satrapi's *Persepolis*." *WSQ: Women's Studies Quarterly* 36.1 and 2 (Spring/Summer 2008): 92–110.

Chute, Hillary, and Marianne DeKoven. "Introduction: Graphic Narrative." *Mfs: Modern Fiction Studies* 52.4 (Winter 2006): 767–782.

Coe, Sue. *Dead Meat*. Intro. Alexander Cockburn. New York: Four Walls Eight Windows, 1996.

————with Holly Metz. *How to Commit Suicide in South Africa*. New York: Raw Books and Graphix, 1983.

Collins, Sean. "Sean Collins' Interview: Phoebe Gloeckner." http://www.alltooflat.com/about/personal/sean/, 5 January 2004.

Community Comment Board: "Students Protesting Book Used in English Class." *Ksl.com.* March 27, 2008. http://www.ksl.com/index.php?nid=148&sid=2952660&comments=true. Accessed May 1, 2009.

Conan, Neal. "*What It Is* Plumbs Depths of Creativity." *Talk of the Nation*, June 2, 2008. http://www.npr.org/templates/story/story.php?storyId=91072892.

Cooper, Audrey. "Council Targets Library Material." *Stockton Record*. http://www.recordnet.com/articlelink/043004/news/articles/043004-gn-12.php. Accessed April 30, 2004.

Cornell, Drucilla. *Beyond Accommodation: Ethical Feminism, Deconstruction, and the Law.* Rev. ed. New York: Rowman and Littlefield, 1999.

―― *The Imaginary Domain: Abortion, Pornography, and Sexual Harassment.* New York: Routledge, 1995.

―― "Introduction." In Drucilla Cornell, ed., *Feminism and Pornography*, pp. 1–15. Oxford: Oxford University Press, 2000.

―― "Pornography's Temptation." In Drucilla Cornell, ed., *Feminism and Pornography*, pp. 550–567. Oxford: Oxford University Press, 2000.

Cornell, Drucilla, ed. *Feminism and Pornography.* Oxford: Oxford University Press, 2000.

Cottington, David. *Cubism in the Shadow of War: The Avant-Garde and Politics in Paris, 1905–1914.* New Haven: Yale University Press, 1998.

Crumb, Robert. "Introduction." In Phoebe Gloeckner, *A Child's Life and Other Stories*, pp. 4–5. Berkeley: Frog, 1998.

Crumb, Sophie. *Belly Button Comix* no. 1. Seattle: Fantagraphics, 2002.

―― *Belly Button Comix* no. 2. Seattle: Fantagraphics, 2004.

Cvetkovich, Ann. *An Archive of Feelings: Trauma, Sexuality, and Lesbian Public Cultures.* Durham: Duke University Press, 2003.

―― "Drawing the Archive in Alison Bechdel's *Fun Home.*" *WSQ: Women's Studies Quarterly* 36.1, 2 (Spring/Summer 2008): 111–128.

Dallof, Sarah. "Students Protesting Book Used in English Class." Ksl.com. March 27, 2008. http://www.ksl.com/?nid=148&sid=2952660. Accessed May 1, 2009.

Davis, Rocío. "A Graphic Self: Comics as Autobiography in Marjane Satrapi's *Persepolis.*" *Prose Studies* 27.3 (December 2005): 264–279.

Davis, Vanessa. *Spaniel Rage.* Oakland: Buenaventura, 2005.

Deane, Seamus. "Notes." In James Joyce, *A Portrait of the Artist as a Young Man*, pp. 277–329. Ed. and intro. Seamus Deane. New York: Penguin: 1993.

De Jesús, Melinda. "Liminality and Mestiza Consciousness in Lynda Barry's *One Hundred Demons.*" *MELUS* 29.1 (Spring 2004): 219–252.

―― "Of Monsters and Mothers: Filipina American Identity and Maternal Legacies in Lynda J. Barry's *One Hundred Demons.*" *Meridians: Feminism, Race, Transnationalism* 5.1 (2004): 1–26.

DeKoven, Marianne. *A Different Language: Gertrude Stein's Experimental Writing.* Madison: University of Wisconsin Press, 1983.

de Lauretis, Teresa. *Alice Doesn't: Feminism, Semiotics, Cinema.* Bloomington: University of Indiana Press, 1984.

Delisle, Guy. *The Burma Chronicles.* Trans. Helge Dasher. Montreal: Drawn and Quarterly, 2008.

―― *Pyongyang: a Journey in North Korea.* Trans. Helge Dasher. Montreal: Drawn and Quarterly, 2005.

―― *Shenzhen. A Travelogue from China.* Trans. Helge Dasher. Montreal: Drawn and Quarterly, 2006.

de Saussure, Ferdinand. *Course in General Linguistics.* Ed. Charles Bally and Albert Sechehaye. Trans. Roy Harris. La Salle, Illinois: Open Court, 1983.

DiMassa, Diane. *The Complete Hothead Paisan: Homicidal Lesbian Terrorist.* San Francisco: Cleis Press, 1999.

Donahue, Deirdre. "'Fun Home' Draws on Real-Life Pain." Review of *Fun Home* by Alison Bechdel. *USA Today* 29 May 2006.

Dorfman, Ariel and Armand Mattelart. *How to Read Donald Duck: Imperialist Ideology in the Disney Comic.* Trans. David Kunzle. New York: International General, 1975.

Doucet, Julie. *365 Days.* Montreal: Drawn and Quarterly, 2008.

——*My New York Diary.* Montreal: Drawn and Quarterly, 1999.

Doyle, Jennifer, and Amelia Jones. "Introduction: New Feminist Theories of Visual Culture." *Signs: Journal of Women in Culture and Society* 31.3 (2006): 607–615.

Dreschler, Debbie. *Daddy's Girl.* Seattle: Fantagraphics, 1995.

——*The Summer of Love.* Montreal: Drawn and Quarterly, 2003.

Drucker, Johanna. *The Alphabetic Labyrinth: The Letters in History and the Imagination.* London: Thames and Hudson, 1995.

——*The Century of Artists' Books.* New York: Granary, 1995.

—— *The Visible Word: Experimental Typography and Modern Art, 1909–1923.* Chicago: Chicago University Press, 1994.

——"Visual Performance of the Poetic Text." In Charles Bernstein, ed. *Close Listening: Poetry and the Performed Word,* pp. 131–161. New York: Oxford, 1998.

Dumas, Firoozeh. *Funny in Farsi: A Memoir of Growing Up Iranian in America.* New York: Villard, 2003.

Duncan, B. N. "A Joint Interview with R. Crumb and Aline Kominsky-Crumb." In D. K. Holm, ed., *R. Crumb: Conversations,* pp. 117–132. Jackson: University Press of Mississippi, 2004.

Ebadi, Shirin. *Iran Awakening: a Memoir of Revolution and Hope.* New York: Random House, 2006.

Eggers, Dave. "After Wham! Pow! Shazam!" *New York Times Book Review,* November 26, 2000, p. 10.

Eisenstein, Berenice. *I Was a Child of Holocaust Survivors.* New York: Riverhead, 2007.

Eisner, Will. *A Contract with God and Other Tenement Stories: A Graphic Novel by Will Eisner.* New York: DC Comics, 1996 [1978].

——*Graphic Storytelling and Visual Narrative.* Tamarac, Florida: Poorhouse, 1996.

Elam, Kimberly. *Expressive Typography: The Word as Image.* New York: Van Nostrand Reinhold, 1990.

Emmert, Lynn. "Life Drawing: An Interview with Alison Bechdel." *Comics Journal* 282 (April 2007): 34–52.

Felman, Shoshana, and Dori Laub. *Testimony: Crises of Witnessing in Literature, Psychoanalysis, and History.* New York: Routledge, 1992.

Felski, Rita. *Beyond Feminist Aesthetics: Feminist Literature and Social Change.* Cambridge: Harvard University Press, 1989.

——*Doing Time: Feminist Theory and Postmodern Culture.* New York: New York University Press, 2000.

Fleener, Mary, ed. "Comics Gal-ore." *Comics Journal* 237 (2001).

—— *Life of the Party: The Complete Autobiographical Collection.* Seattle: Fantagraphics, 1996.

——"Review of *Need More Love.*" *Mineshaft* no. 20 (2007): 31–34.

——*Slutburger Stories.* Montreal: Drawn and Quarterly, 1992.

Flint, Kate. "Painting Memory." *Textual Practice* 17.3 (2003): 527–542.

Forney, Ellen. *I Love Led Zeppelin*. Seattle: Fantagraphics, 2006.

——*I Was Seven in '75*. Seattle: Tchotchke Productions, 1997.

Foster, Hal. "Postmodernism in Parallax." *October* 63 (Winter 1993): 4–21.

Friedman, Susan Stanford. "Cosmopolitanism, Women, and War: From Virginia Woolf's *Three Guineas* to Marjane Satrapi's *Persepolis*," pp. 1–18. Paper delivered at Virginia Woolf International Conference, June, 2008. Transcript.

Frost, Laura. "After Lot's Daughters: Kathryn Harrison and the Making of Memory." In Nancy K. Miller and Jason Tougaw, eds., *Extremities: Trauma, Testimony, and Community*. Urbana: University of Illinois Press, 2002.

Frontera list. http://groups.google.com/group/frontera-list/about?hl=en. Accesssed May 22, 2010.

Fulbeck, Kip. *kip fulbeck: part asian, 100% hapa*. Exhibition. New York: New York University, March 10–May 30.

Galloway, Stephen. "Directors Discuss Their Foreign-Language Frontrunners." *The Hollywood Reporter.com,* January 4, 2008.

Gardner, Jared. "Archives, Collectors, and the New Media Work of Comics." *Mfs: Modern Fiction Studies*: Graphic Narrative Special Issue 52.4 (Winter 2006): 787–806.

——"Autography's Biography, 1972–2007." *Biography* 31.1 (Winter 2008): 1–26.

Garvin, Glenn. "Life in Murder City!" Miami Herald, April 16, 2010. http://www.miamiherald.com/2010/04/06/1565014/life-in-murder-city.html. Accessed May 22, 2010.

Gifford, Don. *Ulysses Annotated: Notes for James Joyce's* Ulysses. Rev. ed. Berkeley: University of California Press, 1988.

Gilmore, Leigh. "Jurisdictions: *I, Rigoberta Menchú*, *The Kiss*, and Scandalous Self-Representation in the Age of Memoir and Trauma." *Signs: Journal of Women and Culture in Society* 28.2 (2003): 695–718.

——*The Limits of Autobiography: Trauma and Testimony*. Ithaca: Cornell University Press, 2001.

Gloeckner, Phoebe. *A Child's Life and Other Stories*. Berkeley: Frog, 1998 [2000].

——Address. NYU Zine Conference. New York, April 16, 2004.

——*The Diary of a Teenage Girl: An Account in Words and Pictures*. Berkeley: Frog, 2002.

——Interview with Hillary Chute. Ann Arbor, December 11–12, 2009.

——*La Tristeza*. In Mia Kirshner, ed., *I Live Here*. New York: Pantheon, 2008.

——Personal communication with Hillary Chute. Email. May 3, 2010.

——"Phoebe Gloeckner." In Andrea Juno, ed., *Dangerous Drawings: Interviews with Comix and Graphix Artists,* pp. 148–161. New York: Juno, 1997.

——"Sexual Memory Game." *Comics Journal: Special Edition* 4, Winter 2004: 112–113.

——"Well, You Know, Maybe I'm Angry After All." Blog entry. Posted September 16, 2005. Accessed December 6, 2005.

Goldstein, Nancy. *Jackie Ormes: The First African American Woman Cartoonist*. Ann Arbor: University of Michigan Press, 2008.

"'Good Shall Triumph Over Evil': The Comic Book Code of 1954." http://historymatters.gmu.edu/d/6543/. Accessed May 1, 2008.

Gopnik, Adam, and Kirk Varnedoe. *High and Low: Modern Art, Popular Culture*. New York: Museum of Modern Art and Abrams, 1990.

Gravett, Paul. "Web-Extras: Marjane Satrapi's Three Inspirations." *Paul Gravett*. http://www. paulgravett.com/articles/003_satrapi/003_satrapi.htm. Accessed June 9, 2009.

Gray, Basil. *Persian Painting From Miniatures of the 13–14 Centuries*. New York: Oxford University Press, 1940.

Green, Justin. *Binky Brown Meets the Holy Virgin Mary*. Rev. ed. San Francisco: McSweeney's, 2009.

——*Binky Brown Meets the Holy Virgin Mary*. San Francisco: Last Gasp, 1972.

——*Justin Green's Binky Brown Sampler*. San Francisco: Last Gasp, 1995.

Gregory, Roberta. *Bitchy Butch: World's Angriest Dyke*. Seattle: Fantagraphics, 1999.

——*Life's a Bitch: The Bitchy Bitch Chronicles*. Seattle: Fantagraphics, 2004.

Grossman, Lev, and Richard Lacayo. "10 Best Books." *Time,* December 17, 2006.

Groth, Gary. "Interview: Phoebe Gloeckner." *Comics Journal* 261 (July 2004): 78–123.

Guess, Carol. "Que(e)rying Lesbian Identity." *Journal of the Midwest Modern Language Association* 28.1 (Spring 1995): 19–37.

Guillén, Michael. "Persepolis—Interview with Vincent Paronnaud." *Twitch*. http://twitch-film.net/site/view/persepolisinterview-with-vincent-paronnaud. Accessed June 4, 2009.

Guppy, Shusha. *The Blindfold Horse: Memories of a Persian Childhood*. Boston: Beacon Press, 1988.

Guerrilla Girls. *The Guerrilla Girls' Bedside Companion to the History of Western Art*. New York: Penguin, 1998.

Gussow, Mel. "Dark Nights, Sharp Pens; Art Spiegelman Addresses Children and His Own Fears." *New York Times,* October 15, 2003, pp. E1, E6.

Hackett, Regina. "Linda Farris, 1944–2005: Gallery Pioneer Promoted Young Artists." *Seattle Post-Intelligencer,* July 23, 2005. http://seattlepi.nwsource.com/visualart/233718_lindafarris.html. Accessed July 22, 2008.

Hajdu, David. "Persian Miniatures." *BookForum*, October/November 2004, pp. 32–35.

Hakakian, Roya. *Journey from the Land of No: A Girlhood Caught in Revolutionary Iran*. New York: Crown, 2004.

Hampton, Howard. *Born in Flames: Termite Dreams, Dialectical Fairy Tales, and Pop Apocalypses*. Cambridge: Harvard University Press, 2007.

——"The Flannel-Swaddled Insomniac." *Believer,* August 2003, pp. 65–71.

Haraway, Donna. "The Persistence of Vision." In Katie Conboy, Nadia Medina, and Sarah Stanbury, eds., *Writing on the Body: Female Embodiment and Feminist Theory,* pp. 283–295. New York: Columbia University Press, 1997.

Harkham, Sammy, ed. *Kramers Ergot* 7. Oakland: Buenaventura, 2008.

Harris, Miriam. "Cartoonists as Matchmakers: The Vibrant Relationship of Text and Image in the Work of Lynda Barry." In Catriona MacLeod and Véronique Plesch, eds., *Elective Affinities: Testing Word and Image Relationships*, pp. 129–144. Amsterdam: Rodopi, 2009.

Harrison, Kathryn. *The Kiss*. New York: HarperTrade, 1998.

Harrison, Randall P. *The Cartoon: Communication to the Quick*. Beverly Hills: Sage, 1981.

Harrison, Sophie. "Dreams of Trespass." *New York Times Book Review,* June 12, 2005, p. 33.

Harvey, Robert C. "Comedy at the Juncture of Word and Image: The Emergence of the Modern Magazine Gag Cartoon Reveals the Vital Blend." In Robin Varnum and Christina Gibbons, eds., *The Language of Comics: Word and Image*, pp. 75–96. Jackson: University Press of Mississippi, 2001.

——— "Describing and Discarding 'Comics' as an Impotent Act of Philosophical Rigor." In Jeff McLaughlin, ed., *Comics as Philosophy*, pp. 14–26. Jackson: University Press of Mississippi, 2005.

Hayles, N. Katherine. *Writing Machines*. Cambridge: MIT Press, 2002.

Heckscher, Willliam S. *Rembrandt's "Anatomy of Dr. Nicolaes Tulp": Anlconological Study*. New York: New York University Press, 1958.

Heath, Jennifer, ed. *The Veil: Women Writers on Its History, Lore, and Politics*. Berkeley: University of California Press, 2008.

Heer, Jeet, and Kent Worcester, eds. *Arguing Comics: Literary Masters on a Popular Medium*. Jackson: University Press of Mississippi, 2004.

Herman, Judith. *Trauma and Recovery: The Aftermath of Violence—from Domestic Abuse to Political Terror*. New York: Basic, 1997.

Hill, C. "Marjane Satrapi Interviewed." *International Journal of Comic Art* 8.2 (Fall 2006): 6–33.

Hirsch, Marianne. "Editor's Column: Collateral Damage." *PMLA* 119.5 (October 2004): 1209–1215.

——— "Family Pictures: *Maus*, Mourning, and Postmemory." *Discourse* 15.2 (Winter 1992–1993): 3–30.

Hirsch, Marianne, and Leo Spitzer. "About Class Photos." Nomadikon: About Images series. October 21, 2009. http://www.nomadikon.net/ContentItem.aspx?ci=162. Accessed February 18, 2010.

Hoberman, J. *Vulgar Modernism: Writing on Movies and Other Media*. Philadelphia: Temple University Press, 1991.

Hoesterey, Ingeborg. *Pastiche: Cultural Memory in Art, Film, and Literature*. Bloomington: Indiana University Press, 2001.

Hohenadel, Kristin. "An Animated Adventure, Drawn from Life." *New York Times,* January 21, 2007, pp. 15, 18.

Horgen, Tom. "Tragicomedy, in Black and White." *Star Tribune* (Minneapolis), October 22, 2006, p. 2F.

Hornby, Nick. "Draw What You Know." *New York Times Book Review*, December 22, 2002, pp. 10–11.

Houghton Mifflin Company. Press kit DVD for *Fun Home: A Family Tragicomic*, by Alison Bechdel. June 2006.

Huffer, Lynne. "'There Is No Gomorrah'": Narrative Ethics in Feminist and Queer Theory." *differences: A Journal of Feminist Cultural Studies* 12.3 (2001): 1–32.

iafrica.com. "Iran Blasts 'Islamophobic' Film." May 29, 2007. http://entertainment.iafrica.com/news/912582.htm. Accessed May 31, 2007.

Independent Publisher Online. "Lynda Barry Faces Her Demons." October 20, 2002. http://www.independentpublisher.com/article.php?page=614. Accessed August 7, 2008.

Jaafar, Ali. "Children of the Revolution." *Sight and Sound* 18.5 (May 2008): 46–47.

Jameson, Fredric. *Postmodernism, or the Cultural Logic of Late Capitalism*. Durham: Duke University Press, 1991.

Johnson, Reed. "Time to Shout." *Los Angeles Times,* August 4, 2004.

Joiner, Whitney. "Not Your Mother's Comic Book." *Salon.com*, March 15, 2003.

Jones, Amelia, ed. *The Feminism and Visual Culture Reader*. New York: Routledge, 2003.

Joyce, James. *A Portrait of the Artist as a Young Man*. New York: Penguin, 1993 [1916].

——— *Ulysses*. New York: Vintage, 1986 [1922].

Juno, Andrea, ed. *Dangerous Drawings: Interviews with Comix and Graphix Artists*. New York: Juno, 1997.

Kannenberg, Jr., Gene. "A Conversation with Art Spiegelman." In Joseph Witek, ed., *Art Spiegelman: Conversations,* pp. 238–262. Jackson: University Press of Mississippi, 2007.

Kaplan, Arie. *From Krakow to Krypton: Jews and Comic Books*. Philadelphia: Jewish Publication Society, 2008.

——— "Trina Robbins." In Arie Kaplan, *Masters of the Comic Book Universe Revealed!* pp. 79–97. Chicago: Chicago Review Press, 2006.

Kaplan, E. Ann. *Trauma Culture: The Politics of Terror and Loss in Media and Literature*. New Brunswick, NJ: Rutgers University Press, 2005.

Karim, Persis M., ed. *Let Me Tell You Where I've Been: New Writing by Women of the Iranian Diaspora*. Fayetteville: University of Arkansas Press, 2006.

——— "Talking with a Pioneer of Iranian American Literature: An Interview with Nahid Rachlin." *MELUS* 33.2 (Summer 2008): 153–157.

Katin, Miriam. *We Are on Our Own*. Montreal: Drawn and Quarterly, 2006.

Kelso, Megan, ed. *Scheherazade: Comics About Love, Treachery, Mothers, and Monsters*. New York: Soft Skull, 2004.

——— *The Squirrel Mother*. Seattle: Fantagraphics, 2006.

Kennedy, Adrienne. *People Who Led to My Plays*. New York: Theatre Communications Group, 1987.

Kirsch, Adam. "Little Arty in Shadowland." *New York Sun,* September 2, 2004, p. 24.

Klima, Stefan. *Artists Books: A Critical Survey of the Literature*. New York: Granary, 1998.

Kominsky-Crumb, Aline. "A Day in the Life of Aline Kominsky-Crumb." *Self-Loathing Comics* no. 1. Seattle: Fantagraphics, 1995.

——— "Aline Kominsky-Crumb." In Andrea Juno, ed., *Dangerous Drawings: Interviews with Comix and Graphix Artists*, pp. 162–175. New York: Juno, 1997.

——— "Aline Kominsky-Crumb Interview by Peter Bagge." *Comics Journal* 139 (1990): 50–73.

——— "Foreword." In Tom Pilcher with Gene Kannenberg Jr., eds., *Erotic Comics: A Graphic History from Tijuana Bibles to Underground Comix*. New York: Abrams, 2008.

——— "Goldie: A Neurotic Woman." *Wimmen's Comix* no. 1. Berkeley: Last Gasp Eco-Funnies, 1972: np [1–5].

——— "Hard Work and No Fun." *Wimmen's Comix* no. 2. Berkeley: Last Gasp Eco-Funnies, 1973.

——— Interview with Hillary Chute. Telephone. July 27, 2009.

——— *Love That Bunch*. Seattle: Fantagraphics, 1990.

——— *Need More Love: A Graphic Memoir*. London: MQP, 2007.

——— "Unlocking the Kominsky Code." Interview by Zaro Weil. In *Need More Love*, by Aline Kominsky-Crumb. London: MQP, 2007: 326–354.

Kominsky-Crumb, Aline, and Robert Crumb. "A Couple a' Nasty, Raunchy Old Things." *Self-Loathing* no. 2. Seattle: Fantagraphics, 1997.

——— *The Complete Dirty Laundry Comics*. San Francisco: Last Gasp, 1993.

Krauss, Rosalind. "The Im/pulse to See." In Hal Foster, ed., *Vision and Visuality,* pp. 51–78. New York: New Press, 1999 [1988].

Kunzle, David. *The History of the Comic Strip: The Early Comic Strip: Narrative Strips and Picture Stories in the European Broadsheet from c. 1450 to 1825.* Vol. 1. Berkeley: University of California Press, 1973.

——— *The History of the Comic Strip: The Nineteenth Century.* Vol. 2. Berkeley: University of California Press, 1990.

Kusha, Hamid R. *The Sacred Law of Islam: A Case Study of Women's Treatment in the Islamic Republic of Iran's Criminal Justice System.* Aldershot: Ashgate, 2002.

LaCapra, Dominick. *History and Its Limits: Human, Animal, Violence.* Ithaca: Cornell University Press, 2009.

LaPlanche, J., and J.-B. Pontalis. *The Language of Psychoanalysis.* Trans. Donald Nicholson-Smith. New York: Norton, 1973.

Larson, Hope. *Gray Horses.* Portland: Oni, 2006.

——— *Salamander Dream.* Richmond: AdHouse, 2005.

Lasko-Gross, Miss. *A Mess of Everything.* Seattle: Fantagraphics, 2009.

——— *Escape from "Special."* Seattle: Fantagraphics, 2006.

Lefèvre, Pascal. "Narration in Comics." *Image and Narrative* 1 (2001): 1–10. www.imageand-narrative.be/narratology/pascallefevre.htm. Accessed May 1, 2009.

Leith, Sam. "A Writer's Life: Marjane Satrapi." *Daily Telegraph,* November 27, 2004, p. 12.

Lemberg, Jennifer. "Closing the Gap in Alison Bechdel's *Fun Home.*" *WSQ: Women Studies Quarterly* 36.1, 2 (Spring/Summer 2008): 129–140.

Lent, John A., ed. "Women and Cartooning: A Global Symposium." *International Journal of Comic Art* 10.2 (Fall 2008).

Leys, Ruth. *Trauma: A Genealogy.* Chicago: University of Chicago Press, 2000.

Liss, Andrea. *Trespassing Through Shadows: Memory, Photography, and the Holocaust.* Minneapolis: University of Minnesota Press, 1998.

Lopez, Erika. *Lap Dancing for Mommy: Tender Stories of Disgust, Blame, and Inspiration.* Berkeley: Seal, 1997.

Lubiano, Wahneema. "To Take Dancing Seriously Is to Redo Politics." *Z Magazine Z Papers* 1.4 (October 1992): 17–23.

Lyvely, Chin. "Chin Lyvely." Interview. *Cultural Correspondence* 9 (Spring 1979): 13.

McCloud, Scott. *Interview with Hillary Chute.* Telephone. November 14, 2006.

——— "Scott McCloud: Understanding Comics." *Comic Book Rebels: Conversations with the Creators of New Comics.* Ed. Stanley Wiater and Stephen R. Bissette. New York: Donald I. Fine, Inc., 1993: 3–16.

——— *Understanding Comics: The Invisible Art.* New York: Kitchen Sink, 1993.

MacCurdy, Marian Mesrobian. *The Mind's Eye: Image and Memory in Writing About Trauma.* Amherst: University of Massachusetts Press, 2007.

McDonald, Helen. *Erotic Ambiguities: The Female Nude in Art.* New York: Routledge, 2001.

McGrath, Charles. "Not Funnies." *New York Times Magazine,* July 11, 2004, pp. 24–33, 46, 55–56.

Mack, Stan. *Janet and Me: An Illustrated Story of Love and Loss.* New York: Simon and Schuster, 2004.

Mackey, Robert. "June 18: Updates on Iran's Disputed Election." *New York Times,* June 18, 2009. http://thelede.blogs.nytimes.com/2009/06/18/latest-updates-on-irans-disputed-election-2/?scp=2&sq=marjane%20satrapi&st=cse. Accessed June 27, 2009.

Malek, Amy. "Memoir as Iranian Exile Cultural Production: A Case Study of Marjane Satrapi's *Persepolis* Series." *Iranian Studies* 39.3 (September 2006): 353–380.

Malkin, Elizabeth. "As Mexican Killings Rise, Groups Take Envoy to Task." *New York Times*, April 12, 2009. http://www.nytimes.com/2009/04/13/world/americas/13envoy.html?scp=1&sq=juarez%20women%20murder&st=cse. Accessed July 1, 2009.

Mansour, Wisam. "The Violence of the Archive." *ELN: English Language Notes* 45.1 (Spring/Summer 2007): 41–44.

Marchetto, Marisa Acocella. *Cancer Vixen: a True Story*. New York: Knopf, 2006.

Martin, Michael. "The Nerve Interview: Phoebe Gloeckner: Inside Her Explicit *Diary of a Teenage Girl*." *Nerve.com*, March 2003. http://www.nerve.com/screeningroom/books/interview_gloeckner/. Accessed February 17, 2010.

Maslenitsyna, S. *Persian Art in the Collection of the Museum of Oriental Art*. Leningrad: Aurora Art, 1975.

Mason, Chuck. "Spectrum/ Do not restrict access to the two books." *Marshall Democrat-News,* October 13, 2006. http://www.marshallnews.com/story/1172864.html. Accessed May 1, 2009.

Mautner, Chris. "Graphic Lit: An Interview with Marjane Satrapi." *Panels and Pixels*, October 30, 2006. http://panelsandpixels.blogspot.com/2006/10/graphic-lit-interview-with-marjane.htmfl. Accessed June 3, 2009.

Meadows, Bob. Review of *Fun Home: A Family Tragicomic. People,* June 12, 2006, p. 51.

"Medical Illustrator." Health Careers Center. www.mshealthcareers.com/careers/medicalillustrator.htm. Accessed May 14, 2008.

Menninghaus, Winfried. *Disgust: Theory and History of a Strong Sensation*. Trans. Howard Eiland and Joel Golb. Albany: State University of New York Press, 2003.

Menu, Jean-Christophe. "Interview by Matthias Wivel." *Comics Journal* 277 (2006): 144–74.

Miller, Nancy K. "Out of the Family: Generations of Women in Marjane Satrapi's *Persepolis*." *Life Writing* 4.1 (April 2007): 13–29.

Miller, Susan B. *Disgust: The Gatekeeper Emotion*. Hillsdale, NJ: Analytic, 2004.

Miller, William Ian. *The Anatomy of Disgust*. Cambridge: Harvard University Press, 1997.

Milner, Marion. *On Not Being Able to Paint*. Foreword by Anna Freud. Illustrated by Marion Milner. 2d ed. New York: International Universities Press, 1957.

Mitchell, W. J. T. *Iconology: Image, Text, Ideology*. Chicago: University of Chicago Press, 1986.

——*Picture Theory*. Chicago: University of Chicago Press, 1994.

——"Visual Literacy or Literary Visualcy?" In James Elkins, ed., *Visual Literacy*, pp. 11–29. New York: Routledge, 2008.

—— *What Do Pictures Want? The Lives and Loves of Images*. Chicago: University of Chicago Press, 2005.

——"Word and Image." In *Critical Terms for Art History*. Ed. Robert S. Nelson and Richard Shiff. Chicago: University of Chicago Press, 1996: 47–57.

Mirzoeff, Nicholas. *Watching Babylon: The War in Iraq and Global Visual Culture*. New York: Routledge, 2005.

Moaveni, Azadeh. *Honeymoon in Tehran: Two Years of Love and Danger in Iran*. New York: Random House, 2009.

——*Lipstick Jihad: A Memoir of Growing Up Iranian in America and American in Iran*. New York: Public Affairs, 2005.

Modan, Rutu. *Exit Wounds*. Montreal: Drawn and Quarterly, 2007.

———*Jamilti*. Montreal: Drawn and Quarterly, 2008.

Moon, Michael. Review of Alison Bechtel, *Fun Home: A Family Tragicomic*. *Guttergeek: The Discontinuous Review of Graphic Narrative*. September 2006. http://www.guttergeek.com/2006/September2006/funhome/funhome.html. Accessed May 1, 2009.

——— Review of Lynda Barry, *What It Is*. *Guttergeek: The Discontinuous Review of Graphic Narrative*. June 2008. http://www.guttergeek.com/whatitis/whatitis.html. Accessed August 7, 2008.

Most, Andrea. "Re-Imagining the Jew's Body: From *Self-Loathing* to 'Grepts.'" In Vincent Brook, ed., *You Should See Yourself: Jewish Identity in Postmodern American Culture,* pp. 19–36. New Brunswick, NJ: Rutgers University Press, 2006.

Moussaoui, Rana. "Lebanon Bans Prize-Winning Cartoon 'Persepolis.'" Agence-France Presse, March 26, 2008.

Mulvey, Laura. "Visual Pleasure and Narrative Cinema." In *Visual and Other Pleasures,* pp. 14–26. Bloomington: Indiana University Press, 1989 [1975].

Mundy, Jennifer. "Letters of *Desire*." In Jennifer Mundy, ed., *Surrealism: Desire Unbound*, pp. 10–53. Princeton: Princeton University Press, 2001.

Nafisi, Azar. *Reading Lolita in Tehran: A Memoir in Books*. New York: Random House, 2003.

Naghibi, Nima, and Andrew O'Malley. "Estranging the Familiar: 'East' and 'West' in Satrapi's *Persepolis*." *English Studies in Canada* 31.2–3 (June/September 2005): 233–247.

Nakazawa, Keiji. *Barefoot Gen: A Cartoon Story of Hiroshima*. San Francisco: Last Gasp, 2003 [1972–1973].

Nash, Alanna. "Bad Trip." Review of *Cruddy: An Illustrated Novel* by Lynda Barry. *New York Times,* September 5, 1999, p. 16.

Nathan, Debbie. "The Juárez Murders." Amnesty International Magazine. Amnesty International USA, Spring 2003. http://www.amnestyusa.org/amnestynow/juarez.html. Accessed May 22, 2010.

Noomin, Diane. "Diane Noomin." In Aline Kominsky-Crumb, *Need More Love*, pp. 156–158. London: MQP, 2007.

——— "Wimmin and Comix." *ImageText: Interdisciplinary Comics Studies* 1.2 (2003): 1–21. www.english.ufl.edu/imagetext/archives/v1_2/noomin. Accessed June 23, 2009.

Noomin, Diane, ed. *Twisted Sisters: A Collection of Bad Girl Art*. New York: Penguin, 1991.

——— *Twisted Sisters 2: Drawing the Line*. Northampton: Kitchen Sink, 1995.

Nussbaum, Martha. "Objectification." In Alan Soble, ed., *The Philosophy of Sex: Contemporary Readings*. Lanham, MD: Rowman and Littlefield, 2002: 381–419.

Nyberg, Amy Kiste. *Seal of Approval: The Origins and History of the Comics Code*. Jackson: University Press of Mississippi, 1998.

Olney, James. "Some Versions of Memory/Some Versions of *Bios*: The Ontology of Autobiography." In James Olney, ed., *Autobiography: Essays Theoretical and Critical,* pp. 236–267. Princeton: Princeton University Press, 1980.

O'Neil, Tim. Review of *Persepolis*, by Marjane Satrapi. *Comics Journal* 259 (April 2004): 37.

Orenstein, Peggy. "Phoebe Gloeckner Is Creating Stories About the Dark Side of Growing Up Female." *New York Times Magazine*, August 5, 2001, pp. 26–29.

Pekar, Harvey. "Introduction." In Aline Kominsky-Crumb, *Love That Bunch*, pp. iii–iv. Seattle: Fantagraphics, 1990.

Pekar, Harvey, and Joyce Brabner. *Our Cancer Year*. New York: Four Walls Eight Windows, 1994.

"Persepolis." Cannes Film Festival profile. 2007. http://www.festivalcannes.com/index.php/
en/archives/film/4434938.

Persepolis 2.0. Ed. Sina and Payman. *www.spreadpersepolis.com.* Accessed September 27, 2009.

Phelan, Peggy. *Unmarked: The Politics of Performance.* New York: Routledge, 1993.

Pilcher, Tim, ed., with Gene Kannenberg Jr. *Erotic Comics: A Graphic History from Tijuana
Bibles to Underground Comix.* New York: Abrams, 2008.

Pillemer, David B. *Momentous Events, Vivid Memories: How Unforgettable Moments Help Us
Understand the Meaning of Our Lives.* Cambridge: Harvard University Press, 1998.

Pope, Arthur Upham. *Masterpieces of Persian Art.* Westport, CT: Greenwood 1970 [1945].

Powers, Thom. "Lynda Barry." *Comics Journal* 132 (November 1989): 60–75.

Press, Joy. "Veil of Tears: Two Children of the Revolution Look Back at Iran." *Village Voice,*
May 2, 2003. http://www.villagevoice.com/2003–05-06/books/veil-of-tears/1. Accessed
June 9, 2009.

PressTV. "Persepolis Another Scenario Against Iran." May 28, 2007. *www.presstv.ir.* Accessed
May 31, 2007.

Printed Matter, Inc. "About PM." Printedmatter.org/about/index.cfm. Accessed August 7,
2008.

Probyn, Elspeth. *Blush: Faces of Shame.* Minneapolis: University of Minnesota Press, 2005.

Pulda, Molly. "The Grandmother Paradox: Mary McCarthy, Michael Ondaatjie, and Marjane
Satrapi." *a/b: Auto/Biography Studies* 22.2 (2007): 230–249.

Rachlin, Nahid. *Persian Girls: A Memoir.* New York: Tarcher/Penguin, 2006.

Ragland-Sullivan, Ellie. "The Real." In *Feminism and Psychoanalysis: A Critical Dictionary,*
pp. 374–377. Oxford: Blackwell, 1992.

Ramazani, Nesta. Review of *Persepolis: The Story of a Childhood,* by Marjane Satrapi, and
Reading Lolita in Tehran: A Memoir in Books, by Azar Nafisi. *Comparative Studies of South
Asia, Africa, and the Middle East* 24.1 (2004): 278–280.

Randall, Jon. "The Goblin Meets Binky Brown Who Met the Holy Virgin Mary." *Goblin.*
http://www.sonic.net/~goblin/Just.html. Accessed June 29, 2009.

Randall, Richard S. *Freedom and Taboo: Pornography and the Politics of a Self Divided.* Berkeley: University of California Press, 1989.

Redwine, Nancy. "A Mighty Force: Portrait From a Teen's Point of View." *Santa Cruz Sentinel,* February 18, 2003.

Reid, Calvin. "The Crumbs Move to Norton." *Publisher's Weekly,* March 10, 2008. http://
www.publishersweekly.com/article/CA6539987.html?q=aline+crumb. Accessed June 27,
2009.

Reidelbach, Maria. *Completely Mad: A History of the Comic Book and Magazine.* Boston:
Little, Brown, 1991.

Rifas, Leonard. "Racial Imagery, Racism, Individualism, and Underground Comix." *Imag-
eTexT: Interdisciplinary Comics Studies* 1.1 (2004). http://www.english.ufl.edu/imagetext/
archives/v1_1/rifas/. Accessed May 4, 2008.

Rivera, John-Michael, ed. "The Specter of the Archive." Special issue of *ELN: English Lan-
guage Notes* 45.1 (Spring/Summer 2007).

Robbins, Trina. *A Century of Women Cartoonists.* Northhampton: Kitchen Sink, 1993.

——— *From Girls to Grrrlz: A History of Women's Comics from Teens to Zines.* San Francisco:
Chronicle, 1999.

——— *The Great Women Cartoonists.* New York: Watson-Guptill, 2001.

————*The Great Women Superheroes.* Northampton, 1996.

————"Trina Robbins." *The Life and Times of R. Crumb: Comments from Contemporaries.* Ed. Monte Beauchamp. New York: St. Martin's Griffin, 1998: 39–42.

Roberts, Martin. "Graphic Novelist Crafts Book on Mexican Murders." *Reuters Canada,* July 30, 2008. http://ca.reuters.com/article/entertainmentNews/idCAL221400 8220080730?sp=true. Accessed June 30, 2009.

Rochlin, Margy. "Lynda Barry's Naked Ladies." *Ms. Magazine,* April 1985, p. 23.

Rodriguez, Teresa, with Diana Montané and Lisa Pulitzer. *The Daughters of Juárez: A True Story of Serial Murder South of the Border.* New York: Atria, 2007.

Rohy, Valerie. "In the Queer Archive: Alison Bechdel's *Fun Home.*" MS. 1–27.

Rose, Jacqueline. "Sexuality and Vision: Some Questions." In Hal Foster, ed., *Vision and Visuality.* New York: New Press and Dia Art Foundation, 1999.

————*Sexuality in the Field of Vision.* London: Verso, 1986.

Root, Robert. "Interview with Marjane Satrapi." *Fourth Genre* 9.2 (Fall 2007): 147–157.

Rosenberg, Meisha. "Multimodality in Phoebe Gloeckner's *Diary of a Teenage Girl.*" *International Journal of Comic Art* 9.2 (Fall 2007): 396–412.

Rosenkranz, Patrick. *Rebel Visions: The Underground Comix Revolution, 1963–1975.* Seattle: Fantagraphics, 2002.

Rossington, Michael, and Anne Whitehead. "Introduction." In Michael Rossington and Anne Whitehead, ed., *Theories of Memory: A Reader,* pp. 1–16. Baltimore: Johns Hopkins University Press: 2007.

Rudahl, Sharon. *A Dangerous Woman: A Graphic Biography of Emma Goldman.* New York: New Press, 2007.

Russell, Mike. "The CulturePulp Q&A: 'Persepolis' Creator Marjane Satrapi." *CulturePulp,* January 25, 2008. http://culturepulp.typepad.com/culturepulp/2008/01/the-culturepulp.html. Accessed June 4, 2009.

Sabin, Roger, and Teal Triggs, eds. *Below Critical Radar: Fanzines and Alternative Comics from 1976 to Now.* Hove: Slab-O-Concrete, 2000.

Sacco, Joe. *Chechen War, Chechen Women.* In Mia Kirshner, ed., *I Live Here.* New York: Pantheon, 2008.

————*Footnotes in Gaza.* New York: Metropolitan, 2009.

————*Palestine.* Seattle: Fantagraphics, 2001.

————*Safe Area Goržade: The War in Eastern Bosnia 1992–1995.* Seattle: Fantagraphics, 2000.

————*The Fixer: A Story from Sarajevo.* Montreal: Drawn and Quarterly, 2003.

————*War's End: Profiles from Bosnia 1995–1996.* Montreal: Drawn and Quarterly, 2005.

Said, Edward. "Homage to Joe Sacco." In Joe Sacco, *Palestine,* pp. i–v. Seattle: Fantagraphics, 2001.

Saltzman, Lisa, and Eric Rosenberg, eds. *Trauma and Visuality in Modernity.* Hanover: Dartmouth College Press, 2006.

Sante, Luc. "She Can't Go Home Again." *New York Times,* August 22, 2004, p. 7.

Sapienza, Anthony. "The Two Phoebes: Diary of an Artist and Her Mother." *Metropole* no. 18, July 27, 2003, pp. 39-48.

Satrapi, Marjane. "Address on *Persepolis.*" New York City, September 8, 2004.

————"An Iranian in Paris." November 8, 2005–November 28, 2005. *New York Times.* http://satrapi.blogs.nytimes.com. Accessed May 24, 2009.

————"The *Time* 100: Art Spiegelman." *Time,* April 10, 2005.

—— "Capone Interviews Marjane Satrapi." *Ain't It Cool News*. www.aintitcool.com/node/35510. Accessed July 2, 2009.

——*Chicken with Plums*. Trans. Anjali Singh. New York: Pantheon, 2006.

——"The Diary of a Nobelist." Op-Ed. *New York Times,* December 10, 2003.

——*Embroideries*. Trans. Anjali Singh. New York: Pantheon, 2005.

——"Home, Sweet Home." *New Yorker,* September 1, 2003, p. 132.

——"I Must Go Home to Iran Again." *New York Times,* July 4, 2009.

——"Iranian-Americans: An Informal Poll." *New Yorker,* October 25, 2004, p. 98.

——Jane E. Ruby Lecture. Wheaton College, Norton, MA, September 17, 2009.

——"Op-Art." *New York Times,* May 28, 2005.

——*Persepolis: The Story of a Childhood*. Trans. Mattias Ripa and Blake Ferris. New York: Pantheon, 2003.

——*Persepolis 1*. Paris, France: L'Association, 2000.

——*Persepolis 2: The Story of a Return*. Trans. Anjali Singh. New York: Pantheon, 2004.

——"Tales From an Ordinary Iranian Girlhood." *Ms.*, Spring 2003.

—— "Veiled Threat." *Guardian,* December 12, 2003. http://www.guardian.co.uk/world/2003/dec/12/gender.uk. Accessed May 24, 2009.

——"Why I Wrote *Persepolis*." *Writing* (November–December 2003): 9–11.

"Satrapi and Makhmalbaf testify on election fraud in Iran, EU Parliament Brussels (06–17–09)." YouTube, June 20, 2009. http://www.youtube.com/watch?v=UfrRA5AHfco. Accessed June 27, 2009.

Satrapi, Marjane, and Vincent Paronnaud. DVD extras. *Persepolis*. Sony Pictures Classics, 2008.

Satrapi, Marjane, and Vincent Paronnaud, dirs. *Persepolis*. 2.4.7. Films, 2007.

Scarry, Elaine. *The Body in Pain: The Making and Unmaking of the World*. New York: Oxford University Press, 1985.

Scott, Joan W. "Experience." In Judith Butler and Joan W. Scott, eds., *Feminists Theorize the Political,* pp. 22–40. New York: Routledge, 1992.

Schrag, Ariel. *Awkward and Definition: The High School Chronicles of Ariel Schrag*. New York: Touchstone, 2008.

——*Potential*. New York: Touchstone, 2008.

——*Likewise* no. 1. San Jose: SLG, 2002.

Schupbach, William. *The Paradox of Rembrandt's "Anatomy of Dr. Tulp."* London: Wellcome Institute for the History of Medicine, 1982.

Seda, Dori. *Dori Stories: The Complete Dori Seda*. San Francisco, Last Gasp, 1999.

Sedgwick, Eve, and Adam Frank, eds. *Shame and Its Sisters: A Silvan Tomkins Reader*. Durham: Duke University Press, 1995.

Segall, Kimberly Wedeven. "Melancholy Ties: Intergenerational Loss and Exile in *Persepolis*." *Comparative Studies of South Asia, Africa, and the Middle East* 28.1 (2008): 38–49.

Seldes, Gilbert. *The Seven Lively Arts*. New York: Sagamore, 1957.

Sheridan, Alan. "Translator's Note." In Jacques Lacan, *The Four Fundamental Concepts of Psycho-Analysis*, Jacques-Alain Miller, ed., pp. 277–282. New York: Norton, 1978.

Shklovsky, Viktor. *Theory of Prose*. Trans. Benjamin Sher. Normal, IL: Dalkey Archive Press, 1990 [1929].

Shnayerson, Michael. "Women Behaving Badly." *Vanity Fair*, February 1, 1997, pp. 54–61.

Sider, Sandra. "Femmage: The Timeless Fabric Collage of Miriam Schapiro." *Fiberarts* 32.1 (Summer 2005): 40–43.

Siebers, Tobin. "Words Stare Like a Glass Eye: From Literary to Visual to Disability Studies and Back Again." *PMLA* 119.5 (October 2004): 1315–1324.

Simmonds, Posy. *Gemma Bovery*. New York: Pantheon, 1999.

——— *Tamara Drewe*. Boston: Mariner, 2007.

Smith, Roberta. "Aline Kominsky Crumb, 'Need More Love.'" *New York Times* 9 March 2007: 34.

Soble, Alan, ed. *The Philosophy of Sex: Contemporary Readings*. Lanham, MD: Rowman and Littlefield, 2002.

Solomon, Deborah. "Questions for Marjane Satrapi: Revolutionary Spirit." *New York Times,* October 21, 2007, p. 28.

Spiegelman, Art. "Art Spiegelman." In Andrea Juno, ed., *Dangerous Drawings: Interviews with Comix and Graphix Artists*, pp. 6–27. New York: Juno, 1997.

——— *Breakdowns/ Portrait of the Artist as a Young %@&*!*. New York: Pantheon, 2008.

——— "Comics: Marching Into the Canon." Lecture at Columbia University. New York City, April 9, 2007.

——— "Ephemera vs. the Apocalypse." *Indy Magazine* Autumn 2005. http://64.23.98.142/indy/autumn_2004/spiegelman_ephemera/index.html. Accessed December 12, 2006.

——— "In the Dumps: A Conversation with Maurice Sendak." *rpt.* In *From Maus to Now to Maus to Now: Comix, Essays, Graphics, and Scraps,* p. 47. Palermo: Sellerio-La Central dell'Arte, 1998.

——— *In the Shadow of No Towers*. New York: Pantheon, 2004.

——— *Maus I: A Survivor's Tale: My Father Bleeds History*. New York: Pantheon, 1986.

——— *Maus II: A Survivor's Tale: And Here My Troubles Began*. New York: Pantheon, 1991.

——— "Reading Pictures: A Few Thousand Words on Six Books Without Any." In Lynd Ward, *Lynd Ward: Six Novels in Woodcuts*. New York: Library of America, forthcoming. 2010. 1–17.

——— "Spiegelman on Crumb." In "Art Spiegelman Interviewed by Gary Groth," an online excerpt from the *Comics Journal*. http://www.tcj.com/2_archives/i_spiegelman.html. Accessed May 4, 2008.

——— "Symptoms of Disorder/Signs of Genius." Introduction to Justin Green, *Justin Green's Binky Brown Sampler*, pp. 4–6. San Francisco: Last Gasp, 1995.

——— *The Complete Maus*. CD-ROM. New York: Voyager, 1994.

Spiegelman, Art, and Joe Sacco. "Only Pictures?" *Nation,* March 6, 2006. http://www.the-nation.com/doc/20060306/interview.

Stables, Kate. "Persepolis." *Sight and Sound* 18.5 (May 2008): 75–76.

Storace, Patricia. "A Double Life in Black and White." *New York Review of Books*, April 7, 2005.

Striedter, Jurij. *Literary Structure, Evolution, and Value: Russian Formalism and Czech Structuralism Reconsidered*. Cambridge: Harvard University Press, 1989.

Sullivan, Gary. "Marjane Satrapi and the Persistence of Memoir." New York Foundation for the Arts Spotlight. http://www.nyfa.org/level3.asp?id=279&fid=6&sid=17&print=true Accessed September 27, 2009.

Sundberg, Sarah. "Love Is a Desert: Iranian Illustrator Marjane Satrapi Knows That Every-

thing Bad Is Good for You." *Nerve.com.* http://www.nerve.com/screeningroom/books/interview_marjanesatrapi_cwp/. Accessed June 3, 2009.

Tebbel, John. *The Life and Good Times of William Randolph Hearst.* New York: E.P. Dutton, 1952.

Terr, Lenore. *Unchained Memories: True Stories of Traumatic Memories, Lost and Found.* New York: Basic, 1994.

Thrupkaew, Noy. "Behind Closed Doors: Marjane Satrapi Reveals What Iranian Women Talk About When They're Alone." *Nerve.com,* 2005. http://www.nerve.com/screeningroom/books/interview_marjanesatrapi/. Accessed June 2, 2009.

Tisdale, Sally. "Talk Dirty to Me." In Alan Soble, ed. *The Philosophy of Sex: Contemporary Readings,* pp. 369–379. Lanham, MD: Rowman and Littlefield, 2002.

Tully, Annie. "An Interview with Marjane Satrapi." *Bookslut.com.* October 2004. http://www.bookslut.com/features/2004_10_003261.php. Accessed May 25, 2009.

Tyler, C. *Late Bloomer.* Seattle: Fantagraphics, 2005.

—— *You'll Never Know: A Graphic Memoir (Book One: A Good and Decent Man).* Seattle: Fantagraphics, 2009.

"Up Front." By the Editors. *New York Times Book Review.* March 29, 2009, p. 2.

Vance, Carole S., ed., *Pleasure and Danger: Exploring Female Sexuality.* Boston: Routledge and Kegan Paul, 1984.

Varnum, Robin, and Christina T. Gibbons, eds. *The Language of Comics: Word and Image,* Jackson: University Press of Mississippi, 2001.

Versaci, Rocco. *This Book Contains Graphic Language: Comics as Literature.* New York: Continuum, 2008.

Ward, Lynd. *Vertigo.* New York: Random House, 1937.

Ware, Chris. "Introduction." In Chris Ware, ed., *Best American Comics 2007,* pp. xiii–xxiv. Boston: Houghton Mifflin, 2007.

Warhol, Robyn. "First-Person Graphic in Bechdel's *Fun Home.*" Address, Modern Language Association Annual Convention, San Francisco, December 29, 2008.

Warren, Roz, ed. *Dyke Strippers: Lesbian Cartoonists A to Z.* San Francisco: Cleis, 1995.

Watson, Julia. "Autographic Disclosures and Genealogies of Desire in Alison Bechdel's *Fun Home.*" *Biography* 31.1 (Winter 2008): 27–58.

Waugh, Colton. *The Comics.* New York: MacMillan, 1947.

Weaver, Matthew. "*Persepolis 2.0*: Iran Poll Inspires Sequel." *Guardian,* June 30, 2009. http://www.guardian.co.uk/news/blog/2009/jun/30/iran-protest. Accessed September 27, 2009.

Weber, Donald. "Genealogies of Jewish Stand-up." In Vincent Brook, ed., *You Should See Yourself: Jewish Identity in Postmodern American Culture,* pp. 255–271. New Brunswick, NJ: Rutgers University Press, 2006.

Webster, Paula. "The Forbidden: Eroticism and Taboo." In Carole S. Vance, ed., *Pleasure and Danger: Exploring Female Sexuality,* pp. 385–398. Boston: Routledge and Kegan Paul, 1984.

Weich, Dave. "Marjane Satrapi Returns." *Powells.com,* September 2004. http://www.powells.com/authors/satrapi.html. Accessed July 2, 2009.

Weiner, Barbara, dir. *Grandma's Way-Out Party.* With Lynda Barry and Kevin Kling. Original broadcast date April 13, 1993. Twin Cities Public Television.

Weinstein, Lauren R. *Girl Stories*. New York: Holt, 2006.

———— *The Goddess of War*. New York: PictureBox, 2008.

Welch, Stuart Cary. *Wonders of the Age: Masterpieces of Early Safavid Painting, 1501–1576*. Cambridge: Fogg Art Museum, Harvard University, 1979.

Wertham, Fredric. *Seduction of the Innocent*. New York: Rinehart, 1954.

———— *The World of Fanzines: A Special Form of Communication*. Carbondale: Southern Illinois University Press, 1973.

Weston, Kath. *Gender in Real Time: Power and Transience in a Visual Age*. New York: Routledge, 2002.

Williams, Linda. *Hard Core: Power, Pleasure, and the "Frenzy of the Visible."* Berkeley: University of California Press, 1989.

———— "Introduction: Proliferating Pornographies On/Scene." In Linda Williams, ed., *Porn Studies*, pp. 1–23. Durham: Duke University Press, 2004.

Williams, Linda, ed. *Porn Studies*. Durham: Duke University Press, 2004.

Wilsey, Sean. "The Things They Buried." Review of *Fun Home* by Alison Bechdel. *New York Times Book Review,* June 18, 2006, p. 9.

Winnicott, D. W. *Playing and Reality*. London: Tavistock, 1971.

Witek, Joseph. *Comic Books as History: The Narrative Art of Jack Jackson, Art Spiegelman, and Harvey Pekar*. University Press of Mississippi, 1989.

Whitlock, Gillian. "Autographics: The Seeing 'I' of the Comics." *Mfs: Modern Fiction Studies* 52.4 (Winter 2006): 965–979.

———— *Soft Weapons: Autobiography in Transit*. Chicago: University of Chicago Press, 2007.

Wojnarowicz, David, with James Romberger. *Seven Miles a Second: An Autobiography*. New York: Vertigo, 1996.

Wolk, Douglas. "L'Association Brings French Comics to the U.S." *Publishers Weekly,* December 6, 2005. http://www.publishersweekly.com/article/CA6289264.html. Accessed May 22, 2009.

Wood, Summer. "Scenes from the Axis of Evil: The Tragicomic Art of Marjane Satrapi." *Bitch* (Fall 2003): 55–58, 94–95.

Worth, Jennifer. "Unveiling: *Persepolis* as Embodied Performance." *Theatre Research International* 32, no. 2 (July 2007): 143–160.

Yi-Sheng, Ng. "Dyke to Watch Out For: Alison Bechdel." *Fridae.com,* November 13, 2008. http://www.fridae.com/newsfeatures/article.php?articleid=2334&viewarticle=1. Accessed April 30, 2009.

Zanganeh, Lila Azam, ed. *My Sister, Guard Your Veil; My Brother, Guard Your Eyes: Uncensored Iranian Voices*. Boston: Beacon, 2006.

Zeisler, Andi, and Lisa Miya-Jervis. "Drawn from Memory: An Interview with Phoebe Gloeckner, artist, storyteller, freaky mam." *Bitch* (Winter 1999): 38–42.

Zuarino, John. "*Bookslut*'s Indie Heartthrob Interview Series: Phoebe Gloeckner." *Bookslut. com*, October 27, 2008. http://www.bookslut.com/blog/archives/2008_10.php#013641. Accessed June 30, 2009.

———— "An Interview with Marjane Satrapi." *Bookslut.com*, November 2006. http://www.bookslut.com/features/2006_11_010204.php. Accessed June 3, 2009.

Zwigoff, Terry, dir. *Crumb*. Superior Pictures, 1994.

Index

196, 201, 202, 205, 206, 209–10, 212, 215;
photographs and, 179, 183, 185, 186, 200,
203, 211, 225*n*28; popularity of, 253*n*12,
253*nn*13–14; queer witnessing in, 255*n*26;
repetition in, 182–84, 193, 207, 213, 217;
suicide in, 77, 260*nn*67–68; touch, 175,
197, 198, 199–200, 216, 256*n*36, 258*n*52;
Ulysses and, 203, 204, 205, 206, 211–14,
259*nn*57–58; visual style, 179, 253*n*16;
William Morris wallpaper and, 179, 180

Gaps, 8; Barry and, 98, 100–103, 105, 132,
134; bodily, 198, 258*n*47; in *Fun Home*,
175, 178, 180, 182, 189, 191, 193, 195–204,
216, 217, 254*n*21; Satrapi and, 147
Gardner, Jared, 193, 225*n*4, 255*n*24, 257*n*42
Gay Comix no. 1, 24
Gaze theory, 228*n*26; male gaze and, 71–72,
81, 83
Gender, 97, 100; life narrative and, 78; mem-
oirists and, 5, 221*n*15; speech, trauma
and, 247*n*38
Gender in Real Time (Weston), 234*n*39
Genitals: Penis, drawn as oversized, 35,
41–45, 71; Penis as object, 40–41; Vagi-
nas, 45; Vulva, 236*n*13
Geno-text, 229*n*39
German Expressionism, 49, 58, 146
Ghost World (Clowes), 255*n*24
Gibbons, Christina, 7
Gibbons, Dave, 253*n*15
Gillray, James, 12
Gilmore, Leigh, 75, 78, 232*n*20, 247*n*38;
autobiographies, trauma and, 69–70; on
trauma, 69–70, 233*n*29; truth-value of
extra-legal kind and, 80–81
Girls and Boys (Barry), 96
Gloeckner, Phoebe, 2, 5, 13, 29, 30, 38, 41, 92,
95, 108, 112, 118, 134, 175, 219*n*2, 220*n*9,
226*n*9, 226*n*15, 232*n*24, 233*n*34, 235*n*10;
addressing self and collective in *Diary*,
86–87; "anticonfessionalism" and, 75;
arousal, images and, 71, 233*n*26; artistry
of, 62; beat of images and, 71; career,

64–66; censorship and, 77, 226*n*15;
R. Crumb's influence on, 16, 223*n*42;
departicularized titles in, 29; desire
and, 61, 74, 78, 79, 83; discursive truth
and, 66; dolls, 89–90; family's reac-
tion to work, 80, 84–85, 233*n*27; figures
(images), *63, 65, 67, 69, 70, 73, 76, 82,
84, 87, 88*; handwriting and, 110; images
as informed by trauma, 61; on incest,
231*n*9; interior images, 91; Kominsky-
Crumb's influence on, 20, 24, 224*n*1;
"Minnie's 3rd Love," 66, *67*, 68, *70*, 75,
76, 77, 80, 226*n*15, 232*n*21; multimodality
and, 231*n*13; new work (Juárez, Mexico),
89, 91, 234*n*36; pornography and work
of, 77–78, 91, 232*n*22; reconstruction,
word-and-image work and, 234*n*36; re-
lationship with mother, 233*n*30, 233*n*33;
repletion in images of, 64; "Sexual
Memory Game," 230*n*8; sexual politics
and, 61, 66, 68–69, 71–72, 74–75, 77–81,
86–87, 89–93; sexual trauma and, 61, 74,
78–79, 83; Stockton library and, 232*n*23;
three-dimensional work, 89–90; visual
style of, 61, 64, 230*n*3, 234*n*37; *see also A
Child's Life and Other Stories*; *The Diary
of a Teenage Girl*; *La Tristeza*
God Nose: Adult Comix (Jackson), 223*n*39
Goethe, Johann Wolfgang von, 12
"Goldie: A Neurotic Woman" (Kominsky-
Crumb), 34–37, 225*n*4; "Hard Work
and No Fun," 37; panel from, *36*; sexual
explicitness in, 21, 24
Goldsmith, Aline Ricky, 33; *see also*
Kominsky-Crumb, Aline
Goldsmith, Arnold "Goldie," 226*n*12
Goldstein, Al, 232*n*22
Goldstein, Nancy, 224*n*45
Gopnik, Adam, 15
Goya, Francisco, 12
Graham, Martha, 127
the grain (Barthes), 59, 229*n*39
Grandma's Way-Out Party, 240*n*42
Granta ("Wrought"), 208, 259*n*56

Graphic narrative, 2, 3, 50; auteurism and, 169; bodily materiality and, 59; ethics and, 3; form and autobiography, 3–7, 91, 141, 143–44, 147; idiom of witness and, 3; mapping as, 26–27; as modeling feminisms, 2; styles and, 146; testimony and, 3; trauma, form and, 2, 4, 61, 89, 173, 182, 183; work of re-imagination and, 90–93

Graphic novels, 2, 3, 14, 17; terminology and Kyle's first public use of, 15; "underground comix revolution" and, 219n3

Graphic Story World, 15

Gray, Basil, 145, 246n32

The Great Women Cartoonists, 224n45

The Great Women Superheroes, 224n45

Green, Justin, 14, 34; autobiographical genre and, 16; influence, 17, 18, 19–20; influenced by R. Crumb, 16–17; *see also Binky Brown Meets the Holy Virgin Mary*

Gregory, Roberta, 1

Griffith, Bill, 39, 62, 226n13

Groening, Matt, 235n5

Grossinger, Richard, 61, 62

Grosz, George, 49

Groth, Gary, 228n29

Guerrilla Girls, 31

Gurstein, Rochelle, 77–78, 232n24

Gutters, 257n39; colors, 163; comics and effect of, 10, 109, 141, 169, 171; as empty space, 6, 8, 9, 45, 111, 132, 172, 180, 216, 217; as Lacanian real, 257n39; lack of, 205; slim, 35, 108, 211; structure of frames and, 72, 93, 147, 163; vertical, 191

Hajdu, David, 146

Halgren, Gary, 226n10

Hampton, Howard, 233n34

Handwriting, 10–11; Barry and, 108, 110–12, 128–29, 238n24, 240n51, 240n52; the body and, 193, 195; in *Diary*, 86; Gloeckner and, 110; Kominsky-Crumb and, 59–60; materiality and, 238n28; process in *Fun Home*, 255n23, 255n25; Satrapi and, 110

Hapa, 235n2

Haraway, Donna, 26, 234n39

Hard Core (Williams, L.), 71, 227n17

"A Harlot's Progress" (Hogarth), 12

Harms, Sally, 226n13

Harrison, Kathryn, 79, 233n31

Harrison, Randall P., 11–12, 222n32

Hartley, Nina, 232n22

Harvey, Robert, 7

Hayles, N. Katherine, 238n28

Hearst, William Randolph, 13, 222n33

Heckscher, William S., 258n45

Herman, Judith, 254n22

Hernandez brothers, 228n29

Herriman, George, 13

Hillenbrand, Cathy, 237n18

Hiroshima Mon Amour, 220n8

Hirsch, Marianne, 61, 70, 246n25

History: comics, prioritizing of sequence and, 221n20; ethics of representation and, 220n8; graphic narrative and, 3, 26, 27, 135, 199; "materializing," 3; *Persepolis*, form and, 139, 145, 152, 173; queer, 255n26; self-representation and, 79, 87

History of the Comic Strip (Kunzle), 13

Hoesterey, Ingeborg, 113, 239n36

Hogarth, William, 12

Homelessness, 140

Homosexuality, 204–8, 259n53; coming out, 181, 199, 254n19; *Fun Home* and, 256n31, 259n63, 259nn59–60; gay-themed work and, 24; queer comic strips and, 251n5; *see also* Bechdel, Alison; Bechdel, Bruce

Hornby, Nick, 100, 236n12

Houghton Mifflin, 176, 252n7

Huffer, Lynne, 3

Hughes, Robert, 31

Human anatomy, medical illustrators and, 230n7; *see also* Bodies; Cadavers

Icarus, 207, 211, 213, 214

Iconology (Mitchell, W. J. T.), 27

Images, 10, 241n50; affect and, 61, 70, 71, 85, 92, 134; ambivalence assigned to, 62, 64,

Mad Comics: Humor in a Jugular Vein
(Kurtzman), 14, 15, 222*n*35, 222*n*37

Makhmalbaf, Mohsen, 137

Male gaze, 71–72, 81, 83

Malek, Amy, 140, 244*n*16

Manet, Édouard, 233*n*32

Manhunt, 32

Manuscript illumination, 246*n*31

Mapping, graphic narrative as form of, 173;
cognitive mapping, 26–27; comics as
temporal map and, 256*n*37; time into
space, 191–93

Mapplethorpe, Robert, 236*n*7

Maslenitsyna, S., 246*n*30

Mason, Chuck, 257*n*43

Mason, Jackie, 228*n*32

Masturbation, 34, 54, 71, 236*n*14

Matisse, Henri, 49, 145

Maus: A Survivor's Tale (Spiegelman), 1,
100, 119, 136, 245*n*22, 246*n*27, 247*n*36,
248*n*43, 252*n*3, 253*n*12, 253*n*14; *Binky
Brown*'s influence on, 17–18; influence,
18, 242*n*1, 243*n*10, 253*n*17; publishing
history, 243*n*6; Spiegelman on, 220*n*5,
220*n*7

Medical illustrators: Gloeckner's work
as, 230*n*8; human anatomy and,
230*n*7

Medved, Michael, 77–78, 232*n*24

Memoirs, 4, 232*n*20; as "excessive," 5; female
authors and, 221*n*15; graphic review of
nongraphic (Bechdel, A.), 253*n*15; of
Iran and Iranian diaspora, 245*n*19; *see
also* Autobiography

Memory, 32; autobiographical, 134; Barry
and, 95, 113–34; cultural memory, 113; as
different from recall, 246*n*28; epi-
sodic, 114; images, comics and, 4, 5, 119,
127–34; Olney on, 220*n*11; *Persepolis*
and, 143–44; *Persepolis* (film) and,
172; placement in space and, 114, 133,
239*n*39; trauma, images and, 114, 220*n*12;
traumatic, 4, 7, 114–16, 128, 133, 134,
233*nn*28–29, 239*n*41

Menu, Jean-Christophe, 136

Michelangelo, 197, 248*n*47

Miller, Susan, 227*n*23

Millett, Kate, 256*n*32

Milner, Marion, 241*n*49

Mini-comics, 235*n*3

Miró, Joan, 227*n*22

Mirzoeff, Nicholas, 221*n*18

Mitchell, Doris, 128–29, 132

Mitchell, W. J. T., 10, 27, 70, 122, 199,
221*n*18, 223*n*38, 258*n*51

Modan, Rutu, 1

Modern Fiction Studies, 9

Moon, Michael, 127, 204

Moore, Alan, 253*n*15

Morris, William, 179, 180

Moscoso, Victor, 15

Most, Andrea, 225*n*4

Mother: Barry's relationship with, 240*n*42,
240*n*43; A. Bechdel and relationship
with, 259*n*52; Blabette as Kominsky-
Crumb's, 227*n*19; in *A Child's Life*,
68; in *Diary*, 83, 85; in *Fun Home*, 205,
259*n*59; Gloeckner's relationship with,
66, 80, 231*n*9, 233*n*30, 233*n*33; in *Love
That Bunch*, 39–41; maternal interven-
tion with child, 79, 83, 233*n*31; in *One
Hundred Demons*, 119–20; *Persepolis*,
feminism and, 242*n*2

Multimodality, 231*n*13

Mulvey, Laura, 91

Murphy, Willy, 226*n*10

Muslims, 138, 244*n*15

Nafisi, Azar, 138, 245*n*19

Naghibi, Nima, 140, 244*n*17, 245*n*23

Nakazawa, Keiji, 220*n*4

Naked Ladies (Barry), 97–98, 99, 103–8,
220*n*9, 243*n*13; as functional object,
236*n*16; pages from, *106–7*; visual self-
insertion and, 236*n*15

Narration: disjuncture between words and
images, 141; doubled, 5; non-verbal, 162;
as self (*Diary*) and, 85

Narrative drawing (Satrapi), 6, 246*n*33;
Embroideries and, 250*n*56

Spicer, Bill, 15

Spiegelman, Art, 1, 2–3, 12, 29, 39, 62, 91, 100, 119, 135, 137, 146, 220*n*4, 222*n*31, 224*n*4, 224*n*43, 226*n*36, 232*n*19, 237*n*21, 241*n*2, 243*n*10, 250*n*62, 252*n*3, 253*n*12, 253*n*14, 253*n*17; Green's influence on, 17, 18; handmade aspect of comics, 11; influenced by Crumb, R., 16, 223*n*41; representing Jewishness and, 225*n*4; on *Maus*, 220*n*5, 220*n*7; picture-writing, 6, 247*n*33; as visible narrator, 140; visual style, 247*n*36; *see also Maus: A Survivor's Tale*

Stables, Kate, 251*n*68

Stein, Gertrude, 127

Stevens, Wallace, 256*n*35

Storace, Patricia, 246*n*27, 246*n*33

Suicide, 140, 167, 176, 195, 207, 214–16, 240*n*41, 250*n*60, 257*n*44, 257*n*49; *Fun Home* and, 260*nn*67–68; linked to coming out, 181; prevention, 83; *see also* Bechdel, Bruce

Surrealism, 43; Barry's collages and, 113; Gloeckner and, 64; sexuality and, 227*n*22; truth and the surreal, 225*n*7

Susann, Jacqueline, 11

Taboo, 13, 61, 219*n*2, 249*n*55

Taylor, Charles, 131

Tebbel, John, 222*n*33

Terminator, 251*n*69

Terr, Lenore, 114, 133, 239*n*39

Terror, 162, 239*n*39

Testimony, 3, 152; *A Child's Life* and, 66; graphic narrative as, 135; *Persepolis* as, 165–66; sexual trauma and *Diary* as, 74, 79; *La Tristeza* and, 90

Texas Ranger, 223*n*39

Theokas, Christopher, 247*n*34

300, 251*n*71

Time: contrasted with space, 10; as space, 7, 8, 9

Tintin, 139

Tisdale, Sallie, 53

Titillation, 29

Tits'n'Clits, 21, 224*n*46

Tomkins, Silvan, 30, 224*n*3

Töpffer, Rodolphe, 12

Torture, 149–51

Touching: Bechdel, A., and, 216; comics and, 199; drawing as, 175, 199, 256*n*36; in *Fun Home*, 188, 197–99, 258*n*52; vision and, 199, 258*n*51; younger versions of self, 175

Trauma, 54; autobiographies and, 69–70; behavior and repetition, 239*n*38, 254*n*22; "breaking frame" and, 231*n*16; Caruth on, 183, 220*n*6, 239*n*37; changing psychiatric definitions, 229*n*2; everyday, 40, 61; Gilmore on, 69–70, 78, 233n29; graphic narrative criticism and, 245*n*22; identity and, 2; knowledge and, 217, 239*n*37; LaCapra on, 182; memory and, 114, 220*n*12, 233*nn*28–29; *Persepolis* and, 144–52; political speech and, 247*n*38; repetition at scene of/around, 182, 220*n*6; and satire in Kominsky-Crumb, 227*n*21; space and, 113–20, 133; *see also* Memory; Unrepresentable/Unrepresentability

Trauma and Recovery (Herman), 254*n*22

La Tristeza (Gloeckner): artistic process, 89–91; blurring of stylistic registers in, 89, 234*n*37

Turner, Ron, 21, 39, 223*n*41

Twisted Sisters (book), 66, 75, 219*n*1, 224*n*47, 226*n*15

Twisted Sisters (comic book), 24, 32, 38–39, 224*n*1, 224*n*47, 227*n*16; cover, *25*; influence, 231*n*14

Tyler, C., 1, 220*n*4

Typography, 112, 238*n*30

Ulysses (Joyce), 203, 204, 205, 206, 211–14, 259*nn*57–58

Underground comix, 13–17, 18, 19; inaugural, 223*n*39; racism and, 223*n*40; women's comics in, 20–24

Underground Press Syndicate, 15

Understanding Comics (McCloud), 7

Wrinkling, 112, 238*n*29, 240*n*46
Writing Machines (Hayles), 238*n*28
Wynette, Tammy, 231*n*15

Yahrzeit candle, 252*n*3
Yellow journalism, 13
The Yellow Kid (Outcault), 13, 222*n*33

Young, Al, 245*n*20
Young Lust, 66

Zanganeh, Lila Azam, 245*n*20
Zap Comix (R. Crumb), 16, 223*n*41
Zines, 235*n*3
Zwigoff, Terry, 226*n*13

Hamlet's Mother and Other Women
Carolyn G. Heilbrun

Rape and Representation
Edited by Lynn A. Higgins and Brenda R. Silver

Shifting Scenes: Interviews on Women, Writing, and Politics in Post-68 France
Edited by Alice A. Jardine and Anne M. Menke

Tender Geographies: Women and the Origins of the Novel in France
Joan DeJean

Unbecoming Women: British Women Writers and the Novel of Development
Susan Fraiman

The Apparitional Lesbian: Female Homosexuality and Modern Culture
Terry Castle

George Sand and Idealism
Naomi Schor

Becoming a Heroine: Reading About Women in Novels
Rachel M. Brownstein

Nomadic Subjects: Embodiment and Sexual Difference in Contemporary Feminist Theory
Rosi Braidotti

Engaging with Irigaray: Feminist Philosophy and Modern European Thought
Edited by Carolyn Burke, Naomi Schor, and Margaret Whitford

Second Skins: The Body Narratives of Transsexuality
Jay Prosser

A Certain Age: Reflecting on Menopause
Edited by Joanna Goldsworthy

Mothers in Law: Feminist Theory and the Legal Regulation of Motherhood
Edited by Martha Albertson Fineman and Isabelle Karpin

Critical Condition: Feminism at the Turn of the Century
Susan Gubar

Feminist Consequences: Theory for the New Century
Edited by Elisabeth Bronfen and Misha Kavka